A LEXICON OF THE LANGUAGE OF COLOUR

A DICTIONARY OF
COLOUR

IAN PATERSON

Published by Thorogood
10-12 Rivington Street
London EC2A 3DU

Telephone: 020 7749 4748
Fax: 020 7729 6110
Email: info@thorogood.ws
Web: www.thorogood.ws

A CIP catalogue record for this book
is available from the British Library.

ISBN 1 85418 247 1

Designed and typeset by Driftdesign.

Printed in India by Replika Press Pvt. Ltd.

The purest and most thoughtful minds are those which love colour the most

Contents

Introduction

Any attempt to define any particular colour merely by means of words is doomed to failure. We can illustrate the general nature of any particular colour by reference to an object having the same quality (which begs the question) or by reference to its wavelength (which is of interest only as a matter of physics) or by reference to another colour (which becomes circular). For example, '**Purple**' is defined in the new Oxford Dictionary as 'a colour intermediate between red and **blue**'. **Blue** is defined as 'a colour intermediate between green and **violet**' and violet is 'a bluish-**purple** colour'.

This work variously employs each of the above methods, but not with a view to providing definitions of colours. The vocabulary of colour is far too imprecise to make that objective a realistic one. The best way to indicate the 'meaning' of a particular colour word is to display its actual colour. Many works have embarked on that task including, in particular, *Maerz and Paul* (A. Maerz and M. R. Paul, *A Dictionary of Color* 3rd Edition, New York, McGraw Hill, 1953). However, there is an infinite number of colours and shades, hues and tints (some suggest as many as 16 million) so that it would obviously not be possible to provide each of them with a distinct name. Furthermore, those colour descriptions which do exist do not have a sufficiently exact meaning to enable any colour to be determined with precision. No colour description in word form can convey the information necessary to enable the precise shade and tone to be identified. Indeed, some colour names included in this Dictionary have several different (and sometimes conflicting) meanings. This is only partly due to the fact that our language is in a constant state of flux. It is also as a result of the fact that the perception of colour is a highly subjective matter. Colour is nothing without sight and sight is the only sense by which we can experience colour. We experience most other stimulae through two or more senses each corroborating the other. We can, for example, both hear and feel sound and we can see, feel and smell heat. We do not have that support system with colour. Furthermore, what I interpret as being green in colour may occur to you as blue.

Rather, the purpose of this work is to provide a treasury of words of, or concerning colour, and to do so in a way which is inviting enough to encourage readers to dabble.

Single subject dictionaries are grossly under-utilised, particularly as an introduction to the subject. All too frequently this powerful resource is dusted down and used in a one-off search for a definition after which it is immediately returned to its place on the shelf. A good dictionary should be regarded as a foreign land calling out for exploration and to which each visit is a journey of discovery, each dictionary entry drawing one onto the next, sucking in the reader and making it difficult for him to leave. I hope that this work might serve just such a purpose and will attract visitors to stay and explore rather than merely to pay a flying visit.

I would hope that this Dictionary, touching on the whole spectrum of colour relevance, will serve as an invaluable resource for art students and students of colour, although it is neither a technical exposition of the many facets of colour nor a guide on how to use colour.

Much of what colour has to offer might appear to some of us as superficial and even banal. It might be thought that colour merely constitutes an alternative to black and white. Colour may merely be associated with fripperies such as cosmetics and fashion or with football shirts, the colour of the car or decorating the hall. Does colour really matter? Does it really deserve study and attention?

Well, yes it does. Not only is colour the stuff of art and a vital constituent of our everyday lives, but without it the most important discoveries and advancements of the 20th century would not have been possible. As Leonard Shlain in *Art & Physics*, New York, Morrow, 1991 explains, colour has provided the key which has made it possible for scientists to determine the elements of distant stars; to verify that our universe is expanding; to understand electro-magnetic fields; to penetrate the complexities of quantum mechanics and to work out the composition of the atom.

Dabbling in this Dictionary will immediately indicate the important role which colour performs in our everyday lives. Colour is used not merely to decorate or to adorn. It provides us with a means of distinction. Colour is nature's way of helping animals to avoid predators; to attract mates; of showing when fruit is ripe to eat or when it is rotten. Colours serve the everyday function of giving us instructions in an effective and simple way – such as with traffic lights. Colours provide a simple and immediate way to convey the degree or seriousness of situations such as flood warnings, traffic congestion, danger and security alerts, to highlight differences and to make it easier to assimilate information whether in written form or on a computer or monitor. Colour is used as a means of diagnosing illness or indicating the seriousness of a particular medical condition. Doctors have, for example, recently discovered that the colour of the spit of patients can show the severity of their lung disease.

In advertising and marketing, colour is used to grab our attention and to stimulate us by reference to the many psychological and physiological responses to colour, as well as the appeal which colour provides for our emotions. We all instinctively appreciate the dimension which colour can bring to product packaging and which it is difficult to create by any other means. Colour can serve to reinforce the identity of products, trademarks, logos and brand images and to create pleasing or favourable associations in the minds of consumers.

Colours are used to indicate those prisoners who are considered prone to escape; to differentiate one team from another in all manner of sporting activities; to enable us to play snooker and card games. Colour is used as a means of indicating status – for example, purple for nobility – and colour has throughout time served as a potent source of symbolism in all cultures.

In short, colour is a powerful shorthand for conveying ideas and information.

In deciding on the parameters of this work it soon became apparent to me that I could not limit myself merely to words which indicate or touch upon colour. Colour cannot exist without light. Hence, I have incorporated all the words I can find which refer to *light* or *illumination.* That, of course, naturally leads onto words of *darkness* and to words of *shadow* and *obscurity,* and thence to words indicating *markings* or *patterns,* all of which I have sought to include. I have, however, stopped short of including entries for animals, plants and flowers whose names include a colour since there are too many of these. I have also held back from including the plethora of fancy names created by paint manufacturers and others. Almost all the colours in this vocabulary can be found in English dictionaries.

The extent to which colour occupies and influences us can be illustrated by reference to the large number of common phrases referring to colour used in daily speech, many of which are included in **Appendix one**.

I would hope that this work might also be used as a resource for wordsmiths, crossword addicts and word game aficionados for whom **Appendix two** and **Appendix three** with their lists of colours may prove useful. The Times Crossword of Friday 22 October 1999, for example, had two consecutive clues:

- 'Earthy colour of old church attracting note'; and

- 'Red pigment in drops sprayed around house'.

Even the recognition that these clues indicate colourwords would not make it easy to find the answers (*ochre and rhodopsin*).

This work also serves as an observer of the way colourwords are used in syntax.

Writers always need ideas and refreshment and it is hoped that this Dictionary might help to provide that elusive spark of inspiration vital to keep the creative process going, particularly for those writing on subjects such as art, design, fashion, furnishings, make-up or gardening. Finding the precise colour adjective where there are so many nuances, might be made easier by referring to the list in **Appendix three**.

Colour is involved in everything we do during our working hours and even invades our dreams. But what is colour? There have been many theories over the centuries as to the exact nature of colour but none of them is adequate to explain all aspects of what colour is. The position is further complicated by the fact that the dynamics of surface colour are very different from those principles governing coloured light.

Colour is the sensation resulting from the light of different wavelengths reaching our eyes. The colour of any object is determined by the extent of the absorption of photons by its atoms. A black object absorbs nearly all the light directed onto it whereas a white object reflects most of that light. A coloured object reacts selectively to light energy – it absorbs protons of some wavelengths and reflects others. An object which is green in colour, for example, will absorb photons from the red to yellow range of the spectrum and reflect (thus enabling us to detect them) photons on the green to violet range. The selection process will depend on the particular pigments contained in that object. Caretonoids, for example, reflect long wavelengths and absorb short wavelengths, so as to produce an orange or pinkish colour. Haemoglobin produces red. Anthocyanin produces the colour of rhubarb and beetroot. Dyes and paints are based on this idea. Some dyes form a new compound with the molecules of the subject matter they are being used to colour.

It is my intention that this work with its panoply of colourwords will provide both an instructive and an entertaining opportunity to appreciate the richness of colour and its many diverse applications through the ages and across the disciplines. The study of colour and colour theory involves reference to many fields of study. A thorough investigation of the subject will involve an understanding of physics and chemistry, biology, medicine, the art of healing, computer sciences, mathematics, psychology, physiology, philosophy, literature, art; the history of art, aesthetics, heraldry, lexicography and language. This short work refers in some measure to each of these disciplines and many more, but concentrates on the last of them in celebration of our magnificent language.

I owe a debt of gratitude to my wife Linda for her unswerving encouragement and for indulging my obsession to write this Dictionary. My thanks also to Mark, Emma and Odette Paterson, Robert Glick, Amanda Blakeley, Eddie Cohen and Neill Ross for their enthusiasm and additional ideas.

Ian Paterson, April 2003

Colours speak all languages

JOSEPH ADDISON (1672-1719)

References and abbreviations

Albers	Josef Albers, 'Interaction of Colour' Yale University, 1975.
Ball	Philip Ball, 'Bright Earth. The Invention of Colour', Viking, 2001.
Chambers	'Chambers English Dictionary' W.R. Chambers and Cambridge University Press, 7th Edition, 1988.
Fielding	'A Dictionary of Colour', 1854.
Gage	A number of references to John Gage's: 'Colour and Culture' Thames and Hudson, 1993 and 'Colour and Meaning', Thames and Hudson, 1999.
Maerz & Paul	A. Maerz and M.R. Paul, 'A Dictionary of Colour', 3rd Edition New York, McGraw Hill, 1953.
OED	'The Oxford English Dictionary', 2nd Edition, Oxford University Press, CD Rom, 2002.
Partridge	Eric Partridge, 'Name into Word', Secker and Warburg, 1949.
WWW or 'World Wide Words	http://worldwidewords.org, Editor Michael Quinion.
WW1	World War 1
WW2	World War 2
Obs.	Obsolete
G	Greek
L	Latin

n **aal**

A red dye from the plant of the same name related to the **madder** plant (and a useful word for word game players).

n **abaiser**

Ivory black.

n **abozzo, abbozzo**

An **underpainting** in one colour; a sketch.

c **absinthe, absinth**

The light green colour of the potent liqueur of the same name which was banned in France in 1915 because of its effect on health and the performance of French troops at the beginning of WW1. It continues to be banned in France and in the US but is allowed in the UK where it has been imported since 1998. The liqueur takes on a milky colour when water is added.

c **acacia**

A greyish or greenish yellow colour.

c **academy blue**

A mixture of **viridian** and **ultramarine**; a greenish blue.

c **acajou**

A reddish-brown from the **mahogany** of the same name.

n **accent colours**

Highlights; sharp colours.

n **accessory pigments**

Those pigments in blue-green algae which in **photosynthesis** transfer their energy to **chlorophyll**.

n **accidental colour**

The **after-image** temporarily fixed on the retina also referred to as 'subjective colour'. When the eye concentrates on one colour and looks away the **complementary colour** often appears as a false or accidental colour.

n **accidental light**

A term used in painting to indicate any light source other than sunlight.

n **acetate dye**

A type of dye (also called **disperse**) developed for acrylic fabrics.

a **acherontic**

Gloomy or dark. Derived from *Acheron* which according to Homer was one of the rivers of Hell – its waters having a deathly foreboding appearance. 'Stygian' (in reference to the infernal River Styx of Greek mythology) has a similar meaning.

a **achlorophyllaceous**

Colourless.

n **achroglobin**

A colourless pigment in some molluscs.

n **achromate**

A person who is unable to detect colour.

a **achromatic**

Free from colour, uncoloured, colourless. From the Greek *a*- without and *chroma*-colour.

adjective	a
adverb	adv
a colour	c
noun	n
prefix	pr
suffix	su
verb	vb

n **achromatic colour**

A colour, such as white, black or grey, which lacks **hue**. White, black and grey are technically not regarded as colours having regard to the absence of hue.

a **achromatistous**

Colourless.

n **achromatopsia, achromatopsy**

The inability to see colours: a severe form of **colour-blindness**.

a **achromic**

Free from colour; without normal pigmentation. See **achromatic**.

a **achromous**

Colourless.

a **achroous**

Colourless – why should there be so many words to describe such a nondescript condition when the English language is so impoverished in the variety of words which describe colours?

n **acid colours**

Colorants such as **chromotrope**, chrome brown, **chromogen**, **acid green** and alizarin yellow used as dyestuffs.

c **acid-drop yellow**

A medium yellow.

c **acid green**

A bright green.

a **acid-washed**

Describing fabric which has been bleached to give the appearance of being worn or faded; particularly denim used for jeans – referred to as 'distressed denim'. Similar results can be obtained by other processes to produce fashion items referred to as 'stonewashed', 'bleached', 'prewashed' or having an 'antique look'.

c **acid yellow**

A medium yellow.

c **acier**

Steel-coloured; grey.

c **Ackermann's Green**

A yellowish green.

c **acorn brown**

The brown colour of the acorn; also simply referred to as 'acorn'.

c **acridine yellow**

A yellow coal-tar dye also used as an anti-bacterial agent.

n **acritochromacy**

Colour-blindness.

a **acronichal**

Occurring at sunset or twilight.

n **acrylic**

Water-based paint consisting of an emulsion with particles of plastic resin suspended in water and pigment to provide colour. Acrylic paint dries rapidly and is very durable. An alternative to watercolour and oil paint but less popular than it was in the 1960's and 70's. The word derives from ACRYLate resIN which is the **binder** used to hold the **pigment** together. Almost all acrylic paints are synthetic. They include colours such as **benzimidazolone** orange, **dioxazine purple**, **indanthrene** blue and **quinacridone** red.

n **acyanoblepsia**

The inability to see the colour blue.

c **Adam blue**

A greeny blue.

n **additive colour**

The result of mixing coloured light (as opposed to pigments such as paint and ink) so that, for example, mixing red, green and blue (called 'additive primaries' or **additive primary colours**) in colour television broadcasting or on a colour monitor will produce white light by the additive process. The process of mixing light of two different colours always produces a result which is lighter than its two forebears. See **subtractive process**.

n **additive primary colours**

Red, green and blue. See **primary colours**.

n **adjacent colours**

Colours which are next to each other on the **colour wheel** or on a painting or design etc. The placement of two colours next to each other often results in both hues taking on a different appearance so that, to take one example, red next to yellow makes the red turn towards purple and the yellow appear green.

c **adobe**

Pinkish-red; probably so called after the sun-dried bricks of the same name used in Latin American countries; also 'adobe red'.

vb **adorn; to**

To decorate or beautify something often by means of colour. Synonyms include decorate, beautify, grace, emblazon, embellish, ornament, deck, bedeck, enhance, enrich, festoon, elaborate, dress, bedaub, beset, deck out, bedizen, trim, gild, trap out, accoutre, prettify, spruce up, rig out, trick out, garnish, crown, paint, colour.

c **Adrianople red**

A red colour also called **Turkey red**.

a **adularescent**

Bluish. According to *Stormonth's English Dictionary* 1884 – having the whitish sheen of moonstone found on Mount Adula in Switzerland.

a **adumbral**

Shadowy.

n **adumbration**

Shading.

c **adust**

A scorched brown colour.

n **advancing colours**

Colours in the range of yellow to red which when applied to a surface make it appear more prominent or as if it is advancing towards the viewer. See also **receding colours**.

pr aene- (L)

Bronze.

a aeneous

Having the colour or lustre of brass.

a aeruginous

Having the colour of **verdigris** or copper-rust.

pr aethio, aetho, aethrio (G)

Bright, firy.

c african violet

The pinkish violet of the flower of the same name.

adv after dark

An ambiguous expression meaning after it has *become* dark rather than after it has *ceased to be* dark.

n afterglow

The glow remaining after the disappearance of light, in particular, in the sky after sunset.

n after-image

The sensation of colour remaining after the stimulus has ceased where, for example, one stares at an image or object and then looks away to a white surface. The shape remains fixed for a while. Often, the colour of the original image is found to be complementary to the after-image. See also **complementary colours** and **accidental colour**.

n Agent Orange

The extremely toxic defoliant used by the US during the Vietnam war. Named not by virtue of the colour of the substance but in reference to the orange stripe on its container.

adjective a
adverb adv
a colour c
noun n
prefix pr
suffix su
verb vb

pr aglao- (G)

Bright.

adv **aglow**

In the glow of a warm colour.

c **Air Force blue**

A dark blue colour. The blue adopted by the Royal Air Force in 1919.

c **air-blue**

Used to describe the light blue of the thrush egg.

n **airbrush colours**

Pigments suitable for use in airbrushes, that is, instruments employing compressed air to spray paint.

pr **aitho, (G)**

Burnt brown.

a **aithochrous**

Reddish-brown.

a **alabaster**

Akin to alabaster in its whiteness and the smoothness of its texture. Shakespeare's *Richard III*, Act 4 Scene 3 *'Gentle babes girdling one another Within their alabaster innocent arms'*.

n **alacktaka**

A red lacquer used in India as a **cosmetic** for the lips.

pr **alb- (L)**

White.

n **albatross**

The path by which many English words have journeyed to the current vernacular, with their multifarious mutations and transformations, is a fascinating study. Albatross is probably a mistaken version of *'Alcatraz'* a Portuguese word for the sea-fowl (and the origin of the the name of the prison island off San Francisco). Curiously, although the Alcatraz was black in colour the word mutated to 'albatross' to describe the white petrel of Coleridge's *Ancient Mariner* gaining credibility on its journey from the 'alb' prefix meaning white.

n **albedo**

Whiteness especially in astronomy in reference to the reflection of light emanating from a planet.

n **albescence**

A medical condition where the skin goes white through being kept in the dark for a sustained period.

a **albescent**

Becoming white.

a **albicant**

Growing white.

n **albication**

The process whereby white spots or bands develop in plant foliage.

a **albiflorous**

White-flowered.

n **albino**

A person or animal having no colouring pigment in the skin, hair or eyes; plants whose leaves do not develop **chlorophyll**. Hence, 'albiness', a female albino.

a **albinotic**

Having the characteristics of an **albino**.

n **albocracy**

Government by white people; see also **chromatocracy**.

n **alcanna, alcana**

The reddish orange body dye from the Oriental plant of the same name which is of the same family as the European **alkanet** plant.

n **aldehyde green**

A green dye also referred to as **emeraldine**.

c **alesan**

A light chestnut colour.

n **alexandrite**

A valuable gemstone named after Tsar Alexander II of Russia. Alexandrite is green in colour but appears columbine-red in artificial light. It has colour shifts from green to orange-yellow to red according to the crystal direction.

c **Algerian**

A yellowish brown.

c **Alice blue**

US term for a greenish-blue after Alice the wife of Theodore Roosevelt. As AliceBlue, one of the 140 colours in the **X11 Color Set.** It has hex code #F0F8FF.

n **alizarin, alizarine**

A synthetic red dye identified in 1820 and replacing the natural red dye from the root of the **madder** plant. It produces crimsons, greens and blues and other shades depending on the **mordant** used, in particular, **alizarin crimson**. Produced artificially since 1868 after which vineyards began to replace the redundant madder fields of Europe. This was the first natural pigment to be made synthetically. Alizarin dyes replaced aniline dyes but were themselves replaced in 1958 by **quinacridones** which have greater **lightfastness**.

c **alizarin crimson**

A bluish-red serving as a substitute for **rose madder**. See **alizarin**.

n **alkali blue**

A class of blue pigment with a very high tinting quality used in making printing inks.

n **alkanet**

An ancient red or orange dye from the roots of the Mediterranean plant of the same name and of the same genus as the **alcanna**. Also called 'anchusa'. See **henna**.

n **alkannin**

A natural bronze-coloured pigment.

n **alkaptonuria**

A rare inherited disease in which urine and ear wax when exposed to the air turn black or red depending on what food the subject has been consuming.

n **alkyd**

The group of synthetic resins used in manufacturing paint and possessing good colour retention and durability; ALcohol+aCID= ALCID or ALKYD; hence 'alkyd paints'.

n **alla prima**

The method of painting where the work is finished at one session and without any preliminary **underdrawing** or **underpainting**.

a **allochorous, allochroous**

Multicoloured or changing colour.

a **allochroic**

Changing in colour.

a **allochromatic**

Referring to a change of colour; as regards minerals, having no colour.

n **allura red AC**

A red food additive used typically in cakes and biscuits (E129).

a **all-white**

'*all*' is often used in conjunction with a particular colour to indicate an absence of any colour other than the one indicated.

c **almagra**

Deep red ochre found in Spain.

c **almond**

Pink or yellowish-brown as in almond blossom; sometimes the greyish-green colour of the underside of the leaves of the almond tree. Used to describe a variety of colours.

adjective	a
adverb	adv
a colour	c
noun	n
prefix	pr
suffix	su
verb	vb

n **almond black**

A black pigment.

c **almond green**

Greyish-green.

a **almost...**

As in 'almost black' (used in the description of certain flowers) and 'almost white'.

n **alpenglow**

The purple gleam on alpine snow.

c **Alp green**

Yellow-green.

a **alpine**

Often used as a description of fresh colours redolent of the Alps.

n **alum**

A whitish mineral also called potassium alum used as a **mordant** in dyeing. See also **burnt alum**.

n **aluminium**

The name given to one of the E food additives (E173) which gives a metallic surface colour.

a **alutaceous**

Having the colour of white leather.

c **amadou brown**

A dark reddish-brown.

c **amaranth**

The reddish-purple or deep crimson colour of the leaves of the Amarantus. The words amarantin, amarantine and amaranthine, signifying 'fadeless', 'immortal' or 'unwithering', refer to Pliny's imaginary and never fading amaranth flower. Also a purple food additive (E123).

pr **amauro- (L)**

Dark.

c **amber**

The clear yellow brown or reddish orange of the stone, amber; 'amber-colour'd raven' Shakespeare's *Loves Labours Lost* Act4 Scene3. Amber as a stone varies in colour and the colour term embraces a wide variety of shades.

c **amber yellow**

A rich **ochre**-coloured yellow.

n **amblyopia**

The condition of having defective vision.

c **amethyst**

Violet-purple or purplish-blue (particularly in heraldry); from the Greek meaning 'preventing intoxication' a characteristic once ascribed to the stone of the same name.

a **amethystine**

Having the colour of **amethyst**.

n **ampelitis**

An ancient black pigment made from burnt vine branches.

a **amphichroic**

Having a dual effect when a colour test is applied.

n **analogous colours**

Colours which appear close to or adjacent to each other on a **colour wheel**.

n **anchusa**

See **anchusin** and **alkanet**.

n **anchusin**

A red dye from the root of the **alkanet** which is also referred to as 'anchusa'.

c **anemone**

A pale violet.

n **Ångström**

The unit of measurement of the wavelength of light named after the physicist A J Ångström (1814-1874) largely replaced by the **nanometre**.

n **anil**

The blue dye now called **indigo**. 'Anil' comes from the Sanskrit word '*nila*' meaning dark blue which is also the root of the word 'lilac'.

n **aniline**

The alcohol and coal-tar base of many different kinds of dyes, in particular, 'aniline black' and **Perkin's mauve** which was one of the first synthetic dyes to be developed; descriptive of dyes and pigments made with aniline. Aniline dyes are not as **fast** as the **azo** dyes which succeeded them. Hence **aniline red** (1859), aniline violet (1860) and aniline blue (1862) the manufacture of which kickstarted the chemical industry and in particular the companies we now know as Bayer, Ciba-Geigy and BASF.

n **aniline leather**

Leather which has been dyed with **aniline** dyestuff rather than by means of pigment and which, as a result, brings out the natural grain of the leather.

c **aniline red**

See **aniline**, **fuchsine** and **magenta**.

n **anomalscope**

Testing equipment used to diagnose the existence of **colour-blindness** and to measure its severity.

n **anotta, anotto, anatto, anato, anatta, annatto, arnotto, arnatto, achiote, achote, notty**

A natural orange-red dye from Central America; also used as a food additive for colouring cheese and margarine (annatto E160(b)).

c **antelope**

The colour of the antelope. Having regard to the fact that there are so many different varieties of antelope and that they have a wide range of different colourings and markings this definition is not very helpful! Perhaps referring to a dusky brown beige or a pale bronze gold colour.

n **anthochlore**

A yellow pigment found in flowers.

n **anthocyanin(e) or anthocyan**

A group of pigments providing a large range of colours in flowers, plants and fruits including blues, purples, violets, maroons, reds and pinks – producing red when acid; blue when alkaline and violet when neutral. Anthocyanin is the name given to one of the E numbered red, violet or blue food additives (E163).

n **antholeucin(e)**

White colouring matter in plants.

n **anthoxanthin**

A yellow pigment in plants; also called **xanthophyll** and **phylloxanthin**.

n **anthracene**

Descriptive of any colour made from the hydrocarbon of the same name, for example, anthracene red and anthracene green.

n **anthraquinone**

A chemical compound related to anthracene and used to manufacture **alizarin** and colours such as alizarin blue.

n **anthraquinone colorants**

A class of dye made from **anthraquinone** used to dye textiles including anthraquinone blue.

n **antimony**

A bluish white pigment from the toxic metallic element of the same name once used as a **cosmetic** for the eyelids.

n **antimony vermilion**

A red pigment made from **antimony**.

c **antimony yellow**

See **Naples yellow**.

adjective a
adverb adv
a colour c
noun n
prefix pr
suffix su
verb vb

a **antique**

As regards colouring, having the effect or intending to have the effect of making the object appear to be antique or to resemble an antique; used as a description of many colours including brass, bronze and gold.

c **antique bronze**

A bronze colour imitative of that of very old objects; also 'antique gold', 'antique green' and 'antique red'.

c **antique ivory**

The yellowish white colour of old ivory.

c **Antique White**

A yellowish white colour adopted as a colour name by Web page creators on the Internet with hex code #FAEBD7. See **X11 Color Set**.

c **Antwerp blue**

A greenish blue variety of **Prussian blue**; also Antwerp brown and Antwerp red.

a **apatetic**

Camouflaged; in zoology, having colours similar to those of a different species. See **cryptic colouring**.

n **apheliotropism**

The phenomenon as regards plants of bending away from the light. See **heliotropism**.

a **aphotic**

Lacking light as, for example, at the depths of the ocean.

a **aplanatic**

A term in optics applied to a lens indicating that it is without spherical aberration or divergence as regards light rays.

a **aposematic**

Referring to the colouring and markings of various insects, reptiles and other animals which warn off their enemies by conveying the suggestion that the animal is dangerous or poisonous, for example, the Eyed Hawk-Moth which has markings on its wings which look like large eyes. See **cryptic colouring**.

c **apple-green**

A pale green; a colour used extensively in the making of Sèvres porcelain.

vb **apricate; to**

To expose to sunlight.

c **apricot**

The orange-yellow colour of the apricot fruit.

c **Aqua**

A light greenish-blue; a colour name adopted by Web page creators on the Internet with hex code #OOFFF. See **X11 Color Set**. The colour aqua was one of the many different colours in which lamp-posts in Notting Hill were painted for the 1999 Carnival.

c **aqua blue**

Light greenish blue.

c **aquagreen**

A light bluish green.

c **aquamarine**

Pale bluish green; sea-colour.

c **Aquamarine**

One of the 140 colours in the **X11 Color Set**. It has hex code 7FFFD4.

c **aquarelle**

A pale bluish-green. Also a technique of painting using thin transparent watercolours.

c **aran**

Beige.

n **arc light**

A lamp providing high-intensity light generated by a flow of electricity either between two rods through the air or between metal electrodes through gas; the light itself.

c **arcadian green**

A pale yellow-tinged green colour.

n **archil**

See orchil.

a **ardent**

Gleaming like a fire.

n **argaman**

An ancient purple dye made from the shellfish murex trunculus referred to in *Judges* viii:26 and rediscovered in 1998.

a **argatate**

Silvery.

c **argent**

Like silver; silvery-white colour; in heraldry a silver or white colour.

pr **argent- (L)**

Silver.

c **argental**

Having a silver content.

a **argenteous**

Silvery.

a **argentine**

Silvery; made of silver.

c **argil**

The reddish-brown colour of clay – argil being potter's clay.

pr **argyr- (G)**

Silver.

a **argyranthous**

Having silver-white flowers.

n **argyria, argyrism**

Pigmentation of the skin caused by silver poisoning or taking medicine containing silver.

n **art masking fluid**

A compound made from an easily removable rubber latex which can be applied to a particular area when painting a watercolour to enable that area to retain its background colour once the compound is removed.

c **artichoke green**

The yellowish-green colour of the artichoke.

n **artificial colours**

Colours produced by a chemical process and not found in nature, for example, **viridian**. Artificial pigments first came into commercial production in 1856. See **pigment**.

n **artificial daylight or light**

Light produced by man.

c **æruca**

A brilliant green made from acetate of copper.

n **ærugo**

Verdigris. Similar to **æruca**, but derived from carbonate of copper.

c **arylide yellow**

A light yellow mentioned in Louis de Berniere's *Captain Corellis Mandolin* (also known as **Hansa yellow** and cadmium yellow). Arylide is an aromatic compound. Also **diarylide yellow** and **azo**.

n **ASCII Purple**

The new supercomputer to be built by IBM capable of carrying out 100 thousand billion calculations each second. Its sister 'Blue Gene/L' will be even more powerful.

c **ash**

Whitish grey or brownish grey.

adjective a
adverb adv
a colour c
noun n
prefix pr
suffix su
verb vb

c **ash-blond(e)**

As regards hair, a light blonde colour; someone having this colour of hair.

c **ash-coloured**

Having the colour of ash, namely, whitish grey or brownish grey.

a **ashen**

Having the same colour as ash; having a very pale **complexion**; like ash, grey, pale; whitish grey.

c **ashes of roses**

A pinkish-grey colour.

a **ashy**

Grey; ash-coloured.

c **asparagus**

The green colour of asparagus; also referred to as 'asparagus-green'.

n **aspergillin**

A black soluble pigment from the fungi *Aspergillus*.

c **asphalt**

Having the brownish-black colour of asphalt; dark grey.

n **asphaltum**

An ancient mixture of oil (or turpentine) and asphalt used by Rembrandt. Also referred to as 'bitumen'.

c **asphodel**

The rich yellow of the daffodil.

c **asphodel green**

A yellowish green.

n **ASTM**

The American Society for Testing and Materials founded in 1898 and now known as ASTM International providing standards in many applications in over 130 industries including artists' colours which are coded according to their

lightfastness or **permanence** (Standard D4302-90). A colour with a 1 or 2 rating is the most permanent. See **Blue Wool Scale**.

pr **atr-, atri-, atro- (L)**

Black; from the Latin *ater* 'black'. The words 'atrocious', 'atrabilious' (melancholy) and possibly 'atrium' (originally, says *World Wide Words,* the blackened walls of a hall where there was a central fire but no chimney) are also derived from this root.

n **atrament, atramentum**

Black ink. Any black colorant. A very dark brown pigment described by Pliny and produced from calcined bones. In the ancient world *atramentum librarium* was used as writing ink; *atramentum sutorium* for dyeing shoe leather and *atramentum pictorium* was used by artists as a varnish.

a **atramentaceous, atramentous**

Inky.

c **atred**

Black.

vb **atrocify; to**

To blacken.

n **atromentin**

A bronze-coloured pigment in fungus.

a **atrorubent**

Reddish-black.

a **atrosanguineous**

The dark red of blood.

a **atrous**

Jet-black in colour.

a **au blanc**

A dish cooked in white sauce.

a **au bleu**

A term applied to fish poached in stock made from root vegetables, vinegar or wine which gives it a blue tinge. For example, *truite au bleu*.

a **au brun**

A dish cooked in brown sauce.

a **au gratin**

Brown – as regards the surface of food. Describing, in particular, a dish which has been cooked with cheese until it has become brown. Also applied to food cooked with breadcrumbs or in a white sauce cooked until brown. From the French, *gratiner*, to brown.

a **au rouge**

Describing a dish cooked or served in a red sauce.

c **aubergine**

The purplish-blue of the vegetable, aubergine.

c **aubergine purple**

A shade of purple.

c **auburn**

A brownish-red or sometimes golden-brown colour especially as regards hair. Auburn derives from the Latin *albus* meaning 'white' and originally indicated a yellowish or brownish white colour. Its meaning changed during the 16th century when (perhaps because it was sometimes spelt 'abrun') it came to be associated with the colour brown.

n **audition colorée**

See **synæsthesia** and **colour hearing**.

pr **aur-, auri-, auro-, aurat- (L)**

Gold, golden.

n **auramine**

A yellow dye.

pr **auranti- (L)**

Orange.

n **aurantia**

Orange-yellow dye.

n **Aura-Soma**

A form of colour therapy involving the application to the skin of a mixture of coloured oils and herbs chosen by the patient from a selection of bottles. See **colour therapy**.

a **aureate**

Gold in colour, gilded; golden-yellow.

a **aurelian**

Golden in colour.

n **aureole, aureola**

In astronomy and in relation to early paintings, a halo of light.

n **aureolin**

A yellow pigment. See **cobalt yellow**.

n **auricome**

Golden hair; hence 'auricomous' – having or regarding golden hair. See also **aurocephalous**.

a **auriferous, aurous**

Containing gold.

n **aurin**

A red pigment made from phenol, oxalic acid and sulphuric acid.

n **auripetrum**

Imitation **gold leaf** made from tinfoil painted with **saffron**.

adjective	a
adverb	adv
a colour	c
noun	n
prefix	pr
suffix	su
verb	vb

n **auripigment**

A vivid yellow also called **King's yellow** and **orpiment**.

a **aurocephalous**

Blond; having a gold head.

c **aurora**

The deep orange colour at sunrise; the dawn or first light of day.

n **aurora australis**

The phenomenon consisting of streams of light (usually red, yellow, and green) moving across the sky at the South Pole. It is thought that the so-called Southern Lights and the Northern Lights (next mentioned) appear at the same time and are in some way connected.

n **aurora borealis**

The phenomenon consisting of streams of light (usually red, yellow, and green) moving across the sky at the North Pole. See previous entry.

c **aurora yellow**

Another name for **cadmium yellow**.

a **auroral**

Resembling the dawn in colour as well as in other respects.

a **aurorean**

Having the brilliant colours of the dawn.

a **aurose**

Golden.

a **austere**

As regards colours, sombre.

n **autochrome process**

The first effective form of colour photography. The process, making use of a plate and starch, was invented by the Lumière brothers Auguste (1862-1954) and Louis (1864-1948) in 1907 and was employed until the 1940's.

n **autokinetic phenomenon**

Appearance of movement of a point of light when shown on a dark background.

n **autolithography**

A colour printing process where the artist creates his work on the plate itself as opposed to using a photographic process.

a **autumn**

An adjective used in the fashion trade to describe those colours considered to be appropriate for wear in autumn and in colour psychology to classify and differentiate between certain colour tones in their appropriateness for different personality types.

c **autumn brown**

A warm reddish-brown.

n **autumnal colours**

The colours characteristic of Autumn, particularly in reference to the leaves of the trees of the English countryside with their rich variety of russets, oranges, browns, yellows and reds. In North America the amazing colour change is referred to as 'fall foliage'. The process occurs by reason of leaves in the fall being sealed off from moisture giving rise to the **chlorophyll** in them breaking down. Their green colour thus gradually becomes masked by yellow, orange and brown pigments known as **carotenoids** also present in the leaves. There are also red and purple pigments called **anthocyanins**. The red, purples and bronzes in some trees derive from the sugar produced in the leaves being trapped by the colder temperatures. See also **erythrophyll, phylloxanthin** and **xanthophyll**.

a **avellaneous**

The light brown colour of the hazel-nut or filbert-nut.

c **aventurine**

A dark brown colour so called after the brown glass of the same name speckled with copper or gold and first manufactured in Italy.

c **avocado**

The green of the avocado – usually in reference to the pulp rather than the skin; also avocado-green. Perhaps from the Spanish *abocado* – a delicacy – or the Aztec, *ahuacatl.*

n **axanthin**

A dye used in food, for example, to dye farmed salmon pink.

c **azalea pink**

An orange-red.

n **azine dyes**

Dyes (including azinc green, azine red etc) produced from azine, an organic compound.

pr **azo-**

Indicating many kinds of coal tar dyes and colours.

n **azo, azoic**

A group of synthetic dyes and pigments mainly made from petroleum by a process known as diazotization first developed in the late 1850's and providing colours with much greater fastness than the **aniline** dyes. Azo pigments include **Hansa yellow** and **diarylide yellow**.

n **azolitmin**

The main colouring matter of **litmus**.

c **azulin, azuline**

A greyish-blue.

c **azure**

Bright blue; frequently used to describe the blue of the sky on a cloudless day. Originates from the Persian word *al-lazhward* meaning blue stone. A literary term. Also 'azure blue'. See **sky blue**.

c **Azure**

One of the colours in the **X11 Color Set**. It has hex code #F0FFFF.

c **azurine**

The colour blue; azure; greyish-blue; also a blue-black dye.

n **azurite**

A greenish-blue pigment made from the mineral, azurite, and used until the end of the 17th century as a cheaper alternative to **ultramarine** or as an undercoat to enhance ultramarine. Also used to produce a green colour, namely, **verditer**.

n **azurite blue**

A mineral pigment producing a blue dye.

adjective	a
adverb	adv
a colour	c
noun	n
prefix	pr
suffix	su
verb	vb

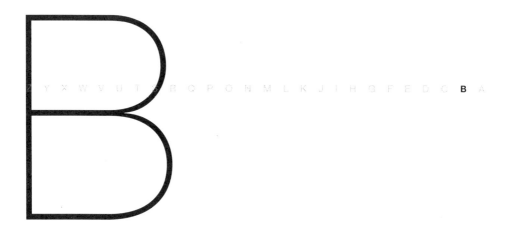

c **baby-blue, baby blue**

A pale blue. 'Baby blues' is a slang term for 'eyes'.

c **baby pink**

A pale pink.

n **background**

See **colour ground**, **ground** and **ground colour**.

n **backlight**

A light emanating from behind the subject matter. Hence 'backlit'.

c **Bacon's pink**

A YELLOW pigment invented by Sir Nathaniel Bacon (1585-1627). See other yellow pinks, for example, **English pink**.

c **badger brown**

The grey-brown colour of the badger.

pr **balio- (G)**

Spotted.

c **banana**

The yellow colour of the banana skin; also 'banana-yellow'.

n **band**

A coloured strip or stripe across a surface.

a **barely**

When used in conjunction with a particular colour describes a shade paler than that colour as in 'barely black' meaning off-black. See **almost** and **almost-white**.

n **barium chromate**

A light yellow also known as permanent yellow, yellow ultramarine and barium yellow.

c **barium yellow**

Barium chromate.

c **bark**

Dark brown.

n **baryta white**

A white pigment also known as **permanent white**.

n **base colour**

A colour which is predominant in a **colour scheme**.

n **basic colours**

According to Berlin and Kay's 1969 work *Basic Colour Terms*, there are, from a linguistic standpoint, only 11 basic colours – black, blue, brown, green, grey, orange, purple, pink, red, white and yellow. Their research involving 98 languages indicated that no language has more than these 11 basic colours and that colour names evolve in languages in a particular order. In priority, comes black and white followed by red. Then comes yellow and green (in either order) and then blue and brown. The colourwords of all those languages studied which had, for example, only five words for colours would always be black, white, red, yellow and green. See **essential colours**.

n **Basic English colours**

Basic English, devised by Charles Kay Ogden between 1926 and 1930 as an international form of English, uses only 850 words of which eight are colours, namely, black, blue, brown, green, grey, red, white and yellow.

n **Batesian mimicry**

The adoption of colouring by a harmless or edible insect or animal causing it to resemble an animal inimical to its predators. Named after the naturalist H W Bates (1825-1892). See **cryptic colouring** and **Müllerian mimicry**.

n **batik**

The art of colouring fabric by the application of wax to particular areas so that only the remainder of the surfaces absorbs the dye applied. An example of **resist-dyeing**.

c **battleship grey**

The bluish-grey colour in which battleships are often painted.

c **bay**

Reddish brown or chestnut colour used particularly in the description of horses; hence 'bay-coloured' and 'bay-brown'.

a **bdellium-coloured**

The shining or sparkling colour ascribed in *Numbers* xi. 7 to Manna, the food provided to the Jews wandering in the wilderness, comparing it to bdellium in its appearance.

n **beam**

A ray of colour or light.

vb **beam; to**

To shine; radiate light; radiate.

a **beautiful**

Originally had the meaning of being light in colouring.

c **beaver**

The greyish brown colour of beaver fur; hence 'beaver-brown' and 'beaver-coloured'.

a **beaver-hued**

Having the colour of a beaver.

vb **bedizen; to**

To dress in a flashy overdecorated manner.

c **beech-green**

A shade of green.

c **beeswax**

A dark orange.

c **beet**

Deep purple-red after the vegetable of the same name.

n **beet red, beetroot red**

The food additive (E162) producing a reddish purple colouring. Also called betanin.

c **beetroot red**

The deep reddish-purple of the vegetable, beetroot.

a **begaired**

Variegated; possibly from the French *bi* (twice) and *garre* (of two colours) (obs.).

c **begonia**

Yellowish-red found in the flower of the same name.

c **beige**

A light brown or yellowish grey. Popular for fashion fabrics but 'renamed' camel, taupe, stone or sand to avoid appearing dated! Beige has the same meaning as écru and grège each being French terms for wool or cloth in its unbleached condition and originally designating a grey colour. First recorded as a colour in 1879.

adjective	a
adverb	adv
a colour	c
noun	n
prefix	pr
suffix	su
verb	vb

c **Beige**

One of the 140 colours in the **X11 Color Set**. It has hex code #F5F5DC.

n **belleric, beleric**

An Indian fruit producing a black dye; the dye itself.

vb **belt; to**

To colour by means of stripes.

a **belted**

As regards animals, having a band of colour round its midriff different from the colouring of the rest of its body as in the case of the spectacular Belted Galloways – the once rare breed of black cattle having a thick white band around it.

n **belton**

The dual colour combination of a dog's coat, for example, the lemon and blue colours of some collies.

vb **benegro; to**

To blacken or darken. The term 'Negro' is now offensive and no longer appropriate to use.

n **Bengal light**

A flare burning with bright blue light and used as a signal.

n **Benham's disk**

A disk with black and white markings which when spun creates the illusion that the disk is coloured.

a **benighted**

Beset by darkness or night; in a pitiful state – *'The outlook for the benighted country is darker than ever'* The Times of 12.5.00.

n **benzathrone**

A yellow powder employed in making vat dyestuffs.

n **benzene**

A flammable toxic compound made from **coal tar** used to manufacture certain dyes.

n **benzidine**

A crystalline compound used in some **azo** dyes including **Congo red**.

n **benzimidazolone**

A class of synthetic organic pigments producing colours such as benzimidazolone yellows, oranges and maroons.

n **berberine**

A yellow dye from the African tree of the same name.

c **berettino**

A bluish-grey hue used in the glazing of the Italian pottery, Maiolica.

n **Berlin black**

Black pigment; a black varnish used on iron.

c **Berlin blue**

Often the same as **Prussian blue** but also a lighter sapphire blue.

a **berry-coloured**

Used as regards **make-up** to describe the red/violet colours. Also 'berry'.

c **beryl**

Pale sea-green or greenish-blue being the colour of the stone, beryl; hence berylline – of the colour of beryl.

a **bespeckled**

Marked or covered in speckles or spots.

n **beta-apo-8'-carotenal**

The orange/reddish yellow food additive (E160(e)).

n **beta-carotene**

A pigment found in carrots and green vegetables. See **carotene**.

n **beta-crustacyanin**

See **pink**.

n **beta-naphthols**

A class of synthetic organic pigments.

n **betanin**

The natural colourant made from the beetroot; see also **beet red**.

n **betaxanthin**

Yellow pigment.

n **bête noir**

A person or thing which is insufferable or the object of displeasure. Literally in French 'black beast' possibly reflecting an ancient fear of black animals.

n **bezetta**

A red or blue dye.

n **Bezold effect**

The optical effect, named after its discoverer, Wilhelm von Bezold, where by changing one colour in a pattern (for example in a rug design) the whole appearance of that rug changes.

n **bible colours**

The colours found in the Bible according to most translations into English are: white, black, brown, blue, purple, red, vermilion, scarlet (or crimson), yellow, green, gold and silver.

c **bice**

The pale blue or green obtained from **smalt.** There is no settled view as to the origin of this word. It is thought that the word derives from the Latin *azura debilis* meaning a weak blue as compared with the richer pigment *azura pura* meaning the best blue. Ball in *The Invention of Colour* has a contrary view, namely, that in the 14th century 'bys' meant 'dark', but 'bys' eventually detached itself from the colour 'azure bys' and came to be used to describe the colour rather than its shade. 'Bice' subsequently became a generic term for a pigment based on copper.

a **bichrome**

Having only two colours.

a **bicoloured, bi-coloured**

Having two colours.

n **Big Blue**

A slang term for IBM – International Business Machines.

n **Bikini alert colours**

Those colours used by the Ministry of Defence and in United Kingdom Government offices and bases abroad to indicate the current state of alert as regards possible terrorist activity. Bikini white indicates the lowest level of alert, Bikini black is the normal level of alert, and Black Special indicates a high level of alert. This is followed by amber, a state of alert (reached, for example, on September 11, 2001) in anticipation of imminent terrorist activity. Red alert indicates the very highest level of security risk. See Red alert.

a **bilious**

Describing discordant shades, for example, 'bilious blue' *The Times* 1.9.99.

n **bilirubin**

Orangey-red coloured pigment in the bile which if not excreted causes jaundice.

n **biliverdin**

A dark green bile pigment produced by the oxidation of **bilirubin**.

n **billiard ball colours**

English billiards is played with three balls: two white balls, being cue balls, one of which has a black spot on it and one red ball which is struck only by the other balls.

c **billiard green**

The deep green of the baize on billiard/snooker tables.

n **binder**

Any **medium** which is mixed with **pigment** so as to give it body enabling it to be manipulated and the ability to adhere to the surface. See **gum arabic**.

n **biochrome**

A colouring matter of animals and plants.

n **bioluminescence**

The light generated by living things such as, for example, fireflies, certain crustaceans and deep sea fish, the function of which may be to aid courtship or to act as a diversion.

adjective	a
adverb	adv
a colour	c
noun	n
prefix	pr
suffix	su
verb	vb

c **bird's-egg green**

A pale green or bluish green. See **ooxanthine**.

a **birdseye**

A textured effect in fabric created by weaving a mixture of white and coloured thread producing tiny white dots (or birdseyes) in the fabric.

n **birthstone colours**

There are many different lists of modern and traditional birthstones and their corresponding colours most of which refer to the calendar months rather than to the star signs. Both the American National Association of Jewelers and the National Association of Goldsmiths in Great Britain and Ireland have promoted their own lists. The following is an amalgam of a number of lists:

deep dark red	**January**	garnet or rose quartz
purple or lavender	**February**	amethyst or onyx
pale blue	**March**	aquamarine or bloodstone
clear or no colour	**April**	diamond or rock-crystal
dark bright green	**May**	emerald or chrysoprase
cream or lavender	**June**	pearl or moonstone or alexandrite
red	**July**	ruby, cornelian, (carnelian) or onyx
pale green	**August**	peridot or sardonyx
deep blue	**September**	sapphire or lapis lazuli
variegated, pink, or rose	**October**	opal or tourmaline
yellow or gold	**November**	topaz or citrine
sky blue or turquoise	**December**	zircon, turquoise or blue topaz.

c **biscuit**

The light brown colour of a biscuit; hence 'biscuit-coloured'. From the Italian *biscotto*, 'twice-cooked'. First recorded as a colour in 1884. Also describing pottery after first being fired and prior to its decoration.

c **Bismarck**

A leather-brown colour.

c **Bismarck brown**

A brown dye also known as phenylene brown, Manchester brown and vesuvin. Used as a stain for histological purposes.

n **bismuth chromate**

An orange-red powder used as a **pigment** in paint.

c **bisque**

A pale pinkish or yellowish brown colour. First recorded as a colour term in 1922.

c **Bisque**

An **X11 Color Set** colour. It has hex code #FFE4C4.

c **bistre**

A dark brown colour; the brown pigment or wash used in pen and ink drawings made from boiling the soot of wood, particularly, beechwood and used by Renaissance painters. Also 'bistre brown'. Superseded by **sepia**.

n **bitumen**

Black **asphaltum**; an unstable brown pigment often the cause of cracking in paintings.

n **bixin**

A peach food colouring agent (E160 (b)).

a **bizarre**

Striped or **variegated** especially as regards flowers.

vb **black; to**

To boycott the sale or distribution of certain goods or services.

c **black**

Having the colour of coal; the blackest looking object will be one which reflects the least light; the absence of any light; dark; enveloped in darkness; lacking in hue; the opposite of white. The colour of mourning. White, however, is the colour of mourning in China, India and parts of the Far East. A symbol of penitence; associated in medieval times with the Zodiac signs Capricorn and Aquarius and with the planet Saturn. The colour of the ring second from the outer ring in archery. Technically, black is not a colour, but the absence of all colour. Although black traditionally represents death, evil and gloom it also represents good luck in English folklore – chimney-sweeps, black cats and coal are all supposed to bring good fortune.

n **black**

A stain or polish to blacken leather boots and shoes; a black pigment.

a **black**

Dirty or unclean; having a deadly, nefarious or wicked purpose; illegal; evil; melancholy; pessimistic, gloomy or dismal.

c **Black**

One of the **X11 Color Set** colours. It has hex code #000000.

n **Black**

Pertaining to those of African or Asian origin – see **coloured**.

n **Blackacre**

A convenient shorthand used by lawyers for a plot of land so as to be able to distinguish it from another called 'Whiteacre'.

n **black-act**

The Act of Parliament which once made it an offence to black one's face to go poaching.

n **Black and Tans**

The armed force fighting the Sinn Fein in the 1920's; so called by reason of the colours of their uniform.

n **blackamoor**

From a 'black Moor'; an archaic term of a person with a dark skin.

n **black and white**

Not in colour; in reference to the distinction between non-colour television programmes or photographs and those supported by colour; descriptive of a regimen based on two extremes with no middle course. Slang for a 'police car'.

n **black arts, the**

The practice of witch-craft.

vb **blackball; to**

To vote against an applicant or candidate, for example, for club membership; to ostracize. The phrase originates from the system of voting in secret where each voter has a black and a white ball either of which he may place in the voting box – the black ball signifying a negative vote.

n **black beauty**

A black horse.

n **black belt**

One of many coloured belts indicating the level of proficiency in the martial arts attained by the wearer. Colours differ from sport to sport and country to country. In Japan and the USA, for example, the first six student grades in Judo are represented by the white belt and the brown belt. In other countries the first six grades follow the order: white, yellow, orange, green, blue, and brown. Thereafter the sequence is black, black or red and white and then red.

c **blackberry**

The colour of the dark purple fruit of the *Rubus* family.

n **black bile**

See **melancholy**.

c **black black**

The colour black when worn to indicate mourning; grieving black. A visit to the Staffordshire County Museum at Shugborough Hall (near Stafford) has revealed the rigorous colour rules for mourning which was recommended in the last quarter of the 19th century. A widow was to mourn for two and a half years wearing bombasine black for the first year and a day with heavy black crepe; she could wear less crepe in the next 9 months; black silk and jet jewellery in the next 3 months and grey or mauve in the last 6 months of mourning. See **black tie**.

n **blackboard**

A slate or board used in schools for writing on with **chalks**.

n **blackboard jungle**

A school of ill-disciplined pupils.

n **black boding**

Portending bad news.

n **black box**

The flight recorder used in all commercial aircraft to record instrument readings and flight crew conversations in order to assist the investigation of crashes. It is, in fact, usually orange in colour to allow for easier detection.

adjective a
adverb adv
a colour c
noun n
prefix pr
suffix su
verb vb

n **black bread**

Dark bread often made from sour dough; bread made from rye flour. See also **brown bread**.

n **black-browed**

Scowling or frowning.

n **black cab**

The ubiquitous London taxicab although many now carry advertisements and come in many different colours.

n **black cap**

The black head covering which was donned by judges prior to passing a sentence of death.

n **black cards, the**

Those 26 playing cards in the deck consisting of spades and clubs. The division of cards into spades, clubs and the red, diamonds and hearts originated in France around 1480.

n **black cats**

Black cats are regarded in European folklore as bringing bad luck carrying associations with the devil and witchcraft whereas in African-American tradition the black cat brings good luck. According to recent research black or dark-haired cats are six times more likely to cause humans to suffer allergies than cats with lighter hair.

n **black-cattle**

Bulls, oxen and cows.

a **black-clad**

Dressed in black. See **black black**.

n **black coffee**

Coffee without milk; Diner to waiter: 'I'll have coffee without milk please'. Waiter in reply 'I'm sorry we don't have any milk. Will you have coffee without cream?'.

n **black comedy**

A form of drama often displaying cynicism and disillusionment and dealing with death, disease or some other macabre or calamitous situation in a way which generates painful amusement.

n **Black Country, the**

The parts of Warwickshire and Staffordshire which used to be involved in heavy industry one particular by-product of which was soot and grime.

c **blackcurrant**

The colour of the round black berry of the *saxifrage* family.

n **Black Death, the**

The Bubonic Plague which it is estimated killed a quarter of the population of Europe in the 14th century. It was not called the Black Death until 1823.

n **black diamond**

Slang for truffles. Also a type of Brazilian diamond. **See diamond colours**.

n **black dwarf**

A small dense star resulting from a cooled **white dwarf**.

n **black economy**

In reference to earnings which are not disclosed to the revenue authorities or other appropriate Government authority; trading which is unlawful or underground.

a **blacked**

Coloured black.

vb **blacken; to**

To make black; to become black.

n **black eye**

The discolouration or bruising to the eye caused by a blow. Since the skin around the eye is loose the bruising is often darker than to other parts of the body. See **Phrases**.

n **black fast**

A fast involving abstinence from both eggs and milk.

n **black flag**

A flag made of black cloth indicating some deadly or nefarious purpose of the bearer, for example, pirates and the Jolly Roger and the Royal Navy flag indicating execution. Also in motor racing the flag used to indicate a dangerous situation requiring a driver to stop.

n **Black Friday**

Used in reference to a variety of calamitous events through history occurring on a Friday and perhaps originating from the time Good Friday was referred to in Britain as 'Black Friday' because the clergy wore black. There has been a series of Black Fridays in US stock market history. See also **Black Monday** and **Blue Monday**. Apparently, the rest of the week portends less risk of disaster although the 'Black Tuesday' of 29th October 1929 was the worst day of the 1929 Wall Street crash, the fall on Wednesday 23rd October 1929 referred to as 'Black Wednesday' was significant and the stock market panics in the US on Thursday 9th May 1901 and Thursday 24th October 1929 are each referred to as being a 'Black Thursday'. Wednesday 16th September 1992, the date when the Conservative government in the UK ignominiously pulled out of the European Exchange Rate Mechanism or ERM, is also referred to as 'Black Wednesday'. The term 'Black Saturday' has also been coined.

c **black glamma**

A rich dark black colour as applied to the fur of the mink.

n **black gold**

Colloquial term for oil or petroleum.

n **blackguard**

A scoundrel; a vicious contemptible person; originally a shoe black.

n **black hats**

A term used to describe those Chasidim or ultra religious Jews who wear wide-brimmed black hats. 'Black Jews' is a term given to the Falashas, the Jews of Ethiopia most of whom now live in Israel.

n **blackhead**

A mass of fatty substance protruding from the skin having a black tip – the blackness resulting from a change in pigmentation caused by exposure to sunlight. It is a feature of types of acne.

a **black hearted**

Evil or malevolent.

n **black hole**

A singularity in space having a massive gravitational pull from which nothing can escape and resulting from the collapse of a huge star at the end of its life.

n **black hole of Calcutta**

A prison in Calcutta in which 123 British prisoners were alleged to have suffocated in 1756; hence any wretched place.

n **black ice**

A layer of ice not immediately apparent to the traveller.

n **blackjack**

A card game also called pontoon, vingt-et-un and twenty-one. 'Pontoon' is possibly a corruption of 'vingt-et-un' owing to the combination of mis-pronouncing the French term as 'vontoon' and confusing it with the word 'pontoon' – a bridge.

n **Black Japan**

A heat-resistant black paint or varnish made from **asphaltum** and oil.

n **black lead**

Graphite.

n **black-leg**

Someone who is prepared to work for an employer in defiance of other employees who are on strike.

n **black-letter**

An old heavy typeface with ornate angular letters also known as Gothic or Old English. A 'black letter day ' is an unlucky day such as Friday the 13th of any month. The Romans indicated lucky days in their calendars in white while unlucky ones (there were apparently 24) appeared in black and were called *dies mali* from which the word 'dismal' originates. This idea was later extended by designating religious feast-days in the Church calendar in red thus giving rise to the **red-letter day**. 'Black-letter law' refers to long established legal rules and

adjective	a
adverb	adv
a colour	c
noun	n
prefix	pr
suffix	su
verb	vb

by extension to laws as they are strictly (or literally) construed. In adopting a 'black-letter' approach a lawyer is sometimes regarded as being concerned simply with what the law is rather than with WHY the law is what it is.

n **black level picture**

The absence of any illumination on the monitor or display unit.

n **black light**

A means of communicating between ships used in WW2. It employed **infrared** thus avoiding detection by the enemy.

n **blacklist**

A list of persons compiled with the purpose of inhibiting their ability to obtain employment, membership of a particular organization or some other advancement.

adv **blackly**

In a dark or gloomy manner; also used as an adjective as in '*it is a blackly comic tour de force*' (jacket of '*Lullaby*' by Chuck Palahniuk (my son's favourite author)).

n **black magic**

Sorcery. Derived from the Latin *necromantia* – the revelation of the future by reference to the dead. This, by association, was transformed into *nigromantia* and, in turn, translated into 'black magic' although *necromantia* has no connection with 'black'.

n **blackmail**

Unlawful conduct involving the making of threats and the use of intimidation to exact money or other value. The word originated in Scotland – 'black' being derived from the Gaelic '*blathaich*' meaning to 'protect' and 'mail' in Scotland meaning 'rent' or a 'tribute' – hence a tax for protection. The extortion of grain or cattle came to be referred to as 'black mail' in contrast to 'white mail' which involved the exaction of silver. In Devon and Cornwall until 1838 the dues of eight pence a year paid by tin mines to the Duke of Cornwall in silver was referred to as 'white rent'. In this way the word 'blackmail' became associated with hue although its etymology has nothing to do with colour.

n **Black Maria**

A card game also known as 'Hearts'; a police or prison van.

n **black market**

An illicit or underground market in goods; hence 'black market goods'.

n **Black Monday**

Used in reference to various disastrous events such as the great Stock Market crash of 19th October 1987 beginning in New York and spreading to London, Tokyo and the rest of the world. There are many earlier so-called Black Mondays. See **Blue Monday** and **Black Friday**.

n **black money**

Money which is not declared to the revenue authorities or which is a result of the **black economy**.

n **blackness**

The state of being black or without light.

n **blackout**

A temporary loss of consciousness as a result of the brain being suddenly deprived of blood supply; a situation such as an air-raid where all lighting is to be extinguished. A temporary loss of electrical power as contrasted with a **brown-out**.

n **black pepper**

The condiment made from grinding the berries and black husks of the pepper plant.

n **black pieces**

The black pieces in chess, draughts, backgammon, go and other games. The pieces in these games are traditionally black and white although draughts' pieces are sometimes red and white.

n **black PN**

A black food additive (E151).

n **black pod disease**

A fungus disease affecting cacao trees and threatening the production of chocolate.

n **black power**

A slogan of the black civil rights movement.

n **black pudding**

A black sausage made with blood and pork fat.

n **Black Rod**

A senior usher of the House of Lords so called because of the rod carried on ceremonial occasions. See also **Silver Stick**.

n **Black Sabbath**

The heavy metal rock group. There are, of course, many groups and organizations with a 'Black' appellation including the Black Monks (an order of Benedictine monks wearing a black habit), the Black Panthers (members of a US militant organization in the 1960's), and the Blackshirts (particularly the Italian fascists of the 1930's and 1940's).

n **Black Sea**

The Sea which is bordered by Ukraine, Russia, Georgia, Turkey, Rumania and Bulgaria.

n **black sheep**

See **Phrases**.

n **blackshirt**

A member of a fascist organization, for example, the Italian fascists of the Second World War.

n **blacksmith**

A person who works in iron usually with the aid of an anvil and a furnace. See **whitesmith**.

n **black smokers**

A colloquial term for the hydrothermal vents releasing gushes of billowing black smoke from the seabed.

n **black spot**

A location at which traffic accidents frequently occur or which is notorious for undesirable goings-on. A term considered by the Sussex police force in 1998 to be politically incorrect.

n **blackstick**

Slang for the clarinet.

n **black studies**

That part of the academic curriculum dealing with African or Afro-American culture.

n **black stuff**

Slang for oil. See also **black gold**.

n **black tea**

Black tea leaves; apparently as high in antioxidants as green tea; tea without milk.

n **black tie**

A black bow-tie worn usually worn with evening dress, the whole uniform elliptically referred to as 'black tie' especially in invitations. This became the fashion after Prince Albert's death in 1861 – Queen Victoria never having lifted it as official court mourning. Before then, evening dress for men was splendidly colourful.

n **black velvet**

The drink made from combining champagne with stout.

n **blackwood**

A bidding convention in the card game, bridge, whereby it is possible (assuming your partner remembers the rules) to find out how many Aces and Kings he or she has in his hand. Also Roman Key Card Blackwood – an advanced form of the convention which can find out even more of what is in your partner's hand!

c **blae**

Between black and blue as the blaeberry or bilberry.

n **blanc de chine**

Unpainted white or cream porcelain originally made in China from the 17th century.

n **blanc fixe**

A synthetic white pigment.

adjective a
adverb adv
a colour c
noun n
prefix pr
suffix su
verb vb

vb **blanch; to**

To whiten or cause to lose colour.

c **Blanched Almond**

A light yellow – one of the colours in the **X11 Color Set.** It has hex code #FFEBCD.

n **blancmange**

A thickened dessert made from milk and resembling jelly in its consistency – literally 'white food' and originally describing a meal of white fish or white meat.

c **blancmange-pink**

A pale pink.

n **blanco**

A substance used to whiten leather.

a **bland**

Colourless, insipid, lacking in stimulation.

c **blatta**

Purple; also the name for silk dyed purple.

n **blaze**

A white stripe on the faces of certain cats, dogs and horses stretching from between the eyes to the muzzle or mouth.

a **blazing**

Flaming, shining. Also used as an adjective of colour especially as regards such as yellow, red and orange.

n **blazonry**

Brilliant colouring as in the colouring of heraldic devices and coats-of-arms. See **heraldic colours**.

vb **bleach; to**

To whiten or to grow pale. An obsolete use of the word has the opposite meaning, namely, 'to blacken'. 'Bleach' is possibly derived from 'black' although some authorities suggest that it comes from the Old English word 'blaec' meaning 'shining'.

n	**bleach**

A substance which is intended to remove stains or colour or to impart colour particularly to hair.

a	**bleak**

Pale.

n	**blee**

Archaic term for a hue or colour.

n	**bleeding**

The spilling over of colour from one section to another coloured section; in painting, the coming to the surface of an **undercolour**.

vb	**blench; to**

To make something white or pale; to become white or pale.

vb	**blend; to**

To combine colours.

n	**blending**

The technique used in oil painting of mixing colours so as to obtain an even gradation of colour on the painted surface.

a	**bloached**

Variegated with blotches (obs.).

n	**blob**

A small blotch of colour.

c	**blonde (f), blond (m)**

Light or fair in colour; especially as regards hair; a light golden colour; hence a person having such hair.

c	**blood-dark**

A dark red.

c **blood-red**

A dark red colour; a rich bluish red.

a **bloodshot**

Reddened (particularly of the eyes).

n **bloodstone**

The name given to red stones such as the **garnet** and the **carnelian**.

c **bloody**

Having the colour of blood.

c **bloom**

'*the blue colour upon plums and grapes newly gathered*' Samuel Johnson; hence 'bloomy'.

n **bloom**

The powdery dappled appearance on the surface of some fruit (see previous entry); the effect created in **watercolour** painting when one **wash** merges into another.

vb **bloom; to**

To glow with colour.

c **blossom**

A soft pink.

n **blot**

A stain, blemish or patch.

vb **blot; to**

To make a stain with ink.

n **blotch**

An irregular application of colour; an irregular patch of colour in particular of ink; hence 'blotchy'.

a **blowzed, blowzy**

High-coloured; ruddy especially as regards the **complexion**.

c **blue**

The colour of the sky or of the sea. One of the three primary colours (but not until the 16th century). The word blue as the name of the colour has had an uncertain history. In some languages there is no name for the colour and it was not regarded by the ancients as a primary colour. It has been confused linguistically with the colour yellow – *flavus* being both the root of 'blue' and Latin for yellow. (See *Cæruleum*). In the Russian language there is no one word for blue, but two words one meaning dark blue and the other light blue which are regarded as different colours. Describes any colours having wavelengths between approximately 480 and 445 nanometres. One of the three **additive primary colours**. Coloured or tinted lenses are used to correct various reading disorders including some forms of dyslexia and blue lenses apparently are the most effective. A symbol of piety; associated in medieval times with the Zodiac signs Pisces and Sagittarius and with the planet Jupiter and with darkness. In English folklore blue represents loyalty, is the colour for baby boys and is supposed to bring good luck to brides who heed the superstition to wear on their wedding day *'something old, something new, something borrowed, something blue'*. Blue is the colour of the ring second from the centre in archery. Conservative – in relation to the Tory Party in the UK.

a **blue**

Risqué as in 'blue jokes'; pornographic. One theory put forward in *World Wide Words* as to the origin of 'blue' to indicate pornography is that prostitutes used to wear blue gowns in prison and were referred to as 'bluegowns'. In China a pornographic book is referred to as a 'yellow book'.

a **blue**

Melancholy.

n **blue**

Someone who represents the Universities of Oxford or Cambridge in some game, sport or other activity – a dark blue for Oxford and a light blue for Cambridge. Hence 'a blue' is the honour received as well as the person receiving it Also used as regards Eton and Harrow Schools. See **Cambridge blue, Oxford blue**.

adjective a
adverb adv
a colour c
noun n
prefix pr
suffix su
verb vb

c **Blue**

One of the 140 colours in the **X11 Color Set**. It has hex code #0000FF.

n **blue baby**

A new-born baby with **cyanosis,** having a lack of oxygen in its blood caused by a congenital defect.

n **blue bag**

The blue sack traditionally used by barristers to carry their papers.

n **blue beads**

According to the superstition rife in London amongst the working class, at least until WW1, wearing blue beads wards off bronchial problems.

n **Bluebeard**

A mythological man who is said to have murdered his wives after locking them in his tower.

c **bluebell**

The blue colour of the plant of the same name having blue bell-shaped flowers also called 'wood hyacinth'.

c **bluebird**

Used in reference to the colour of the plumage of this bird.

c **blue-black**

Black with a touch of blue.

n **blue black**

A kind of **carbon black**. See **Frankfort black**.

n **blue book, the**

Jargon term for particular registers, official publications, directories, manuals, rulebooks and the like in various callings and professions so called by reference to the colour thereof.

n **blue-bloodied**

Having noble or royal ancestors; from the Spanish *sangre azul* meaning pure Spanish ancestry with no Moorish blood.

bluebottle

Nickname for a policeman; the cornflower; the blow-fly.

Blue Carpet

£800,000 was spent in 1998/9 on painting 2,500 sq. metres of central Newcastle-Upon-Tyne in blue – the so-called 'Blue Carpet'.

blue cheese

Cheese the mould in which creates blue-green veins. Amongst the best known are Gorgonzola, Stilton, and Roquefort.

blue chip

Top notch or first class as in 'blue chip securities'. The phrase dates from 1929 and originates from the blue chips which were often the highest denomination chips at the gaming table.

blue-collar worker

A manual worker.

blue devils

A fit of melancholy.

Blue Ensign

A flag which has a blue background and bears the Union Jack in the corner, flown by some Royal Navy vessels and yacht clubs.

Blue Flag

The acknowledgement given to European seaside resorts for maintaining the cleanest beaches.

Blue Four, the

Der Blaue Reiter (Blue Rider) the group of avant garde artists formed by Kandinsky, Klee, Marc and Feininger in 1911 which had a significant influence on modern art before WW1.

Blue Gene/L

See **ASCII Purple**.

n **bluegrass**

A type of US country music played on stringed instruments including the banjo.

c **blue-green**

There are, of course, an infinite number of colour combinations – this one is chosen as a representative so as to give some recognition to the almost extinct Tansy beetle whose blue-green iridescent wing casings were used in Victorian days to decorate dresses. Seven down *The Times Crossword* 6.2.03: '*Blue, not green*'. (5 letters). See **Solution to blue-green crossword problem**.

n **blueing**

The blue substance used by laundries to prevent clothes going yellow.

n **blue, in the**

The light blue condition of leather which has been subjected to chrome tanning. If sold in a partly-processed wet condition such leather is referred to as 'wet blue leather'.

n **bluejacket**

A sailor.

n **blue jeans**

The ubiquitous blue denim trouser invented by Levi Strauss. On BBC Radio 4 on 27 May 1998 mention was made of growing blue cotton so as to avoid the need to dye it for use in manufacturing blue jeans.

n **blue joke**

A joke containing some explicit reference to sex; a risqué or pornographic joke. In other languages different colours fulfil a similar role to describe such humour, for example, in Spanish the term 'green joke' is used and in Japanese 'pink joke'.

n **blue law**

US term in reference to repressive Puritanical laws regulating individual conduct in Colonial times including laws prohibiting adultery – the penalty for which was death – and restricting entertainment and business activities on Sundays. Possibly so called because of the blue posters announcing the new laws.

n **blue-light**

Slang for an emergency in reference to the flashing lights on the vehicles of the emergency services.

n Blue Monday

A Monday on which the trading of stock on Wall Street is slow perhaps after the Blue Monday of the Middle Ages being the Monday before Lent when last minute drinking caused serious hangovers! Monday 11th June 1928 (which saw a significant fall in the San Francisco Stock Exchange), Monday 28th May 1962 (a major drop in the Dow Jones index) and Monday 21 November 1966 (a serious market decline on Wall Street) are also referred to as being a Blue Monday. See **Black Monday** and **Black Friday**.

n blueness

The quality of being blue in colour.

n bluenose

Someone with puritanical or prudish views possibly in reference to **blue laws**.

vb blue pencil; to

To edit or censor script in reference to the traditional blue pencil often used by editors for this purpose.

n Blue Peter

The blue flag with a white square indicating a boat's imminent departure from port. Possibly a corruption of 'blue repeater' which was displayed to ask another vessel to repeat an earlier message. Also a classic long-running children's programme on BBC television.

n blue period

The period between 1901 and 1904 during which Pablo Picasso (1881-1973), affected by the suicide of his close friend Casagemas, used a characteristic blue in a variety of shades in each of his paintings depicting melancholy and misery. This was followed between 1905 and 1907 by the so called rose period – a period in which Picasso used much brighter colours.

n blue plate special

A main course meal with vegetables or a set course meal available at a special price in an inexpensive restaurant – particularly in the US.

adjective	a
adverb	adv
a colour	c
noun	n
prefix	pr
suffix	su
verb	vb

n **blueprint**

A photographic print of a technical plan or drawing. The process of reproducing such prints, which originated in 1840, relied on the fact that ferroprussiate reduces to ferrous on exposure to light. Figuratively, any detailed scheme or plan.

c **blue-red**

Mid-way between blue and red on the **spectrum**.

n **blue revolution**

the objective of ensuring that the poorer nations have adequate water for drinking and irrigation purposes. Possibly derived from the use of 'green' to indicate environmentalism.

n **blue ribbon**

The highest award given; originates from the badge of the Order of the Garter consisting of a blue ribbon. See **cordon bleu**.

a **blue-ringed**

Having blue rings as in the case of the Australian blue-ringed octopus one of the most deadly poisonous creatures. It displays its true blue colours only on the point of attack.

n **blue rinse**

The light blue hair tint which favoured by elderly middle-class women.

n **blue ruin**

Slang for gin.

n **blues**

The mournful yet exuberant music of the Southern United States originated by Black Americans and the forerunner of jazz. Strictly twelve bars long and including many so-called 'blue notes', that is, minor 3rds and 7ths.

n **Blues**

Regiment of Royal Horse Guards.

n **blue sky laws**

Laws formulated in the US in the early 20th century to protect unwitting investors from fraudulent schemes involving fake securities and so called in reference to a judge's statement that such schemes had no more basis than *'so many feet of blue sky'*.

n **blue-sky project, research**

Theoretical research carried out without a specific aim or regardless of any possible practical application. See **sky blue**.

n **blue stars**

The colour of a star indicates the range of its temperature with blue stars being the hottest. Blue-white is the next in intensity followed by white, yellow, orange and then red. Stars are divided into seven types referred to by the letters: O B A F G K and M – M stars being the coolest. Each star type is further classified by the numbers 0 to 9 – 9 being the coolest so that the sun is classified as a G2 indicating that it is yellow in colour and has a surface temperature of between 5,000 and 6,000 degrees **Kelvin**.

n **blue-stocking**

An epithet disparaging of an over-intellectual woman described by JJ Rousseau as *'a woman who will remain a spinster as long as there are sensible men on earth'*. However, according to Michael Quinion in his erudite *World Wide Words* the first blue-stocking was possibly male – namely, the 18th century poet Benjamin Stillingfleet – who could not afford the black silk stockings customarily worn by the gentry at the literary evenings to which he was invited.

c **bluet**

The blue of the cornflower – *bluet* being French for 'cornflower' and a variety of US cornflower.

n **bluetooth**

A revolutionary new system allowing electronic devices to communicate with each other over short distances by means of radio waves. Bluetooth technology, for example, allows mobile telephones to communicate with a personal computer instructing it to turn on or off a particular piece of equipment in the home. So called after King Bluetooth of Denmark a powerful Viking who in the 10th century managed to force peace on hostile factions.

n **blue trout**

Trout cooked in vinegar the effect of which is to turn it blue. Referred to in menu terminology as *'truite au bleu'*.

n **blue verditer**

Blue copper pigment.

c **BlueViolet**

One of the colours in the **X11 Color Set**. Its hex code is #8A2BE2.

n **blue-vitriol**

Copper sulphate.

n **blue water**

The open sea.

n **Blue Wool Scale**

British standard (BS 1006-97) commonly referred to as 'the Blue Wool Scale' (BWS) adopted as an International Standard (ISO) and used by some manufacturers as the standard for measuring the **lightfastness** of their pigments – BWS 7 and 8 indicating an extremely permanent pigment. See also **ASTM**.

adv **bluely**

With a blue appearance.

n **bluey**

The flimsy blue note-paper supplied to British troops serving abroad, enabling them to send letters to friends and family, free of charge, by a system dating back to 1799 and now operated by the British Forces Postal Office (BFPO). An updated electronic system known as 'e-bluey' is also operated by the BFPO which prints out email messages addressed to serving members of HM Forces. Also, tending towards the colour blue.

n **blue yonder**

The far distance; also referred to as 'the far *green* yonder'.

a **bluish**

Tinged with blue; bluish rather than blueish.

c **blunket**

A greyish blue.

vb **blur; to**

To smear paint; to make indistinct.

vb **blush; to**

To change one's facial **complexion** when becoming embarrassed, stressed or angry; to colour, flush, go red or redden.

c **blush**

Red-coloured; having the same colour as a blush.

c **blush pink**

Delicate pink.

c **blush rose**

A delicate pink; also seen as a *dark* shade of rose.

n **blusher**

A **cosmetic** used to add colour to the face and to give it shape. Available in many forms including powder, cream, gel and liquid stain.

c **boat-green**

Used by Charles Dickens in his *Nicholas Nickleby*.

n **body**

The filler creating the opacity of paint in **gouache**.

n **body colour**

See **gouache** and **masstone**.

c **bois de rose**

The dark rich brown colour of rosewood.

a **bold**

As regards colour – emphasised, standing out, striking.

adjective a
adverb adv
a colour c
noun n
prefix pr
suffix su
verb vb

n **bole**

An orange red or reddish-brown earth colour used as a **pigment**; originating from the unctuous clays of the same name.

a **bombasic**

Having a pale yellow colour.

a **bombycinous**

Having a pale yellow colour.

c **bone black**

An ancient black pigment derived from carbonised bones and used to the present day.

n **bone brown**

Charred bone dust.

c **bone white**

A white pigment used since the Middle Ages consisting in the main of calcium phosphate.

c **bonny blue**

A blue colour also referred to as 'Scotch blue'.

c **Bordeaux**

A bluish red the colour of Bordeaux wines.

n **Bordeaux**

Red obtained from beta naphthol.

c **Bordeaux blue**

A shade of blue.

c **Botticelli blue**

A pale greyish-blue.

c **Botticelli pink**

A shade of magenta.

n **bottle-blonde**

Someone with hair dyed **blonde** as opposed to naturally blonde hair.

c **bottle green**

The dark green of some wine bottles; also a dark yellowish green.

n **bow-dye**

A scarlet dye taking its name from Bow in Essex.

a **box-coloured**

Dyed by immersion into a tray.

c **bracken**

The olive-brown or orange brown colour of bracken.

c **bran**

The brown colour of bran.

a **brazen**

Having the colour of brass; made of brass; without shame.

n **brazilin**

A red pigment derived from Brazilwood and used as a dye.

c **brazilwood**

A vivid red colour from the dye of the tree of the genus *Caesalpinia* known as the Brazil tree which begot the name of the country rather than vice versa.

n **break colour**

See **broken colour**.

c **Bremen blue**

Blue copper pigment.

c **Bremen green**

See **malachite**.

a **brended**
Variegated (obs.).

c **brick**
The deep orange-red of brick; **lateritious**.

c **brick-red**
Having the colour of red brick; in the US a brownish or yellowish red colour.

a **bricky**
See **lateritious**.

a **bright**
Used in relation to colours to indicate vividness or intensity; emitting or reflecting a lot of light; glistening.

n **brightening agent**
An additive which when applied to textiles heightens their brightness.

n **brightness**
The condition of being bright. The **value** or **luminosity** of a colour. Yellow has the highest value in the spectrum and violet is the darkest in the **spectrum**. The two extremes of brightness are, of course, black and white. The addition of black or white to a hue changes its brightness. See **tint, tone** and **shade**. Brightness is referred to in some colour notations as 'value'.

a **brilliant**
Sparkling, shining, vivid, reflecting a large amount of light or brightness, lustrous, gleaming. See b**rilliant dyes**.

n **brilliant black**
The black food additive (E151). Also called 'Black PN'.

n **brilliant blue FCF**
The blue food additive (E133).

n **brilliant dyes**
Colorants including brilliant red, blue, orange, violet, black, yellow, green, flavine and pink.

n **brilliant green**

A disinfectant.

n **brilliant scarlett 4R**

A red colouring agent added to food (E124). Also called 'Poncean 4R'.

c **brilliant yellow**

Mixture of **cadmium yellow** and **Cremnitz white** or **zinc white**.

a **brindled, brinded**

Flecked with or having a streak of a darker colour, particularly, as regards dogs. See also **tabby**.

c **brique**

A light brownish red; found only in the OED and French dictionaries.

c **brochure-blue**

The clear shimmering blue of the sea as appearing in all travel brochure illustrations.

a **brocked**

Having a black and white **mottled** appearance.

c **brocoli green**

The green shade of the vegetable brocoli.

a **broken**

As regards a colour, altered by adding another colour or colours.

n **broken colour**

A diverse term used to describe a variety of effects such as the technique of interspersing flecks of colour with another colour or colours used, in particular, by the Impressionists and creating a blended effect when observed from a suitable distance; the effect produced by the random distribution of particles of colour on a surface; pure colours intermixed with black; the result of mixing one colour with another; the effect of an underlying layer of colour showing through a superimposed layer of oil paint; a new tone of a particular

adjective a
adverb adv
a colour c
noun n
prefix pr
suffix su
verb vb

colour created by juxtaposing another colour with it; the application of different shades of paint or glaze to a base coat which is broken up in a number of different ways to create a special finish for decorative purposes – see, for example, **graining** and **marbling.** As regards flowers, the result of them having burst into colour.

n **broken white**

White paint or other pigment to which a tint is added without producing a definitive alternative colour.

vb **bronze; to**

To **tan** usually by the sun's rays or some **cosmetic** application (hence a 'bronzer'); to carry out a process of covering a work of art, such as a sculpture, in bronze.

c **bronze**

The brilliant brown colour of the metal – bronze; derived from 'Brindisi' the town in Italy. Bronze sculptures left to the elements will, by a process of oxydization, develop a patina of **verdigris** and turn green in colour.

n **bronze medal**

The third prize after the gold and silver prizes in games, sports and other pursuits including, in particular, the Olympic Games.

n **bronzing**

A **pigment** added in the process of manufacturing paint which results in a metallic lustre; the metallic lustre of certain colours such as **Milori blue**; the process of applying imitation gold leaf or powder to a surface.

c **brown**

The colour of earth and of wood; in the wavelength range of approximately 620-585 nanometres. Latin had no specific word for 'brown'. The Hebrew word used for 'brown' as used in *Genesis* xxx: 32 means 'sun-scorched' and a variant form of black. Its early meaning was 'dark'.

c **Brown**

A colour in the **X11 Color Set**. It has hex code #A52A2A.

brown bread

n

Bread made from unbleached flour or rye; any bread darker than white bread; also used as a colour. For bread to be classified as 'brown bread' it must comprise at least 85 per cent whole wheat grain. The Colours in Food Regulations 1995 make it unlawful in the UK to dye bread.

n **brown chalk**

Another name for **umber**.

n **brown coal**

Lignite – a blackish-brown coal.

n **brown dwarf**

A huge conglomeration of gases lacking the temperature and mass to convert itself into a star. Very few have been located.

n **browned off**

Fed up.

n **brownfield land**

A site previously built on and now appropriate for development; in comparison to **greenbelt** or countryside. Also referred to as 'brownlands'.

n **brown FK and brown HT**

Brown food colouring additives (E154 and E155).

n **brown goods**

A marketing term for a group of consumer goods including television sets, video recorders, hi-fi equipment and radios etc. See **white goods**.

n **brownheart**

A disease of turnips and apples causing internal decay.

n **Brownie**

A girl guide; from 'brownie' meaning an elf.

n **browning**

A substance used to make soups and sauces brown.

a **brownish**

One of the **ish's**.

n **brownness**

The state of being brown.

n **brown-nose**

Slang for a sycophant or subservient person.

n **brown-out**

A temporary reduction in voltage causing lights to dim or a reduction in power; a partial **blackout**.

n **brown paper**

Wrapping paper sometimes waxed and originally coming in many sizes including Kent cap, imperial cap and the largest, quad imperial (45'x 58'). Nowadays, with the use of brightly coloured gift-wrapping, brown paper is less often used. Reminders sent out by dentists in brown envelopes are less successful in their purpose than those dispatched in white envelopes (BBC4 September 2000).

n **brown pink**

A yellow vegetable pigment. See also **English pink**.

c **brown red**

A red made from burnt **ochre**.

n **brown rot**

A fungal disease of timber and fruit trees.

a **brumous**

Misty.

c **brunette**

Dark brown particularly as regards a woman's hair; a woman having hair of this colour.

pr **brunne- (L)**

Brown.

a **brunneous**

Dark brown.

c **Brunswick black**

Black pigment.

c **Brunswick blue**

Blue pigment.

c **Brunswick green**

A bluish-green; a green pigment. See **emerald green** and **chrome green**.

n **brushmark**

The mark made by the bristles of a paintbrush appearing on the surface of a painting.

n **brushwork**

The characteristic manner in which an artist applies paint; work which is carried out by means of a brush.

c **bruyère**

A greyish purple; the colour of heather.

c **bubble-gum pink**

A sickly gaudy pink which is characteristic of bubble-gum.

c **bud green**

A yellowish-green.

c **buff**

A pale yellowish-brown colour; a light yellow; of the colour of buff leather which having regard to its proximity to human skin colour gave rise to the phrase 'in the buff' meaning 'naked'. Also 'buff-coloured'.

adjective a
adverb adv
a colour c
noun n
prefix pr
suffix su
verb vb

c **buffish**

Close to **buff** in colour.

c **Burgundy**

The reddish purple colour of Burgundy wine – less blue than **Bordeaux**. Hence 'Burgundy red'.

c **BurlyWood**

A tan colour – one of the colours in the **X11 Color Set**. Hex code #DEB887.

c **Burmese ruby**

A pinkish red.

vb **burnish; to**

To give a surface a glossy appearance, for example, as part of the guilding process. Literally 'to make brown'.

c **burnt**

A yellowy brown colour; hence 'burnt-coloured'.

a **burnt**

As regards pigments, having been darkened by scorching. As regards colours, made from calcined pigments or having the appearance of having been scorched. See e.g **burnt alum**, **burnt carmine** and following entries.

c **burnt-almond**

A light brown.

n **burnt alum**

A pigment resulting from treatment of alum by fire.

n **burnt carmine**

Red pigment resulting from treatment of **carmine** by fire or having the appearance of having been scorched.

a **burnt-coloured**

See burnt (*c*).

n **burnt ochre**

Light brown pigment resulting from treatment of ochre by fire or having the appearance of having been scorched.

c **burnt orange**

A reddish orange colour.

n **burnt sienna**

Dark-reddish brown pigment resulting from treatment of sienna by fire or having the appearance of having been scorched. Also referred to as 'burnt terra di Sienna'.

c **burnt sugar caramel**

A deep yellowy brown.

n **burnt umber**

Reddish-brown pigment resulting from the treatment of umber by fire or roasting.

c **buttercup yellow**

The pale yellow of buttercup petals.

n **butterfly nose**

The condition in dogs where de-pigmentation of the nose causes it to lose colour and to become mottled or spotted.

c **butter-nut**

The brownish-grey colour of the butter-nut.

c **butterscotch**

A yellowish brown.

c **butter yellow**

A dye made from coal tar used for colouring butter.

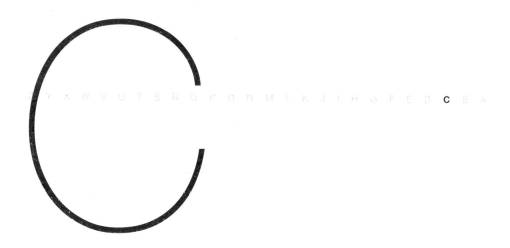

c **cabbage green**

The green of the cabbage leaf.

c **cacao brown**

The brown of the cacao bean used for making cocoa and chocolate.

c **cactus green**

The green of the cactus.

a **cadaverous**

Pale.

c **cadet blue**

A bluish grey or strong blue colour; sometimes referred to as 'cadet grey'.

c **CadetBlue**

One of the 140 colours in **the X11 Color Set**. It has hex code #5F9EA0.

a **cadmium**

Descriptive of the mainly strong colours containing cadmium sulphide and cadmium selenide first isolated in the 18th century. Cadmium pigments first came into use in the 1820's and were a favourite of the artist Claude Monet (1840-1926). Nowadays its use is in decline because of the scarcity of cadmium and its toxicity.

c **cadmium green**

Made by mixing cadmium yellow and viridian.

c **cadmium lemon**

A bright greenish yellow.

c **cadmium lithopone**

A pale yellow.

c **cadmium orange**

A bright orange made from cadmium sulphide. See **greenockite**.

c **cadmium red**

A bright red primary colour made from a mixture of cadmium sulphide and cadmium selenide and first marketed in 1910.

c **cadmium vermilion**

A bright red.

c **cadmium yellow**

A fine yellow in many varieties first made in 1820 from cadmium sulphide and used by artists extensively in the 19th century. Sometimes referred to 'aurora yellow'. Also 'cadmium lemon yellow' which has a more orangey hue.

c **cadmopone yellow**

A pale yellow also called cadmium lithopone.

pr **caesi- (L)**

Bluish-grey.

a **caesious, caesius**

Having a bloom of a bluey-grey colour. Also a pale bluish green.

c **café**

Coffee colour.

c **café au lait**

The colour produced by mixing milk with coffee.

adjective a
adverb adv
a colour c
noun n
prefix pr
suffix su
verb vb

n **café sunburn**

Slang for a 'pallid complexion'. See also **nightclub tan**.

a **cain-coloured**

Red or reddish yellow possibly in reference to the blood of Able shed by his brother Cain; having red hair; Shakespeare's *Merry Wives of Windsor* Act 1 Scene 4.

a **calcareous**

Lime coloured.

n **calcium carbonate**

A white food colorant (E170).

n **calcographer**

Someone who draws with **crayons** or **chalks**.

n **calcography**

Art of drawing with coloured **crayons** or **chalks**.

n **Caledon Jade Green**

A synthetic green dye discovered in 1920.

n **Caledonian brown**

A red pigment but moving towards black when calcined.

c **calico**

The **piebald** or spotted colouring (similar to printed calico) of horses.

pr **calig- (L)**

Dark.

n **caligation**

Dimness of sight (obs.).

a **caliginous**

Dim, dark, obscure. See also **tenebrous, thestral, darksome, dusky, murky, obfuscous**.

n **calotype**

An early form of photography where the object, lit by the sun, had to remain still for three minutes.

c **Cambridge blue**

The light blue Eton colour adopted, it is said, in haste in the 1836 annual Cambridge and Oxford varsity boat race by the Cambridge cox having forgotten his team's own colours. See **blue** (n).

c **camel**

The fawn colour of the camel; beige.

a **camleted**

Variegated with wavy lines.

n **camouflage**

The disguise of animals, personnel or equipment by the use of such colours as make the object in question appear to merge with its surroundings. Derived from the French 'camoufler' – to disguise. It is an offence to wear camouflage clothing in Barbados unless the wearer is part of the Defence Force. See **cryptic colouring**.

c **campanula**

A violetish-blue after the flower of the same name. Used by the art theorist Charles Blanc (1813-1882).

n **camwood**

Dye from wood initially white and turning red on exposure to air.

c **canard**

A dark blue.

c **canary**

Bright yellow resembling the colour of the canary's plumage.

c **canary green**

A dark yellow colour.

c **canary yellow**

The bright yellow of the canary.

n **candela**

A unit of light intensity.

a **candent**

Glowing with white heat (obs.).

pr **candid- (L)**

White The root of the word 'candid' (developing its meaning from 'white' or 'pure') and of 'candidate' – candidates having worn white togas in Roman times. See *toga praetexia*.

n **candle-light**

The light of a candle. See **lux**.

a **candy-coloured**

Having a shade of pink. Also 'candy pink'.

a **candy-striped**

Having a pattern of alternate stripes of colour usually pink on white.

a **cane-coloured**

Having the colour of cane.

a **canescent**

Becoming or tending towards white.

n **cangiantismo**

The technique used by Michelangelo where an object painted in one colour bears another colour as it goes into shadow.

n **canities**

Grey or white hair; the change in hair colour to grey or white.

c **cannelas**

A cinnamon-brown colour.

c **cantaloupe**

A light shade of yellow after the melon of the same name.

n **canthaxanthin**

A chemical colorant used in some foodstuffs fed to hens to yield a uniformly bright yellow yolk in eggs. Also used to give a pink colour to salmon. It is thought that the chemical can damage the retina of the eye and some supermarkets have banned eggs from chickens so fed (E161(g)).

c **canvas**

Of the colour of canvas.

n **canvas**

A painting; the material or **colour ground** on which an artist paints.

n **Cappagh brown**

A native bituminous earth containing manganese oxide once mined in Cork, Ireland. When the mine became exhausted **Winsor & Newton** acquired the remaining stock. Otherwise called Cappah brown.

a **cappucino-tinted**

From *The Times* of 1.9.99 – presumably, having the colouring and markings suggestive of the whipped cream and powdered chocolate expected on the top of a cup of cappucino coffee.

n **capsanthin**

An orange red food colouring agent (E160 (c)).

n **capsicin**

The red pigment in cayenne pepper.

c **capucine**

A dark yellowy orange.

c **caramel**

A pale brown colour; the colour of toasted sugar. The dark brown colouring used as a colouring agent in food (E150).

n **carbon black**

The darkest of pigments. Another name for **lampblack**. One of the **E-number colours** (E153). See also **blue black** and **charcoal black**.

adjective a
adverb adv
a colour c
noun n
prefix pr
suffix su
verb vb

c **cardinal (red)**

The scarlet colour of a cardinal's vestments.

c **carmine**

A crimson colour. See next entry.

n **carmine**

An ancient red, orange or crimson pigment originally derived from the **kermes** insect and subsequently from the **cochineal** insect. Used, amongst other things to manufacture eye **make-up**. See **cremosin**.

n **carmoisine**

Red colouring used as an additive in food, particularly, in confectionery and marzipan (E122). Research at the Asthma and Allergy Research Centre suggests that E122 might lead to hyperactivity in children.

c **carnadine**

Carnation colour.

c **carnation**

Rose-pink, flesh-coloured. *'A' could never abide carnation- 'twas a colour he never lik'd'* Shakespeare's *Love's Labour's Lost Act 2 Scene 1.* From *carneus* the Latin for flesh-coloured. It was not until the 20th century that 'carnation' also came to be used as the colour of the flower although having regard to the many varieties of the flower in modern times the colour term used in this context has little precision.

c **carnelian**

A pale reddish-brown or ruby colour after the semi-precious stone of the same name; see **sard.** Also called **cornelian.**

n **carotene**

The yellow or orange pigment occurring in many plants, in particular, carrots. Also called carotin. Used to give butter its yellow colour (E160(a)). See **carrot orange**.

n **carotenoids**

A group of yellow, orange or red pigments including **carotenes, xanthophylls** and **fucoxanthin,** found in many plants and animals.

c **carrot orange**

The yellowish-orange colour of the carrot previously referred to as **carrot red**. Carrots have not always been orange in colour. The Egyptians from 2000 BC grew purple carrots and the Romans ate purple and white carrots. Black, red, green and yellow carrots were also grown but Dutch carrot-growers favoured their chosen orange colour which became the standard colour for carrots from around the 16th century. The orange colouring derives from **beta-carotene.** Purple carrots are now being grown in England.

c **carrot red**

This colour dates back to before the 17th century when red carrots were grown.

c **carroty**

Having the reddish orange colour of the carrot.

n **carte blanche**

Full power and authority to take any action; literally 'white paper' on which the vanquished in battle would sign a blank sheet of paper with authority to the victorious side to write whatever terms it thought fit.

n **carthamin(e)**

The red dye of the safflower.

c **cæruleum**

In Roman times this Latin term designated both blue and yellow and perhaps also green. See also **cerulean**.

n **casein**

Milk protein mixed with **pigment** and serving as a **binder** or an emulsion in the preparation of **paint**.

c **Cassel brown**

A brown pigment made from lignite and named after the town of the same name now called Kassel; also Cassel green and **Cassel yellow**.

n **Cassel earth**

An earth pigment referred to from the end of the 18th century as **Vandyke brown**.

c **Cassel yellow**

A yellow pigment also called Montpellier yellow.

n **cassius**

A purple pigment.

n **cast**

A pale shade or tinge of colour; a shade or colour; a dash of colour imposed on another.

pr **castane- (L)**

Brown, chestnut.

a **castaneous**

Chestnut-coloured.

c **Castillian**

A deep red.

c **castor**

Referred to in the *Daily Mail* of 5 June 1923. A dark brownish grey or a light brown beaver colour named, it is hoped, after the star in the constellation, Gemini, and not after the unctuous malodorous secretion of beavers.

n **catechu**

A dye (also called **cutch**) containing **tannin** made from the bark of certain trees found in Asia and used in the tanning industry and in dyeing.

c **catechu brown**

The shade of brown derived from **catechu**.

c **cathay**

A bluish purple.

n **cats' eyes**

A reflecting module contained within the surface of some unlit highways to indicate the way. Solar-powered cats'-eyes have now been developed.

a **Caucasian**

One of the divisions of mankind indicating human beings who are fair-skinned or white; named after the region known as the Caucasus.

a **Caucasoid**

Same as **Caucasian**.

c **cedar**

A reddish-brown colour.

c **cedary**

Of the colour etc of the cedar tree.

c **celadon**

A pastel green also referred to as Celadon green – Celadon, according to Partridge being a rustic lover in French pastoral poetry. Used in glazing Chinese porcelain. Celadonite is another name for **terre verte**.

n **celandine**

A natural dye made from the plant, celandine, yielding a yellow colourant.

c **celestial blue**

A greenish blue.

c **celestine**

Sky blue.

c **cendre**

Ash-coloured.

c **cerise**

After the French for cherry but not necessarily the same colour as the fruit. Often a bluish-red or a purplish red.

pr **cerule-, ceruleo- (L)**

Blue, sky blue, but in Roman times probably designated a yellow colour.

adjective a
adverb adv
a colour c
noun n
prefix pr
suffix su
verb vb

c **cerulean**

The deep blue colour of a cloudless sky; **azure**; also spelt cerulian, ceruleum, ceruline, coeruleun, coerulein and caerulean. See **sky blue**.

c **cerulean blue**

A vivid light greenish blue pigment made from oxides of chromium cobalt and tin discovered in 1860 by the firm George Rowney and Son.

c **cerulin, cerulein**

A vivid blue substance derived from **indigo**.

n **ceruse**

Another name for **white lead**; a white **cosmetic**.

n **chakra**

One of the seven energy centres in Yoga each accorded its own colour, namely, magenta (or violet), violet (or indigo), blue, green, yellow, orange and red.

c **chalcedony**

Used to describe both a shade of crimson and a browny yellow colour. Chalcedony is a precious stone, a **versicoloured** variety of quartz.

pr **chalco- (G)**

Designating copper in compound words.

c **chalk**

A grey white.

n **chalk**

A piece of soft rock used for drawing or writing; a filler or **extender** used in manufacturing pigment or priming canvases; a white pigment made from calcium carbonate.

c **chalk-white**

The white of chalk.

a **chalky**

Like **chalk** in colour etc.

pr **chalybd- (L)**

Steel.

a **chalybeous**

Having a dark blue metallic colour.

c **chambray**

A shade of blue.

n **chambray**

Similar to **gingham** in pattern.

n **chameleon**

A lizard able to change the colour of its skin to suit its environment or situation. Dr Andrew Parker's theory is that animals developed colours in the Cambrian period as part of the evolutionary process in order to hide from other creatures or to frighten off their enemies. See also **sematic, startle colours cryptic colouring** and **chromatophore**.

c **chamois**

The yellowish-tan colour of a chamois leather.

c **champagne**

Yellowy-white or yellowy-pink; a 1920's mink colour.

c **charcoal**

A dark grey colour.

a **charcoal**

Descriptive of those pigments made from or containing charcoal as in 'charcoal black'.

n **charcoal**

An ancient medium for black and white drawing coming in many different forms including **pencils**, charcoal sticks and compressed charcoal.

n **charcoal black**

An ancient pigment made from charcoal; also called **carbon black**.

c **charcoal brown**

A dark brown.

c **charcoal grey**

A dark grey.

c **Charron blue**

A blue used by the artist Paul Gauguin (1848 1903) made by mixing barium sulphate with **cobalt blue**.

n **Chartered Colorist**

The qualification offered by the Society of Dyers and Colorists. A Fellow is an 'FSDC', an Associate is an 'ASDC'.

c **chartreuse**

A pale apple-green colour with a yellow tinge; a colour name adopted by Web page creators on the Internet; see **X11 Color Set**. It has hex code #7FFF00.

c **chasseur-blue**

The dark blue colour of the jacket of the French Chasseur soldier.

a **chatoyant**

Having a changing iridescent lustre comparable to that of **cats' eyes** at night. See also **chatoyment**.

n **chatoyment, chatoyement**

The play of colours as for example exhibited in certain minerals.

n **chay, chaya, choya, shaya, shaii**

A red dye made from the root of the Indian plant *oldenlandia umbellata* which is of the same family as the **madder** plant.

n **check**

A **chequered** pattern or fabric design.

a **checked**

Has the same meaning as **chequered**.

n **cheek-colour**

A **cosmetic** used for colouring the cheeks.

n **chemi-luminescence**

The shining light emanating from some insects and animals, for example, glow-worms and fireflies and produced by a chemical reaction.

a **chequered, checkered**

Having various colours; having a geometric pattern or motif composed of alternate stripes of colour or light and shade as on a chess board. There is no specific term in the English language for this black and white pattern, but John Gage in *Colour and Meaning* refers to the frequent use of this motif in the Inca tradition and to one Inca language which has a special word for it.

c **Cherokee red**

The dark bricky-red shade chosen by the American architect Frank Lloyd Wright (1869-1959) as his **signature colour**.

c **cherry**

Bright red; the colour of cherries; hence cherry-coloured. See **cerise**.

c **cherry-red**

Of the colour of the red cherry.

c **chestnut**

Reddish-brown after the name of the shell of the chestnut.

c **chestnut-brown**

A reddish-brown.

n **chevron**

A V-shaped or inverted V-shaped pattern or marking.

c **Chianti**

A dark cerise colour after the wine from Tuscany.

adjective a
adverb adv
a colour c
noun n
prefix pr
suffix su
verb vb

chiaroscuro

A manner of painting where only light and shade rather than colour is used; otherwise known as *clair-obscur*.

n **chica**

Orange-red dye from South American plant.

c **chilli-red**

A strong red colour.

c **China blue**

A lavender blue.

a **Chinese**

Indicating a colour or pigment possibly originating in China.

c **Chinese blue**

A blue pigment made from mixing **cobalt blue** with **flake white**. Synonymous with **Prussian blue**. Also Chinese white, orange and yellow; all originating in China according to Partridge although **Prussian blue** was discovered in Berlin.

c **Chinese red**

A chrome red pigment. Obsolete name for **cinnabar**.

c **Chinese vermilion**

A vivid yellow-red pigment;.

c **Chinese white**

A white pigment prepared from zinc oxide and possibly so named after the fine porcelain from China. This was the first permanent opaque white watercolour. See **zinc oxide**.

c **Chinese yellow**

A vivid yellow pigment made from arsenic.

c **ching**

A vivid greenish-blue.

c　　**chinoline-blue**

A blue colour made from quinoline.

pr　　**chiono- (G)**

Snowy.

c　　**chlorine**

Light green; of the colour of vegetation.

pr　　**chloro- (G)**

Green.

a　　**chlorocarpous**

Bearing green fruit.

n　　**chlorocruorin**

A green pigment present in some marine creatures.

a　　**chlorophanous**

Having a yellowish appearance.

n　　**chlorophobia**

Fear of the colour green.

n　　**chlorophyl(l)**

A pigment absorbing red, yellow, violet and blue light but reflecting green light; the green colouring matter of plants and vegetation. The greenish olive food additive (E140).

n　　**chloroplasts**

Minute bodies found in the cells of plants and containing **chlorophyll**.

n　　**chlorosis**

The process whereby a plant or part thereof (such as a leaf) turns green from some other colour; an inadequacy of **chlorophyll** in a normally green plant the effect of which is to make it turn yellow or white. The term thus has two opposite meanings.

a **chloroxanthous**

According to the OED having a 'green or olive and yellow colour'.

c **chocolate**

A deep brown, the colour of chocolate, although it embraces many shades. Also **chocolate brown**.

c **Chocolate**

One of the colours in the **X11 Color Set**. Its hex code is #D2691E.

c **chocolate brown**

A dark brown colour; a food additive producing a brown colouring and used particularly in chocolate cake mixes (E155). Also called 'Brown HT'.

n **chord**

In relation to colours, an effective juxtaposition of various hues.

c **chow**

A vivid blue.

n **chroma**

The extent of a colour's **brightness** or **saturation**; the purity of a colour. From the Greek '*chroma*' meaning 'colour'.

n **chroma colour**

A water-based paint similar to **acrylic** paint originally used in the making of cartoon films.

a **chromatic**

Descriptive of the brightness of a colour – the brighter it is the more chromatic it is considered to be; having colour or pertaining to colour.

n **chromatic colour**

The technical term for **colour**; as regards surface colours, a hue having a degree of colourfulness.

n **chromaticity**

Hue and **saturation** taken together.

n **chromatics**

The scientific study of colour and colours.

n **chromatocracy**

Government by a particular colour, for example, **albocracy**.

a **chromatogenous**

Generating colour.

n **chromatometablepsy**

Colour-blindness.

n **chromatophore**

A pigment-containing cell in the deeper layers of the skin of some animals producing changes in skin colour. In the fish called the Osbeck such cells enable it to change from red to white in 8 seconds. Many fish and animals can change their colouring. This is achieved in some species (including the African clawed frog) by the release of a hormone which changes the position of the dark pigment **melanin** contained in chromatophores and which variously makes the creature appear dark or colourless. See **chameleon**.

n **chromatopsia**

An inability to determine or distinguish certain colours.

c **chrome**

A reddish-yellow shade.

c **chrome black**

Colour produced from black dye.

c **chrome green**

A permanent yellowy green the result of mixing **chrome yellow** with **Prussian blue**. It is called by many names including **Brunswick green**, **cinnabar green**, **Milori green**, zinc green and **chromium oxide** from which it is made. It is also referred to as, but should not be confused with, **viridian green**.

adjective a
adverb adv
a colour c
noun n
prefix pr
suffix su
verb vb

c **chrome orange**

A reddish orange also referred to as Derby red, Victoria red or Persian red. See **lead chromes**.

c **chrome red**

A deep scarlet red also called **Chinese red** and Derby red.

c **chrome yellow**

Brilliant yellow produced by mixing sodium chromate and lead nitrate both of which are colourless.

n **chromidrosis**

According to Partridge this means *'(secretion of) morbidly coloured perspiration'*.

n **chrominance**

The signals which provide the hue and saturation components in television colour; that particular quality of light which enables us to detect colour.

c **chromium**

The grey metallic colour of the metal of the same name.

n **chromium**

First used by the chemist Louis-Nicholas Vauquelin (1763-1829) in 1797 in the manufacture of a large range of yellows, oranges and greens.

n **chromium oxide**

A pigment used to make **chrome green** and also **viridian**. It can produce a brilliant green sometimes described as 'transparent green' although the matt form is a dark opaque green. Also called 'oxide of chromium'.

pr **chromo-, chroma-, chromato-(G)**

Designating colour or pigment.

n **chromocyte**

A pigmented cell.

n **chromogen**

A compound that can be converted into a dye.

a **chromogenic**

Having the quality of producing colour.

n **chromolipids**

Yellow, red or brown pigments.

n **chromometer**

See **metrochrome**.

a **chromophil**

Having the quality which readily admits of the application of dye or staining.

n **chromophobia**

The fear of colour. The architect and painter Le Corbusier (1887-1965) argued that colour was suited *'to simple races, peasants and savages'* and the art theorist Charles Blanc (1813-1882) regarded design as having a more important function in art than colour – *'colour is a mobile vague, intangible element while form is precise, palpable and constant'*.

n **chromophores**

A group of colour-producing chemicals.

n **chromoptometer**

An instrument for measuring colour sense.

n **chromotherapy**

See **colour therapy**.

n **chromotrope**

An acid colorant or dye.

a **chromotropic**

Changing colour or having the ability to change colour.

n **chryography**

The art of writing in gold lettering.

a **chrysal**

Golden.

n **chrysaniline**

A golden-yellow dye also called 'aniline yellow'.

c **chrysanthemum**

Used variously to signify the vivid yellow and brownish-red colours of the flower of the same name.

a **chryselephantine**

Pertaining to objects made or decorated with gold or ivory.

pr **chryso-, chrys- (G)**

Golden or golden yellow.

n **chrysocolla, chrysocollum**

A shiny greenish-blue substance made by the Greeks from copper silicate and used both as a **cosmetic** for the eyes and to fix **gold leaf**. Literally – 'gold solder'.

c **chrysolite green**

Of the colour of chrysolite, namely, yellowish green (although varying to dark green).

c **chrysoprase**

A bright golden green or an apple green after the beryl gemstone of the same name which derives from the amalgam of **chryso-** (gold) and **praseo-** (leak green).

c **ciel**

Sky blue.

c **cigar**

The brown colour of the cigar.

c **cimmerian**

Grey, ashen.

c **Cincinatti Red**

An intense orange-red.

a **cinereous**

Grey, ashen; ash grey; especially of birds.

a **cinerescent**

Ashen; having a grey colour.

a **cineritious**

Ashy-grey as applied to nerve matter.

c **cinnabar green**

A non-permanent green made from **cinnabar**; also said to be produced by mixing **cadmium yellow** (or sometimes **chrome yellow**) with **Prussian blue**. Referred to also as **chrome green**, zinnober green and green cinnabar.

c **cinnabar red**

A permanent vermilion.

c **cinnabar, cinnebar, zinnober**

Mercuric sulphide used in crystalline form as a red pigment since ancient times; the colour itself, a vermilion; see also **cinnabar green** and **cinnabar red.** Cinnabar was widely used by the Chinese since the third millennium BC and was formerly referred to as **Chinese red**.

c **cinnamon**

The yellowish-brown of cinnamon; sometimes reddish-brown or greyish-brown tinged with red. Also the colour name given to deep brown diamonds having little value. See **diamond colour**.

pr **cirrho- (G)**

Tawny, orange.

a **citreous**

A greeny-yellow; lemon-coloured.

pr **citrin-, citro- (L)**

Lemon, yellow.

adjective a
adverb adv
a colour c
noun n
prefix pr
suffix su
verb vb

c **citrine**

Though originally lemon-coloured (and still having that meaning in France) Maerz & Paul show how the word in the English language strictly has the same meaning as **citron**.

c **citron**

A browny yellow from mixing green and orange. Also 'citron yellow' a colour often used by Vincent Van Gogh.

c **clair de lune**

A pale blue glaze for ceramics.

c **claret**

Reddish-violet; of the colour of claret wine; a red having the same hue as bordeaux wine. From the Latin *clarus* meaning 'clear' from which the words 'clarity', 'clarinet' and 'clarion' all derive.

n **clashing colours**

As regards two or more colours, conflicting; colours which do combine effectively.

c **clay**

A light brown.

n **clean colour**

Sometimes used to refer to light colours produced from white mixed with a single pigment rather than more sombre colours produced by mixing several others.

a **clear**

As regards colour, indicating a brightness, brilliance, purity, vividness or intensity.

c **clematis**

A bright bluish violet similar to the colour of the flower of the same name.

c **Cleopatra**

A vivid greenish-blue.

a **clinquant**

Glittering.

n **cloud colours**

A greyish hue with a hint of perhaps pink, lilac and blue.

c **clove brown**

A greyish brown.

c **clover**

A pinkish purple.

n **clown white**

A **cosmetic**.

n **CMYK (or CYMK)**

An acronym for **c**yan, **m**agenta, **y**ellow and blac**k** – the four colours which are used in colour photography and printing. The letter 'K' is used to avoid confusion with the 'B' in **RGB** and also refers to black as the 'key' or 'keyline' colour. Although black can be obtained from mixing the other three colours it is produced in printing by using a black ink. CMYK uses the **subtractive process**. Compare RGB.

c **coal-black**

The black colour of coal.

n **coal-tar**

A group of aromatic hydrocarbons (including benzene) used as as the primary raw material for synthetic-dye and paint manufacturing.

n **coal-tar colours**

One of many dyes made from **coal-tar**.

c **coaly**

Coal-black.

a **cobalt**

Indicating pigments made from salts of cobalt, for example, **cobalt blue** and **cobalt green**. The word cobalt comes from the German word *kobolds* meaning a ghost and was used in Bohemia to describe the pigment because it was considered to be plagued by spirits. The blue colouring agent in **smalt**.

c **cobalt blue**

A deep greenish-blue or purplish-blue similar to **Prussian blue**. Used in the staining of glass. A synthetic pigment also known as **Thénard's blue, Dresden blue** and **King's blue** first made in 1802 by the chemist J-L Thénard (1777-1857).

c **cobalt green**

A bright yellowish-green discovered in 1780 by Rinmann and also referred to as 'Rinmann's green'.

c **cobalt turquoise**

A blue made from cobalt titanium oxide.

c **cobalt violet**

A very light-toned toxic violet pigment first used in 1860 and superseded by manganese violet.

c **cobalt yellow**

A yellow pigment otherwise known as **aureolin**.

pr **coccin- (L)**

Scarlet.

a **coccineous**

Having a scarlet colour.

n **cochineal**

A natural red or scarlet dye from the female *coccus cacti* insect used until 1954 to dye the uniforms of the British Guards. One of the few natural colorants still used both for textiles and in food manufacture (E120).

c **cochineal red**

The red colour of **cochineal**.

n **cochinillin**

The colouring matter of **cochineal** also called **carmine**.

n **cockshut**

Twilight – the time when the birds are shut up!

c **cocoa**

The brown of cocoa powder. See **cacao**.

c **cocoa brown**

The colour of cocoa; a colour particularly popular in the 1930's.

c **coeruleum**

See **cerulean blue**.

c **coffee**

Having the colour of coffee.

c **cognac**

A pale brown; the colour of Cognac brandy.

c **coke bottle green**

One of the distinctive colours of Coca-Cola™ bottles.

n **colcothar**

A reddish-brown iron oxide pigment; used as theatrical rouge and to polish gold and silver. See **jeweller's rouge**.

n **cold colours**

As regards painting, those colours such as blue, green and grey suggesting cold-ness compared with **warm colours** such as orange, red and yellow. Cold colours appear to retreat towards the background. Also referred to as 'cool colours'.

n **cold light**

Light accompanied by little or no heat.

c **colibri**

A bluish-green also known as 'humming-bird'.

n **Cologne earth**

A brown pigment made from calcined **Vandyke brown.** Also called Cologne brown.

adjective a
adverb adv
a colour c
noun n
prefix pr
suffix su
verb vb

c **colombe**

The grey of the dove.

n **color**

The US spelling of the word 'colour'. In British English spelling most compounds of the word 'colour' include the letter 'u' as in 'colouring', 'colourless' and 'colourant'. However, some derivatives omit the 'u' as in 'coloration', 'colorimeter' and 'decolorize'.

c **colorado**

Colorado – the 38th State of the USA – was probably so called after this Spanish word once meaning 'well-coloured' but later coming to indicate the colour 'red'.

n **colorant**

Any colouring agent or a substance that imparts colour such as **dye**, **pigment**, **paint** or food additives (see **E-Number colours**). A dyestuff is soluble in the medium in which it is applied whereas a pigment is not.

n **coloration**

An arrangement of colours, in particular, the markings on animals; the appearance of an object as determined by the light emitted or reflected from its surfaces; to be distinguished from 'colour'.

n **colores floridi**

Ancient pigments such as **chrysocollum**, **cinnabar**, **coeruleum** and indicum (**indigo**).

pr **colori- (L)**

A combining form indicating colour.

a **colorific**

Pertaining to colour.

n **colorimeter**

An instrument for measuring colour and its intensity, in particular, in photographic images. Used to measure **brightness** and **saturation**. Hence, 'colorimetry'.

n **colorology**

The study of colour. See also **chromatics**.

a **colour**

Designating something which handles colours, such as in **colour television**.

n **colour**

The particular appearance or attribute of anything visible to the eye varying according to the wavelength of light reflected from its surface to the viewer. Colours are seen by humans as combinations of the three **primary colours**. Colours are distinguished from each other by reference to **brightness, hue** and **saturation**; a particular hue, such as red or blue, also referred to as **chromatic colour** or **spectral colour;** the variety of tone or quality of the music of voices or instruments; a dye or paint or other substance whereby colour can be imparted; an appearance of truth or semblance of something, see **colourable;** vividness, interestingness.

vb **colour; to**

To decorate with colour or colours; to add colour to; to change the colour of something; to colour in an area or shape; to give colour to something; to change one's facial **complexion** when becoming embarrassed, stressed or angry.

a **colourable, colorable**

Capable of being coloured; but more often indicating plausibility or the appearance or the semblance of truth.

n **colour acupuncture**

A form of colour therapy where beams of coloured light are directed onto the acupuncture points. Also referred to as **colourpuncture**.

n **colour adjectives**

Where colours are used to describe nouns in the company of other adjectives, in which order should they be used? We instinctively know the right order – but what are the rules? Take the sentence: '*my two valuable old green shiny British racing cars*'. Any other order of the descripters would sound wrong. While the rules are not absolute the correct order appears to be as follows: **1**. determiners such as, my, your, the, some, a very **2**. adjectives of number **3**. adjectives of intangible qualities: (awful, valuable, exciting) **4**. basic adjectives relating to length, weight, size, shape, age or temperature **5**. adjectives of **colour** come in fifth position **6**. adjectives relating to inherent characteristics often indicating material qualities: (shiny, rusty) **7**. adjectives of origin (classes 6. and 7. are often interchangeable) **8**. adjectives of purpose, often as a compound noun or gerund (as in, racing car, office block).

colour atlas

A chart showing colours. See also **colour card**.

colour balance

The relationship between different colours in juxtaposition.

colour bar

A set of rules or a policy discriminating against people of another race, particularly as applied by White people against Blacks.

colour bath plug

A recently invented bath plug the liquid crystals in which go red when the bath water is too hot, blue when it is too cold and green when it is just the right temperature.

colour-beginning

The particular colouring technique (such as **underpainting**, **dead-colouring** or applying a **wash**) used by artists when starting a painting.

colour-blindness

The inability to recognise or distinguish any or all of the colours red, green and blue. Colour blindness affects males more than females in the proportion of 20 to 1. Whilst the human eye has red, blue and green **cones** almost all other mammals (the exceptions are apes and Old World monkeys) have only blue and green (or blue and yellow) **cones** although dolphins and whales cannot see the colour blue. Giraffes are unable to differentiate between yellow, orange and green and, apparently, horses, bulls, hedgehogs and mice, amongst others, cannot distinguish colour, having no cones in the retinas of their eyes. Parrots can group objects by reference to their colour. Total colour-blindness consists of **rod** vision with the ability to see only shades of dark and light with no perception of the colours of the **spectrum**. See **dichromacy, trichromacy, achromatopsia** and **monochromacy**.

colour box

A paint-box; a receptacle used by artists to hold paints, colours, brushes and the like.

colour card, colour chart

A chart showing colour samples usually of fabrics or paint.

n **colour circle**

See **colour wheel**.

n **colour code or coding**

A method of indicating differences by the use of different colours in a large number of situations. Examples include, flags used for signalling in shipping; traffic signals; railway signalling; pavement and street markings; safety warnings on machinery and equipment; warnings on vehicles carrying dangerous substance; directional indications; sizes of clothes; the wiring of electrical plugs and teaching children how to read. An interesting application has been adopted in Gwynnedd Hospital in Wales where bracelets of different colours are worn according to whether patients wish to speak Welsh, English or both. Using colour and colour coding is a powerful method of enhancing memory. See also **colour wires, colour symbolism, compass colours** and **signal red**.

n **colour coder**

Equipment contained in a **colour television** to decode colour signals.

n **colour combination**

The conception of a scheme for the effective combining of different colours in design, decoration or clothing etc.

n **colour combing**

The technique of using combs which when applied to a surface of wet paint on a different coloured background produce coloured patterns.

a **colour conscious**

Racially prejudiced, a euphemism. See **colour prejudice**.

n **colour constancy**

The phenomenon where, irrespective of the kind or colour of light directed onto a surface, the human eye is able to determine the correct colour of that surface.

n **colour contrast**

The phenomenon of colour appearing to vary according to the colour surrounding it.

adjective a
adverb adv
a colour c
noun n
prefix pr
suffix su
verb vb

a **colour co-ordinated**

Particularly as regards clothing and home furnishings, all aspects effectively combining or harmonising in accordance with a **colour scheme** or plan.

n **colour correction**

The alteration of colours in digital images or in the printing process to produce a more representative picture. See **RGB**.

n **colour depth**

Indicates the number of different colours capable of being picked up by a digital camera.

n **colour difference signals**

Television codes used for colour transmission.

n **colour dreams**

Dreams viewed in colour as opposed to black and white.

n **colour dynamics**

The concept of the movement of colours. Charles Henry in his *Cercle Chromatique in 1889* regarded red as moving upwards, blue as moving to the left and yellow as moving to the right. Colours have often been employed as an indication of direction (North, South, East and West) particularly in Mexico although without any degree of uniformity. See also **colour symbolism** and **compass colours**.

a **coloured**

Having or possessing colour. The term 'coloured' used to describe people of African or Asian descent is offensive and politically incorrect. Although there remains uncertainty as to the correct terminology, the word 'Black' is used extensively in the UK. The preferred term in the USA for people of Negroid origin is 'Afro-American', the words 'Negro' and 'black' being no longer acceptable. See **dark-skinned**.

n **coloured gems**

The process by which light is absorbed and refracted within the particular structure of any gemstone is complex. The colour manifested is also effected by the metal content of the mineral. Hence iron creates red, blue, green and yellow; titanium and iron give rise to the blue of sapphires; copper produces the green and blue of turquoise and chromium produces the red of the ruby and the green of emeralds. See also **alexandrite, labrador blue, lapis lazuli, opal** and **sapphire.** See **diamond colours.**

coloured hat problem 1

There are many mathematical/logic problems which depend on the colour of hats. There follows one soluble and one possibly insoluble example. Four subjects each wear either a white or a red hat. One faces a brick wall. The other three also face the brick wall but on the other side and one behind the other. The last in line, no. 1, can see 2 and 3, 2 can see 3 but none of them can see 4 who is behind the wall. None of them can see his own hat. The subjects are merely told that each of the four is intelligent and that only two white and two red hats have been distributed. The puzzle is to determine who should be the first subject to work out the colour of his own hat. **See solution to coloured hat problem**. See also **Green-hat thinking.**

coloured hat problem 2

The following problem, attributed to Dr Todd Ebert at the University of California at Irvine, has become a celebrated and important puzzle for mathematicians researching coding theory which has application both in telecommunications and computer science. Three players each have a red or a blue hat placed on his head – the colour being determined by the flip of a coin. Each player can see the others' hats but not his own. Players are allowed only to discuss their strategy at the outset but cannot otherwise communicate with each other. The task is for them simultaneously to guess the colour of their own hat or alternatively, to pass. If at least one of them guesses correctly and none of them guesses incorrectly then the team will win a large money prize. The basic problem is to find the best strategy for winning taking into account that the game can be played with any number of players in the team. There are apparently many strategies which vary depending on the number of participants.

coloured plastic

A kind of polymer with special characteristics including molecules which are not rigid and which can therefore conduct electricity. The result (as discovered by Professor Ifor Samuel of the University of St Andrews) is that such plastic can generate light of various colours according to the core of the particular molecule. Plastics of this kind are likely to have numerous practical applications.

coloured strobe therapy

The treatment of many conditions such as depression, phobias, dyslexia, epilepsy and strokes by use of colour strobes. See also **colour therapy.**

n **coloured wires**

The current in electrical cables and wiring is carried to the appliance by the live wire which is indicated in the EU by a brown or red sleeve. The neutral wire (blue or black sleeve) carries the energy onwards. The earth wire which carries the current to 'earth' is housed in a yellow or green sleeve.

n **coloured words**

A system for teaching grammar using different colours to indicate different parts of speech.

n **Coloureds**

The classification given by South Africa to racially mixed groupings under apartheid.

n **coloureds**

Those bits of laundry which must be washed separately from white items (the **whites**) to avoid colour run.

a **colour-enhancing**

Bringing out the natural colour as in 'colour-enhancing shampoos'.

n **colourer**

A person who colours books, prints etc.

n **colour-fade**

The term used by manufacturers of hair-dye to indicate the rate at which dyed hair returns to its natural colour. This is most graphically illustrated by the Organics advert in the Summer of 2000 showing a redhead peeping inside her bikini bottom and bearing the caption: '*Keeps hair colour so long, you'll forget your natural one*'.

a **colourfast**

Usually as regards fabric which has the quality of constancy of colour and the absence of colour running and **discolouration**, despite being washed or worn. Hence, 'colourfastness'.

n **colour-field art**

Paintings (such as those of Mark Rothko (1903-1970)) where the entire canvas is covered by one or more solid blocks of colour. See also **white paintings**.

colour filter — n

A thin layer of coloured glass or other transparent material which limits the transmission of certain wavelengths while allowing others to penetrate.

colourful — a

Having many different colours; having bright colours; full of interest. Hence 'colourfully'. (You might like to experiment mouthing the word 'colourful' to someone of whom you are very fond in order to see how they read your lips).

colourful language — n

Swearing; expressions of a vulgar kind.

colour gamut graph — n

A graph which compares the range of colours which can be perceived or produced by, for example, the human eye, colour monitors and offset-printing.

colour gloss treatment — n

A semi-permanent hair dyeing process.

colour ground — n

In painting, the surface on which paint is applied after it has been prepared (possibly by the application of **bole** or **gesso**) in order to make it less absorbent and to prevent reaction with the paint. See **ground**.

colour harmony — n

See **harmony**.

colour healing — n

Methods of healing by the use of colour. See **Aura-Soma**, **chromotherapy** and **colour therapy**.

colour hearing — n

The condition where sounds are automatically associated with colours. Some people have the facility to associate particular numbers with colours. See **synæsthesia**.

adjective a
adverb adv
a colour c
noun n
prefix pr
suffix su
verb vb

colour illumination therapy

A treatment used in **colour therapy** involving the exposure of a patient (or sometimes part of a patient's body) to light of different colours.

colour index

The difference in the magnitude of stars.

Colour Index (C.I.)

The standard reference on dyes and pigments published by the Society of Dyers and Colorists. The C.I Name indicates the kind of dye or pigment, the hue and the number assigned. The C.I. Number is a five digit reference number indicating the structure of the pigment. Also the Colour Index International.

colouring

The markings on an animal (see **variegated**); the colour of the human **complexion**; the appearance of anything as regards its hue, shade tone etc; the application of colour; exaggeration or false appearance. A syrup made by simmering sugar, butter and water until it reaches a brown colour.

colouring agent

An additive the effect of which is to produce a particular colour; the pigment or dye itself.

colouring book

A book with outline drawings in black and white for children to colour in with paint or **colouring pencils**.

colouring (or coloured) pencils

Pencils of different colours containing wax and used for drawing and painting. Pencils are also available with a water-soluble ingredient contained in the lead.

colouring power

As in 'the colouring power of turmeric' which is the subject of a British Standards Institute publication.

colouring strength

See **tinting strength**.

n **colour irradiation**

The result of looking at a strong colour and seeing its complementary colour. See **after-image**.

vb **colourise; to**

To add colour, in particular, to a black and white film using electronic means.

n **colourist**

A designer or an artist adept at using or applying colour. Titian was reputed to be the finest with his use of vivid colours. See **Titian's Colours**. Also used to describe members of some painting schools such as the 'Scottish Colourists' who were renowned at the beginning of the 20th century for their vivid use of colour.

n **colour layering**

A technique involving the application of multiple layers of toner employed by **colour printers** to produce colour images.

a **colourless**

Devoid of colour; devoid of interest.

n **colour-maker**

Someone (usually a chemist or technologist) who devises, creates and tests new pigments for use in making paints and dyes.

n **colourman**

A dealer in paint and other artists' materials. Colourmen became established in the 17th century as ready-made colours for artists became available. See also **reddleman**.

n **colour management**

The craft of choosing the appropriate colours for a particular project; the use of computer software in digital imaging for producing consistent colours over a range of computer devices.

n **colour mark-up**

Art-work containing instructions to the printer as to the colours required.

n **colour measuring instrument**

A system for measuring colour including **colorimeters** and **spectrophotometers**.

colour memory

The ability to store a particular colour in one's memory and to retrieve it faithfully.

Colour Museum, The

The museum in Bradford dedicated to colour and established in 1978 by the Society of Dyers and Colorists.

colour-music

A composition combining music and colour where different colours are displayed by reference to the notes played, for example, by means of the colour-organ generating colours on a screen. Oliver Messiaen (b.1908) worked on colour in music, in *Chronochromie*, 1960.

colour nouns

Colours are most oftenly used as adjectives but can also be used as nouns, as in: *'M&S bought too much grey this year'; 'my daughter wears only black'; ' Green helps actors to relax'.*

colour organ

A device invented by the Dane Thomas Wilfred in the 1920's for displaying compositions of colour in silent concerts.

colour party

A soldier or guard carrying the regimental or other colours such as a **colour sergeant**. A party where guests are invited to arrive wearing items of clothing each having a different colour with a view to swapping them so as to be able to return home with apparel of only one colour.

colour photography

One of many methods of producing coloured images on paper or film.

colour plate

A colour print made from a plate; the plate itself.

colourpoint

A cross between a Siamese and a Persian cat.

colour prejudice

An illogical antipathy or opposition on the part of a person to persons having a different coloured skin often resulting in unfair treatment such as a **colour bar**.

colour printer n

A printer attached to a computer and capable of printing in colour. Amongst the different kinds of technology available are laser printers, inkjet printers, thermal wax printers and solid ink printers.

colour printing n

The process of producing colours on the printed page by a number of different methods including: the four-colour process (see **four-colour production** and **colour separation**); the flat colour process involving the selection of colours from a tint chart or by means of a computer.

colour psychology n

The study of the effects of colour on behaviour. The discipline which subscribes to the view that the personality of individuals and the essence of corporate entities, as well as the environments in which they operate, can be expressed and reinforced by the use of particular colours and the avoidance of others.

Researchers at Leeds University and Kyoto Institute of Technology have found a correlation between colours and the mood or emotion generated by them. It is thought that this will give guidance to manufacturers as to the best colours to use in their products. The researchers have also found that the way colours are received differs from country to country. Colour psychology has application in many areas. Some colour psychologists consider that the colour of the clothes worn by job applicants will have a significant effect on the employers perception of the interviewee. Green, for example, conveys a sense of a balanced candidate; grey indicates a lack of self-confidence and blue suggests a good intellect. Colour influences our perception of smell and taste. Research indicates that the colour of wine may influence wine-tasters more than the TASTE of the wine, the same description having been given by a group of professional tasters to the taste of a particular red wine and a white wine which had been stained red.

colourpuncture n

A form of **colour therapy** which involves the application of beams of coloured light to acupuncture points.

colour qualia n

The conscious experience of colour – (the singular form is 'quale') – and a term used by philosophers particularly in the context of their debate as to whether colour exists in the physical world or whether it resides only in the mind so that the quality would not exist but for the ability of the eye and brain to recognise it.

adjective a
adverb adv
a colour c
noun n
prefix pr
suffix su
verb vb

n **colour ramp**

Computer programming tool used in generating electronic colour on a monitor so that, by a process of gradation, it shades into another colour.

n **colour reflection readings**

A diagnostic method involving colour cards employed in **colour therapy** to determine imbalances.

n **colour run remover**

A household product used to reverse the accidental colour change of a garment when washed with an item (usually an odd sock) the colour of which has run.

n **colour scheme**

A combination of colours carefully selected, in particular, for furnishings, interior decoration, clothes etc to co-ordinate or, which when juxtaposed, appear to go well together. Research indicates that colour in the working environment exerts a significant influence on our working life. See, for example, **green room**.

n **colour sense**

The attribute of being able to discriminate colours effectively.

n **colour separation**

The process whereby the **primary colours** in a picture are separated to make colour plates which are used to print one colour on another.

n **colour sergeant**

The sergeant whose duty it is to carry or guard the regimental colours. Also colour guard.

n **colour, shot of**

A rush of colour, for example, to one's face.

n **colours of alchemy, the**

The main colours of the alchemists of the Middle Ages were black, gold, red and white. Colour played an important role in the philosophy of the alchemists as highlighted by the psychoanalyst Carl Jung in the 1920's. He found a connection between the significance of colour as determined by alchemy on the one hand and the colours of the fantasies and dreams of his patients and derived some notion of a 'collective unconscious'.

colourspeak

A term coined by the writer to indicate the particular use of a word in its application to matters concerning colour as opposed to some other discipline or context in which that word may also have meaning. 'Gold' in colourspeak indicates the colour but refers to the precious metal in other contexts.

colour spine charts

Colour charts allocating colours to parts of the spine used by colour therapists often as part of **colour illumination therapy**.

colour spot-test

A test employed to determine the presence of a particular substance or drug such as cocaine. To test for cocaine, for example, a pink solution referred to as a 'cocaine reagent' is used which when added to cocaine turns turquoise.

colourstore

The place in a dye factory where dyestuffs are stored.

colour supplement/section

The glossy colour magazine included particularly with weekend newspapers.

colour symbolism

Colours have many and varied symbolic associations. The significance of colour changes according to culture, religion, fashion etc. The following are some recognised connections in the Western world: blue – loyalty, constancy, mystery; yellow – cowardice, envy, treachery; green – inexperience, freedom, vitality, the environment; white – innocence, purity, death; black – death, sorrow, evil; red – aggression, love, fire,honour; violet – repentance. In ancient and medieval times the world was treated as composing 'four elements' – earth, water, air, and fire each of which had its own symbolic colour, namely, black, white, yellow and red respectively. Colour remains an important symbol in Church ceremony and ritual varying according to tradition – white being a symbol of Christmas or Easter; gold of Easter; red of Pentecost and the feast of martyrs; purple a symbol of Advent and Lent and green of the new year. In ancient Egypt, black was associated with rebirth and in India and China white is the colour of mourning. Colours have also been widely identified with shapes. An experiment in Germany in the 1930's found that the three **primary colours** red, yellow and blue were associated respectively with the triangle, the circle and the square. Johannes Itten, the Bauhaus teacher (1888-1967), correlated red with the square, yellow with the triangle and blue with the circle.

n **Colour Symphony, The**

The Symphony composed in 1922 by Sir Arthur Bliss (1891-1975) with movements entitled 'Purple', 'Red', 'Blue' and 'Green'.

n **colour systems**

Systems devised for categorising and measuring colours. See, for example, **colour theory**, **colour wheel**, **Munsell Colour System**, **Ostwald circle**, **Natural Color System**, **ISCC-NBS** and **Commission International de l'Eclalrage**.

n **colour technologist**

Anyone whose job it is to involve himself with the technicalities of colour in many different disciplines including paint mixing, dyeing, printing, film, television broadcasting and Internet web-site building.

n **colour television**

The system by which the camera filters the three **primary colours** to produce coloured televised pictures.

n **colour temperature**

A quality of colour used by photographers to determine the correct kind of film and the appropriate filter to be used in relation to a particular light source. Colour temperature is measured in **Kelvin Units** (K's) or **mireds** by using a colour temperature meter. A particular temperature reading indicates the light source rather than its temperature and tells us that the light source emits a light resembling that which would be given out by a body having a temperature equal to the reading. Colour temperature increases the higher the blue wavelengths. A blue sky can produce a measurement 16,000 K and sunrise a measurement of between 2,000 and 3,000 K. Colours can be described as **warm colours** or **cold colours**.

n **colour theory**

The large volume of ideas concerning the nature of colour, what it is and how it is perceived as expounded by experts in a wide range of disciplines including philosophers, scientists, theorists, artists, psychologists, designers and colorists. Amongst those who have added substantially to our understanding of colour are Aristotle (384-322), Leon Alberti (1404-1472), Johann Wolfgang von Goethe (1749-1832) ('*Theory of Colours*' 1810), Sir Isaac Newton (1642-1727) ('*Optiks*' 1704), Michel-Eugène Chevreul (1786-1889), Wassily Kandinsky (1866-1944), Wilhelm Ostwald (1853-1932), Albert Munsell (1858-1918) and Josef Albers (1888-1976) ('*Interaction of Color*' 1963).

n **colour therapy**

The treatment of physical, mental, emotional, psychosomatic and other disorders and ailments by the use of colour. It has been found that using blue and red light can be a valuable aid in getting rid of acne – the blue light kills the bacteria and the red light repairs skin tissue. Red can help to cure rheumatism and blue can reduce blood pressure and is used to help jaundiced babies to recover. Russian scientists have recently discovered the benefits to cosmonauts of wearing coloured lenses in space and coloured contact lenses are being used to help dyslexics. Green lenses aid relaxation (see **green room**) and orange-red lenses are apparently conducive to greater and more effective work output. Colour therapy has been practised since Egyptian times. In Roman times coloured material was used to aid the healing process in wounds and hospitals continue the practice of the Middle Ages in using differently coloured rooms to aid the recovery of the ill. See also **Aura-Soma, chakra, Electro-crystal therapy** and **colour illumination theory**.

a **colour-tinted**

In relation to hair, a euphemism for dyed. Also, 'colour-corrected' etc.

n **colour touch**

A semi-permanent hair-dyeing process.

n **colour trends**

The influence particularly of the haute couture fashion houses in determining those colours which will be fashionable for clothes and accessories in the coming seasons. The International Color Marketing Group of the Color Association of the US provides its opinion as to colour trends in a variety of industries 24 months in advance. See **Autumn**.

n **colour wash**

Distemper.

n **colourway**

A **colour scheme**; one of a number of different colour combinations in which a particular pattern is printed; a colour combination as in 'dresses in various colourways' – 'when ordering please state the fabric colourway required'.

adjective a
adverb adv
a colour c
noun n
prefix pr
suffix su
verb vb

n **colourword, colour word or colour-word**

A word which pertains to colour. Two instances of 'colourword' occur in the OED.

n **colour 'weight'**

Colours are perceived to have varying 'weights' and affect our perception of the size of objects – the 'heavier' the colour of an object the smaller it appears to be. Red is apparently the heaviest colour. Orange, blue and green come next followed by yellow and white.

n **colour wheel**

A circle of touching colours in a diagrammatic form. One particular circle used to help mix paints comprises 12 colours including the three **primary colours**, the three **secondary colours** and the six **tertiary colours** in the following order: YELLOW>yellow-green>**GREEN**>green-blue>**BLUE**>blue-purple>**PURPLE**> red-purple>**RED**>orange-red>**ORANGE**>yellow-orange. Colour wheels are used to correct colours on scanners and monitors. Many wheels or colour circles have been devised including those of Sir Isaac Newton (1642-1727), Wilhem Ostwald (1853-1932), Johannes Itten (1888-1967), Johann Wolfgang von Goethe (1749-1832), Moses Harris (1731-1785), Ignaz Schiffermüller, Philipp Otto Runge (1777-1810), Ogden Rood (1831-1902) Albert Munsell (1858-1918) and Michel-Eugène Chevreul (1786-1889). See **Ostwald circle**.

a **coloury**

Having colour; possessing an abundance of colour.

n **colour zone**

An area set aside in a hair-dressing salon for dyeing hair.

c **columbine**

The colour of a dove. '*A kind of violet colour*' Samuel Johnson.

c **columbine-red**

A red describing the colour of the precious stone **Alexandrite** in artificial light.

n **combat colours**

Those colours used in clothing worn by soldiers often with the purpose of providing **camouflage**.

n **Commission International de l'Eclairage (CIE)**

The International Committee on Illumination having responsibility for making recommendations as regards **colorimetry** and **photometry** and for standardising colour notation. The CIE in 1931 produced a 'Colour Standard Table' or chromaticity diagram for measuring the colour of light which was revised in 1976.

compass colours

In some ancient civilizations primary colours were associated with the points of the compass. The Mayas of Central America, for example, made the following connections: white>N, red>E, yellow>S and black>W. In ancient China the associations they made with the compass were: white>N, blue>E, red>S and black>W. See **colour dynamics**.

complementary colours

Pairs of colours which are opposite each other on the **colour wheel** and which enhance each other, for example, red and green, yellow and purple and blue and orange. See **secondary colours**. Two complementary colours, such as blue and yellow, when juxtaposed produce a perfect contrast. A colour will appear most vibrant when juxtaposed with its complementary. Complementary colours always consist of one of the **warm colours** and one of the **cold colours** and either a **primary colour** and a **secondary colour** or two of the **tertiary colours**. See **split complementary colours**.

complexion

The *complex* colouring of the human skin. Specific terms for different kinds of complexion abound including, **ashen, blowzed, florid, leucomelanous, melanous, pasty, rambunctious, sallow, wan, xanthochroid, xanthomelanous** and **xanthous**.

composite colours

The intermingling of related hues producing a harmonious overall effect.

compound colours

Colours compounded of the **primary colours**.

computer graphics

The technique of creating and manipulating colours (over 16 million are possible) by means of a computer.

cones

Light sensitive cells in the retina of the eyes of many vertebrates providing the means of detecting colour. They contain pigments and respond to bright light whereas rods respond only to dim light. There are over 5 million cones in each human eye, but relatively few blue cones so that, for example, blue text placed on a black background is particularly difficult to read. See also **colour-blindness**.

c **Congo red**

A red cotton azo dye first produced in 1884 also used to treat diphtheria and rheumatism.

a **conker-coloured**

Reddish-brown (used in *The Evening Standard* 12.8.99 to describe leather boots).

n **conté crayons**

Coloured crayons made from pigment and graphite and bound with gum.

n **contrast**

The comparison of two or more colours in a manner which displays their difference; the juxtaposing of different colours in a way which enables them to be effectively compared or differentiated.

n **contrasted colours**

More usually referred to as **contrasting colours**.

n **contrasting colours**

Colours opposite to each other on the **colour wheel**, for example, red and green; blue and orange. See **complementary colours**.

n **contre-jour**

The use of backlighting in photography; those paintings in which the light source originates from behind the subject-matter of the work.

n **cool colours**

See **cold colours** and compare with **warm colours**; distant colours such as blue, green and violet which appears to move away from the viewer and recede into the background. See **advancing colours**. Also referred to as 'soft colours'.

n **coomassie blue**

A trade name for a dye used to detect certain proteins.

c **Copenhagen blue**

A bright purplish blue; a light blue. Also referred to as 'copen blue'.

c **copper**

Having the colour of the metal copper. Derived from 'Cyprus'.

n copper-green

A generic name for green pigments made from copper including **Scheele's green**, **chrysocolla**, mineral green, **Montpellier green**, **verditer** and verdigris.

n copper oxide

Used (particularly in the Middle Ages) to colour glass either green or red according to the length of time used for the heating process.

n copper resinate

A green pigment introduced in the 15th century made from **verdigris.** Also called copper resin.

a coppery

Incorporating a coppery hue as in 'coppery-brown.... flowers'.

c coquelicot

The red of the poppy; brilliant red; a colour term used by Jane Austin. Also called **ponceau**.

c corabell

A light orange coral colour tinted with crimson.

c coral

A deep pink or reddish orange.

c Coral

One of the colours in the **X11 Color Set**. It has hex code #FF7F50.

n corallin

Red or yellowish-red dye.

c coralline

Having the colour of red coral.

c coral pink

A deep orange-pink; sometimes a medium pink or a yellowish pink.

adjective a
adverb adv
a colour c
noun n
prefix pr
suffix su
verb vb

coral red

Bright red or a deep pink.

corbeau

Dark green.

n **cordon bleu**

An award indicating the highest degree of accomplishment especially in the culinary arts. 'Blue ribbon' originates from the blue sash which was a mark of the Order of the Garter, the highest order of knighthood, and from a similar insignia worn by the Knights of the Holy Cross, the highest order of chivalry in France.

c **corinthian pink**

A purplish pink.

c **cork**

A beige colour.

a **corn-coloured**

Resembling the colour of corn.

c **cornelian red**

The red colour reflected by the stone, cornelian or cornaline. See **carnelian**.

c **Cornflower Blue**

The darkish blue of the cornflower – one of the 140 colours in **the X11 Color Set**. It has hex code #6495ED.

c **Cornsilk**

A beige colour – one of the colours in the **X11 Color Set**. It has hex code #FFF8DC.

n **corona**

The circle of light radiating from the sun observable around the moon during a total eclipse of the sun.

c **corpse grey**

A macabre colour description requiring no further explanation.

vb **coruscate; to**

To glitter or sparkle.

a **corvine**

Having the characteristics of a crow – in particular, a glossy black colouring.

n **cosmetic**

A preparation use to add colour to the skin (particularly the face) usually to make the wearer appear more attractive. See **alacktaka**, **antimony**, **blusher**, **cheek-colour**, **eye-colour**, **eye-shadow**, **fucus**, **galena**, **greasepaint**, **henna**, **kohl**, **make-up**, **slaister** and **yehma**.

c **couleur de rose**

Rose coloured.

n **counterglow**

See **gegenschein**.

c **Coventry blue**

A blue dye providing good fastness of colour; thus used to describe a person who shows great loyalty. Takes its name from a blue thread once made in Coventry. See **true blue**.

n **covering power**

See **opaque**.

c **cowslip**

A light yellow.

c **coxcomb**

A bluish-red.

c **cramoisy**

Crimson.

c **cranberry red**

The dark red of the cranberry.

a **crane-coloured**

Having the pale grey colour of the crane bird.

a **crane-feather**

Having the grey colour of a crane's feathers.

n **crawling**

Defects in paintwork such as bare patches.

n **crayon**

An instrument made of **chalk**, wax or other material used for colouring, in particular, on paper. See also **conté crayons**.

n **crayonist**

An artist who uses **crayons**.

c **cream**

Having the colour of the milk-product cream; yellowish-white.

a **cream-faced**

Bearing a cream face, in particular, out of fear.

n **cream wove**

Cream writing paper which has an even surface.

a **creamy**

As regards colour, resembling cream.

c **creamy-white**

'a shade that settled at some indefinable point between yellow and creamy-white' *Captain Corelli's Mandolin* Louis de Bernieres.

c **creme de violette**

A deep violet.

n **cremello**

An albino horse having blue eyes and a creamish pink coat.

c **Cremnitz white, Kremnitz white**

A bright white made from a lead pigment; also called Krems white, Vienna white, Nottingham white, **flake white**, **silver-white**, **white lead** and **ceruse**.

c **cremosin**

Cremosin, cremesin, cremoysin, cremsin, cremysyn, cremysy, cremasie and qerinasi are all obsolete forms of **crimson** and **carmine**.

a **crepuscular**

Relating to twilight. Crepuscular rays – light from the sun shining through clouds – are on occasions misread for sitings of UFOs.

c **cresson**

A shade of green resembling the colour of water-cress; also 'cress-green'.

c **crevette**

The deep pink of the shellfish of the same name.

n **criblé**

An engraving bearing tiny white dots as background.

c **crimson**

A bluish-red. See **cremosin**. Originally made from the **kermes** insect.

c **Crimson**

One of the 140 colours in the **X11 Color Set**. It has hex code #DC143C.

c **crimson lake**

A synonym for **carmine**.

adjective a
adverb adv
a colour c
noun n
prefix pr
suffix su
verb vb

n **crimson madder**

A permanent bright red pigment by reference to which the **lightfastness** of **inks** used to be compared.

n **crocein**

A group of acid azo dyes used in the production of red and orange paint.

pr **croceo- (L)**

Saffron-coloured. See **saffron**.

a **croceous**

Saffron-coloured. Also 'crocreal'.

n **crocin**

The red powder of Chinese Yellow pods used to dye the vestments of Chinese mandarins.

vb **crock; to**

To stain any article with colour or dye.

pr **croco- (L)**

Orange.

n **croquet balls**

The colours of the balls used in croquet are blue, red, black and yellow. In singles each player has two balls. Blue and black always play red and yellow.

a **crottle, crotal**

Having the golden-brown colour of lichen.

n **cryptic colouring**

Camouflage especially as regards animals who disguise their shape. See also **apatetic, aposematic, chameleon, chromotropic, epigamic colours, episematic, metachrosis, procryptic, pseudepisematic, sematic, startle colours, tinctum-utant** and **Batesian mimicry**.

n **cryptochromism**

Camouflage.

c **cucumber green**

The dark green colour of the rind of the cucumber.

n **cudbear**

A natural red, violet, purple or brown dye made from fermented lichens.

c **cuir**

A yellowish-brown; the colour of leather.

c **cumquat, kumquat**

The yellowy-orange of the cumquat fruit.

a **cupreous**

The reddish brown colour of copper; copper-coloured; a bronze colour.

pr **cupri- (L)**

Copper.

n **curcum**

An ancient yellow dye from the kurkum plant.

n **curcumin(e)**

The orange-yellow colouring matter of turmeric. An additive used for food colouring (E100).

n **curry colours**

See **tartrazine, sunset yellow** and **Ponceau 4R**. The colouring from natural spices such as **saffron**, turmeric and chilli is preferable since artificial additives can apparently cause hypertension, asthma and other conditions.

c **custard-coloured**

Used by Charles Dickens in *My Mutual Friend*.

c **custard-yellow**

As regards hair as in custard-yellow streak.

n **cutch**

A natural brown dye from the Acacia tree and others. Another name for **catechu**.

n **cutting**

Filling (such as barite, clay or **chalk**) added to a pigment.

c **cyan**

Greenish blue. Hence, 'cyanic'. One of the three **subtractive primary colours**.

c **Cyan**

One of the colours in the **X11 Color Set**. It has hex code #00FFFF.

a **cyaneous**

Dark blue. Occurring in Homer's *Iliad* on 45 occasions.

n **cyanin**

The blue colouring matter of violets, the cornflower and other flowers.

n **cyanine**

A group of synthetic dyes including cyanine blue used particularly in photography.

pr **cyano- (G)**

Blue.

n **cyanobacterium**

Micro-organisms or algae of a kind existing billions of years ago containing (blue) **phycocyanin** and (green) **chlorophyll** producing beautiful colours and the bloom of which may be the reason why the **Red Sea** appears to be red.

n **cyanophil**

A blue-green colorant in certain plants.

n **cyanosis**

Blueness of the **complexion** due to lack of aeration or oxygen.

c **cyclamen**

The red or pink or reddish-purple colour of the cyclamen flower.

a **cymophanous**

Opalescent.

c **cypress**

Dark grey.

c **cypress green**

A yellowish green.

c **cypress green**

A green pigment also referred to as **Verona green** and Appian green.

n **cytochrome**

Colourless pigment found in all living matter.

adjective a
adverb adv
a colour c
noun n
prefix pr
suffix su
verb vb

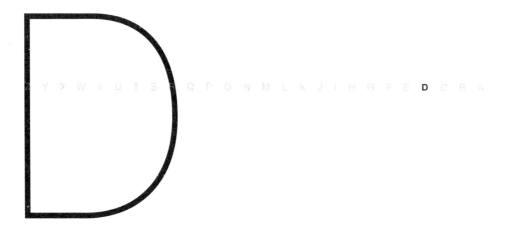

vb **dabble; to**

To daub, spatter, splash or smear with paint or colour.

c **daffodil yellow**

The yellow of the daffodil. See also **asphodel** from which word daffodil emanates – *de affodil* meaning from the affodil or asphodel a genus of the lily.

c **dahlia**

The bluish-red of the flower which was named after the Swedish botanist, Dahl, who was the first to cultivate the plant.

n **Daltonism**

Colour-blindness; the inability to distinguish red from green.

a **damascene**

Having the dark purple colour of the **damson**. Both this and the next entry are derived from 'Damascus'.

c **damask**

Deep pink, rose; blush-coloured. *'There was a pretty redness in his lip, A little riper and more lusty red Than that mixed in his cheek. 'Twas just the difference Betwixt the constant red and mingled Damask'* Shakespeare's *As You Like It* Act 3 Scene 5.

n **dammar**

Varnish.

c **damson**

The deep purple colour of the damson fruit or of the plum; also damson brown. From the same root as **damask**, namely, 'damascene' pertaining to the city of Damascus.

c **dandelion**

The vivid yellow of the petals of the flower of the same name. From *dent de lion* literally the tooth of the lion in reference to the tooth-like roots of the plant.

n **dapple**

A round spot of colour.

a **dappled**

Having patches or spots of different colours; mottled; '*dappled things*' Gerald Manley Hopkins. Hence 'to dapple'.

c **dapple-grey**

A grey colour with darker patches of grey; used especially in describing horses. This is an old word used by Chaucer (? 1343-1400) in the Canterbury Tales and is possibly a corruption of 'apple-grey'.

a **dark**

As regards colour, reflecting only a small amount of light; a colour is said to become darker the more grey there is in it. Having limited or no light, as regards hair or **complexion**, not fair, swarthy, brunette; gloomy, iniquitous, hidden, obscure.

n **Dark Ages, the**

The period in European history from about 470 AD to 1000 AD. Some academics consider that the Dark Ages began in 540 AD as a result of the Northern hemisphere being struck by fragments of a large comet which plunged large parts of Europe into darkness as a consequence of the resulting debris and dust in the atmosphere.

c **DarkBlue**

One of the 140 colours in the **X11 Color Set**. It has hex code #00008B.

c **DarkCyan**

One of the colours in the **X11 Color Set**. It has hex code #008B8B.

n **darkening**

The process whereby oil paint colours, if left to dry in the dark, will themselves darken. Their colour can be restored during the drying process by being exposed to light.

c **DarkGoldenrod**

A light brown colour – one of the colours in the **X11 Color Set**. It has hex code #B8860B.

c **DarkGray**

One of the colours in the **X11 Color Set**. It has hex code #A9A9A9.

c **DarkGreen**

One of the colours in the **X11 Color Set**. It has hex code #006400.

c **DarkKhaki**

One of the colours in the **X11 Color Set**. It has hex code #BDB76B.

vb **darkle; to**

To darken.

a **darkling**

In darkness. Originally an adverb meaning in the dark.

adv **darkly**

Mysteriously; in a threatening manner; dark-looking.

c **DarkMagenta**

One of the colours in the **X11 Color Set**. It has hex code #8B008B.

n **dark matter**

The highly elusive matter which is expected to provide the key to understanding the universe. Although it constitutes 90 per cent of the universe's mass, scientists have not yet been able to trace it.

c **DarkOliveGreen**

One of the colours in the **X11 Color Set**. It has hex code 556B2F.

c **DarkOrange**

One of the colours in the **X11 Color Set**. It has hex code #FF8C00.

c **DarkOrchid**

One of the colours in the **X11 Color Set**. It has hex code 9932CC.

c **DarkRed**

One of the colours in the **X11 Color Set**. It has hex code 8B0000.

c **DarkSalmon**

One of the colours in the **X11 Color Set**. It has hex code E9967A.

c **DarkSeaGreen**

Another of the colours in the **X11 Color Set**. It has hex code 8FBC8F.

a **dark-skinned**

Having a **complexion** other than white. According to recent research, when man originated in Africa 100,000 years ago he had a mid-brown skin. A whiter complexion developed as man spread North to colder regions as a means of generating more vitamin D. Darker complexions developed as man travelled nearer the equator where he acquired additional protection from the sun. The Nobel prize-winner involved in mapping the structure of DNA – James Watson – created some controversy in December 2000 when he put forward the proposition that those with dark skins have a greater sex drive compared with those of paler complexions owing to heightened levels of melanin resulting from exposure to the sun.

c **DarkSlateBlue**

One of the colours in the **X11 Color Set**. It has hex code #483D8B.

c **DarkSlateGray**

One of the colours in the **X11 Color Set**. It has hex code #2F4F4F.

a **darksome**

Dark; somewhat dark.

adjective a
adverb adv
a colour c
noun n
prefix pr
suffix su
verb vb

c **DarkTurquoise**

One of the colours in the **X11 Color Set**. It has hex code #00CED1.

c **DarkViolet**

One of the colours in the **X11 Color Set**. It has hex code 9400D3.

n **dash of colour, a**

The addition of a mere stroke of colour especially to a painting possibly having great effect.

vb **daub; to**

To paint colour haphazardly or without skill.

c **Davy's grey**

A grey slatey colour named after Henry Davy.

c **daw**

A pale yellow or primrose colour.

c **day-glo pink, dayglo pink**

A bright gaudy pink colour.

n **daylight**

The light of the day; also figuratively, the space between two competitors in a closely-run race.

vb **dazzle; to**

To blind someone temporarily with the use of bright light.

a **dazzling**

Brilliant, effulgent.

n **dead-colour**

The initial application of a dull or neutral colour to enhance the tone of a painting. Also 'dead-colouring'.

c **dead gold**

A gold colour lacking **lustre**.

c **dead-leaf brown**

See **feuillemorte**.

a **dead white**

Pure white; white without any **lustre**.

n **dealbation**

Hair bleaching; the process of whitening, particularly, hair.

a **deathly white**

Greyish-white, particularly as used in relation to the **complexion** of someone who has experienced extreme shock or fear.

vb **decolorize; to**

In its transitive form, to remove colour from an object; in its intransitive form, to cease to have colour.

n **décor**

The style or **colour scheme** of a room or interior.

vb **decorate; to**

To make something more attractive often by the addition of colour; to paint a house; to paint or wallpaper the inside of a home.

a **deep**

In relation to colours, having an intense hue as in 'deep purple' whereas in the phrase 'the deep blue sea' it is the ocean that is deep and not the colour!

n **Deep Blue**

The IBM Supercomputer which in May 1997 beat the reigning World Chess Champion, Garry Kasparov. Kasparov was at least relieved at the fact that Deep Blue could feel no pleasure at winning!

a **deep-hued**

Having an intense colouring. Also 'deep-coloured'. See **deep**.

c **DeepPink**

One of the colours in the **X11 Color Set**. It has hex code #FF1493.

c **DeepSkyBlue**

One of the colours in the **X11 Color Set**. It has hex code #00BFFF. See **sky blue**.

a **deer-coloured**

Having the tawny-red or greyish-brown colour of deer.

c **Delft blue**

The distinctive blue which is characteristic of Delft chinaware; a colour originally coming from China and effectively reproduced by the potters of Delft, Holland in the 18th century.

a **delicate**

As regards colours, subtle or soft.

vb **delineate; to**

To trace something in outline.

n **deliquium**

The disappearance of light as in a total eclipse of the sun (obs.).

c **delphine**

A shade of blue possibly the same as **delphinium blue**.

c **delphinium blue**

A blue tinged with violet. Also called 'delphinium'.

n **demi-permanent**

As regards hair dyes, not permanent.

vb **denigrate; to**

To blacken particularly as regards someone's character or reputation.

n **densitometer**

An instrument for measuring colour density.

vb **depurpleise; to**

To bowdlerise text in order, for example, to rid it of steamy sex scenes and oversentimental expressions.

c **Derby red**

See **chrome red** and **chrome orange**.

n **deuteranomaly**

A mild form of **colour-blindness** characterised by a reduction in sensitivity to the colour green and to variations in the colours green, orange red and yellow. See **trichromacy**.

n **deuteranopia**

A form of **colour-blindness** suffered by 'deuteranopes' who do not have cones which detect the colour green and thus find it difficult to distinguish the colours brown, green, yellow, orange and red. Green is seen as brown and yellow as orange. Sometimes referred to as 'green blindness'.

c **Devonshire blue**

A paler shade of **delphinium blue**.

n **Dewey Classification**

The main Dewey Decimal Classification in libraries for the subject, colour, is 752. There are many other locations for colour subjects such as in architecture (729), personality tests (155.284), colour chemistry and dyes (667.2), photography (778.6 and 616.07571), colour reproduction (686.23042), **colour television** (621.38804) and **colour therapy** (615.831).

n **diamond colours**

The purest diamonds are colourless or pure white with a hint of blue. If the extent of the blue is slight the diamond may be classified as of 'premier' quality. A yellow tinge is classified as 'cape'. A diamond with a deep yellow tinge is referred to as a 'canary'. There is an extensive colour categorization for diamonds and the USA has its own terminology including 'Wesselton' for a white diamond. Natural diamonds are found in a variety of colours including pink, red, blue and orange. See also **coloured gems**.

n **diaphanie**

A method of producing imitation coloured glass by the use of coloured paper.

a **diaphonous**

Transparent; see-through.

adjective a
adverb adv
a colour c
noun n
prefix pr
suffix su
verb vb

c **Diarylide yellow**

A dark **azo** yellow.

n **diatomin**

The yellow-brown pigment of certain algæ.

pr **dichro(o)- (G)**

Two coloured.

a **dichroic**

Having two colours as in double-refracting crystals. See also **trichroic**.

n **dichromacy**

A more serious form of **colour-blindness** than **trichromacy** in which only two of the three **primary colours** can be detected. See **deuteranopia, protanopia** and **tritanopia**.

a **dichromatic**

Particularly as regards animals, having two colours.

n **dichromatism**

The condition where the combination of two colours as opposed to the usual three are adequate to generate a colour.

a **dichromic**

Having or pertaining to only two colours.

n **diffraction**

The phenomenon of bending light which occurs when it hits an opaque body or passes through a narrow opening.

n **diffraction grating**

Shallow grooves or ridges on a surface producing a **spectrum** of colours when the surface is tilted towards light as appears, for example, with **rainbow**s, opals and on the underside of a CD or compact disc with its array of reds, oranges, greens and purples.

a **diffusion**

The spreading out of light as, for example, through fog or frosted glass or plastic light coverings.

n **digital colour**

Colour produced on television and computer monitors or PC's etc. Computer colour consists of a mixture of red, green and blue each of which consists of 256 values so that over 16 million different colours can be created. See **RGB**.

n **diluent**

A substance, such as turpentine, used to dilute paint. Also called 'thinner'.

a **diluted**

As regards colour, less concentrated.

a **dim**

Poorly lit, indistinct. As regards colour, lacking in lustre or brilliance.

c **DimGray**

One of the colours in the **X11 Color Set**. It has hex code #696969.

a **dingy**

Dark, lacking in brightness. Having a dull colour. Also used to qualify colours as in 'dingy white'. Possibly derived from 'dung'.

c **dioxazine purple**

A popular purple made from carbazole dioxazine.

n **dioxazines**

A class of complex organic dyes and pigments made mainly from chloranil.

vb **dip; to**

To immerse something into a dye or colouring agent.

a **dirty**

Indicating a mirky dark colour as in 'dirty-brown'.

n **discoloration, discolouration**

The process whereby something becomes **discoloured**.

vb **discolour; to**

To change the colour of something; to stain or tarnish.

a **discoloured**

Faded; changed in colour, particularly, to an **off-colour** by action of the sun, the elements or some chemical action.

n **discord**

All colours can be juxtaposed with another to create a discord (the opposite to a **harmony**) so as to create an impression of disunity, sourness, jarring or incompatibility. While this is a matter for individual taste there appear to be some natural rules as evidenced in the perception of **complementary colours**.

vb **disperse; to**

In physics, to bring about a separation of the spectral colours of **white light**.

n **disperse dyes**

A class of textile dyestuff dispersed in an aqueous solution.

n **dissembling colour**

'*his hair is of the dissembling colour*' says Rosalind in Shakespeare's *As You Like It,* that is, false or dyed hair. Thought to be a reference to red-haired villains. Although in ancient times red hair was considered to be alluring, at the time of Shakespeare red hair was associated with cheats and witches. Despite a revival in the popularity of red hair during Elizabethan times (Elizabeth I used a large number of red wigs) it again developed disparaging connotations at the beginning of the 19th century when it conjured up allusions to prostitutes. Hollywood and the silver screen have helped to restore the image of the **redhead** although there appears still to be much prejudice against those with red hair.

n **distemper**

In painting, a technique using pigments mixed with water and glue to produce an opaque coloration; in house painting, **whitewash** used on walls.

a **distinct**

As regards certain species of fauna and flora, markings or decoration which enable that species to be easily distinguished.

n **dithered colours**

The optical effect produced by juxtaposing dots of colours in a particular way. See **non-solid colour** and **Pointillism**.

n dithering

In web graphics and the design of websites on the internet, the process whereby the computer program provides an approximate simulated colour to one which the monitor is unable to display.

a diversicoloured

Having various colours.

n divisa

The coloured ribbons used in bull-fighting.

n divisionism

See **optical colour**.

c DodgerBlue

One of the colours in the **X11 Color Set**. It has hex code #1E90FF.

a dogtooth

A check patterned fabric used for clothing, in particular, suits and shirts.

c doré

Golden; as an adjective has the meaning of containing gold.

a dotted

Bearing or covered in dots.

n double loading

The technique of employing two applications of paint on a brush at the same time.

c dove

A grey colour.

a dove-coloured

Having a pinkish or purplish shade of grey.

c dove-grey

The bluish-grey of the plumage of the dove.

adjective a
adverb adv
a colour c
noun n
prefix pr
suffix su
verb vb

n **downlight**

Lighting which casts its light towards the floor. Compare **uplight**.

n **DPP**

A class of organic pigments conceived in 1973 the full name of which is 'diketopyrrolo-pyrroles'.

c **drab**

Dull brown or grey colour; of a dull light-brown or yellowish-brown; lacking in colour. Also **olive drab**.

n **draconin**

The red colourant in **dragon's blood**.

n **dracorubin**

A natural red pigment.

n **dragging**

One of the decorative **broken colour** effects produced by drawing a dry brush over a surface to which a colour **glaze** has been applied.

c **dragon**

A bright greeny-yellow.

n **dragon's blood**

The bright red resin of the Indian palm tree, *Calamus Draco* (or perhaps of the shrub *Pterocarpus draco*) used as a paint pigment and as an additive to varnish. Also called *sang-de-dragon*.

n **drawing**

A sketch, picture or other representation consisting of lines on a surface in pen or **ink** or **chalk** or similar medium (as opposed to paint) usually in black and white.

n **drawing ink**

Ink used for drawing; see **India ink**.

a **dreary**

As regards colouring, gloomy or dismal.

c **Dresden blue**

See **cobalt blue**.

n **drip painting**

The style of painting in which the paint is dripped onto the canvas.

n **drop**

A painted theatre curtain or scenery.

n **drop black**

A high quality **bone black** made from calcinated animal bones used as an intense black pigment.

n **dry colours**

Pigments which have been prepared in powder form and require the admixture of water until they form a paste.

c **duck-egg blue**

A light turquoise blue.

c **duck green**

An imprecise pale green referring to the eggs of the duck and not to the duck itself. Hence often called 'duck's egg green'.

a **dull**

As regards colours, dim or indistinct; lacking in brightness or vividness. Synonyms include: obscure, flat, drab, lacklustre, faded, fading, faint, muted, sombre, subdued, softened, washed-out, dulled, muffled, insipid, dreary, unclear, toned-down, subfusc, murky, blurred, gloomy, colourless.

c **dun**

Greyish-brown, dingy, dusky, dull; as in the mouse.' *A colour partaking of brown and black'* – Samuel Johnson.

n **duograph**

A picture in two colours.

c **dusk**

According to Fielding's Dictionary of Colour 1854 *'perfect dusk is that colour to which if yellow is added it becomes yellowish, if red is added it becomed reddish and if blue is added it becomes bluish'.*

a **dusk**

Dark-coloured; dark; dim, blackish; usually in reference to twilight. Darkish as in dusk yellow or duskish yellow.

n **dusk**

Twilight or that period just before darkness. Also refers to that point of time in the morning when darkness is lifting.

a **duskish**

Blackish; somewhat dusk.

a **dusky**

Dark.

a **dust-coloured**

Having the pale brown colour of dust.

a **dusty**

Describes a colour which appears to have a coating of dust.

c **Dutch blue**

A blue-grey.

c **Dutch pink**

A brilliant YELLOW. See **English pink**.

vb **dye; to**

To change the colour of something permanently; to stain or give colour to something.

n **dye**

An intensely coloured substance in the form of a liquid solvent now mainly synthetic but formerly derived from natural sources. Used to colour textiles, fibres, plastics, metals, wood, basketware, carpets, furnishings, ceramics, inks, cosmetics, food, paper, leather and the human body. Also used in paint, medicine and photography. Dyes come in many varieties including acid dyes, **disperse dyes**, solvent dyes, **reactive dyes**, azoic diazo dyes, vat dyes and basic dyes. Derived from Old English and spelt as such to differentiate from the word 'die'.

a **dyeable,**

Something which can be dyed. Hence 'dyeability'.

n **dyebath**

A vat used to hold dyestuff.

n **dyer's rocket**

The plant *Reseda luteola* used to produce **weld**. It derives its name from the fact that the plant grows very quickly and to a great height – about 6 feet.

n **dyestuff**

A **dye** or a substance from a dye can be produced.

a **dysphotic**

Lacking in light as, for example, in the ocean depths.

| adjective a |
| adverb adv |
| a colour c |
| noun n |
| prefix pr |
| suffix su |
| verb vb |

n **E-number colours**

Those colours and colourants (both natural and synthetic) tested and approved by the European Community as food additives and numbered E100 to E180. Though approved, there is concern that some of the additives cause allergic reactions. Higher E-Numbers are allotted to other additives such as preservatives (E200-E297); emulsifiers and stabilisers (E322-E495); flavour enhancers (E620-E640); and sweeteners ((E950-E957).

a **earth-coloured**

Having one of the **earth colours**.

n **earth colours**

The colours found in nature. Natural earth displays itself in a vast array of different colours dependent on the chemicals or minerals present. For example, carbon or magnetite will produce a black earth, cobalt, magnesium or zinc has a blue effect; iron silicate or ferrous oxide has a green effect; iron oxide or lithium a red effect; feldspar, kaolin and quartz produce a whitish earth and limonite and ferric oxide produce a yellow effect; the whole range of oranges, ochres, russets, umbers and browns.

n **earth pigments**

A pigment obtained from native earth such as the ochres, siennas and umbers.

c **eau de nil**

Light green; literally 'water of the Nile' and hence also called Nile Green.

c **ebony, ebon**

Black coloured from the wood of the same name; *'ebon-coloured ink'* Shakespeare's *Loves Labours Lost* Act 1 Scene 1.

a **eburnean**

Having the colour of or resembling ivory.

n **eclipse**

The blocking out of light from something, particularly of the sun or the moon by the interposition of the earth.

vb **eclipse; to**

To obscure or cast a shadow over something.

c **écru**

The beige colour of unbleached linen; see also beige and grège. *'The colour of piecrust'* (clue 22 down *The Times* Crossword Puzzle 5.12.00).

n **efflorescence**

Redness of the skin.

a **effulgent**

Emitting bright light, shining brightly.

n **egg tempera**

Paint made particularly in the 14th and 15th centuries by mixing the white of the egg or the yolk (or both) with pigment, oil and water. It was the primary painting medium until replaced by oil painting around 1500. See **tempera**.

c **eggshell**

A pale beige; the colour of the shell of a hen's egg.

a **eggshell**

As regards paint, a surface or finish which is mid-way between gloss and matt, giving a slight **lustre**.

c **Egyptian blue**

An ancient rich purplish blue or turquoise colour made by heating copper, lime and quartz, also known as 'Egyptian frit'. Perhaps the first synthetic pigment. Sometimes called 'Pompeian blue'.

n **Egyptian frit**

An early turquoise blue pigment. See **frit**.

c **Egyptian red**

A dark red.

a **eidetic**

Vivid.

c **Eleanor blue**

A blue made popular by Eleanor Roosevelt.

c **electric blue**

A brilliant light blue.

n **electro crystal therapy**

A form of **colour therapy** involving the application of electromagnetic waves to the body through coloured crystals.

n **Electrodiagnostic Neurophysiological Automated Analysis ('ENAA')**

Equipment which records the impact of light on the eye and the brain and used to detect eye diseases, MS, depression and other conditions.

n **elementary colours**

Leonardo da Vinci (1452-1519) the master of the Renaissance considered that the six most important colours fell into a hierarchy and that each indicated one of the elements as follows: **1**. white – light **2**. yellow -earth **3**. green – water **4**. blue – air **5**. red – fire **6**. black – darkness. See also **essential colours** and **primary colours**.

c **elephant**

Light grey; sometimes a dark grey. Also 'elephant grey'.

c **elephant's breath**

A light grey 'art shade'; according to Maerz & Paul finding the authentic colour of this famous colour is very difficult.

n **eleutherin**

A natural yellow pigment.

a **elydoric**

Describing a mode of painting produced both with oils and water colours.

vb **embellish; to**

To adorn or beautify something possibly by the use of colour.

vb **emblaze; to**

To light up; illuminate.

vb **emblazon; to**

To make something bright by adding colour to it.

a **embossed**

Having a raised pattern or surface.

vb **embronze; to**

To bronze.

vb **embrown; to**

To make something go brown. Compare **empurple** and **embronze**. These appear to be the only three colours bearing the transitive em-prefix. But see also **encrimsom**, **engolden**, **envermeil** and **envermil**.

a **embrued**

See **imbrued**.

adjective a
adverb adv
a colour c
noun n
prefix pr
suffix su
verb vb

c **emerald green**

A dark yellowish-green originally made from copper aceto-arsenate (ite) which was also used as an insecticide. Used extensively by the artist Paolo Veronese (1528-1588) to a point where the colour was called vert Paul Véronèse in France. It was not commercially produced until 1822. Also called Schweinfurt(h) green which in turn is referred to as **Paris green**, Vienna green, imperial green and **Brunswick green**. Though toxic it was used in the manufacture of wallpaper and was considered in the 1860's to be the cause of a number of deaths resulting from arsenic fumes.

n **emeraldine**

A green dye. See **aldehyde green**.

n **Emerald Isle, the**

Ireland – in recognition of its greenness.

c **emeraude**

The French for 'emerald' but according to Maerz & Paul not the same green as emerald green.

c **emily-coloured**

An unknown colour at least to the author. Used in a poem by Edith Sitwell and according to Willard R. Espy in *'Thou Improper, Thou Uncommon Noun'* a typographical error. But an error for what?

n **éminence grise**

The power behind the throne – originating from Cardinal Richelieu's Secretary, Père Joseph, who was so referred to because he appeared in the background as a shadowy character.

c **empire blue**

A greenish-blue.

vb **empurple; to**

To make purple. See **embrown**.

n **emulsion**

A watery substance mixed with oil and an emulsifying agent to prevent the combination separating and used as a **medium** in the preparation of paint.

a **encaustic**

Having colours fused or burnt into the surface by means of heat and the use of wax or resin. Encaustic painting was one of the most important painting techniques in ancient times. Also refers to the process of decorating porcelain with enamel colouring. See **frit**.

a **enchased**

Variegated by way of ornamentation with gold or silver.

vb **encrimson; to**

To make crimson.

vb **endamask; to**

To tinge with a lighter colour.

c **English pink**

Most curiously, English pink is the name of a brilliant yellow. But this curiosity is not, as one might expect, a manifestation of English eccentricity for each of **French pink, Italian pink** and **Dutch pink,** (as well as **Bacon's pink**) are yellow shades – so named because the process of manufacture resembles that used to make **lakes**. There are also green pinks, brown pinks and rose pinks the last of which was probably instrumental in shifting the meaning of the word 'pink' from the process to the colour itself. Also sometimes a pink colour.

c **English red**

Red iron oxide also referred to as **Indian Red, Pompeian Red, Venetian Red** and **Persian red**.

vb **engolden; to**

To make golden; ('ensilver' and 'engreen' also appear in the OED).

a **engrailed**

Decorated with a variety of colours.

c **ensign**

The dark blue of naval uniforms.

vb **envermeil; to**

To tinge with vermilion.

vb **envermil; to**

To make red.

n **eosin, eosine**

A red dye made from coal-tar used in the cosmetic industry, for dying silk and as a biological stain. From the Greek *eos*, the dawn, in reference to the colour of the sky when the new day dawns.

n **epigamic colours**

The colours displayed by animals during and as part of the process of courtship. The male South Australian cuttlefish can take on the colouring of a female cuttlefish to enable it to mate by stealth with a rival's sexual partner. Once it pounces it reveals the black and white stripes of the male. Researchers at Naples University have found that when a telephone is positioned near to squid, the squid change colour. 19th century naturalists believed that almost all animal colour patterns developed for the purpose of **camouflage**. However, it is clear that many animals (particularly fish) change their body colour for a variety of other purposes including to locate members of the same species (see **episematic**), to frighten off the enemy and courtship as referred to above. Slow colour change is often effected by means of hormones whereas more rapid change is effected by the nervous system (as in the case of human blushing). See also **camouflage**.

c **epinard**

The dark green colour of the vegetable, spinach – *épinard* being the French for spinach. There are many other French words which take on a close resemblance to the English equivalent word once the initial 'é' is replaced by the letter 's' – for example, école, écriture, épellation, épice, éponge, état, étage and étranger.

a **epipolic**

Fluorescent (optics).

a **episematic**

Referring to the natural colouring of animals which helps them to locate members of the same species (see **aposematic**).

a **erne-coloured**

Having the colour of an eagle. Also 'eagle hued'.

a **erubescent**

Blushing, reddening. Hence 'erubescence'.

n **erythema**

A reddening of the skin.

n **erythrism**

Abnormal reddening especially of birds plumage.

pr **erythro- (G)**

Red.

n **erythrogen**

A range of red pigments produced in vegetables.

a **erythroid**

Having a red colour.

n **erythrophobia**

The fear of blushing or of red lights.

n **erythrophores**

Chromatophores with a red pigment.

n **erythrophyll**

Red colouring matter present in Autumn leaves. See **Autumn Colours**.

n **erythrosin, erythrosine**

A pinkish red stain made from fluorescein and used by photographers; the red/pink food additive (E127) used particularly in glacé cherries and in the baking of biscuits.

n **essential colours**

See **basic colours**, **Basic English Colours**, **bible colours**, **elementary colours**, **five original colours**, **four colour theory**, **primary colours**, **rainbow**, **simple colours**.

adjective a
adverb adv
a colour c
noun n
prefix pr
suffix su
verb vb

n **estate colour**

A particular colour favoured by old country estates as a uniform colour-wash for their cottages and buildings.

a **etherean**

Delicate in colour.

vb **etiolate; to**

To bleach something by depriving it of sunlight – particularly as regards plants and vegetables; to drain something of colour.

n **etiolin**

A yellow pigment found in plants which grow in the dark.

c **Eton blue**

The light blue of Eton public school adopted in the 16th century and appropriated by Cambridge University. See **Cambridge blue**.

n **eumelanin**

A pigment contained in birds' feathers.

a **euphotic**

Relating to that depth of water (possibly 100 metres) through which light can penetrate to enable photosynthesis to take place. See **aphotic**.

a **evanescent**

As regards colour having no permanence; quick to disappear.

c **evergreen**

A yellowish-green.

a **evergreen**

Always green in colour; descriptive of those shrubs and trees the foliage of which maintain their green colour throughout the year.

n **excitation**

The process of generating light from certain atoms such as in neon tubes and in lightning.

n **extender**

Substances such as gypsum and **chalk** added in the paint-making process to make the pigment go further or to dilute its colour.

a **exuberant**

'exuberant colours' *The Evening Standard* 15.4.99.

n **eye-colour**

Cosmetic colour for the eyelids; the colour of a creature's eyes. Some humans have two distinctly different coloured eyes – see **heterochromia**. Research shows that eye colour in humans is indicative of a person's disposition towards certain hearing conditions so that those, for example, with dark eyes are less likely to suffer noise-associated hearing loss and those with light-coloured eyes are more than five times as likely to suffer deafness after contracting meningitis than people who have dark eyes.

n **eyeshadow**

A cosmetic used to colour the eyelids.

F

n **face colour**

The aspect of the colour of paint (in particular, metallic paint) when looked at from an ordinary angle in contrast to **flop colour**.

n **facula**

The bright spots on the surface of the sun. See also **macula**.

a **faded**

As regards colour, the loss of brightness, vividness or freshness.

n **fade-marks**

Those parts of a surface or area which have faded or indicate fading.

a **faint**

As regards colours, lacking in brightness or vividness such as 'faint-yellow'.

a **fair**

Light in colouring especially as regards **complexion** and hair. (Hence the 'fairer sex').

n **fairground colours**

The bright colours of Pop Art and cartoon strips.

n fake blonde

A person whose hair has been dyed blonde. See **bottle blonde**.

n fake tan

The bronzing of the body by artificial means such as sun-ray lamps, creams and lotions rather than the sun.

c fallow

Reddish-yellow or yellowish-brown; the colour of ploughed and unsown land, namely, pale or ruddy brown.

n false colour

As regards dyes, a non-permanent colour; in painting, a paler tint; in computer and other displays, a colour used as a shorthand – for example, red to show hot temperatures.

n family of colours

Colours which relate to each other; also *famille rose* used to describe the predominant pink enamel colouring used in Chinese porcelain of the 17th to the 18th centuries. *Famille verte* refers to porcelain with a predominant apple-green colouring. Also *famille noire* (black) and *famille jaune* (yellow).

n fanlight

The upper part of a window opening separately from the rest in reference to the the shape of a fully-opened fan.

n fard

White face paint.

n far-red light

Light in the region of 730 **nanometres** to which certain plants respond through the medium, for example, of **phytochrome**.

n fascia

The band of colour on a plant or insect.

n fashion colours

Those colours which the haute couture fashion houses have determined as the colours of the season.

adjective	a
adverb	adv
a colour	c
noun	n
prefix	pr
suffix	su
verb	vb

a **fast**

As regards colour and paint, not prone to fade or to change colour. Hence, **fastness** – the quality or attribute of being fast or fixed.

n **fastening**

The binding together of pigment particles, for example, by applying varnish.

n **fastness**

As regards dyed textiles, the quality of being able to resist changes to colour from exposure to light, water or abrasion etc.

a **fauve**

Vivid or bright in colour after the Fauvists – a group of French artists (including Henri Matisse (1869-1948)) who were renowned for their celebration of colour in art. Their vibrant paintings elevated colour to a point where it became the single most important element in their work.

a **favillous**

Of the colour of hot ash.

c **fawn**

Light yellowish brown.

c **feldspar**

A creamy or yellowy white; the mineral feldspar is white or red in colour.

n **felt-tipped pen**

A pen with a felt-tip which dispenses coloured ink.

a **fernticled**

Freckled. See also **lentiginous**.

n **ferriferrocyanide**

Used in **Prussian blue**.

pr **ferro- (L)**

Iron.

pr **ferrugin- (L)**

Rusty.

a **ferruginous**

The colour of iron-rust; reddish-brown (see **iron**).

c **fesse**

A light blue.

c **festucine**

Greeny-yellow straw colour.

c **feuille**

A light green colour.

a **feuillemorte**

Having the brown colour of dead leaves. Also referred to as filemot, philimot, philomot, philamot, phyllamort, phylamort and other variations. Also 'dead-leaf brown'.

a **ficelle-coloured**

Having the colour of twine.

c **field grey**

The grey colour of military uniforms particularly those worn by the German infantry.

a **fiery**

Having the appearance of flames or fire as in 'fiery-red'. 'Firy' is an obsolete form.

c **fiesta**

A reddish shade of orange.

c **fiesta pink**

A bright pink colour.

c **filemot**

The colour of a dead leaf (see **feuillemorte**).

n **filter**

A transparent glass or plastic screen which cuts out some coloured rays but which allows others to pass through; used particularly in photography to correct colour imbalance.

c **fire engine red**

A bright vivid red.

c **fire-orange**

A reddish-orange.

c **fire-red**

A colour in Ignaz Schiffermüller's **colour wheel** (*feueroth*) which also contains 'fire-blue' (*feuerblau*).

c **FireBrick**

A light maroon colour – one of the 140 colours in the **X11 Color Set**. It has hex code #B22222.

n **firefly**

An insect giving off a **phosphorescent** or **luminescent** light from its abdomen.

n **firelight**

The light given off by a fire.

c **fir green, fir-green**

A dark muted green.

n **fisetin**

A yellow dye.

n **Five Colours**

Chinese porcelain of the Ming era (1368-1642) decorated with enamel in five main colours – apple green, aubergine, **iron red**, violet and yellow. Also called 'wu t' sai'.

n **five original colours**

In painting, the colours red, green, yellow, blue and purple are sometimes referred to as the 'original colours' (in addition to black and white). Aristotle's theories indicated that all other colours could be produced by adding black or white to these five colours. In the 17th century Guido Scarmiglioni and Robert Boyle regarded black, white, blue, red and yellow as the five simple colours from which all others were derived. See **essential colours.**

c **flag**

Similar to the dark blue of the flower, iris; violet.

a **flake**

Used to describe those pigments which are in the form of flakes.

c **flake white**

The pure toxic white pigment often in the form of flakes used by all the famous oil painters of the past; made from lead carbonate. Also known as **Cremnitz white, silver-white** or **lead white.** Used by the ancient Chinese, Egyptians and Greeks and the only white pigment until the 1830's.

c **flambe**

The yellow colour of the yellow iris.

n **flambé**

A crimson and blue glaze originating in China in the Sung Dynasty (968-1280) giving the appearance of flames.

a **flamboyant**

Florid; showy; coloured in a flamelike manner.

c **flame**

A bright yellowish-red akin to the colour of flame. Also called 'flame-red'.

a **flame-coloured**

Of the colour of flame; Shakespeare in Henry IV Part 1 and Twelfth Night and in C S Lewis' *Perelandra*.

adjective a
adverb adv
a colour c
noun n
prefix pr
suffix su
verb vb

c **flame pink**

A dark orangey-pink.

c **flame-red**

A bright red.

c **flame-yellow**

A bright orangey-red.

a **flaming**

Used to describe colours which are intense or very bright.

c **flamingo**

A reddish orange shade.

c **flamingo pink**

A strong pink colour; an orange-pink.

pr **flamme- (L)**

Flame-colour.

a **flammeous**

Having the colour and other qualities of flame – a reddish orange.

a **flammulated**

Red, ruddy, rusty.

a **flamy**

Flamelike.

n **flare**

A sudden burst of flame.

a **flaring**

Descriptive of bright colours.

a **flash**

A brief and sudden burst of light.

n **flashing lights**

'*The lights are flashing red in terms of the survival of the tiger*' Michael Meacher *The Times* 21.1.99.

n **flashlight**

A lamp used for signalling or providing a warning; an electric torch.

a **flashy**

Gaudy, garish, showy, loud or flamboyant.

a **flat**

'flat' in relation to paint means lacking in gloss, not shiny. Colour printed on coated paper with a smooth or glossy surface will provide maximum colour density whereas printed onto a matt surface the colour will look flatter due to the refraction of light. A colour with a 'flat tone' is one in which there is little graduation of hue, brightness or saturation.

n **flat-tone**

See **flat**.

pr **flav-, flavi- (L)**

Prefix indicating yellow.

n **flavaniline**

A yellow dye.

a **flavescent**

Turning or becoming yellow; yellowish.

a **flavicomous**

Having a head of yellow hair.

a **flavid**

Yellow.

n **flavin**

A class of pale yellow biochromes.

n **flavin, flavine**

Yellow dye from quercitron bark.

n **flavones**

A group of yellow pigments found in plants.

n **flavonol**

Mainly yellow pigment from waste products.

a **flavous, flavus**

Yellow; a golden yellow. The Latin word *flavus* is the root of the word blue.

c **flax**

Of the colour of flax, a yellowish beige.

a **flaxen**

Golden – particularly in relation to hair.

n **fleck**

A speck of colour.

a **flecked**

Marked with small streaks, flecks or spots or similar markings; speckled. Used in conjunction with colours such as '**gold-flecked**'.

a **fleckered**

Having flecks, streaks or other markings.

a **fleeten**

Having the colour of skimmed milk.

n **flemingin**

A yellow dye used on silks.

c **Flemish blue**

A rich or dark grey-blue.

c **flesh**

A moderate pink. Also 'flesh pink'.

a **flesh-coloured**

A moderate pink colour; a description given in the 1920's to pink silk stockings. Hence 'flesh-colour' and 'flesh-toned'. Also 'flesh-tint'.

c **flesh-red**

A red colour frequently used to describe minerals and crystals.

a **flesh-toned**

Bearing the pinkish shades redolent of the human **complexion**.

vb **flicker; to**

As regards light (particularly a flame), to shine unsteadily or waveringly. Hence, 'flickering'.

a **flinty**

Resembling flint in colour etc.

n **floodlight**

A strong lamp used to illuminate a large area. Hence 'floodlit'.

n **flop colour**

The aspect of the colour of paint (in particular, metallic paint) when looked at from an angle close to the horizontal in contrast to **face colour**.

c **Floral White**

One of the 140 colours in the **X11 Color Set**. It has hex code #FFFAF0.

c **Florence brown**

A greyish shade of red.

c **Florentine brown**

A copper colour also called Hatchett's Brown and Roman Brown.

adjective a
adverb adv
a colour c
noun n
prefix pr
suffix su
verb vb

a **florid**

Resplendently bright, flushed with red, flowery: as regards the **complexion**, reddened or ruddy.

c **flower de luce green**

A moderate green.

n **fluctuating colours**

Colours which tend to fade in the light but which can retrieve their colour in the dark, for example, **Prussian blue**.

n **fluorescein(e)**

An orange fluorescent dye made from coal-tar marketed since 1874 and used as a tracer in water. A stain used in testing eyes.

n **fluorescence**

The luminosity produced by the emission of radiation or light from certain substances hence 'fluorescent' and 'flourescent lamps'. See **luminescence** and **phosphorescence**.

vb **flush; to**

To blush or change one's facial **complexion** when becoming embarrassed, stressed or angry.

n **flush**

A reddish or rosy hue particularly of the **complexion**.

su **flushed**

Having a tinge of colour as in 'red-flushed'.

n **folding green**

Slang for US bank notes. Also **greenback**.

c **fondant pink**

A pastel red.

n **food colouring**

Liquid or dry mix ingredients used as colouring for a wide variety of foods including ready-made meals, convenience foods, soups, sauces, seasoning, beverages, cakes, desserts and dough. One US company, D.D. Williamson, produces 62 different types of caramel colouring for convenience foods. See also **E-number colours**.

n **footlights**

Theatre lighting set out in a row across the front of the stage and pointed towards the actors.

c **forest-green**

An olive green slightly darker than **Lincoln green**; sometimes a yellowish green or a dark muted green.

c **ForestGreen**

One of the colours in the **X11 Color Set**. It has hex code #228B22.

c **forget-me-not blue**

The pale blue colour of the forget-me-not flower – a symbol of constancy.

n **four colour theorem, the**

The mathematical proof that on a map of any number of different territories, however their boundaries may be configured, no more than four different colours are required to ensure that no two contiguous territories need have the same colour.

n **four colour theory**

The notion advanced by Pliny that the painters of ancient Greece deliberately restricted themselves to a palette consisting of only four colours – red, black, white and yellow. However, since there has been much linguistic confusion between yellow and blue (the old French word *bloi* meant both colours – and see *flavus*) the four colours may have included blue rather than yellow. Some experts argue that the four colours were red, yellow, blue and green.

n **four-colour reproduction**

Printing employing four coloured inks – cyan, magenta, yellow and black. See **CMYK**.

n **fovea**

Part of the mechanism of the eye at the centre of the retina and containing **cones** which respond to colour.

c **fox**

A reddish or yellowish brown; a colour in Winifred Nicholson's 1944 *'Chart of Colours'*.

n **foxing**

The discolouration of books and paper caused by damp often turning them a yellowish brown; hence 'foxed'.

c **foxy**

The reddish-brown colour of the fox.

a **foxy**

Excessive use in painting of red tints; over-hot in colouring.

c **fraise**

Strawberry in colour.

c **framboise**

The red of the raspberry.

c **Frankfort black**

A black pigment used in copper-plate engraving; also called 'blue black'.

a **freckled**

Having small brown spots discolouring the skin; **variegated**.

n **freckles**

A localised discolouration of the skin involving small brown or red spots on the skin; also called **lentigo**. See **melanin**.

a **freestone-coloured**

An orangey-yellow; having the colour of limestone or sandstone; Shakespeare's *As You Like It* Act 4 Scene 3.

a **French**

Used to describe colours originating or made in France.

c **French beige**

A light brown.

c **French berry**

An orangey-yellow.

c **French blue**

A greeny-blue; sometimes a purplish blue.

c **French green**

A yellowy green.

c **French grey**

A bluish grey.

c **French navy**

A shade of navy.

c **French ochre**

An orangey-yellow.

c **French pink**

A pale yellow. See **English pink**.

c **French purple**

A purple dye, very popular in the 1850's, made from lichens and instrumental in giving rise to the word 'mauve' which moved from describing the dye to designating the colour of the dye. See **mauve**.

c **French ultramarine**

See **ultramarine**.

c **French yellow**

A yellowish or orangey-brown.

c **fresco**

An orange red.

adjective a
adverb adv
a colour c
noun n
prefix pr
suffix su
verb vb

a **fresh**

As regards colour, unfaded.

n **frit**

A vitreous composition used as a glaze or colouring in the production of porcelain and other ceramics. Although porcelain was produced in China as early as the 7th century BC the secret process did not become known in Europe until 1709.

a **frog-coloured**

Used by Samuel Coleridge in his *Biographia Literaria*.

a **frosted**

Glittering, particularly as regards animals having silver scales or hair; as regards glass, coated with a rough whitish surface so as to make it opaque. As regards colours, pearlised.

a **fucate**

Having artificial colour (obs.).

c **fuchsia**

Purplish red as in the fuchsia flower named after the German biologist Leonard Fuchs (1501-1566). According to a MORI poll referred to on BBC2 television on 23.9.98 fuchsia (with white and grey) are the most unpopular colours in the UK.

c **Fuchsia**

One of the 140 colours in the **X11 Color Set**. It has hex code # FF00FF.

c **fuchsia pink**

A purplish pink colour.

n **fuchsine**

A deep bluish aniline red dye discovered in France by François-Emmanuel Verguin in 1859. Also known as **aniline red**. Aniline red was manufactured in London as **roseine** and later **magenta**.

n **fucoxanthin**

A pigment giving algae its brown colour.

n **fucus**

A **cosmetic** or colouring of the face used by the Greeks and the Romans and also called **litmus**; any colouring matter or dye.

a **fugitive**

As regards paint, a low degree of permanence of colour.

n **fugitive colours**

Those colours or inks which tend to fade or change when exposed to light.

a **fulgent**

Shining, dazzling.

a **fulgid**

Glittering or flashing.

vb **fulgurate; to**

To flash as in or like lightning.

pr **fuligin- (L)**

Sooty.

a **fuliginous**

Soot-coloured; dusky or sooty.

a **full**

As regards colour, intense or deep.

n **full colour**

Pure rich colour in contrast to grey colour; also indicating as regards an image that it is represented in its entirety in colour rather than partly in colour as in 'full-colour photograph'.

n **Fuller's Earth**

Used for **whitening**.

a **full-toned**

A colour with an intense hue.

n **fulsion**

The condition of shining forth.

pr **fulv- (L)**

Tawny.

a **fulvid**

Reddish yellow, tawny, yellowish-grey or yellowish-brown.

a **fulvous**

A variant of **fulvid**; a reddish-yellow.

n **functional colour**

See **incidental colour**.

n **fundamental colours**

See **primary colours**.

a **funky**

As regards colours – fashionable, exuberant or unconventional.

pr **fusc-, fusco- (L)**

Brown, tawny, dark.

a **fuscescent**

Having a dark brownish colour.

a **fusco-ferruginous**

Having the colour of rust.

a **fusco-piceous**

Reddish black.

a **fusco-testaceous**

A reddish brown.

a **fuscous**

Brown, dingy, dark, sombre; also a brownish-grey.

n **fusteric**

The colouring matter found in **fustet**.

n **fustet**

A yellow dye from the tree of the same name.

n **fustic**

Yellow dye from the wood of the South American fustic tree.

adjective	a
adverb	adv
a colour	c
noun	n
prefix	pr
suffix	su
verb	vb

a **gaily-coloured**

Brightly coloured.

c **Gainsboro**

A light grey colour – one of the 140 colours in the **X11 Color Set**. It has hex code #DCDCDC.

pr **galb- (L)**

Yellow.

n **galena**

A common lead ore once used for **cosmetic** purposes such as darkening the eyelashes.

n **gallamine blue**

A blue dye.

n **gallocyanine**

A bluish violet dye.

c **gamboge/camboge**

A strong yellow; reddish yellow. A yellow resin pigment originating from Cambodia and used in England from the beginning of the 17th century. Replaced in 1851 by **aureolin**.

a **gambogious**

An adjective invented by Ivor Brown in *'Words on the Level'*, Bodley Head, 1973, in celebration of the flamboyance of the word **gamboge**.

a **garish**

Lurid or excessively bright or showy.

c **garnet**

The deep red or maroon colour of the precious stone of the same name. Also reddish brown. Hence 'garnet red' and 'garnet-coloured'.

c **garter-blue**

The blue colour of the ribbon of the Knights of the Garter. A dark blue shade though previously light blue.

n **gas black**

A black pigment.

n **gaslight**

A lamp (or the light from it) using gas to provide illumination.

a **gaudy**

Brightly coloured to the point of vulgarity.

c **gaugoli**

See **Indian yellow**.

n **gegenschein**

The pale glow in the sky opposite to the sun also called 'counterglow'.

c **gentian**

The reddish-blue of the a plant from the genus *gentiana*.

n **gentian violet**

A violet dye derived from coal-tar and used also as an antiseptic.

c **geranium**

The vivid red of the geranium flower a colour popular in the 1950's.

c **geranium pink**

A deep pink.

c **German blue**

A blue pigment made from **azurite**.

n **gesso**

A loose paste made from gypsum and **chalk** – used to prime canvases and other supports in order to make the surface smoother. Now refers to any white material used to create a **ground**. Used also for sculpting.

c **GhostWhite**

One of the 140 colours in the **X11 Color Set**. It has hex code #F8F8FF.

c **giallorino, giallolino, gialolino**

According to Samuel Johnson this was a bright gold earth found in Naples – perhaps derived from a volcanic lead antimonate produced by Mount Vesuvius and called **Naples yellow**. However, there is much uncertainty as to the precise meaning of the word which may merely have been a generic term for a yellow pigment – *giallo* – meaning yellow in Italian. The pigment may have been known to the early Egyptians and may be the same bright yellow as **massicot**. It may also be the word from which **gingerline** derives.

n **gilding**

The process of applying thin sheets of gold to a surface usually as decoration.

a **gilt-edged**

Having edges which are gilded; of the highest quality. By extension, used to refer to safe financial investments.

pr **gilv- (L)**

Pale yellow.

c **ginger**

Red or reddish-brown; often of hair in humans and animals especially cats.

c **gingerline, gingeline, gingelline, gingeoline, gingioline**

The colour ginger; a deep brown. Perhaps a corruption of **giallorino**.

n **ginger-nut**

Colloquial term for a redhead. 'Carrot-top' is another disparaging term. See **dissembling colour** and **redhead**.

n **gingham**

A pattern of coloured checks or stripes usually applied to cottons or other fabrics and possibly deriving its name from Guingamp in Brittany, France where it was made. Gingham was used as a covering for umbrellas instead of silk and umbrellas so produced were referred to as 'Ginghams'.

a **glandaceous**

Having the colour of the acorn.

a **glaring**

Extremely bright or dazzling.

vb **glash; to**

To occur as a flash of light.

pr **glauc-, glauco- (L)**

Grey, silvery, bluish-grey but in Roman times possibly yellow.

a **glaucous**

A light greenish blue, sea-green; a dull greenish blue usually descriptive of the sea; sea-green. Covered with a **bloom** in the same way as a plum.

n **glaze**

A layer of transparent paint used as part of the process of **glazing** which can create an effective translucent depth in colour in oil painting.

adjective a
adverb adv
a colour c
noun n
prefix pr
suffix su
verb vb

n **glazing**

In painting, the ancient technique of covering a layer of colour with one or more transparent layers to create a new tone; in pottery, a coating made of powdered glass and chemicals used as part of the process of manufacture to protect and give a smooth glossy finish to pottery and to produce a colourful finish.

a **gleaming**

Glowing with light.

a **gleamy**

Emitting gleams of light (obs.).

a **glenting**

Shining.

a **glimmering**

As regards a light or candle, flickering or shining faintly.

a **glinting**

Gleaming; shining brightly.

a **glistening**

Reflecting light; gleaming. This and the next two entries have similar meanings each used in the phrase 'all that g...... is not gold'. See **Phrases**.

a **glistering**

Sparkling.

a **glittering**

Sparkling; reflecting light in flashes. It is not mere coincidence that this and the previous 7 entries all begin with 'gl' and have very similar meanings. They all derive from the Indo-European root *gel* or *ghel* meaning bright, smooth or shiny. See **yellow**.

n **glitz**

An extravagant display of sparkle and colour often in poor taste. Hence, 'glitzy'.

n **gloaming**

Twilight.

n **gloom**

Darkness – either partial or complete.

a **gloomy**

Dismal or dark.

n **gloss**

A sheen or lustre.

a **glossy**

Having a shiny appearance like gloss paint; also used as an adjective as in 'gloss white'.

n **glow**

The light emanating from something that has been heated; warm colours; reddening especially of the cheeks or **complexion**.

a **glowing**

As regards colour, rich, warm; radiating a steady light.

n **glow-worm**

A beetle which emits a greenish light from luminous organs in its abdomen.

c **gobelin blue**

A greyish blue.

c **gold**

A deep yellow colour; the colour of the precious metal; the colour of the bulls eye, the centre of the British five zone target in archery; in Renaissance times the background colour used by artists to represent heaven; associated in medieval times with the Zodiac sign Leo and with the sun.

c **Gold**

One of the 140 colours in the **X11 Color Set**. It has hex code #FFD700.

n **gold**

Used since ancient times as a pigment especially in painting (often indicating in Renaissance art some supernatural element), the decoration of picture frames and illuminated manuscripts. Also used in thin sheets – see **gold foil** and **gold leaf**. The name given to one of the E food additives (E175) giving a metallic surface colour. One of the five code-names given to the D-Day Overlord Normandy landings. The 'Gold' landing on 6 June 1944 was carried out by the British 50th Division and the 8th Armoured Brigade. One of the deception plans was referred to as 'Glimmer'. The other landings were named 'Utah', 'Omaha', 'Juno' and 'Sword'.

a **golden**

Having the colour of gold; shining as gold.

n **golden age, the**

A period idyllised as being pre-eminent as regards peace or prosperity or literary or other cultural achievement; any era where a particular skill is regarded as having been at its zenith. Applied, in particular, to the classical age of Latin literature.

n **golden boy, girl, child**

Idiomatic reference to a person who has achieved some pre-eminence or success or popularity in a sphere of endeavour – for example in sport. Also 'golden wonder'.

c **golden brown**

A rich yellowy-brown.

n **golden bullet**

A business term for a very successful product.

n **golden calf**

The idol made from gold worshiped by the Israelites while Moses received the Ten Commandments (*Exodus*) and by analogy any idea or concept to which undue deference is given.

n **golden child**

Said of a child pop star.

n **golden fleece**

A difficult goal to achieve in reference to the fleece won, according to Greek mythology, by Jason against fearsome odds and a vigilant dragon.

n **golden goal**

The first goal scored in extra time in some sports, particularly soccer tournaments, bringing the match to an instant end and giving victory to the team scoring that goal.

n **golden goodbye**

A substantial payment made by an employer to an employee on the occasion of his retirement.

n **golden-haired**

Having yellow or gold coloured hair.

n **golden handcuffs**

A payment or other benefit promised by an employer to an employee as an inducement to his remaining in employment for a defined period.

n **golden handshake**

A payment made to an employee by way of compensation for loss of office or on retirement. What size does the payment have to be in order to be described as 'golden'? Perhaps £30,000 – being the threshold over which payments for loss of office cease to be exempt from Schedule E income tax. A more substantial golden handshake is sometimes referred to as a 'platinum handshake'.

n **golden hello**

A payment or other benefit made by an employer to a person in consideration of his becoming an employee.

n **golden jubilee**

The 50th anniversary of some particular occasion. Hence a 'golden wedding anniversary'. See **silver jubilee**.

n **golden mean**

The mid-way position between two extremes.

n **golden number**

A number system for determining the moon's cycles and hence new moons and full moons – referred to as the Metonic cycle.

adjective a
adverb adv
a colour c
noun n
prefix pr
suffix su
verb vb

n **golden opportunity**

A propitious time to tackle a particular task.

n **golden parachute**

A payment (usually substantial) promised to a senior executive of a company in the event that it is taken over. Normally payable if the executive is dismissed or is demoted as a result.

n **golden ratio**

The ratio of 1 to 1.61803 the latter figure being the result of dividing [(the square root of 5)] +1) by 2. Used in geometry, architecture and design. Sometimes referred to as the 'golden section' or the 'Divine Proportion'.

n **golden rice**

Rice which, by the addition of **beta-carotene** to the seed in order to provide a source of vitamin A, takes on a yellow or orange colour.

c **Goldenrod**

A vivid yellow colour from the plant of the same name; a mustardy colour – one of the 140 colours in the **X11 Color Set**. It has hex code #DAA520.

n **golden rule, the**

Any important rule or principle.

n **golden share**

A share in a company giving the holder voting control or a veto over specific transactions. Used particularly as regards shares held by the British Government in order to prevent takeovers. Golden shares have come under attack from the EU.

n **Golden State, the**

The motto of the State of California. Kentucky is 'the Bluegrass State', Nevada 'the Silver State', Vermont 'the Green Mountain State' and Washington 'the Evergreen State'.

n **golden wedding**

The 50th anniversary of a wedding.

c **golden yellow**

A deep orangey-yellow.

n **gold foil**

Thin sheets of gold slightly thicker than **gold leaf**.

a **gold-flecked**

Having **fleck**s of gold.

n **goldilocks**

A nickname for someone (usually a young girl) with golden hair.

n **gold lamé**

Fabric interwoven with gold thread.

n **gold leaf**

Gold in the form of very thin sheets used for the purpose of **gilding**. Although often used by artists up to the 15th century, it became the fashion to use yellow with a judicious use of light to create the illusion of a gold colour. See **gold** and **gold foil**.

n **gold medal**

A medal, gold in colour if not in content, awarded as first prize in some endeavour, particularly, the Olympic Games.

n **golds**

Should there be a disaster of any kind in London plans involve command of the incident being assumed by a joint committee of the three emergency services and the local authority involved. The top officers, responsible for overall strategy, are called 'golds'. The 'silvers' devise tactics and the 'bronzes' implement tactics. Those casualties with the highest priority would be labelled 'orange', with yellow and green designating the next two levels of priority. White will signify the dead.

n **good colour**

As regards printing, a term referring to an even or consistent application of ink.

c **goose grey**

A dark grey. 'Goose-wing-grey' is the description of the poles used in Barnett in NW London in the erection in 2002 of the eruv – the boundary of the area in which observant Jews may carry on the sabbath.

c **gooseberry green**

The yellowish green of the gooseberry; a colour name of the 1920's. Also 'gooseberry'.

c **gosling-green**

A light yellowy green;.

n **gouache**

An ancient water-based painting technique making use of opaque colours where pigments are mixed with gum or **chalk** to form a paste; the pigment itself. Also called **body colour.** To be compared with **watercolour,** as strictly defined, which produces a much more transparent effect.

c **Goya**

A rich orange-red.

vb **gradate; to**

To move imperceptibly by stages from one colour tone to another.

c **grain**

A tan colour.

c **Granada**

A dark rich red colour.

c **granite**

A purplish grey.

c **grape**

A dark purple or violet.

a **graphic**

As regards colour, vivid as in 'graphic reds'.

c **graphite**

A dark metallic grey. Also 'graphite grey' made from crystallised carbon.

c **grass-green**

'*grass-green turf*': Shakespeare's *Hamlet* Act 4 Scene 5 – a yellowish green; bearing the colour of grass.

a **grassy**

Resembling grass in colour etc.

c **gray**

The Americanised spelling of 'grey'. According to George Field's *Chromatography* (1835) 'grey' indicates a colour composed of black and white whereas 'gray' indicates any **broken colour** having a cool hue.

c **Gray**

One of the 140 colours in the **X11 Color Set**. It has hex code #808080.

n **greasepaint**

A thick greasy theatrical **make-up.**

a **green**

Inexperienced; new. Environmentally friendly. A colloquial expression describing concrete at the stage before it has set.

adjective a
adverb adv
a colour c
noun n
prefix pr
suffix su
verb vb

c **green**

The colour of growing grass. From the Old English 'gréne' and the Old Teutonic root 'grô' from which we derive 'grass' and 'to grow'. Green is said to have more variations than any other colour and yet, despite the richness of our language, there is a woefully inadequate supply of words to describe the variety of greens in the British landscape. Ranges from approximately 575 to 500 **nanometres**. One of the three **additive primary colours**. A symbol of hope; associated in medieval times with the Zodiac signs Libra and Taurus and with the planet Venus. The holy colour of Islam and used on the flags of many Muslim countries. Associated once with fertility and springtime and now with environmentalism. Why is it that surgeons gowns are usually green in colour and first aid kits are also often green? Is it perhaps that (as **chromotherapist**s believe) the colour green can help to staunch the flow of blood? One of the 140 colours in the **X11 Color Set** having hex code #008000. In English folklore green is widely supposed to be unlucky especially as regards items of clothing – *'wear green and you will soon wear black'*. Why this should be so is uncertain but is sometimes explained by reference to the fact that green is the colour taken to be worn by fairies who punish others for wearing it. Research in Münster has found that green police cars generate little respect in Germany – green having been adopted in Germany for this purpose as a rejection of militarism. It was found that blue and white or blue and red patrol vehicles had a much more powerful effect.

n **greenback**

Slang for a US dollar note. Also **folding green**.

n **green belt**

An area of the countryside protected by planning laws against urban development.

n **Green Book, the**

The popular name for the Rules of the County Court in England and Wales.

n **green brilliant**

A green food additive (E142). Also called 'Green S'.

n **green earth**

Another name for the mineral, glauconite, used as a pigment; a brown pigment.

a **green-eyed**

Envious or jealous.

n **green-eyed monster; the**

Indicating jealousy – Shakespeare's *Othello* Act 3 Scene 3.

n **green fairy**

Slang for **absinthe**.

n **green famine**

A term, particularly used in reference to Africa, where although there is green vegetation on the land there is a serious food shortage possibly because the rainfall is insufficient to produce adequate crops. Also 'green drought'.

n **green flash**

The phenomenon capable of being observed at the moment the sun sets below the horizon.

n **greengage**

A plum imported from France by Sir William Gage around 1725. He also popularised the bluegage and the purplegage.

n **Green Goddess**

The name of the fire engines first produced in 1953, approximately 827 of which are still used to fight fires in the UK at times of crisis and emergency such as a strike by the Fire Brigades Union. The Green Goddess has only basic equipment and one ladder with a 35ft reach in contrast to the five 45ft reach ladders carried by the modern red fire engines. In Northern Ireland these vehicles are painted yellow to avoid confusion with other army vehicles and are referred to as 'Yellow Goddess' fire tenders.

n **green gold**

A name for sisal fibres.

n **green-hat thinking**

A system devised by Dr Edward de Bono to teach creative thinking in meetings etc. Green-hat thinking is intended to generate new ideas. There are five other 'hats' – white-hat-thinking is objective and neutral; black-hat thinking critical and negative; yellow-hat, speculative; red-hat allows for feelings and emotion and blue-hat thinking manages the thinking process.

n **greengrocer**

Someone who sells fruit and vegetables.

n **greenhorn**

A person lacking in experience; a new recruit; a novice; a simpleton.

n **greenhouse**

A structure made of glass or other transparent material which, by letting in heat and light and at the same time providing protection from the elements, is ideal for growing plants, flowers and vegetables.

n **greenhouse effect**

The process whereby, as a result of the increasing build-up of gases (particularly carbon monoxide) in the lower atmosphere, the surface of the earth is being warmed to give rise to so-called global warming.

n **green ink brigade**

A phrase used mainly by journalists to refer to those correspondents often regarded as obsessive or eccentric, who write indignant letters of complaint to the press or dotty letters warning of impending doom, many of which are alleged to be written in green ink. But the use of green ink is not always stigmatised – a primary school in Smethwick, West Midlands, will not allow teachers to use red ink to correct pupils' errors for fear of upsetting them. Green ink is to be used instead!

a **greenish**

One of the 'ish's'.

n **Green Isle, the**

See the **Emerald Isle**.

n **green light**

A light or signal, green in colour, used as an indication that it is in order to proceed, for example, on traffic lights; a sign that it is in order to go ahead with any course of action.

n **green line**

One of the most famous green lines is that which has divided the Greek Cypriots and the Turkish Cypriots on the island of Cyprus since December 1963. The line (so called because the British authorities in first determining the buffer zone on a map of Cyprus used green ink) divides the city of Nicosia – the only capital in the world still so divided.

n **green lung**

Greenfield land in towns and cities protected from development.

adv **greenly**

With a green colour, youthfully, timidly as in Shakespeare's Henry V Act 5 Scene 2: *Kate, I cannot look greenly, nor grasp out of my eloquence.*

n **greenmail**

Jargon for a scheme (particularly in the US) whereby a potential bidder buys a large enough percentage of the shares in a publicly quoted company to force it to buy its own shares at a higher price in order to prevent a takeover. Greenmail (which is not unlawful) is compared with **blackmail** which is.

n **green number**

The zero or double zero in roulette.

n **greenockite**

A mineral containing cadmium sulphide named after Lord Greenock and used to produce **cadmium yellow** and **cadmium orange.**

n **Green Paper**

A government document in the UK and Canada containing proposals for introducing new policies or legislation with the purpose of soliciting opinion. See **White Paper.**

adjective a
adverb adv
a colour c
noun n
prefix pr
suffix su
verb vb

n **green pound**

A unit used in working out the amount of the UK's contribution to the Common Agricultural Policy of the European Union.

n **green room**

Originally a retiring room for actors which was decorated in green to provide relief from the glare of the **limelight** but now also a room in which performers and guests relax before appearing on television. *World Wide Words* suggests that the term has nothing to do with the relaxing effect on the eyes of the colour green since green rooms are referred to as early as the 17th century when candles were the only form of stage lighting. It is possible that the expression derives from the fact that some stages in the 17th century were decked with green baize to prevent damage to actors' costumes or because waiting rooms were decorated with imitation grass. There may, however, be some truth in the fact that green can promote relaxation since Russian scientists have discovered that green lenses help cosmonauts to relax. The theatre's connection with the colour is further extended by the Cockney rhyming slang term 'green' (greengage) for the stage. The adoption of green in all this is somewhat odd since it has long been regarded as unlucky in the theatre to have a green set or green costumes.

n **greens**

A familiar term for cooked green vegetables.

n **Green S**

A food additive giving a green colouring (E142).

n **green-sickness**

A form of anaemia indicated by a pale greenish **complexion**. According to Stormonth this is chiefly confined to unmarried females and according to Websters 1906 edition to virgins! Shakespeare's *Anthony & Cleopatra* Act 3 Scene 2, *Pericles* Act 4 Scene 6, *Henry IV Part 2* Act 4 Scene 3 and *Romeo & Juliet* Act 3 Scene 5 (where the term is used as an adjective).

n **greensward**

An area covered in grass or turf.

n **greentailing**

Retailing carried out in a manner which takes account of environmental considerations, for example, shops concentrating on organic goods.

n **green taxes**

Those duties and impositions intended by government either to encourage taxpayers to have a more responsible attitude towards the environment or to raise money to enable the government to spend money on improving the environment.

n **greenth**

Greenness; *'Amidst the gleams and greenth of summer'* George Eliot's *Daniel Deronda.*

n **green thumbs**

The equivalent in the US to British green fingers. See **Phrases**.

n **Green Travel**

With effect from 6 April 1999 the Inland Revenue has reduced the incidence of tax and National Insurance from certain travel plans (known as 'Green Travel Plans') which are intended to reduce the use employees make of cars such as free or subsidised works' buses.

n **green welly brigade**

A derogatory term for upper middle class denizens of the British countryside (and those who visit it) distinguished by their green wellington boots as opposed to the more common black variety.

n **greenwash**

Misleading information or spin disseminated by businesses in order to make them appear more environmentally responsible. Possibly a play on 'eye-wash'.

c **Green Yellow**

One of the colours in the **X11 Color Set**. It has hex code #ADFF2F.

c **grège**

See **beige** and **greige.** An olive grey colour.

c **greige**

A combination of grey, and beige; also referred to as grège. A similar colour to **écru**.

c **grenat**

Deep red as in the precious stone **garnet** of which the colour happens to be an anagram.(It is merely coincidence that it is also an anagram of the next entry). Also known as 'granat'.

c **Gretna Green**

A 'greenish yellow-green' says Partridge from the Scottish village made famous for runaway marriages. Until around the time of Elizabeth I it was customary for wedding dresses to be in green rather than white.

c **grey**

The colour of lead and of ash and of the hair of the middle-aged; a mixture of black and white. A bleak colour but perhaps resurrected by the Chinese government's decision to paint the buildings of Beijing grey as part of its bid to stage the 2008 Olympic Games – 'Grey matches our climate, cultural background and tradition' says Beijing as reported by *The Times* (7.11.00) in what must be one of the very few Leaders devoted to a colour. An achromatic hue. An example of how colours are used as nouns occurs in Marks & Spencer's explanation of why their 1999 half year pre-tax profits halved to £546.1 million – '*we bought too much grey*'. A colour used in this way, that is in a referential sense, is intended to include all shades of the colour whereas a person using a colour term in an adjectival or descriptive sense has a particular hue in mind.The part of the brain which perceives and processes grey-scale images is different from that part of the brain which deals with colour. The US spelling is 'gray'.

n **grey area**

A problem or issue which does not admit of a clear unequivocal answer or resolution; something which has ill-defined characteristics; something with features causing it to be positioned between two extreme categories by virtue of having some of the characteristics of each category.

n **grey economy**

That element of a country's economy generating income from activities (such as **moonlighting** and housework) which, though not part of the illegal **black market**, are not included in government official figures.

n **grey goo**

The science fiction term devised by Eric Drexler in *The Engines of Creation* and extended by authors such as Michael Crichton in his novel *Prey* to describe the mass of useless objects which could be created by the application of nanotechnology thus causing a blight on the surface of the earth. Nanotechnology could, in theory, give rise to uncontrollable minute robots (or nanobots) replicating themselves without human involvement and manipulating molecular structures so as to be able to create new objects. However, this is thought not to be a merely hypothetical risk. The astrophysicist Sir Martin Rees in his book *Our Final Hour* warns of the risk of nanotechnology ravaging civilisation unless research in this area is controlled and Prince Charles in April 2003, with the support of environmentalists, has joined the clamour for more serious debate with a view to avoiding a doomsday catastrophe resulting from grey goo experiments.

adv **greyly**

With a grey appearance.

n **grey market**

A less extreme variety of a **black market**; also the population of senior citizens.

n **grey matter**

Brain power or intelligence referring to the grey tissue at the centre of the central nervous system.

n **greyout**

The condition where astronauts and airline pilots suffer a temporary loss or deficiency in their vision due to an inadequacy of oxygen. So called because the occurrence is less severe than a **blackout**.

n **grey scale**

An achromatic scale moving through a successively darker range of greys from white to dark grey and used to compare colours. The scale devised by Wilhelm Ostwald (see **colour wheel**) showing that the increment required to produce an even progression of grey is to double the absorption value at each step.

c **greystone**

An olive grey.

n **grey vote**

The collective vote of pensioners. *'The government will attempt to win back crucial grey votes'*...by promising a £2- a week increase in the basic pension'. Also 'greying', the process whereby the proportion of retired persons in the community increases.

c **gridelin**

Violet grey; greyish-violet. From the French *gris-de lin* (grey of flax). Also a mixture of red and white.

c **gris**

Grey.

adjective a
adverb adv
a colour c
noun n
prefix pr
suffix su
verb vb

n **grisaille**

A painting or technique of painting using only shades of grey. An **underpainting** or sketch in grey made in preparation of a full-colour painting.

pr **grise- (L)**

Grey.

a **griseous**

Bluish-grey.

c **grizzle**

Grey.

vb **grizzle; to**

To make something grey; also as a noun – grey hair or hair which has grey streaks; a grey wig.

a **grizzled, grizzly**

Grey; greyish; streaked with grey.

c **grotto**

A strong greeny-blue.

c **grotto blue**

A vivid greenish blue.

n **ground**

The surface on which a painting or drawing is worked; the first application of colour on a painting performing the function of background colour or of a support for further colour. Perhaps a foreshortening of 'background'. See **colour ground**.

n **ground colour**

The background colour to a design or lettering; the colour of the canvas, wood or other surface to which paint is to be applied.

c **grulla**

A greyish-blue colour used to describe horses.

n **guanine**

A substance forming part of DNA and a common organic compound in nature. It is the minute flattened crystals of guanine which reflect light thus causing fish scales to shimmer in a multitude of different colours.

c **Guignet's green**

A bright bluish green patented in 1859 by the chemist C E Guignet and sometimes referred to as permanent green. See **viridian.**

c **Guimet's yellow**

A yellow used for painting porcelain or enamel.

c **Guinea**

Having the colour of a gold guinea coin.

c **gules**

A red colour especially as regards heraldry. See **heraldic colours**.

c **gull**

A very old name for a shade of grey.

c **guly**

Red.

n **gum arabic**

A **binder** made from the sap of the Acacia tree (*acacia arabica or acacia senegal*) which, in the form of a paste, is mixed with crushed pigment to form watercolours either as **pan colours** or **tube colours**. Also called 'acacia gum' and 'Senegal gum'.

c **gunmetal**

The dull blue-grey colour of gunmetal; a dark grey. Also 'gunmetal blue'.

n **gutta**

A small spot of colour on the wing of an insect.

a **gutté, goutté, goutty, guttée, gutty**

Particularly in heraldry, sprinkled with spots of colour.

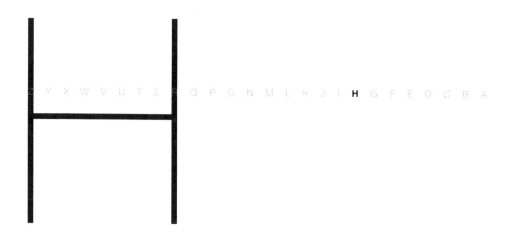

n **haem**

The dark red constituent of **haemoglobin**.

n **haemachrome**

A red pigment in blood such as **haemoglobin**.

n **haematoxylin**

A crystalline solution obtained from the **logwood** tree and providing black, red, blue, and purple dyes.

pr **haemo- (G)**

Blood.

n **haemocyanin**

A blue colouring matter found in the blood of humans.

n **haemoglobin**

The protein pigment of red blood cells.

n **haemosiderin**

An ochre yellow pigment responsible for the colour of the liver.

n **hair-dye**

Dye which is used to colour hair. In ancient times the Greeks used **saffron** to dye their hair. The Romans used vinegar and fermented leeches as a black dye with the caution to keep oil in the mouth during use to prevent one's teeth also going black. Blonde hair was more often the fashion until Elizabeth I created a move towards red hair. See **dissembling colour** and **tattoo**. Some modern hair-dyes, particularly those containing para-phenylene diamine, are known to be capable of affecting people who suffer from allergies (and possibly of causing anaphylactic shock) making it essential to carry out a skin test before use. Researchers at the University of Southern California have also found that permanent hair-dyes can increase the risk of women getting bladder cancer. Even semi-permanent hair-dyes (especially those in dark colours) have been linked with an increased risk of certain cancers.

n **half-colour**

Indicating someone who is half-way towards obtaining his full **colours**.

n **half-light**

A dim light – especially around the time of dawn and dusk.

n **half-shade**

In painting, a shade of colour one half of the extreme colour.

n **half-tint**

Intermediate tone between light and dark.

n **half-tone**

Representing light and shade; a tone midway between extreme light and extreme shade.

a **hand-dyed**

Dyed by hand rather than by some mechanical process.

c **han green**

A shade of green introduced in the 1980's. Perhaps deriving its name from the Han Dynasty of China from 206 BC to 221 AD.

adjective a
adverb adv
a colour c
noun n
prefix pr
suffix su
verb vb

c **Hansa yellow**

An organic bright yellow pigment. Also 'Hansa yellow light' – a light yellow – both made from **Arylide yellow**.

n **hard colours**

See **warm colours**.

a **harlequin**

Variously coloured; parti-coloured; **variegated**. Usually in outlandish colours.

c **harmala red**

A red colouring agent from the harmala or harmel plant.

n **harmonious colours**

See **harmony**.

n **harmony**

Colours are said to be in harmony when their juxtapostion produces a satisfying unity or balance to the viewer. Colour harmonies can be created by using two or more shades of the same hue (a monochromatic harmony) or using different colours (polychromatic harmony). Colours next to or close to each other on the **colour wheel** are harmonious. See also **contrasting colours** and **composite colours**.

c **Hatchett's brown**

A copper colour. See **Florentine brown**.

n **hatching**

The process and result of drawing parallel lines on a map or design; variations in the form of hatching are used, particularly in heraldry, to indicate different colours. See **heraldic colours**.

c **havana**

A dark shade of brown resembling Havana cigars and formerly applied to breeds of brown cats and rabbits. Also 'havana-brown'.

c **hay**

A light olive green.

c **hazel**

A brown tinged with red.

c **heather**

Having the speckled purplish-grey-blue colour of heather.

n **heat-induced colours**

As some heated objects or substances become hotter they pass through successive stages and change colour. This is an important factor, for example, in the process of forging and tempering steel where the particular colour of the heated steel indicates its temperature and the stage it has reached in the process. Colour charts are used for this purpose. As regards, for example, the forging and hardening of steel, such charts tell us that white indicates a temperature of 1200 degrees, and move down in stages through yellow, orange, red cherry to brown-red indicating a temperature of 600 degrees. Polymers that change colour by reference to heat are being developed at the University of Rhode Island, USA and have numerous possible applications. Examples include road signs indicating ice, clothing showing overheating, packaging which indicates the temperature of food and parts which show overheating on vehicles or trains. Heat sensitive polymers can be added to plastic, rubber, paint and other substances See also **pyrometer** and **colour plastic**.

a **hectic**

The flush on the cheek; formerly feverish.

n **helianthin**

An orange-yellow dye.

c **helio**

A bright orange.

c **helio fast pink**

A pink coal-tar pigment similar to rose madder.

c **helio fast red**

A brilliant red **coal-tar lake**.

pre **helio- (gk)**

Relating to the sun.

n **heliochrome**

A photograph in natural colours.

n **heliotherapy**

The use of sunlight to cure disease.

c **heliotrope**

Bluish-pink or purple from the flower of the same name which means 'turning towards the sun'.

n **heliotropism**

The phenomenon as regards plants of bending towards the light. See **apheliotropism**.

n **helminthosporin**

A maroon-coloured pigment from fungus.

n **hemeralopia**

Day as opposed to night blindness where objects are seen more clearly when it becomes darker.

n **hemin**

A red colouring agent in blood.

c **henna**

Reddish-brown.

n **henna**

A dye frequently used as a **cosmetic.** Usually red, but also brown and black. Derived from the Arabic *al-hinna* and *al-hannat* which is also the root of **alkanet**. See also **tattoo**.

a **hepatic**

Liver-coloured.

n **heraldic colours**

In **blazonry** (the art of painting heraldic devices) the five main colours (or tinctures) are, azure (blue), gules (red), sable (black), vert (green), purpure (purple). There are two other tinctures: tenné (orange) and murrey (reddish purple or sanguine). In addition, there are the two metals, or (gold) and argent (silver or white). See **Sylvester Petra-Sancta**. Also **sinople green**.

a **heterochromatic**

Possessing different colours; having more than one colour especially as regards plants.

n **heterochromia**

The condition of having organs of different colours where usually they are of the same colour, particularly as regards the eyes.

c **hickory**

A dark grey-brown.

n **high colour**

A ruddy face or **complexion**.

a **high-coloured**

Florid; having a rich colouring.

n **highlight**

The particular point in a painting, drawing or photograph at which an object appears to reflect the most light.

n **highlights**

A dyeing procedure involving bleach whereby streaks of hair are given a colour slightly lighter than the rest of the head. Also referred to as 'hilites'. See also **lowlights**.

a **highly-coloured**

Having strong or bright colours; having many different colours or an abundance of colour.

n **hinau**

A black dye.

adjective a
adverb adv
a colour c
noun n
prefix pr
suffix su
verb vb

a **hirsutoatrous**

Having black hair.

a **hirsutorufous**

Red-haired.

c **hoar**

Greyish-white, especially as regards frost.

c **hoary**

Grey or white with age.

c **holly green**

An olive green.

n **hologram**

A 3-dimensional image produced by the use of lasers.

c **homage**

A deep ultramarine blue.

c **homard**

The pinkish-red of the lobster.

a **homochromatic**

See **monochromatic**.

c **honey**

A greyish-yellow; also 'honey-coloured'.

c **honeydew**

A yellowy pink; an orangey-pink.

c **Honeydew**

A pale green colour – one of the colours in the **X11 Color Set**. It has hex code #F0FFF0.

c **honeysuckle**

Pale pinkish-yellow; a yellowish brown.

c **Hooker's green**

A yellowy green originally prepared from **Prussian blue** and **gamboge** and now more usually from **cadmium yellow** and phthalo blue.

c **horizon blue**

A light greenish blue.

n **horse colours**

Dapple-grey, grulla, roan, strawberry roan, bay, grey, piebald and **skewbald** are all colours particularly applied in the description of horses. In *Colour & Culture* John Gage refers to the fact that writers in the 5th and 7th centuries listed thirteen colours used in Latin to describe horses (some of which however depicted markings).

a **hot**

As regards a particular colour, vivid or intense; for example, **hot pink, hot orange and even hot pink-orange**.

c **hot orange**

An intense orange colour.

c **hot pink**

An intense pink colour; a colour particularly popular in the 1950's.

c **HotPink**

One of the 140 colours in the **X11 Color Set**. It has hex code #FF69B4.

n **hue**

Hue indicates a particular colour sensation which is dependent simply on the relevant wavelength; the inherent colour of a thing; the purest or brightest form of a colour having no white or black mixed with it. A particular colour or colour name. Each hue has an intrinsic tonal value on the chromatic scale.

c **Hunter's green**

A dark yellowish-green.

c **hunting pink**

The colour of the coats worn by foxhunters. The colour, however, is scarlet rather than pink, but, according to the Masters of the Foxhound's Association even that is likely to change to black or some other less invasive colour – no doubt as a measure intended to help change the image of foxhunting.

c **hyacinth blue**

A purplish blue; a colour popular in the 1930's.

c **hyacinth red**

A reddish orange.

c **hyacinthine**

The purplish-blue of the hyacinth; blue-red; hyacinth violet or pink.

a **hyaline**

Transparent, **translucent**, **see-through** or **colourless**.

a **hyaloid**

Clear – particularly as regards membrane of the eye.

c **hydrangea pink**

A yellowy pink. Also hydrangea blue and hydrangea red.

n **hyperchromasia**

Medical term for abnormal coloration of the skin.

n **hypernic**

A red dye.

adjective a
adverb adv
a colour c
noun n
prefix pr
suffix su
verb vb

pr **ianthin- (G)**

Violet.

c **ianthine**

Having a violet colour.

n **iceblink**

The strange phenomenon seen in the sky resulting from the reflection of light from an expanse of snow or ice.

c **ice blue**

Greenish-blue; a pale blue.

n **ice colour**

An azo dye applied directly onto the cotton or fabric by means of the interaction of two solutions cooled by the means of ice.

n **ice-cream colours**

Pastel pinks, blackcurrants, strawberries, lemons etc (used in *The Times* of 8.3.00 to describe suede handbags).

c **ice-green**

An extremely pale shade of green.

a **icteritious**

Jaundiced yellow.

n **identification colour**

The particular distinctive colour applied to an object in order to draw attention to its function or the danger which attends it, for example, the white of a blind person's walking stick, the red of a no-entry sign and the green of the uniforms of the ambulance service. See **colour code**.

n **ilixanthin**

A yellow dye extracted from holly.

a **ill-coloured**

Bearing colours which are inharmonious, incongruous or inappropriate.

n **illuminant**

Something which produces light. In **colourspeak** this indicates the predominant light source in which an object is being viewed such as a bright sky, a cloudy sky, light bulbs of various kinds, sodium lights and mercury lights. The colours we see will vary considerably according to the particular illuminant in which we see them.

vb **illuminate; to**

To light up; to decorate with lights; to highlight in colour particularly as regards the lettering or borders of a manuscript. Thus 'illuminated' and 'illuminated manuscripts'.

n **illumination**

That which provides light; the amount of available light in a given place.

n **ilmenite black**

A black pigment used in paint applied to metals.

a **imbrued, embrued**

Stained with blood.

n **impasto**

The technique of using oil paint in thick application so as to show the brush marks and to give a textured effect.

a **imperial**

First used in relation to **imperial yellow** and subsequently borrowed by other colours with pretensions of majesty.

c **imperial blue**

A deep blue; a dye.

c **imperial green**

See **emerald green**.

c **imperial red**

A deep bluish red.

c **imperial yellow**

A deep yellow colour originating from the yellow porcelain produced in China. The colour was considered to be the reserve of the imperial court; see also **yellow**.

n **imprimatura**

A **primer** or **glaze**, applied usually as a secondary **colour ground** to a canvas – the ground first having been prepared with **gesso**. The colour of a primer may be green, grey or sometimes yellow or brown.

a **inaurate**

Gilded.

c **inca brown**

A dark brown.

n **incandescence**

The quality of a body which, as a result of its high temperature, emits light.

a **incandescent**

Shining brightly; emitting light as a consequence of reaching a high temperature. Thus 'incandescence'.

c **incarnadine**

Carnation colour, **flesh-colour**ed; now associated with the colour of blood. Also used as an adjective.

vb **incarnadine; to**

To dye or make something red.

c **incarnate**

Light pink or **flesh-coloured**.

a **incarnate**

Flesh-coloured.

n **incidental colour**

Colour occurring in nature which has no functional purpose in contrast to functional colour serving, for example, in certain animals and plants as a means of camouflage, courtship or mimicry. See **epigamic colours** and **cryptic colouring**.

n **indamine**

A blue dye.

n **indanthrene**

A class of complex synthetic organic dyes and pigments; also referred to as **indanthrone**.

c **Indanthrone blue**

A coal-tar blue used in watercolour painting; the chemical description of **anthraquinone** blue; an antiseptic containing blue dye.

c **inde blue**

A greyish purple; a dye.

a **Indian**

Usually indicating colours or dyes originally made from pigments found in India or the Indies.

c **Indian brown**

A dark reddish brown.

adjective a
adverb adv
a colour c
noun n
prefix pr
suffix su
verb vb

n **Indian ink, India ink**

Ink which originated in China but was produced from a pigment (**lampblack, carbon black** or **bone black**) made in India.

c **Indian orange**

A vivid reddish-orange colour.

c **Indian red**

A dark brownish red originally made from iron oxide. See **Venetian red**.

c **IndianRed**

One of the 140 colours in the **X11 Color Set**. It has hex code #CD5C5C.

c **Indian yellow**

A vivid golden yellow pigment known in India for many years but now synthetically produced. It was originally made from earth on which mangoleaf-eating cows or camels had urinated over many weeks. Since mango leaves give insufficient nourishment, the export of Indian yellow was banned to avoid cruelty to animals and by the beginning of the 20th century it had ceased to exist. Also referred to as **purree**, puri, peoli and gaugoli.

c **indigo**

The blue shades between approximately 445 and 425 nanometres; the blue derived from the dye **indigo** and ubiquitous since the advent of blue jeans in the 1950's.

c **Indigo**

One of the 140 colours in the **X11 Color Set**. It has hex code #4B0082.

n **indigo**

A natural blue dye from the leaves of various plants of the *Indigofera* family and sometimes including **woad**. 'Indigo' derives from *indikos* – the Greek for India. Synthetic indigo was developed from around 1856 having a severe impact on the indigo fields of India and its 2800 indigo factories existing in the 1870's even though mass production did not take place until the end of the 19th century. Indigo was not produced in England until 1916 when the forerunner to ICI started production. When first brought to the British isles it was called 'indico'.

c **indigo blue**

A dark sometimes purplish blue; also the name of the dye.

n **indigo carmine**

A blue colouring additive (E132) used particularly in confectionery and biscuits. Also used for a diagnostic purposes.

n **indigo white**

The colourless form to which **indigo** is reduced to enable it to be taken up by wool for dyeing blue.

a **indigoid**

Having the characteristics of **indigo**.

n **indigoid**

A dye so called by reason of having a chemical composition similar to **indigo**.

n **indigotin(e)**

Used in the manufacture of **indigo**.

n **indoaniline**

A violet dye.

n **induline**

A coal-tar dye producing a blue colour.

n **infrared**

That invisible part of the electromagnetic **spectrum** with wavelengths between approximately 750 nanometres and 1millimetre.

n **infrared reflectogram photography**

See **underdrawing**.

vb **infucate; to**

To colour.

n **infuscation**

The process of making something dark (obs.).

c **ingenue**

Yellowish-green.

v **ingrain; to**

As regards textiles and carpets, to dye with **colourfast** dyes. To engrain or ingrain originally meant to dye something in red dye but came to mean dyeing in any dye-stuff. (See **kermesic acid**).

c **ink**

A dark blue colour.

n **ink**

A liquid available in many different colours used for printing, writing, drawing and painting. See **atramentum, bistre, sepia** and **Indian ink**.

n **ink-blot**

An accidental spillage of ink creating a stain.

c **ink-blue**

A dark blue.

a **inky**

Black. Also used in conjunction with blue to describe the colour of **indigo** – hence 'inky-blue'.

n **inocarpin**

A red colorant from the *Inocarpus edulis* tree.

n **inorganic pigments**

See **organic pigments**.

a **insipid**

As regards colour, dull, lifeless.

a **intense**

As regards colour, deep, strong.

n **intensed pulsed light (IPL)**

A form of treatment for removing wrinkles and unwanted hair by applying bursts of multi-coloured light using several wavelengths.

n **intensity**

Refers to the **brightness** of a colour or to the degree of its purity or **saturation**. Vivid colours have the greatest intensity and become less intense when mixed with white.

a **intercoloured**

Interspersed with colours.

n **intermediate colours**

More usually referred to as **tertiary colours**.

a **intermingled**

As regards **paint**, mixed together.

a **intermixable**

The quality of **paint** which allows for the mixing of different colours.

a **intermixed**

As regards **paint**, mixed together.

c **international Klein blue**

An intense blue created and patented by the artist Yves Klein (1928-1962) together with Edouard Adam in 1955. Klein's monochrome paintings lifted abstract art to a new plain in which colour could be treated as an independent element in art. See **white paintings**.

c **international orange**

A vivid orange colour.

c **invisible green**

A very dark green so called because it verges on black.

a **inwrought, enwrought**

The embroidering of a pattern onto a fabric. *'Had I the heavens' embroider'd cloths, Enwrought with golden and silver light';* Aedh wishes for the cloths of Heaven W B Yeats (1865-1939).

adjective a
adverb adv
a colour c
noun n
prefix pr
suffix su
verb vb

c **iodine scarlet**

An obsolete red pigment introduced in 1811 which rapidly proved to lack **permanence**.

c **iodine yellow**

A bright yellow.

pr **iodo-, iono- (G)**

Violet.

n **iodopsin**

A light-sensitive pigment found in the **cones** of the eye enabling man to distinguish between different colours. Also called 'visual violet'.

c **Iraq red**

A deep red.

a **iridal**

Pertaining to the **rainbow**.

a **iridescent**

Rainbow-like; nacreous; opalescent; opaline; pearlescent. From the Greek for **rainbow**. Hence, 'iridescence'. Iridescence as appearing, for example, on the wings of butterflies (to help them to avoid predators) or on beetles, oil slicks or soap bubbles is caused by the structure of the surface of the object.

pr **irido- (L)**

Rainbow.

c **iris**

The reddish-blue of the lily – iris. Also a **rainbow** in reference to, Iris, the messenger of the Gods, and by extension the colours of the rainbow.

c **iris green**

A medieval green dye made from the leaves of the buckthorn or possibly from iris flowers.

a **irisated**

Iridescent.

c **iron**

Having the colour of iron; see **ferruginous**.

c **iron grey**

A dark grey.

n **iron oxide**

Iron oxide pigments include natural earth pigments such as **ochres**, **siennas** and **umbers**. Iron oxide ores include **haematite**, **magnetite**, **limonite**, **siderite** and **pyrite**. Synthetic iron oxide are used in **Mars** colours including orange, black, brown, yellow Also the name for E172, a food additive providing black, brown, orange, red and yellow.

c **iron red**

A bright rusty red used as a porcelain glaze. See **Five Colours**.

vb **irradiate; to**

To direct beams of light onto something thus causing it to become bright; more usually associated with the application of radiation.

a **irrorate**

Coloured with dots or small speckles of colour.

c **isabel yellow**

The same as **isabel**.

c **isabel, isabella**

A dingy yellow grey colour which Chambers suggests is possibly named after either the daughter of Philip II who wore the same underclothes for three years or Isabella of Castile who had a similar predeliction for keeping on her apparel.

c **isabelline**

Greyish-yellow; see **isabel**.

n **isatin**

A lustrous yellowish-red substance made from **indigo**.

n **ISCC-NBS**

A US system devised in 1955 for allocating names to colours using the adjectives 'vivid', 'brilliant', 'strong', 'deep', 'light', 'dark' and 'pale'.

su **-ish**

A very old suffix first used in the description of origins such as 'Pictish'. Also used to mean 'resembling' as in 'childish'. The suffix is now used with adjectives (particularly colours) to indicate the quality of being 'somewhat', 'nearly' or 'slightly' as in 'reddish' and 'bluish'. Some colours are capable of bearing this suffix including black, white, pink, red, brown, yellow, green, blue, grey, ochre and purple, but not orange, gold, silver, or olive or many other colours. Fielding refers to 'duskish' and Albers to 'violetish'.

su **-ishness**

Tending towards a certain colour; the quality of being somewhat blue or etc. See -ish.

a **isochroous**

Having one colour throughout.

n **isolated colour**

The technique in painting of leaving the edges around an object unpainted so as to highlight it.

c **Italian pink**

A brilliant YELLOW lake made from **quercitron bark**. See **English pink**.

c **ivory**

The off-white colour of an elephant's tusks.

c **Ivory**

One of the 140 colours in the **X11 Color Set**. It has hex code #FFFFF0.

c **ivory black**

A black pigment with a brown tinge originally made from carbonised bones. The Impressionists stopped using this colour because they considered that black did not occur in nature.

c **ivory white**

The white of ivory.

c **ivory yellow**

A light yellow approaching white.

c **ivy green**

A dark olive green.

adjective a
adverb adv
a colour c
noun n
prefix pr
suffix su
verb vb

J

c **jacinth(e)**

Reddish-orange; sometimes yellow.

c **jacinthine**

The dark purple of the jacinth and sometimes a brilliant reddish-yellow.

c **jacqueminot**

The red colour of the Jacqueminot rose.

c **jade**

A green in various shades, but mainly yellowish-green.

c **jade green**

A blue-green or yellowy green.

c **Japan black**

A black varnish with a glossy finish.

c **Japan blue**

Dark blue.

c **Japanese red**

A reddish brown.

c **jasmine**

A pale yellow colour.

a **jaspé**

Mottled in the same fashion as the stone, jasper.

c **jasper**

Yellowish-green; a blackish green.

a **jaundiced**

Yellowish.

c **jaune brilliant**

A variety of **Naples yellow**.

a **jazzy**

As regards colour, flashy, gaudy or showy.

c **Jenkin's green**

A dark green made from amorphous carbon.

c **Jersey blue**

The blue of the uniform of New Jersey soldiers in Colonial days.

c **jet**

Black; jet-black. From the Greek *gagates* meaning mineral from Gagas – the Roman name for Lycia where jet was mined. Corrupted from 'jayet' (Partridge).

c **jet black, jet-black**

A deep black.

c **jetty**

Jet-black.

n **jeweller's rouge**

A powdered red oxide used as a buffing agent to polish gold and silver plate; also also called 'Crocus Martis', **colcothar** and **Venetian red**.

c **jockey club**

A deep blue.

c **jonquil**

A pale yellow shade after the narcissus flower of the same name; also a vivid yellow.

c **Judas-coloured**

Having red hair; from the supposed red hair of Judas Iscariot.

a **juicy**

Used by the artist Wassily Kandinsky in the phrase *'juicy green'* (*Reminiscences* 1913) and by Jane Shilling in *The Times* (19.5.00).

c **jungle green**

A deep yellowy-green; a dark or blackish green.

c **'just-back-from-holiday brown'**

A condition which at the same time causes the wearer to look in the best of health and the viewer to feel ill.

adjective a
adverb adv
a colour c
noun n
prefix pr
suffix su
verb vb

n **kaleidoscope**

A changing pattern of colours.

vb **kalsomine; to**

To **whitewash**.

n **kamala**

An orange powder used to dye silk yellow.

c **Kelly green**

A strong mint green colour.

n **Kelvin Unit**

The unit of temperature employed to determine **colour temperature** and named
after Lord Kelvin (1824-1907).

c **Kendal green**

This old colour is not known even by Maerz & Paul and probably refers to the
green cloth of the same name.'*But, as the devil would have it, three misbegotten
knaves in Kendal-green came at my back and let drive at me'* Shakespeare's Henry
IV Part 1 Act 2 Scene 4.

n **keratin**

A dye used as a hair colorant.

c **kermes**

A brilliant red or scarlet used extensively in the Middle Ages and the Renaissance period. The words **crimson**, **carmine** and **cremosin** derive from the word kermes. See **kermesic acid**.

n **kermesic acid**

The red dye obtained from crushing and boiling the insect referred to as *Kermococcus ilicis* or *coccus ilicis* or *kermes vermilio*. In medieval times this red or scarlet dye was known as granum or grain from which we derive the term 'ingrained'. In Shakespeare's *Twelfth Night* Act 1 Scene 5 Olivia refers to her **complexion** as *'Tis in grain sir'*. See also **kermes**.

n **ketchup colours**

A variety of reds. Used to describe a designer dress of Donatella Versace. Also 'ketchup'.

c **khaki**

A drab yellowish-brown dust-colour; sometimes with a greenish tinge. One of the 140 colours in the **X11 Color Set**. It has hex code #F0E68C. A generic term for the fabric used to make British army field-uniforms. From khaki meaning 'dust-coloured' in Hindi.

c **kingfisher blue**

A brilliant blue. Also referred to simply as 'kingfisher'.

c **King's blue**

A light blue resulting from mixing ultramarine and **Cremnitz white**. See **cobalt blue**.

c **King's yellow**

A brilliant yellow.

n **klieg light**

Bright light used for film-making.

n **kohl**

Fine black powder used in the East and in ancient times in Egypt as a **cosmetic** shade to the eyes. Also used as an adjective as in *'heavily kohled eyes'* (*The Autograph Man* by Zadie Smith).

c **Krems white**

See **Cremnitz white**.

c **labrador blue**

The dark blue of the mineral labradorite. The most common colours of labradorite are blue and green although it can also display gold, red, pink, purple and bronze. The marvellous display of colour is caused by light reflected from the unique spacing of the planes of crystals often producing a three-dimensional image. See **coloured gems**.

a **labradorescent**

Displaying a brilliant array of colours; especially as regards some varieties of the mineral, feldspar (in particular labradorite and orthoclase) when examined under a light. Hence 'labradorescence'.

c **lac**

The crimson colour of **lac**.

a **lacklustre, lack-lustre**

Lacking in brightness or lustre. See **dull**.

n **lacmoid**

A blue coal-tar dye.

n **lacquer**

A resinous lightly coloured varnish used to produce a highly polished waterproof finish to wood, brass etc.; derived from '**lac**'. Also used as an adjective as in 'red-lacquered'. See **shellac**.

c **lacquer-black**

A glossy lustrous black colour as in '*Madonna with long lacquer-black tresses*' (*The Evening Standard* 1.2.99).

a **lacteous**

Of the colour of milk.

c **lake**

The colour of lac, namely, crimson.

n **lake, lac**

A dark-red crimson resin deposited on certain trees and plants by the insect *coccus laccae* (possibly *laccifer lacca*) originally used as a dye or pigment or glaze. (Compare **cochineal** and **kermes**). The term has for many centuries come to designate any insoluble compound of organic matter produced from plants, vegetables, coal-tar or clay which absorbs colorant and is used to produce pigments of many different colours with a high degree of translucency.

n **lake colours**

An expression referring to the origin of the pigment, **lake**, and not to any particular colour. 'Lake' is used as a qualifying word for many colours including red, crimson, green and madder.

n **laking**

See **madder lake**.

a **laky**

As regards blood, where the red corpuscles have become colourless – transparent; pertaining to **lake**, the pigment.

a **lambent**

As regards light, radiant or bright.

n **lambert**

A unit of light intensity equal to 0.32 candles per square centimetre.

n **lampblack, lamp black**

A dull black pigment composed of soot or carbon; also called **carbon black**.

pr **lampro- (G)**

A combining form meaning bright, shining or clear.

n **lapachol**

A yellow pigment occurring in the wood of of the Tecoma tree.

c **lapidary blue**

A brilliant blue.

c **lapis lazuli**

A bright blue; also 'lapis lazuli blue'. A mineral used from the 13th century to make **ultramarine**. For many years the only known deposit was in Badakhstan in Afghanistan. Its vivid blue is the result of its sulphur content.

c **larkspur**

The pale greenish-blue colour of the plant of the same name; a colour in Winifred Nicholson's 'Chart of Colours' 1944.

n **laser**

Light **A**mplification by **S**timulated **E**mission of **R**adiation. A laser consists of a pulse of monochromatic light in concentrated form the colour of which is determined by the particular gas used in the flash tube.

n **laserlight**

The light from a **laser**.

a **lateritious, latericeous**

Brick-red.

n **lattice**

A regular geometric pattern created by interwoven strips.

c **laurel**

A dark yellowy green.

c **lava-red**

An intense orangey-red.

c **lavender**

Pale lilac; having the colour of lavender flowers; also lavender grey and lavender blue. Possibly derived from the Latin *lavare*, to wash. Referring, particularly in the US, to homosexuality – see the **Lavender List**.

c **Lavender**

One of the 140 colours in the **X11 Color Set**. It has hex code #E6E6FA.

n **Lavender List**

Harold Wilson's infamous list of resignation honours containing names recommended (apparently on lavender notepaper) by his secretary, Marcia Williams (later to become Lady Falkender). The list of courses at the University of Maryland involving lesbian, gay, bisexual and transgender issues.

n **lavender marriage**

A marriage of convenience entered into by a homosexual.

c **LavenderBlush**

One of the colours in the **X11 Color Set**. It has hex code FFF0F5.

c **LawnGreen**

Another of the colours in the **X11 Color Set**. It has hex code #7CFC00.

n **lazouri lake**

A blue pigment.

a **lazuline**

Having the colour of **lapis lazuli**; blue stone.

c **lead**

The colour of the metal lead, particularly in the form used for roofing purposes.

c **lead-blue**

A greyish blue.

adjective a
adverb adv
a colour c
noun n
prefix pr
suffix su
verb vb

n **lead chromate**

A yellow compound made from chrome and first used as a pigment in paint at the beginning of the 19th century; for example, **chrome yellow, chrome orange, chrome red** and **lemon chrome**.

n **lead chromes**

A class of pigments which contain **lead chromate** producing a range of brilliant colours from light yellow, to gold, orange and red.

n **lead colour**

A grey paint used as an undercoat.

a **leaden**

A dull grey colour.

a **leaden-coloured**

Having a grey colour or aspect.

n **lead monoxide**

See **red lead**.

n **lead oxide**

A mineral used to produce a red dyestuff.

c **lead-tin oxide**

A manufactured yellow used by Titian also referred to as lead-tin yellow. See **Titian's colours**.

c **lead-tin yellow**

See **lead-tin oxide**.

c **lead white**

An ancient poisonous white pigment made from lead and replaced gradually over the period from 1780 and 1909 (when its use in painting buildings was banned in France) by non-toxic whites made from zinc and titanium. Also known as **white lead**.

c **leaf-green**

Having the colour of leaves; sometimes the yellowy-green of young leaves. One of the colours in the **Ostwald circle**.

c **leafmold**

A dark reddish-orange colour.

a **leaming**

Gleaming (obs.). There are not many words the meaning of which remains similar despite the omission of its initial letter. Some further examples are 'brash', 'cram' and 'erase'.

c **leather brown**

The brown tan colour of shoe leather.

n **LED**

A light-emitting diode used in television sets, video recorders, CD players, calculators, measuring equipment and in some computers etc. LEDs emit light when activated by electric current. They have many applications. A refined form of LED has been developed in London which by means of its strong red light emitted at exactly 680 **nanometres** can activate drugs which are able to get rid of bacterial infections such as stomach ulcers. A fireman has invented a torch with 12 red LEDs which will make it possible to see through clouds of smoke in a way the white light of an ordinary torch cannot. This relies on the principle that red light can be seen more easily than other colours because it is not subject to being dispersed as much by particles in the atmosphere. The light emitted can also detect fires.

n **LED therapy**

The use of light-emitting diodes to treat sports and other injuries, Also practised by veterinary surgeons. See **LED** and **colour therapy**.

c **leek-green**

The green of the vegetable of the same name; sometimes an olive green. See **prasinous**.

c **leghorn**

The yellow colour of straw; from Leghorn in Italy (now Livorno) which produced a particular kind of wheat from which Leghorn straw hats and bonnets were made. The straw when harvested was green in colour, but was bleached before being used.

n **lemnian ruddle**

A dark red pigment named after the Greek island, Lemnos. Also called 'lemnian reddle'. See **reddleman**.

c **lemon**

A vivid yellow; the colour of the outer part of the fruit of the same name.

c **LemonChiffon**

One of the colours in the **X11 Color Set**. It has hex code #FFFACD.

n **lemon chrome**

A brilliant yellow pigment.

c **lemon yellow**

A strong yellow composed in a number of different ways one of which includes strontium nitrate.

a **lentiginous**

Freckly.

n **lentigo**

A **freckle**.

n **leopard-print**

A fabric pattern resembling the black spots and fawn background of the skin of the leopard.

c **lettuce green**

The yellowish green colour of lettuce leaves.

pr **leuc(o)- (G)**

White.

n **leucipotomy, leucippotomy**

The art of carving white horses out of hillsides. There are at least 17 such white horses in England, 9 of them in Wiltshire including the famous *Westbury Horse*.The Uffington white horse in Oxfordshire is considered to be the oldest. A new technique – **Optical Stimulated Luminescence (OSL)** – suggests that it dates back to 1400 BC – much earlier than previously supposed.

n **leucoderma, leukoderma**

The condition of the skin when it lacks normal pigmentation. See also **vitiligo**.

a **leucomelanous**

Having a light **complexion** but dark hair and eyes.

n **leucophores**

Chromatophores with a white pigment.

a **leucospermous**

Bearing white seeds.

a **leucous**

White or **albino**.

c **Levant red**

See **Turkey red**.

n **liaison**

A device used by Eugène Delacroix (1799-1863) whereby he connected two objects by reflecting the colour of one of them in the depiction of the other.

c **lichen-green**

The whitish-green of the lichen plant.

n **light**

The natural medium without which sight and colour would not be possible.

c **LightBlue**

One of the 140 colours in the **X11 Color Set**. It has hex code #ADD8E6.

n **light box**

A piece of equipment with coloured **fluorescent** lights (typically, blue and red) used to treat acne. The blue light when applied to the surface of the skin generates oxygen which helps to kill bacteria while the red light encourages healing. Also a form of decoration or work of art in its own right. See **light therapy**.

adjective a
adverb adv
a colour c
noun n
prefix pr
suffix su
verb vb

n **light bulb**

A glass bulb containing a filament and gas which produces light when an electric current is applied. Long-lasting bulbs using **LED**s have been invented in Japan and at Cambridge University – the first using gallium nitride and capable of burning for 100,000 hours and the second capable of lasting for 50 years and using only one-tenth of the electricity normally required.

a **light-coloured**

Having a light or pale colour. European legislation requires workers in abattoirs to wear 'light-coloured' overalls.

c **LightCoral**

A pinkish red colour – one of the 140 colours in the **X11 Color Set**. It has hex code #F08080.

c **LightCyan**

One of the colours in the **X11 Color Set**. Its hex code is #E0FFFF.

n **lightfastness**

The permanence of a colour, pigment or dye; the degree to which a colour or paint is resistant to change or to fading when exposed to light. Hence 'light-fast'. See **permanence.** Lightfastness is measured by a number of standards including the **Blue Wool Scale** originating in the UK and by the **ASTM** which is based in the US. Lightfastness is a characteristic of each particular pigment. The light absorbed by a colorant is converted to heat which will affect the permanence of the colorant according to its molecular composition. A **tint** of a colour may well have a very different lightfastness rating from that of the **mass-tone** of that colour and lightfastness can depend on the **ground**, substratum or paper on which it is painted or printed.

c **LightGoldenrodYellow**

A colour in the **X11 Color Set**. It has hex code #FAFAD2.

c **LightGreen**

A colour in the **X11 Color Set**. Hex code #90EE90.

c **LightGrey**

Another of the colours in the **X11 Color Set**. Hex code #D3D3D3.

n **lighthouse**

The last manned lighthouse in the UK (North Foreland in Kent) went over to computerised automatic mode in November 1998.

a **lightless**

Very dark, without any light.

n **lightness**

That attribute of a colour which indicates the extent of the light which it reflects; used sometimes as a synonym for **brightness** in colour notation.

n **lightning**

A flash of light caused by an electrical discharge during a thunderstorm.

c **LightPink**

One of the 140 colours in the **X11 Color Set**. It has hex code #FFB6C1.

a **lightproof**

As regards a pigment, resistant to change from light.

c **light red**

A brownish red made by calcifying **yellow ochre**.

c **LightSalmon**

One of the colours in the **X11 Color Set**. It has hex code #FFA07A.

c **LightSeaGreen**

Another of the colours in the **X11 Color Set**. It has hex code #20B2AA.

n **lightship**

A sea-going vessel equipped to serve as a lighthouse warning other ships of danger.

a **light-skinned**

Having a pale **complexion**.

c **LightSkyBlue**

One of the colours in the **X11 Color Set**. It has hex code #87CEFA.

c **LSlateGray**

One of the colours in the **X11 Color Set**. It has hex code #778899.

c **LightSteelBlue**

One of the colours in the **X11 Color Set**. It has hex code #B0C4DE.

c **light straw**

The colour of white wine.

n **light therapy**

The practice of using light and colour to cure disease and other disorders; also referred to as light medicine. See **colour therapy** and **light box**.

c **LightYellow**

One of the colours in the **X11 Color Set**. It has hex code #FFFFE0.

c **lilac**

The pale purple colour of lilac blossom. See **anil**. Pertaining to lesbianism; see **lavender**.

a **lilaceous**

Having the colour of lilac.

a **lilacky or lilacy**

Having a lilac colour.

c **lily-green**

The green of the lily. Rarely used, but compare 'lily-white'.

a **lily-livered**

See **Phrases**.

c **lily-white**

The pristine white of the lily (Shakespeare's *Midsummer Night's Dream* Act3 Scene1) and extended to indicate someone who is beyond reproach or guilt.

c **lime**

The green or yellowy green of the fruit, lime.

c **Lime**

Another of the 140 colours in the **X11 Color Set**. It has hex code #00FF00.

c **lime blue**

A moderate blue.

c **lime green**

A greenish yellow or olive colour; a pale green.

c **LimeGreen**

One of the colours in the **X11 Color Set**. It has hex code #32CD32.

n **limelight**

Before electricity, stage lighting consisted of burning lime. See **green room**.

c **limestone**

A brownish grey colour.

n **limestone**

A mineral dyestuff producing white.

c **lime white**

Having the colour of calcium oxide or lime.

c **lime yellow**

A medium yellow or greenish yellow.

a **lime-proof**

As regards a pigment, resistant to change from lime.

n **lime-resisting colours**

Those colours or pigments which do not react to alkali and can thus be applied to surfaces recently plastered.

adjective	a
adverb	adv
a colour	c
noun	n
prefix	pr
suffix	su
verb	vb

vb **limn; to**

To draw or paint in water colours; to draw or paint in outline.

n **limonite**

An iron ore producing a yellow pigment.

c **Lincoln green**

A yellowish green colour being the colour of cloth of the same name and associated with Robin Hood and his band of outlaws.

c **linden green**

A greenish yellow.

a **lineated**

Marked with lines.

c **Linen**

A light beige colour – one of the 140 colours in the **X11 Color Set**. It has hex code #FAF0E6.

n **linseed**

Drying oil used to alter the consistency and drying time of oil colours.

n **lip-colour**

Cosmetic colouring for the lips; lipstick.

n **lipochrin**

According to the OED, *'a yellow colouring matter obtained by treating the eyes of frogs with ether after removing the retinæ'*.

n **lipochrome**

Natural pigment in animals and plants containing a lipid – usually red or yellow.

pr **liro- (G)**

Pale.

n **lissamine green**

A stain used in eye testing.

n **litharge**

A yellow or brownish olive colour; a by-product of melting white lead also referred to as **massicot**.

n **lithol red**

A red **azo** dye or pigment.

n lithopone

A white pigment used in paint-making.

n litmus

The blue colouring agent derived from lichens and giving rise to 'the litmus test' on account of the fact that when an alkaline solution is applied litmus paper turns blue whereas it turns red with an acid solution. From the Old Norse *litmosi* being a compound of *litr* meaning colour and *mosi* meaning moss. Sometimes known as **lacmus** or **fucus**.

c Littler's blue

A vivid blue used to decorate porcelain.

c liver-colour

The reddish-brown of the liver. Hence, 'liver-coloured' or 'hepatic'.

n livery

The distinctive colours or markings on a commercial vehicle or included in the packaging of a product intended to promote the brand or trade mark of the owner or manufacturer; originating from the uniform worn by the servants of a particular landowner or by guild members. According to a survey reported in the *The Evening Standard* on 8.11.00, 62 per cent of shoppers purchase goods because of the colour of the packaging.

a livid

Bluish; black and blue; lead colour; pale. A word with a history of shifting meanings. Originally indicating black and blue (the colouring of bruising) from the Latin *lividus*, but used to designate many other colours including lead-colour; grey; ashen; blackish; and purple. Possibly from the Old Slav word *'sliva'*, a plum (from which the Russian drink *slivovitz* originates). As from the 20th century the word has taken on the meaning of 'intensely angry' – possibly in reference to the fact that intense anger can give rise to all or any of the above colours. That the colour-word has been hijacked in this way is remarkable particularly seeing that anger is usually associated with the colour red (see, for example, **red mist**).

pr livid- (L)

Ashen, black and blue, blueish.

c lizard-green

A shade of green resembling the colour of a lizard.

n **local colour**

The actual colour of something when seen close up in daylight or white light as opposed to its apparent colour distorted by the effect of a shadow or by the absorption of the longer wavelengths when viewed from a distance; those detailed characteristic features of a particular period or place which when described create an authentic picture.

c **loden**

Dark green after the cloth of the same name.

n **logwood**

A dye extracted from logwood and used as a colorant for inks, textiles, silk, nylon, leather, hair and pigments; see also **haematoxylin**.

c **London purple**

A shade of purple.

c **lotus-colour**

The pinkish-orange colour of padparadscha sapphires – *padparadscha* being the Sinhalese for lotus-colour.

a **loud**

As regards colour, brash or noisy.

c **lovat**

Dull green; from the Scottish town and used in reference to Tweed cloth. Originally 'Lovatt'. Sometimes 'lovat green'.

n **Lovibond tintometer**

An instrument for measuring the colours of a particular object or substance.

n **lowlights**

A procedure whereby streaks of hair are dyed (but not bleached) to give a tone slightly darker than the rest of the head. See also **highlights**.

a **lucent**

Glowing with light; giving light.

pr **luci- (L)**

Light.

a **lucid**

Bright, shining.

n **lucidity**

The quality of being lucid.

n **luciferin**

A substance in organisms such as fireflies and glow-worms which, when oxidized, produces light.

a **luciferous**

Illuminating; giving light.

a **lucifugous**

Avoiding light.

vb **lucubrate; to**

To work by artificial light.

a **luculent**

Transparent, shining.

n **lumen**

A unit of light intensity referred to as 'lm'. See **lux** and **phot**.

n **luminance**

The quality of emitting light. *'Colours are only symbols. Reality is to be found in luminance alone'* Pablo Picasso (1881-1973).

n **luminescence**

The emission of light without the aid of heat as **fluorescence** and **phosphorescence;** measures the amount of light in a particular shade. A 0 degree of luminescence produces black while 240 produces white.

adjective a
adverb adv
a colour c
noun n
prefix pr
suffix su
verb vb

a **luminescent**

Light-emitting.

a **luminiferous**

Transmitting, producing or generating light.

n **luminophore**

A substance which produces light.

n **luminosity**

The quality of being **luminous.** The luminosity of stars is classified in astronomy by reference to Roman numerals I to VI with type I indicating the brightest.

a **luminous**

Emitting light; bright; glowing; an adjective of colour indicating a glaringly bright hue, such as 'luminous pink', hence 'luminous colour'.

n **luminous paint**

Paint with a fluorescent, phosphorescent or similar pigment which after exposure to light continues for varying periods of time to glow in the dark; a type of radioactive paint used to mark out the hands or figures in wrist watches.

a **lurid**

Greyish-orange; pale,wan, sallow as regards the face; shining or glaring.

n **Lüscher colour test**

A diagnostic procedure devised by the psychologist Max Lüscher in the 1940's to enable psychologists to test personality. It involves the subject selecting those colours (out of a selection of 73 in its extended format) which are the most and the least pleasing.

n **lustre**

Gloss or sheen; the condition of having a shiny or luminous surface; refulgence.

a **lustrous**

Brilliant.

pr **lute-, luteo- (L)**

Yellow, yellowish-brown, yellowish-orange.

n **lutein**

Yellow colouring from yolk of the egg.

a **luteo-virescent**

Greenish yellow.

n **luteolin**

The yellow colouring matter of **Reseda luteola** or **weld**.

a **luteolous**

An orangey-yellow.

a **luteous**

Having a deep reddish yellow; golden yellow.

a **lutescent**

Tending towards yellow.

n **lux**

A unit of illumination being 0.0929 candles; a measure of light equivalent to the light from one lighted candle. See **lumen** and **phot**.

n **luxmeter**

An instrument used for the measurement of brightness.

su **-ly**

See -**y**.

c **lychee**

Brown 'Parisian art shade'.

n **lycopene**

An antioxidant pigment which gives tomatoes their red colour and which can help to reduce cancer and heart disease. Processing lycopene breaks up the cells making it easier for the body to absorb thus possibly making tomato sauce and tomato purée more healthy than raw tomatoes. Also gives colour to watermelons, apricots, pink grapefruits and guavas. One of the **E-numbers** (E160(d)) providing a red colouring agent for food.

n **lymnato**

An irregular decorative effect from a continuous flow of paint onto a surface produced by means of a paint spray gun.

M

c **mackerel blue**

A silvery greenish blue.

n **mackle**

A blurred print occurring in the printing process.

vb **mackle; to**

To spot; to cause print to become blurred.

n **macula, macule**

A patch of colour, particularly, in anatomy or pathology. The dark spots on the sun's surface. See **facula**.

vb **maculate; to**

To stain.

n **maculation**

A series of spots particularly or stains on plants and animals.

n **madder**

An ancient bright natural red dye from the plant *Rubia tinctorum* used in Egyptian tombs and brought to Europe at the time of the crusades; colour from madder dyes or pigments; frequently used with a defining word, for example, crimson

madder (**Turkey red**), madder black, madder brown and madder rose. Efforts were made in 1755 to encourage the cultivation of madder in England so as to reduce reliance on imports. The production of madder virtually ceased after the discovery of synthetic **alizarin** in 1863.

c **madder lake**

A beautiful red pigment made from root of the **madder** plant which is added to an inert substrate (such as alum) by a process known as 'laking' to produce a substance capable of being ground in oil. Also called **rose madder** or **alizarin**.

n **maderisation, maderization**

The discolouration process whereby, as a result of the absorption of oxygen, white wine develops a rusty or brownish colour.

c **madonna blue**

A deep blue.

c **Magdala red**

Red dye taking its name from a town in Ethiopia.

c **Magenta**

A violetish colour – one of the 140 colours in the **X11 Color Set**. It has hex code #FF00FF.

c **magenta**

The brilliant crimson aniline dye and colour manufactured from 1860 in London, and taking its name from the town in Lombardy, Italy where in June 1859 the French and the Sardinians defeated the Austrians in battle and so called to commemorate that battle. Called **fuchsine** in French and also called **aniline red**, **roseine** and **rosaniline**.

n **magnetite**

An iron ore producing a black or dark brown pigment.

c **magnolia**

The pale pink off-white colour of magnolia blossom.

c **mahogany**

The reddish-brown of mahogany wood when polished.

| adjective a |
| adverb adv |
| a colour c |
| noun n |
| prefix pr |
| suffix su |
| verb vb |

n **mail**

A speck on a bird's feather or on cloth particularly as caused by ironing it.

c **mail box red**

The US equivalent of **pillar-box red** – a distinctive bright red colour.

c **maise**

An orangey yellow.

c **maize**

Sometimes a bright yellow; also a pale yellow used to describe dress fabric. Also called **sun yellow**.

n **make-up**

Cosmetics used mainly to adorn the face.

n **malachite**

A very old bright green pigment or dye from the mineral of the same name. Also referred to as green malachite and mineral green. Its synthetic form is called Bremen green.

c **malachite green**

A bright green; a yellowish green; a dark green. A toxic and possibly carcinogenic and mutagenic chemical used to protect farmed salmon from fungal infection but banned in Britain since 2002 (and since 1991 in the US). See **malachite**.

n **malillumination**

Light deprivation.

c **mallard blue**

A medium clear blue colour.

c **mallow**

Reddish-purple.

c **mallows (mallow) red**

A deep crimson or purplish red.

c **Maltese**

A bluish-grey colour.

n **Manchester yellow**

A yellow dye produced from Napthalin.

c **Mandarin**

A strong yellow.

c **Mandarin orange**

A reddish yellow. Also 'Mandarin red'.

n **mandorla**

An almond-shaped halo of light enclosing any sacred figure. See **aureole** and **nimbus**.

a **manganese**

Those colours derived from manganese or manganate of barium.

n **manganese**

A mineral dyestuff producing black.

c **manganese blue**

A blue first produced in the 19th century and made synthetically in 1935 from copper **phthalocyanine**.

c **manganese violet**

Introduced in 1868 as a less toxic alternative to **cobalt violet** and also referred to as 'Nuremberg violet'.

c **mango**

The brownish orange colour of the mango fruit.

n **mangostin**

A yellow pigment from the mangosteen tree.

c **manilla**

A pale yellowy brown – the colour of manilla paper, that is, paper made from Manilla hemp. Hence 'manilla envelopes'.

a **many-coloured**

Multi-coloured.

c **maple**

An orangey-yellow.

n **maquillage**

The application of face **make-up**.

vb **marbleize; to**

To colour something so as to give it the appearance of marble.

n **marbling**

A **broken colour** effect produced by manipulating paint and other decorative applications on a surface to create the impression of a marble finish.

a **margaric**

Having the lustre of pearl.

a **margaritaceous**

Pearly.

c **marigold**

The orange-yellow colour of the flower, marigold.

c **Marina green**

A shade of green the first recorded use of which was in 1935.

c **marine blue**

A dark blue – the colour of the Royal Marines' uniform.

n **mark-white**

The bull's-eye on a target board.

c **marmalade**

Of the colour of marmalade. Fowler's *English Usage* says this was first used as a colour in 1926.

a **marmorated**

Variegated like marble.

c **maroon**

A brownish crimson; from the French *marron*, chestnut. Perhaps in turn from *armon*, Hebrew for chestnut. According to a survey reported in *The Sunday Times* of 24.5.98 houses with maroon (or black) front doors are the least likely to be burgled! According to a Cheltenham & Gloucester survey in February 2003 the most effective front door colour to advance the sale of your home is blue, followed by red, white, black and green. The front door colour which is least effective for this purpose is yellow.

c **Maroon**

One of the colours in the **X11 Color Set**. It has hex code #800000.

n **marquetry**

The art form consisting in the inlaying of small pieces of different kinds of wood to produce a picture or pattern of different colours.

c **marron glace**

A pale yellowy-brown.

a **Mars**

Describing colours made from earths containing iron oxide such as **Mars brown**, **Mars orange**, **Mars red**, **Mars violet** and **Mars yellow**.

c **Mars brown**

A dark brown.

c **Mars orange**

A reddish orange.

c **Mars red**

A pigment made from red iron oxide.

adjective a
adverb adv
a colour c
noun n
prefix pr
suffix su
verb vb

c **Mars violet**

A brownish violet.

c **Mars yellow**

A synthetic iron oxide pigment first made in the 1920's and having an orangey-yellow colour.

n **mascara**

A **cosmetic** applied to eyelashes to darken or colour them.

n **massicot**

An ancient yellow pigment made from heating **lead monoxide**. Also referred to as **litharge** and sometimes **giallorino**. An olivy green. See **red lead**.

n **masstone, mass tone**

The full-strength colour of a pigment as it appears from the tube or the pile of paint in its undiluted solid form – in contrast to a halftone, undertone or tint. Masstone is sometimes also referred to 'top tone' or 'body colour'. Some paints and inks appear to have a different colour once applied. Also used to refer to the application of a colour which completely obscures a background.

c **mastic**

A pale olive brown. The pale yellow colour of mastich – a gum from the tree of the same name.

n **matching colour or colours**

Colours harmonising with or bearing a similarity to each other; colours of a similar shade.

c **matelot blue**

A deep blue.

n **matt**

A non-glossy finish as regards paint or photographs.

c **matt gold**

Particularly as regards glass gilding, those areas of gold which have a matt finish in contrast to burnished gold areas.

pr **mauro-, mavro- (G)**

Dark, black.

c **mauve**

Lavender-coloured; reddish-bluish-purple; initially called aniline purple or Perkin's mauve after William Perkin who discovered the dye in 1856. It took the name *mauve* in France after the purple streaks in the mallow flower which is called *mauve* in French.

n **mauveine**

Perkin's early mauve dye – see **Perkin's mauve**; the base of aniline purple (see **mauve**).

c **mauvette**

A violet, purple or purplish pink.

c **Maya blue**

An ancient blue based on **indigo** used by the Central American Mayan civilization.

c **mazarine blue**

A dark rich blue; possibly derived, says Partridge, from Cardinal Mazarin (1602-1661) who became Prime Minister of France after Richelieu.

n **medium**

The liquid or **binder** with which **pigment** is mixed to constitute **paint** and which serves to allow the paint to be applied to and to remain on the surface or **colour ground**.

c **MediumAquamarine**

One of the 140 colours in the **X11 Color Set**. It has hex code #66CDAA.

c **MediumBlue**

One of the colours in the **X11 Color Set**. It has hex code #0000CD.

c **MediumOrchid**

One of the colours in the **X11 Color Set**. It has hex code #BA55D3.

c **MediumPurple**

One of the colours in the **X11 Color Set**. It has hex code #9370DB.

c **MediumSeaGreen**

One of the colours in the **X11 Color Set**. It has hex code #3CB371.

c **MediumSlateBlue**

One of the colours in the **X11 Color Set**. It has hex code #7B68EE.

c **MediumSpringGreen**

Another of the colours in the **X11 Color Set**. It has hex code #00FA9A.

c **MediumTurquoise**

One of the colours in the **X11 Color Set**. It has hex code #48D1CC.

c **MediumVioletRed**

One of the colours in the **X11 Color Set**. It has hex code #C71585.

a **medley**

Variegated.

n **megilp**

A mixture often of linseed oil and turpentine used as a vehicle for oil colours as well as watercolours to make them easier to work with. The entry in Fairholt's *Dictionary of Art*, 1854 gives the term 24 different spellings.

pr **melan-, melano- (G)**

Black, dark.

n **melancholy**

Depression or sadness. In medieval times it was thought that our moods were determined by the four humours, namely, phlegm, blood, choler and black bile – melancholy (from the last of these) indicating a sombre mood.

a **Melanesian**

Relating to the people of Melanesia – the islands in the Pacific- and so called because of the dark **complexion** of its islanders. From the root **melan-**.

n **melanin**

A black, brown or grey pigment in humans and animals imparting colour to hair, skin and to the iris of the eye produced by melanocytes. The amount of melanin produced is increased when the skin is exposed to the sun. The skin therefore becomes darker thus giving greater protection from ultraviolet light. Moles and **freckles** are caused by melanocytes producing too much melanin in a particular area of the skin. Researchers at the South Bank University in London have discovered the possibility that drug-testing using the subject's hair can overstate the level of the presence of drugs by up to 10 per cent if the subject is black or has black hair. This is because the darker the hair the greater its melanin content and drugs bind themselves to the melanin. Research by James Mackintosh suggests that man developed dark skin because of the anti-microbial powers of melanin rather than as a protection from the sun.

n **melanism**

The condition of those animals producing excessive **melanin** rendering their skin, features, hair or eyes black in colour.

a **melanochorous**

Variegated in the colours of yellow and black.

n **melanocytes**

Cells in mammals producing the pigment, **melanin**, which causes the skin to darken.

n **melanophore**

A colour-changing cell or **chromatophore** which contains black pigmentation.

n **melanosporous**

Having black spores.

a **melanotrichous**

Having black hair.

a **melanous, melanic**

Having black hair and a dark **complexion**. See also **xanthous**, **xanthocroid** and **leucomelanous**.

adjective a
adverb adv
a colour c
noun n
prefix pr
suffix su
verb vb

n **melanuria**

The condition where urine appears as dark blue or black in colour.

a **melichrous**

Honey-coloured.

c **meline**

Canary yellow; the colour of the quince.

a **mellay**

Variegated in colour (obs.).

a **mellow**

As regards colours, soft, rich, indicative of ripeness.

c **mellow yellow**

A pale yellow colour; a slang term for the banana skin when smoked by way of an intoxicant.

a **mellow-coloured**

Having a soft colour or colours.

a **menald**

Speckled.

c **mennal**

A **dappled** red colour.

a **merle**

In relation to collies and other dogs, having a bluish-grey coat with black streaks or blotches. Also the dog itself.

a **metachromatic**

Having the quality (usually in biology) of altering the colour of a stain which has been applied to it.

n **metachromatism**

A change in colour especially one caused by variations in temperature.

n **metachrome**

A kind of dye which can be applied simultaneously with another.

n **metachrosis**

The ability of some animals enabling them by means of contracting and expanding **chromatophores** to change their colour.

n **metachrosis**

Change of colour.

a **metallic**

Having a lustrous reflective finish especially in motor vehicles as in 'metallic blue' etc.

a **metameric**

Having different chemical properties despite being of the same composition; extended to refer to the phenomenon where colour harmonises in light of one kind but not in that of another. Fabric or wallpaper which takes on a different colour outside the shop compared with that under the artificial lighting inside, can be said to be 'metameric'. The same colour often appears different according to the chemical composition of the surface on which it appears – another manifestation of 'metamerism'.

a **meteoric**

Transitorily bright.

n **methyl green**

A green dye.

n **methyl violet**

One of the first synthetic dyes to be developed.

n **methylene blue**

An antiseptic containing blue dye to assist in diagnosis.

n **metrochrome**

A 19th century instrument for measuring the strength of colours using coloured filters. Also referred to as a chromometer.

a **micacious**

Sparkling, shining.

a **mid**

As regards colours; having a shade midway between two other colours.

c **midnight black**

An extremely dark black colour.

c **midnight blue**

An intense blue colour; apparently the correct shade for mens' evening dress.

c **MidnightBlue**

One of the 140 colours in the **X11 Color Set**. It has hex code #191970.

n **miello**

The technique of applying a black inlay to gold or silver.

c **mignon**

A bluish violet.

c **mignonette**

The greyish green colour of the mignonette flower similar to **reseda**.

a **milken**

Having the colour of milk.

c **milk-white**

A pure white. Also 'milk-blue' and 'milk-green'.

a **Milori**

Descriptive of those colours attributed to A. Milori, a French originator of colours in the 19th century.

c **Milori blue**

See **Prussian blue** and **Milori**.

c **Milori green**

The same as **chrome green. See Milori.**

n **miltos**

An ancient natural ochre of Asia Minor used as a red paint and mentioned by Homer. Called sinopic and possibly the same as **sinoper**.

n **mimetic colours**

The colours possessed by certain animals which enable them to mimic those of another species.

a **mineral**

Used in relation to pigments which contain or consist of materials which have or were originally mined.

c **mineral blue**

Similar to **Prussian blue**.

c **mineral green**

The same as **malachite green**.

n **mineral grey**

A bluish-grey pigment made from **lapis lazuli**.

n **mineral white**

A permanent white pigment used since the 1830's and also called **permanent white**.

a **Ming**

Indicating a hue used in making Ming porcelain, for example, 'Ming blue' and 'Ming green'.

n **mingled colours**

Shakespeare's *King John* Act 2 Scene 2.

vb **miniate; to**

To paint red.

a **miniate, miniatous**

Vermilion.

adjective a
adverb adv
a colour c
noun n
prefix pr
suffix su
verb vb

a **minious**

Having the red colour of **minium**.

c **minium**

Vermilion, red; minium or red minium is another name for **red lead**.

n **mink colours**

Minks range in colour from white to black there being at least 20 mink colours achieved by breeding. See, for example, **champagne**.

c **MintCream**

One of the 140 colours in the **X11 Color Set**. It has hex code #F5FFFA.

c **mint-green**

The green of the leaves of the aromatic plant, mint; a pastel green.

c **mirador**

A reddish-orange colour.

n **mired**

A unit of measurement of colour temperature. Whilst **Kelvin** units indicate the highest readings for blue light and the lowest for red, mireds operate to register colours in the opposite direction.

a **mirk**

Dark, obscure.

c **mist**

A blue 'art shade'. Also 'mist grey'.

a **misty**

Descriptive of colours which have an indistinct quality.

c **MistyRose**

One of the 140 colours in the **X11 Color Set**. It has hex code #FFE4E1.

c **mitis green**

An emerald green also referred to as **Scheele's green**.

c **mixed white**

A combination of **Cremnitz white** and **zinc white**.

c **Moccasin**

A yellowish beige colour – one of the 140 colours in the **X11 Color Set**. It has hex code #FFE4B5.

c **mocha**

The dark-brown colour of mocha coffee.

n **mock-colour**

An impermanent colour.

c **mode**

Pale bluish-grey.

n **mode**

A genre of light colours popular in the 19th century.

c **modena**

Crimson or deep purple. Artificial colouring created in Modena Italy and used to dye ecclesiastical and academic apparel.

a **moderate**

Applied to colours which are not intense.

c **mole**

A shade of grey; see **taupe**.

c **molybdenum blue**

A blue colour resulting from mixing oxides.

pr **molybdo- (G)**

Lead.

n **Monastral blue**

A trade name for a very durable intense synthetic blue lake pigment first identified by ICI in 1928 by accident. The forerunner to **phthalocyanines**. Also called **phthalocyanine blue**, Windsor blue and Winsor blue (a trade name of Winsor & Newton Company). 'Monastral' is sometimes in error referred to as 'Monestial'.

n **Monastral green**

A green pigment similar to **Monastral blue**.

n **mondegreen**

Not a colour but a delightful term for a mishearing. The word originates from an article by Sylvia Wright in Harper's Magazine in 1954 where she recounts her mishearing of the last line of the following Scottish ballad called 'The Bonny Earl of Murray': Ye Highlands and ye Lowlands, O where hae ye been? They hae slain the Earl of Murray And Lady Mondegreen, where she had always understood the last line to be: 'And lade him on the green'.

a **monestial**

See **Monastral blue**.

a **monochroic**

See monochromatic.

a **monochromatic**

Having a single colour. As regards light, having one or a narrow band of wavelengths only (also homochromatic and monochroic).

n **monochromatism, monochromacy**

A rare form of complete **colour-blindness** caused by a defect in the **cones** where all colours appear to be grey. In Austria and some other countries monochromats and protanopes (see **protanopia**) have not been allowed to obtain driving licences.

n **monochromatopia**

The condition of lacking some degree of **cone** or **rod** vision.

n **monochrome**

Black and white – in reference to photographs, drawings, paintings, printing etc. Also used to describe the use of several shades or tints of just one colour.

c **monsignor**

A vivid reddish-violet.

c **Montpellier green**

See **verdigris**. See also **Cassel yellow, verdigris and copper-green**.

a **moon-blanched**

'*Where the sea meets the moon-blanched land*' from *Dover Beach* by Matthew Arnold (1822-1888).

c **moonlight**

The colour of **moonlight**.

n **moonlight**

The light of the moon or more properly the light of the sun reflecting off the moon!

n **mordant**

A fixing agent or fixative used in dyeing. Mordant also helps paint to stick to the surface. The process of mordanting is at least 2000 years old. As regards the process of dyeing, becoming fixed.

c **mordoré**

A reddish brown.

c **morello**

A dark red; similar to **murrey**.

n **morin**

Yellow dye from **fustic**.

a **Moroccan**

As regards colours originating or supposedly originating from Morocco.

c **moros**

A blue colour used particularly in the description of horses.

n **mosaic**

The art form consisting of inlaying many small pieces of different coloured stone, glass or other material to produce a picture or pattern.

n **mosaic gold**

A yellow pigment used to gild parchment.

adjective a
adverb adv
a colour c
noun n
prefix pr
suffix su
verb vb

c **moss**

A shade of green.

c **moss green**

A yellowy-green colour; an olivy green.

c **moss-grey**

A greeny-grey.

n **mote**

A speck or spot.

c **mother of pearl**

The iridescent colour of the **nacreous** surface of some seashells particularly oystershells.

n **motif**

A repeated pattern or design used for decoration.

a **motley**

Variegated. Possibly derived from **mote**.

n **motorway snooker**

A method allegedly used by some policemen where there are many offenders for deciding which cars to stop for speeding dependent on their colour and the order of potting snooker balls.

a **mottled**

Marked with patches, spots or blotches of colour.

n **mottling**

A broken colour effect used in decorating certain kinds of wood.

n **mountain blue**

Blue copper pigment; azurite blue. Also 'mountain green'.

a **mouse-coloured**

Having a grey colour resembling that of the common house mouse; also called 'mouse-dun'.

a **mousy, mousey**

Especially as regards hair, having a drab grey or light brown similar to that of a mouse. Also 'mouse-coloured'.

n **mousy blonde**

A drab blonde colour especially as regards hair.

c **mud**

Used to describe the colour of wet soil. One of the colours in Winifred Nicholson's 1944 'Chart of Colours'.

c **mud brown**

A dark brown.

a **muddy**

As in 'muddy colours' in reference to those colours which appear murky or cloudy. Used both literally and figuratively as in 'muddy waters'.

a **mulatto**

Tawny; the yellowish-brown **complexion** of a person born to a black parent and a white parent.

c **mulberry**

Of the colour of the mulberry; Job Trotter in Charles Dickens' *'Pickwick Papers'* was a *'wolf in a mulberry suit'*. Also 'mulberry red'.

n **mulch dye**

A green dye used to make, amongst other things, grass greener as in Birmingham, England in May 1998 when a stretch of newly-laid turf failed to turn green in time for President Clinton's visit.

n **Müllerian mimicry**

The form of mimicry named after the zoologist J.F Müller (1821-1897) where inedible insects develop colouring or patterns in order to imitate other species of insects which are either unpalatable or poisonous with a view to deterring their enemies. Cf **Batesian mimicry**.

n **mulling**

The process of grinding pigment and oil to create oil paint.

n **multi-coloured paint**

Paint consisting of several colours most effectively applied by means of a spray and producing a **flecked** finish with each colour appearing separate from the next.

a **multi-coloured, multicoloured**

Having many colours.

a **multi-hued, multihued**

Having many colours.

n **mummy**

The dark brown bituminous pigment said to be produced from the **asphaltum** of Egyptian mummies!

c **mummy brown**

A bituminous yellowish-brown colour made from **mummy**.

n **munjistin**

An orange colouring agent derived from munjeet.

n **Munsell Colour System**

The notation system devised in 1905 by Albert Munsell and revised in 1929 to put colours into an ordered collection by reference to **hue, chroma** and **lightness** in a 3-dimensional setting.

n **murex**

A mollusc producing purple dye.

n **murexide**

A synthetic purple dye made from uric acid found in the excrement of guano the Peruvian sea fowl and marketed as 'Roman purple' in the mid 18th century in reference to the revered **Tyrian purple** of the ancients.

n **murk, mirk**

Darkness, gloom.

a **murky**

Gloomy, dark as in 'murky brown'.

c **murrey, murry**

Dark purplish red; **mulberry** colour; purplish-red or blood-colour like that of the mulberry for which it is a shortened form. Also called 'murrie' although that term is sometimes said to be the colour **morello**.

c **mushroom**

A pale shade of brown similar to the vegetable, mushroom.

c **mushy-pea green**

The green colour of mushy processed peas used (that is, the term) in relation to an Yves St Laurent design.

c **musk-coloured**

Having the dark brown colour associated with musk – the strong-smelling substance secreted by the male musk-deer.

c **mustard**

A reddish-yellow. Also 'mustard-coloured'.

c **mustard brown**

A deep brownish-yellow.

c **mustard yellow**

A deep yellow colour popular in the 1930's.

a **muted**

As regards colour, softened or of a reduced intensity.

c **myrtle green**

A green resembling the green of the myrtle leaf. Sometimes reduced to 'myrtle' (which has also been seen as a purple colour).

c **mythogreen**

A brilliant yellowish-green.

adjective a
adverb adv
a colour c
noun n
prefix pr
suffix su
verb vb

N

z y x w v u t s r q p o **N** m l k j i h g f e d c b a

c **nacarat**

Orange-red.

n **nacre**

Mother of pearl.

a **nacreous**

Having iridescence like **nacre**.

c **nankeen**

Yellow from the cotton cloth of the same name.

n **nanometre**

A very small unit of length (one thousand-millionth of a metre) used in the measure-ment of wavelengths of light. The wavelength of light is very short – about half a millionth of a metre. Hence, for ease, it is measured in nanometres – 1 nanometre being equal to 10 (-9) metres – *nanos* being Greek for nine. Visible light to human beings ranges from approximately 380 nanometres to 760 nanometres. In *Bright Earth – The Invention of Colour* Philip Ball refers to the phenomenon that although green and red are respectively in the range of 520 and 620 nanometres and yellow is in the region of 580 nanometres, when green and red light are mixed to produce yellow light no new wavelength is created.

n **naphtha**

A solvent produced from petroleum or coal tar.

c **naphthamide maroon**

A maroon first produced in 1960 together with other **benzimadazolone** pigments, but expensive to produce and not commonly found. Also 'naphthamide blue'.

c **naphthol red**

A medium red made from naphthol. Also 'naphthol red light' and 'napthol crimson'.

a **Naples**

Refers to pigments originally produced in Naples.

c **Naples yellow**

A heavy and dense yellow pigment containing antimony and used from the 17th century (and possibly long before) in place of lead-tin oxide. It was in turn replaced by cadmium colours. Also known as 'jaune brilliant' and 'antimony yellow'. Naples yellow is toxic – Vincent Van Gogh's illness having possibly been caused by his use of this colour. Now refers to the particular hue rather than the pigment itself.

c **nasturtium**

Used in combination with colours such as orange, red, blue and yellow in reference to the plant of the same name. Hence colours such as 'nasturtium red'.

c **National blue**

A deep blue.

n **native colours**

Colours in their natural unadulterated state.

c **Nattier blue**

A very soft blue colour used by Jean Nattier (1685-1766).

a **natural**

Commonly used to describe a wide range of colours representing natural substances such as undyed cloth, earth, stone and wood including light browns, greyish browns, **off-white**, **grey**, **drab**, **écru**, **beige**, **grège** and similar colours.

a **natural-coloured**

Having an off-white colour. Often used in describing the colour of cloth. See **natural colours**.

n **Natural Colour System (NCS)**

A system of colour notation originating in Sweden whereby colours are described by reference to the six colours red, yellow, green, blue, white and black employing a percentage scale. This system was intended to enable colours to be determined without the need for colour measuring instruments.

n **natural dyes**

Natural dyes and pigments derived from plants, from minerals and from animals and insects. Plant or vegetal dyes include **alizarin**, **cutch**, **fustic**, **indigo**, **madder**, **safflower**, **saffron**, **weld** and **woad**. Mineral dyes include **lapis lazuli**, **ochre**, **azurite**, **lead oxide**, **cinnabar**, **limestone**, **manganese** and **malachite green**. Animal dyes include **carmine** and **cochineal**. Plants often produce a dye which is of a different colour from that of the plant. For example, the strawberry produces a beige dye.

n **natural earth**

See **earth colours**.

n **natural order of colour**

The colours placed in order of their lightness of tone from yellow (the nearest to white) through orange, red, purple, blue, green and violet (the nearest to black).

c **nauseous green**

Compare with 'bilious blue'!

c **NavajoWhite**

One of the 140 colours in the **X11 Color Set**. It has hex code #FFDEAD.

a **nævous**

Freckled.

c **navy**

A dark blue. Short for **Navy blue**.

c **Navy**

Another of the 140 colours in the **X11 Color Set**. It has hex code #000080.

c **navy blue**

A dark purplish blue. Derived from the colour of the uniform traditionally worn by some navies.

a **nebulous**

Indistinct or vague.

c **Negro**

A dark brown colour name now offensive and inappropriate to use.

n **neon colours**

Very bright garish colours.

c **neon pink**

A bright garish pink. Also 'neon-lime'.

c **neptuna**

A green named after the seagod Neptune.

c **nettle**

A shade of dark green.

a **neutral**

Having no predominant coloration. Without hue. A colour is said to be neutralised or made duller when it is mixed with its **complementary colour**.

a **nicotine-stained**

As regards the fingers of heavy smokers of tobacco, the yellowish colour or stain taken on as a result of such smoking.

n **niello**

A black alloy of copper, lead, silver, and sulphur, used as an infill in engraving silver so as to provide a contrast.

c **nigger brown**

Once a term for dark brown, but now deeply offensive.

adjective a
adverb adv
a colour c
noun n
prefix pr
suffix su
verb vb

c **nightclub tan**

My father's description of a wan **complexion**! See also **café sunburn**.

pr **nigr- (L)**

Black.

a **nigrescent**

Becoming or turning black.

a **nigresceous**

Black.

a **nigricant**

Black, swarthy.

n **nigrosin(e)**

Blue/black colorant.

a **nigrous**

A very deep black.

c **Nile blue**

Greenish-blue. Also a chemical used as a blue stain particularly for fatty acids.

c **Nile green**

The pale green colour of the river Nile; also called **eau de nil**.

n **nimbus**

In painting, the halo of gold light appearing behind the head of a sacred person. See **mandorla**.

pr **nipho- (L)**

Snowy.

c **Nippon**

A dark navy blue colour.

n **nitency**

The state of being bright or lustrous.

a **nitid**

Bright glossy or lustrous.

a **nitidous**

Smooth or lustrous.

pr **nival- (L)**

Snowy.

a **niveous**

Snowy, white.

n **nivosity**

Snowiness.

a **nixious**

Snowy.

n **no-colour**

A nondescript colour hard to specify as in 'no-colour hair' (*The Evening Standard* 23.8.99).

a **noctilucent**

Shining at night. In particular, 'noctilucent cloud' – electric blue cloud at high altitudes which at dawn or dusk reflects the light of the sun – a phenomenon sometimes mistaken as a sighting of a UFO.

a **noctilucous**

Glowing at night like phosphorous.

c **noir**

Black in roulette; used in the game rouge et noir.

n **non-fade colours**

Colours which are **colourfast**.

a **non-fading**

'*non-fading golden yellow flowers*' said of the orchid called Mystic Golden Leopard.

n **non-solid colour**

In computer science, colour resulting from the pattern of pixels; see also **dithering** and **dithered colour**.

n **non-yellowing paint**

Paint designed to maintain its whiteness or purity.

n **norbixin**

A red food colouring agent (E160 (b)).

n **Northern Lights**

See **aurora borealis**.

n **nuance**

A subtle variation in the **shade** or **tone** of a colour.

c **nude**

A brownish pink. *The Times* of 1.3.00 refers to Dior's '*nude-coloured chiffon dresses*'.

c **nugrey**

A purplish-grey.

c **Nuremberg violet**

See **manganese violet**.

c **nut-brown**

Often the reddish-brown colour of the hazel nut but strictly a general brown colour used to describe the many shades of nuts.

c **nutmeg**

'*He's of the colour of the nutmeg*'; Shakespeare's *Henry V Act 3 Scene 7*; variously a light or dark brown and sometimes a greyish brown.

c **nutria**
An olive grey.

n **nyctalopia**
Night-blindness; sometimes used in the opposite sense of blinded by the light of day or seeing only by night!

pr **nycti-, nycto-**
Dark.

adjective a
adverb adv
a colour c
noun n
prefix pr
suffix su
verb vb

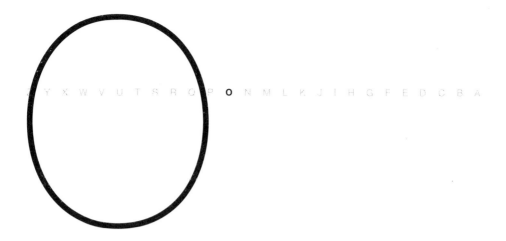

c **oak**

A deep brown; the colour of the wood of the oak tree.

c **oakwood**

A yellowish-brown.

c **oatmeal**

A greyish-yellow colour.

vb **obfuscate; to**

To darken or obscure something. From *fuscus* (L) dark. Hence, obfuscation.

a **obfuscous**

Dusky, dark.

vb **obnubilate; to**

To obscure or darken. From *nubes* (L) a cloud.

pr **obscur- (L)**

Dark.

a **obscure**

Dark, gloomy, dim; unclear, vague or indistinct.

a **obsidian**

Dark-coloured; having the bright **jet black** quality of granite.

a **obsidional, obsidionary, obsidious**

Each having the same meaning as **obsidian**.

vb **obtenebrate; to**

To darken or overshadow; to cast into the shade. From *tenebrare* (L) to make dark.

vb **obumbrate; to**

To overshadow or darken. From *umbrare* (L) to shade.

n **occamy**

The imitation of silver.

n **occecation**

Blindness.

c **ocean green**

A yellowy green.

a **ocellated**

Decorated or marked with an **ocellus** or spot resembling an eye.

n **ocellus**

A spot of colour on birds or insects resembling an eye; more usually found in the plural form – ocelli; an organ of sight in molluscs. See **aposematic**.

a **ochraceous, ochreous, ocherish**

Having the the light brown or yellow colour of **ochre**.

c **ochre, ocher**

A light brown; an orangey-yellow; a shade of yellow.

n **ochre, ocher**

An ancient mineral pigment containing clay and silica used in producing paint to create colours ranging from red to yellow to brown.

a **ochreous**

A light yellowy brown colour resembling that of **ochre**.

c **ochre yellow**

A yellowish brown.

pr **ochro- (G)**

Pale yellow.

a **ochroid**

Looking pale yellow.

a **ochry, ochery**

Having the light brown colour of **ochre**.

c **oeil-de-perdrix**

A ruby red; a pink or red colour particularly as regards wines and champagnes.

pr **oeno- (G)**

Wine-coloured.

a **off colour**

Bleached or suffering from colour loss such as in the case of the onshore coral of Australia's Great Barrier Reef. See 'feel off colour' in **Phrases**.

n **off-colour**

A faded or indeterminate colour resulting from a process of bleaching or discolouration.

c **off-white**

A shade close to white. See **barely** and **natural colours**. Also 'off-black'.

a **offusc**

Dark, obscure (obs.).

n **offuscation**

Another form of **obfuscation**.

n **Oil and Colour Chemist's Association**

The learned society formed in the UK in 1918 the membership of which includes persons working in the surface coating industry.

n **oil colour**

Paint produced by mixing oil with ground pigment.

n **oil paint**

Pigment mixed with oils such as **linseed** oil, walnut oil, poppy oil or **safflower** oil.

n **oil painting**

A method of painting making use of **oil paint**; the painting itself.

n **oilproof**

As regards a pigment, resistant to change despite the application of oil.

a **old**

Used in conjunction with pigments (such as 'gold') which give the appearance of age when applied to a surface.

c **old coral**

Red-orange.

c **old gold**

A glossy yellow colour first recorded as a colour term in 1879.

c **OldLace**

A light beige colour – one of the 140 colours in the **X11 Color Set**. It has hex code #FDF5E6.

c **old rose**

Deep pink.

n **oleograph**

A lithograph in oil colours.

adjective a
adverb adv
a colour c
noun n
prefix pr
suffix su
verb vb

a **olivaceous**

Olive-coloured.

c **olive**

The yellowish-green colour of unripened olives.

c **Olive**

One of the 140 colours in the **X11 Color Set**. It has hex code #808000.

c **olive drab**

The olive green of US army uniforms.

c **OliveDrab**

One of the 140 colours in the **X11 Color Set**. It has hex code #6B8E23.

c **olive green**

A colour similar to olive. 'Olive green' is the term used in the UK in preference to the US 'olive'.

c **olive grey**

A green shade of grey also called 'Scotch grey'.

c **Olympic blue**

A deep blue or greenish blue.

n **ombré**

The technique of blending one or several colours to create a graduated effect ranging from light to dark, particularly, in the dyeing of fabrics but also in painting.

n **ommatidium**

Organs of sight in molluscs.

n **oocyan**

The blue-green pigment in the shell of some birds' eggs. Although birds' eggs come in a variety of colours (many of them speckled) we are accustomed to hen's eggs being either white or brown. However, there are some chicken breeds which produce eggs in a variety of shades. The Old Cotswold Legbar breed, for example, lays eggs on a commercial basis in many colours including turquoise, olive and blue.

n **ooxanthine**

The yellow pigment in the shell of some birds' eggs.

vb **opacate; to**

To darken; to make opaque.

n **opacity**

The quality as regards pigments of being able to cover another colour; the quality of being **opaque.** The amount of light a surface will let through will determine the opacity of that surface.

c **opal**

The colour of the precious stone – the opal – sometimes a milky bluish green, but uncertain. Also used to refer to a changing or uncertain range of colours after the variety and changeability of the colours displayed by an opal caused by **diffraction grating**.

vb **opalesce; to**

To shine as an opal. See **opal**.

a **opalescent**

Having an **iridescent** quality similar to that of an **opal**.

a **opalesque**

Opalescent.

c **opaline**

A light muted green.

a **opaline**

Having the colour and iridescent quality of an **opal**.

a **opaque**

Not transparent; lacking lustre; not reflecting light or allowing images to penetrate. A colour is regarded as having opacity if it can inhibit light passing through it, for example, in painting when it is superimposed on another colour preventing that other colour from showing through. A colour with that capacity is described as having good 'covering power' and a colour without it is described as **transparent**.

n **optical colour**

The technique (widely used by the Impressionist school of artists) of painting broad bands, blotches or spots of colour next to each other so as to create an illusion in the brain of the viewer of a third or extra colour when the work is observed from a distance. Also called **divisionism**. A similar and more startling effect can be obtained from computer-generated 2-dimensional colour designs which when studied carefully appear to transform into a 3-dimensional image having a new (and more luminous) colour. Another example occurs with the blending of colours on a spinning colour circle. See also **Pointillism**.

n **optical fibres**

Conduits as thin as human hair through which **infrared** light can travel at speed without degradation and with many applications including telecommunications, in particular, the Internet.

n **Optical Stimulated Luminescence (OSL)**

A new technology used by archeologists to determine when soil was last exposed to sunlight.

c **or**

In heraldry, the colour gold or yellow.

c **orange**

The colour of the fruit, orange, when it is ripe. (The orange was previously called a 'narange' – an adaptation from the Spanish 'naranja' or 'naranj'. There are several English words from which the initial 'n' has been dropped, by way of a process known as aphesis including 'apron' which was formerly 'napron' and 'adder' which evolved from 'nadder'. The change works in both directions, for example, 'nickname' originates from ' an eke name' (an additional name)). Orange covers a wide variety of colours in the range of approximately 630 to 600 **nanometres**.The colour of William of Orange and of the Ulster Orangemen; the colour of goldfish and of Penguin Books from 1935. Orange is one of the few colours (see also **violet**) which does not have a rhyming word thus giving rise to Willard R. Espy's Procrustean rhyme in *Words to Rhyme With – A Rhyming Dictionary* – MacMillan 1986, '*The four eng,- ineers, wore orange, brassières*'.

c **Orange**

One of the 140 colours in the **X11 Color Set**. It has hex code #FFA500.

n **orange chrome**

An orange pigment made from lead. Also red chrome.

c **OrangeRed**

One of the 140 colours in the **X11 Color Set**. It has hex code #FF4500.

c **orange-tawny**

Dull yellowy-brown; Shakespeare's *Midsummer Night's Dream* Act 1 Scene 2. A colour once allocated to persons supposed to be of lowly status.

c **orange-vermilion**

A red hue devised by the **colourman** George Field and used extensively from the 1830's.

a **orangey, orangy**

Tending towards the colour orange.

n **orcein**

Red-colouring matter occurring in orchids.

c **Orchid**

One of the 140 colours in the **X11 Color Set**. It has hex code #DA70D6.

c **orchid pink**

A lightish pink; sometimes a deep pink or purplish pink.

c **orchil**

A medium red shade.

n **orchil**

A natural red or violet dye from fermented lichens yielding the chemical testing substance called **litmus.** Also called 'archil'.

n **orellin**

Yellow colouring agent found in **anotto**.

adjective a
adverb adv
a colour c
noun n
prefix pr
suffix su
verb vb

n **organic pigments**

Those pigments the principle constituent of which comes from plants, animals and other living organisms (for example, **sepia** from cuttlefish and **madder lake**); any matter with an organic base used as a colorant. Pigments are now sometimes classified as organic pigments if they contain carbon in their composition. Organic pigments are now mainly made synthetically and include **azo** pigments, disazo **(diarylide)** pigments, **Beta-Naphthol** pigments, **Benzimidazolones** pigments, **phthalocyanine** pigments and other complex pigments such as **quinacridones, indanthrones, perylenes, perinones, pyrroles** and **dioxazines.** Inorganic pigments are made from minerals and include the **earth pigments, lead chromes, cadmiums** and **cobalts.** Synthetic inorganic pigments are mostly metallic compounds. See also **colorant, natural dyes** and **pigment.**

n **oriency**

As regards colour, a brilliance; a strong or bright light.

c **oriole**

A browny orange colour.

n **ormolu**

Originally gold powder used for guilding metals; now a gold-coloured alloy made from copper (72%), tin (3%) and zinc (25%).

n **orpiment**

An ancient yellow mineral (also called Yellow Arsenic) used as a pigment. Used as a fake gold as its Latin name (**auripigmentum**) suggests; see **King's yellow.**

c **orpin**

A brilliant yellow.

c **orseille**

A purplish shade of red; a variant form of **orchil.**

a **orthochromatic**

In relation to photographic plates, sensitive to all colours other than red.

n **Ostwald Circle**

A colour circle in which colours are arranged as **complementary colours** thus allowing colour assessment and the determination of which colours can be used in harmony. The Ostwald circle shows either 8 standard colours or the full set of 24 colours. See **colour wheel**.

c **otter**

A yellowish greyish brown.

c **otter brown**

See **perique**.

a **overcast**

As regards the weather, cloudy, gloomy.

n **overlaid colour**

The technique of building up layers of watercolour so as to create the impression of depth.

vb **overpaint; to**

As regards painting, to cover one colour with another.

c **oxblood**

A dark red.

c **Oxford blue**

A dark blue.

c **Oxford chrome**

Yellow ochre.

c **Oxford grey**

A dark grey.

c **Oxford ochre**

An orangey-yellow.

c **oxheart**

A deep red.

n **oxide of chromium**

See chromium oxide.

n **oxyhaemoglobin**

A bright red pigment. The pigment which brings the bright pink colour (with **livid** blotches) to the complexion of someone being poisoned by cyanide!

c **oyster**

A greyish white. According to Fowler's *English Usage*, first used as a colour description in 1922.

c **oyster grey**

A brownish shade of grey.

c **oyster white**

A light grey or greyish white.

adjective a
adverb adv
a colour c
noun n
prefix pr
suffix su
verb vb

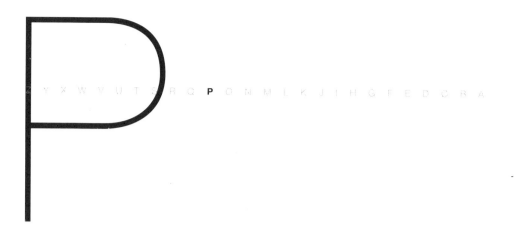

n **paint**

A fluid suspension applied thinly to the surface of objects for the purpose of decoration, protection or preservation. Paint usually consists of **pigment** in tiny particles mixed in a **medium** which binds the pigment and causes it to adhere to the surface. References to different kinds of paint may indicate the kind of pigment or the medium so that 'lead paint' refers to paint with a lead compound whereas 'oil paint' refers to the medium. Paint was possibly first used as long as 30,000 years ago by primitive man (but possibly much earlier; see **pigment**). Paint now comprises three main substances – resin known as the **binder, solvent** to dissolve the binder and to give the paint its required consistency and pigment which imparts the colour. Paint, seemingly a functional unglamorous product, has nonetheless not escaped the trend towards goods being marketed as designer goods. Ralph Lauren has produced at least 200 colours (including 32 types of white paint) each with its designer name. Specialist decorative paint finishes abound. They include sponging, **rag-rolling,** brushed colour-washes, stippling (see **stippled**), faux marbling, wood graining, metal leaf finishes and sparkle paints.

vb **paint; to**

To apply colour to an object or surface.

n **painting**

The process or act of applying paint to a surface; the result of such process.

a **Paisley**

The distinctive pattern originating from clothes made in Paisley, Scotland.

a **pale**

Dim, lacking brightness; as regards colours, whitish, lacking an intensity.

n **paleface**

A white person so called by the North American Indians in Westerns.

c **PaleGoldenrod**

One of the 140 colours in the **X11 Color Set**. It has hex code #EEE8AA.

c **PaleGreen**

One of the colours in the **X11 Color Set**. It has hex code #98FB98.

n **palette**

A hand-held platform used to carry and to mix an artist's colours which are usually arranged in a particular order. John Gage in his *Colour and Culture* devotes a whole chapter to the palette and refers to Eugène Delacroix (1799-1863) who used a fresh specially prepared palette for each new painting. In oil painting some artists like to use a palette having the same colour as their **canvas** or **ground** so as to enable them to see the precise hue of the paint.

c **PaleTurquoise**

One of the colours in the **X11 Color Set**. It has hex code #AFEEEE.

c **PaleVioletRed**

Another of the colours in the **X11 Color Set**. It has hex code #DB7093.

c **palew**

Light yellow.

pr **pallid- (L)**

Pale; a pale yellow.

a **pallid**

Lacking colour; having only a faint colour; wan; indicating a pale shade as in 'pallid-grey'.

n **pallidity**

Paleness.

a **pallidiventrate**

Having a pale belly!

n **pallor**

Unnatural paleness, particularly of the complexion.

n **palm oil**

Used as a food colouring.

n **palmellin**

A red dye found in a type of algae.

n **pan colours**

Watercolour paint extruded and cut into into shapes suitable to put into paint-boxes.

a **panchromatic**

Especially as regards film and photographic paints, sensitive to every visible colour.

c **pandius**

A medieval term which probably embraced a variety of colours including red, blue and yellow.

a **paned**

Created by joining different coloured strips of cloth together.

c **Pannetier green**

An emerald green created by M. Pannetier. See **viridian**.

c **pansy**

A deep violet or purple.

c **Pantone 109**

One of the thousands of Pantone colours (see **Pantone Red**). This distinctive yellow shade has been registered as a trade mark by the Automobile Association for use on its **livery**. By registering a colour as a trade mark a business can stop others from using that colour in conjunction with a similar business. Other examples of trade mark registrations in the UK include the orange registered by Dyno-Rod and the yellow and green registered by BP. Colour names can also be registered as trade marks. An action for passing off can also be used to protect a business's use of a distinctive colour but this is difficult to substantiate. In 1990 *The Financial Times*, which has been printed on distinctive salmon-pink coloured newsprint since January 1893, failed in its attempt to stop *The Evening Standard* from publishing its centre business pages in a similar shade. A colour or a combination of colours can constitute a Community Trade mark to the extent that it distinguishes the goods or services of a business from those of another.

c **Pantone Red**

According to *The Times* of 22.4.98 the British Tomato Growers Association has adopted Pantone red as its trade logo though a small proportion of British tomatoes reach this dark rich red hue. Pantone colours have been developed and marketed by Pantone, Inc a leading provider of technology and systems for the communication of colour and colours. The Pantone Textile Colour Guide provides a comprehensive classification of 1,701 colours for the textile industry.

c **pæonin**

A red colour.

c **PapayaWhip**

One of the colours in the **X11 Color Set**. It has hex code #FFEFD5.

c **paprika**

The reddish-orange colour of the spice paprika; a shade of brown.

c **para-red**

A deep red.

a **parachroous**

Having a false colour or deprived of colour.

adjective	a
adverb	adv
a colour	c
noun	n
prefix	pr
suffix	su
verb	vb

n **pararosaniline**

An alcohol base used in producing some red dyes. See **rosaniline**.

c **parchment**

The colour of parchment.

c **Paris black**

Ivory black.

c **Paris blue**

A bright blue pigment (sometimes dark blue or violet). See **Milori blue**.

c **Paris green**

A bright yellowy-green; a light green pigment. See **emerald green**.

c **Paris red**

A red colour.

c **Paris white**

A high grade of **whiting**. Also called 'Spanish white'.

c **parma**

A shade of purple.

c **parma red**

A deep red.

c **parma violet**

A deep shade of purple.

c **parrot green**

The vivid yellowish green of the plumage of the parakeet.

c **parsley green**

An olive green.

a **parsnip-coloured**

Having the colour of the vegetable, parsnip.

c **Parson grey**

A dark grey.

a **parti-bendy**

In heraldry, indicating a division of a shield into two colours.

a **parti-coloured**

Coloured in part in one colour and in the other part by another colour; *'parti-coloured lambs'* Shakespeare's *Merchant of Venice* Act 1 Scene 2. See **multi-coloured**.

n **paste colours**

A term used to describe common pigments such as **burnt umber** and **ochre** when they are in the form of a paste.

a **pastel**

Indicating a pale **shade** or a **tint** of a particular colour as in 'pastel pink'. *The Evening Standard* (21.1.99) – *'in every hue from pastel-soft to techno-intense'*.

n **pastel colours**

Colours such as pastel blue and pastel pink to which grey has sometimes been added.

n **pastel painting**

The technique of painting with sticks or **pastels** made from ground dry pigment mixed with clay or **chalk** and bound with gum or (in the case of oil pastels) with animal fat and wax. Pastels are also available for use in conjunction with water. This medium consists of producing **tints** and shades of colours which are intended to be mixed on the surface or **ground** rather than on the **palette**.

n **pastels**

Finely ground pigment made into coloured sticks or pencils. See **pastel painting**. Soft colours.

a **pastose**

Heavy with paint as with **impasto**.

a **pasty**

Having a pale **complexion**.

n **patch**

A small area on a surface having a colour which is different from the immediate surrounding area.

n **patchwork**

A hand-stitched work consisting of geometric blocks of differently coloured materials put together to make a quilt or work of art; any pattern consisting of a collection of disparate parts together forming a whole.

c **patent blue**

A deep greenish blue.

n **patent blue V**

A deep greenish blue or bluish-violet food colouring additive (E131); also used for diagnostic purposes.

c **patent yellow**

A yellow pigment made from lead oxychloride patented in 1781 by James Turner and also called Turner's patent yellow or simply Turner's yellow. A by-product of the soda industry.

n **patina**

A film or incrustation produced by oxidation on the surface of old bronze, usually of a green colour. Hence extended to a similar alteration of the surface of marble, flint, or other substances or objects esteemed as ornaments.

vb **patinate; to**

To cover with a **patina**.

n **pattern**

A design of repeated **motifs** the decorative value of which is improved by the use of appropriate colours.

c **pavonazzo**

Peacock-coloured; greenish blue.

a **pavonine**

Iridescent; pertaining to the peacock in colour or other characteristics; greenish blue.

c **Payne's grey**

A greyish blue.

c **pea green**

A yellowy-green found in fresh green peas.

c **peach**

The yellowish pink colour of the fruit, peach; *'peach-colour'd'* used by Shakespeare in *Measure for Measure and Henry IV Part 2.*

c **peach-black**

A black pigment made from peach stones. Also referred to as 'peach-stone black'.

c **peach bloom**

A deep pink used as a ceramic glaze.

c **peach-blossom**

The light purplish-pink of peach blossom.

n **peaches and cream complexion**

The classic British female **complexion** with a fair cream-coloured skin and pinkish cheeks.

c **PeachPuff**

One of the 140 colours in the **X11 Color Set.** It has hex code #FFDAB9.

c **peacock blue**

Greenish-blue.

a **peacock-coloured**

Having a greenish-blue colour.

c **peacock green**

A yellowish green.

c **pearl**

The light greyish-blue of the pearl.

| adjective a |
| adverb adv |
| a colour c |
| noun n |
| prefix pr |
| suffix su |
| verb vb |

a **pearlescent**

Pearly or nacreous; see **iridescent**.

c **pearl grey**

A blue-grey.

n **pearly whites**

A slang term for 'teeth'

c **peat**

A dark grey shade.

pr **pello- (G)**

Dusky.

a **pellucid**

Perfectly clear.

n **pencil**

An instrument for drawing or writing generally consisting of graphite rather than lead. Originally a holder with a stick of graphite and now usually graphite encased in a wooden surround – the best quality pencils being made from cedarwood. From the end of the 17th century graphite was mined in Cumberland in the Lake District of England where '*crayons d'Angleterre*' were manufactured – the origin of Cumberland coloured pencils. The development of the modern pencil can be traced through a series of innovators such as the Germans, Friedrich Staedtler and Kasper Faber, the Frenchman Nicolas-Jacques Conte and the Hardtmuth family – Franz Hardtmuth perfecting the distinctive high quality yellow Koh-I-Nor pencil in his factory in Czechoslovakia which before the First World War was the biggest pencil factory in the world. The word 'pencil' originally meant an artist's brush and originates from the Latin '*peniculus*' and '*pencillus*' – a brush which in turn comes from the word '*penis*' in its sense of a tail. All these words have developed from '*Penates*' gods of the interior from which we derive the word 'penetrate'. See **colouring pencils, pastels** and **silverpoint**.

n **Penny black**

The original adhesive one penny postage stamp issued in 1860 in the United Kingdom; also Penny blue and Penny purple.

a **pentachromatic**

See **pentachromic**.

a **pentachromic**

Having five colours; able to see five (or only five) colours; (possibly also 'pentachromatic').

n **penumbra**

A region of half-shadow cast by an object; in drawing or painting, a shadowy area where the shade fades into light.

c **peoli**

See **Indian yellow**.

c **peony-pink**

The pink of the flower, peony.

c **peony-red**

A dark red.

a **pepper-coloured**

Presumably having the colour of pepper, but whether this relates to white or black pepper or any other colour is not clear. (Used in *Unofficial Rose* by Iris Murdoch).

n **perezone**

A naturally occurring orange pigment.

c **peridot**

The dark yellowy-green colour of the precious stone chrysolite which is called '*peridot*' in French.

n **perinone**

A class of complex organic synthetic dyes and pigments producing perinone red (a maroonish red) and oranges and yellows. See **organic pigments**.

c **perique**

A strong tobacco colour; otherwise known as otter brown.

c **periwinkle**

Purplish blue.

c **periwinkle blue**

A light purplish blue.

n **Perkin's mauve**

A synthetic **lightfast aniline** mauve dye made from **coal-tar** invented by William Perkins in 1856 and perhaps the first synthetic dye to be used commercially. Also called **mauveine**.

a **perlaceous**

Pearly.

n **permanence**

The quality in a colour or pigment of being durable or resistant to fading or to damage from heat, water, acid or other substances. Hence 'permanence rating'. Compare with **lightfastness** which strictly indicates resistance to light.

a **permanent**

Used to describe pigments which tend not to fade. The **earth colours** are the least prone to fade.

n **permanent**

A peroxide based hair dye remaining effective until the dyed hair grows out. See **semi-permanent**.

c **permanent blue**

A dark blue.

c **permanent green**

A dark green. See **Guignet's green**.

c **permanent rose**

A pinkish-red.

c **permanent white**

A white pigment made from barite also known as **mineral white**.

n **peroxide blonde**

Used, often disparagingly, to describe a woman who has bleached her hair blonde with hydrogen peroxide.

c **perse, pers**

Dark blue; a mysterious word said to derive from Persia although Maerz & Paul and Gage doubt this. In medieval times the word covered a wide range of colours from blue to red. In *Colour and Culture* Gage suggests that perse might indicate a kind of cloth. There are indeed many examples of the name of a type of cloth coming to designate the colour itself – see **écru** and **grège**; and also **Kendal green, Lincoln green, loden, lovat, nankeen, russet, scarlet, turkin and stammel.** (The colour **khaki** provides an example of the obverse, that is, where the colour begets the name of the fabric.) There are also instances where colournames are based on the materials used to create those colours, for example, **sil, sinope, silver** and **gold.**

c **Persian blue**

A strong blue colour; a pale violet.

c **Persian orange**

A reddish yellow.

c **Persian red**

A purplish red pigment. See **Venetian red.** Also refers to **chrome orange**.

c **persimmon**

A reddish orange; the colour of the fruit of the same name. Also the red-brown colour of persimmon wood.

c **Peru**

A light brown colour – one of the 140 colours in the **X11 Color Set**. It has hex code #CD853F.

c **pervenche blue**

The blue of the periwinkle, *pervenche* being the French term for that flower.

adjective a
adverb adv
a colour c
noun n
prefix pr
suffix su
verb vb

n **perylene**

A class of synthetic organic pigments used to produce reds and maroons; a yellow hydrocarbon used to make dyes.

c **petrol blue**

The metallic shade of blue also referred to as 'petroleum blue'; a dark bluish green.

c **petunia**

A dark purple.

c **pewter**

Having the dark bluish grey colour of pewter.

n **Pfister-Heiss**

A test which associates different emotions with particular colours. See also **Lüscher colour test**.

a **phalochrous**

Dark-skinned.

n **phantom colours**

The optical phenomenon where a background appears different in colour from its actual colour because of the 'migration' of colour from lines or patterns drawn on that background.

n **pharology**

The science of signalling by means of lights.

n **phenicine**

A purple colouring matter.

a **phenicious**

Red with the addition of grey.

n **phenosafranine**

A synthetic red dye.

n **phenyl blue**

A purplish blue dye.

n **phenyl brown**

A brown colouring matter.

a **philimot**

See **feuillemorte**.

n **phloxine**

A brilliant red dye.

n **phoenicin**

A natural yellow-coloured pigment.

pr **phoenico- (G)**

Purple.

n **phoenix**

A purple-red dye given its name by the Phoenicians and called such by the Greeks.

n **phosphor**

A tiny coating of blue, green or red fluorescent powder on a cathode ray tube emitting coloured light onto a television screen or colour monitor when stimulated by electron beams. From these three colours all other colours can be produced – yellow, for example being generated by a mixture of green and red. See **trichromatic** and **RGB**.

n **phosphorescence**

Luminescence which continues for a significant period of time (measured in nanoseconds) after the stimulus has ceased as compared with **fluorescence** where the luminescence disappears more quickly.

a **phosphorescent**

Glowing in the dark. Phosporescent pigments contain radioactive elements.

n **phot**

A unit of illumination equivalent to 10,000 **lux** and to one **lumen** per centimetre square.

a **photic**

Pertaining to light.

n **photochromic**

Light sensitive; changing colour when exposed to light or some other source of energy.

n **photodynamic therapy**

An experimental treatment using light-sensitive drugs to penetrate and cure diseased tissue, in particular, cancerous tissue. See **colour therapy**.

n **photodynamics**

The study of how light effects animals and plants.

n **photography**

The process of creating images by exposing light-sensitive paper to a light source. It is thought that the first colour image on a photograph was produced in 1861 by James Clerk Maxwell.

n **photokinesis**

The reaction of a living organism to light.

n **photometry**

The measurement of light and its intensity.

n **photon**

The energy of which light is composed.

a **photophilous**

Light-loving; seeking light as in certain sun-loving plants. See **heliotropism**.

n **photophobia**

The condition where the eye cannot tolerate light; the fear of light.

n **photophore**

A luminous organ in certain creatures, in particular, fish and custaceans.

a **photophygous**

Avoiding strong light.

n **photopia**

The adaptation of the eye to daylight.

n **photopic vision**

That kind of colour vision which uses the **cones** in the eye as the principal receptors.

n **photoreceptor**

A living structure (for example, the eye) responding to or stimulated by light; hence 'photoreceptive'.

n **photosynthesis**

The process by which plants harness sunlight to produce energy.

n **photosynthesis pigments**

Those pigments which as part of photosynthesis are involved in light absorption.

a **phototrophic**

Obtaining energy from sunlight.

n **phthalein**

A class of dye-yielding substances made from phenol and phthalic anhydrine.

n **phthalin**

A colourless crystalline compound derived from **phthalein**.

a **phthalo**

Descriptive of blues, greens, reds and yellow-greens made from phthalcyanine. See next three entries.

n **phthalocyanine blue**

A pigment producing an intense blue introduced by ICI in 1936. See **Monastral blue** and **tinting strength**.

n **phthalocyanine green**

A green pigment introduced in 1938. See next entry.

adjective a
adverb adv
a colour c
noun n
prefix pr
suffix su
verb vb

n	**phthalocyanines**

A group of synthetic organic pigments discovered between 1907 and 1927 producing in particular blues and greens. See also **Monastral blue**.

n	**phycochrome**

Blue-green dye from some algae.

n	**phycocyanin**

Blue colouring matter in certain algae.

n	**phycoerythrin**

A pigment absorbing yellow, green, violet and blue light but reflecting red light. It is present, for example, in algae in the **Red Sea** thus providing its name – 'phyco' meaning algae and 'eryth' indicating red.

n	**phycophaein**

Reddish-brown pigment found in certain seaweeds.

n	**phycoxanthin**

A yellow colouring matter.

n	**phylloxanthin**

The yellow pigment of autumn leaves. See **autumn** and **xanthophyll**.

n	**phytochrome**

A bluish-green pigment in certain plants.

a	**piceous**

Pitch-black.

n	**picric acid**

A saffron-coloured dye made from phenol used particularly for dyeing silk in the 1840's. Not being **lightfast** it had a short life-span extended only by reason of its use in making explosives!

pr	**picto- (L)**

Painted.

c **piebald**

Especially as regards horses, having a colouring involving white and black (or other dark colour) patches; **parti-coloured**. See **skewbald**. A horse having such colouring.

c **piecrust, pie-crust,**

The colour of piecrust. 'Piecrust' contains within it, the name of another colour – écru. Some other colourwords happen to hide colours including: atred, castaneous, labradorescent, platinum, santaupe, tango and travertine.

a **pied**

Having two or three colours in patches; **parti-coloured**.

c **pigeon's-blood, pigeon blood**

A dark red colour.

n **pigment**

Any organic or inorganic substance or compound in particle form used in a **medium** for colouring, painting or dyeing. Strictly, pigment is a substance, such as an artists' colour, which possesses body whereas 'colour' is the term purely describing the visual attribute of a pigment. Pigments are not soluble in water – a colorant which is soluble being referred to as a dye. A substance found in the tissue of man, animals and plants providing a characteristic colour. The painted Stone Age caves at Lascaux in Central France discovered in 1940 and at Altamira in Spain discovered in 1869 indicate the use of two iron oxides, yellow goethite and red haematite in wall paintings of mammoths and deer. French researchers believe that these natural pigments were heated to obtain different colours including red, orange, yellow, violet and purple. The caves at the Grotte Chauvet in Southern France which contain cave art at least 30,000 years old were thought to evidence the first pigments used by man. However, findings at the Blombos caves in South Africa reported in January 2002 in the journal *Science* indicate that decorative art existed more than 70,000 years ago. Research at the University of Bristol has found evidence (which includes paint-grinding equipment) that Stone Age man in Africa used yellow, red, pink, brown and purple pigments (perhaps as body paint) possibly as long as 350,000 to 400,000 years ago indicating that the origins of art began much earlier than previously appreciated. See **natural dyes** and **organic pigments**.

n **pigment code**

The index number given by the **Colour Index** to particular pigments.

n **pigment rubine**

The name given to one of the reddish E food additives (E180).

n **pigmentary colours**

The colours produced, for example in fish, by the presence of granules on their surface.

n **pigmentation**

The coloration resulting from the presence or formation of a **pigment**; the coloration of animals and plantlife.

c **pillar-box red**

The red colour of the British letter-box sometimes abbreviated to 'pillarbox'. The first pillar-boxes to be erected in in England (in 1853) were painted green. It was a further 20 years before the distinctive red livery was used and not until 1916 that 'pillar-box red' was recorded in use as a colour description.

c **pimento red**

The vivid red of the pimento.

c **pine**

The light brown of the wood of the pine tree; also describes a dark green.

c **pink**

Light reddish-purple; a pale red. The term 'pink' as used to describe the colour (there are numerous other meanings of the word) may come from the small sweet-smelling flower the Garden Pink (*Dianthus Plumarius*) and its many varieties although theories as to the origin of the colourword abound. It may have derived from the Dutch *pinck* meaning 'small'. In turn, this may possibly derive from 'pink' meaning 'having jagged edges' or petals (as in pinking shears). It appears in any event that this is a case where the colour derives from the name of the flower rather than the other way round. Also a generic term referring to the manner of manufacture as in **English pink**. Flamingos are initially white in colour, but turn pink as a result of eating sea-food containing **caretonoids.** Scientists at Imperial College in London have shown that lobsters turn pink when cooked because of the effect of heat on a protein called beta-crustacyanin. Pink is one of a number of proscribed colours in certain areas of the UK where Town and Country planners consider that brightly coloured exteriors threaten the architectural character of listed buildings and thus regularly issue enforcement notices against offenders. See **hunting pink**.

c **Pink**

One of the 140 colours in the **X11 Color Set**. It has hex code #FFC0CB.

n **pink**

A reference to excellence or perfection; *'the very pink of courtesy'* Shakespeare *Romeo & Juliet* Act 2 Scene 4. See also 'in the pink of perfection' in **Phrases**. Slang for homosexual or lesbian.

c **pink carmine**

A deep pinkish red.

n **pink champagne**

Champagne deriving its colour from the skin of the grape or by the addition of red wine during the fermentation process.

n **pink elephant**

One of a variety of hallucinations or fantasies which may be experienced as a result of imbibing alcohol (perhaps too many **pink gins** or **pink ladies**).

n **pinkeye**

The condition where the conjuctiva is inflamed resulting in a reddening of the ball of the eye.

a **pinkish**

An **-ish**.

n **pink gin**

Gin and bitters.

n **pink grannies**

The pet name given by Diana Princess of Wales to fifty pound notes as dramatically revealed by her butler Paul Burrell in November 2002 after his prosecution for theft had been halted in the light of a conversation he had previously had with the Queen. Princes Di called ten-pound notes 'brown grannies' and five-pound notes 'blue grannies'.

adjective a
adverb adv
a colour c
noun n
prefix pr
suffix su
verb vb

n **pink holes**

So-called pink holes have been discovered in space by Australian scientists. They apparently have a pink glow and are between 1 and 12 billion years old.

n **pink lady**

A cocktail made from gin, grenadine and egg white.

adv **pinkly**

With a pink appearance.

n **pink noise**

Noise of a random kind having higher amplitudes at low frequencies compared with **white noise**.

n **pinko**

Slang for being very drunk; radical or leaning to the left in reference to a person who is not quite a **Red**.

n **pink pound or pink dollar**

A reference to the aggregate amount spent by gay and lesbian consumers.

n **pink primer**

A **primer** for wood made from white lead and red lead.

n **pink slip**

A US euphemism for notice of termination of employment.

n **pink territories**

Those territories traditionally coloured pink (or red) on maps in some atlases indicating membership of the British Commonwealth or, formerly, of the British Empire.

n **pink viagra**

The nickname given to the female version of the blue drug used by men to enhance their enjoyment of sex.

n **pinstripe**

Cloth or fabric with a thin stripe, particularly cloth used for making mens' suits; also used as an adjective.

a **pinto**

Mottled or **piebald**; usually as regards horses. Hence,'pinto-coloured'.

c **pistachio green**

A yellowish-green; the green of the inside of the kernel of this nut. Also called 'pistache'.

c **pitch-black**

A colour term meaning extremely black although sometimes referring to the brownish-black colour of pitch; also referring to complete darkness.

n **pitch-blende**

Uranium ore producing a black and orange pigment.

a **pitchy**

Black; having the characteristics of pitch.

n **plaga**

A stripe usually of colour.

pr **plagat- (L)**

Streaked.

a **plain-coloured**

Having a nondescript colour.

c **plaster white**

An ancient white.

c **platinum**

A metallic grey colour resembling the precious metal.

c **platinum blonde**

Referring especially to the silvery blonde colour of a woman's hair artificially generated; used also to describe the wearer herself.

c **platinum yellow**

A pale yellow pigment previously referred to as 'platina yellow'.

a **pleochroic**

Having the characteristic of displaying different colours when observed from different directions (see also **dichroic** and **trichroic**) especially as regards certain crystalline forms. Also referred to as polychroic and pleochromatic.

c **plum**

The purple colour of the plum; a reddish-purple. *The Sunday Times* (8.9.02) refers to '*rich plummy shades*'.

c **Plum**

One of the 140 colours in the **X11 Color Set**. It has hex code #DDA0DD.

pr **plumb- (L)**

Lead.

a **plumbaceous**

Having the colour of lead.

c **plumbago**

The purplish grey of the graphite of the same name.

a **plumbeous**

Having the colour of lead.

c **plumbine**

Having the colour of lead.

c **plunket**

Greyish blue.

c **poilu-blue**

The shade of greyish blue of the French infantry men of WW1.

n **Pointillism**

A technique of painting practised by the Impressionists and involving an elaborate array of dots of paint of various colours which blend together to create the effect of brilliant intermediate colours in the eye of the viewer. Also referred to as 'chromo-luminarism'. See also **optical colour**.

pr **polio- (G)**

Grey.

n **poliosis**

Premature greying of the hair.

a **polychroic**

See **pleochroic**.

n **polychroite**

The colouring matter of **saffron** also referred to as **safranine**.

a **polychromatic**

Having many colours.

a **polychrome**

Having many colours in contradistinction to **monochrome**; also used as a noun to refer to a work executed in many colours.

n **polychrome sculpture**

A coloured sculpture. It was probably not until the 19th century that it was appreciated that most stone sculptures of the ancient world originally bore colour.

n **polychromy**

The process of painting or staining in several colours, in particular, as regards statues and bas-reliefs; any decorative art involving the use of several colours.See two previous entries.

n **polyporic acid**

The bronze colouring matter of certain fungi.

n **polyvinyl-acetate paint**

A cheaper alternative to **acrylic** paint using a vinyl emulsion as the **binder**.

c **pomegranate**

The golden-orange/red colour of the rind of the fruit of the same name; sometimes a pinkish red.

adjective a
adverb adv
a colour c
noun n
prefix pr
suffix su
verb vb

c **Pomona green**

A yellowish-green.

c **Pompadour**

Variously described as pink, crimson or blue and so named after the mistress of the French monarch Louis XV, la Marquise de Pompadour. Also 'rose Pompadour'.

c **Pompadour green**

A shade of green named after la Marquise de Pompadour.

c **Pompeian blue**

See **Egyptian blue**.

c **Pompeian red**

The red found in the frescos of Pompeii. See **Venetian red**.

c **ponceau**

A bright poppy red colour also referred to as 'coquelicot'.

n **Ponceau 4R**

An artificial red additive used in preparing curry dishes (E124). Research at the Asthma and Allergy Research Centre suggests that E124 might lead to hyperactivity in children.

c **pontiff purple**

A purple.

c **popinjay**

The predominant colour of the green parrot.

c **poppy**

A bright orange-red also referred to as 'poppy red'.

n **porphobilin**

A group of red-brown pigments.

pr **porphyr(o)- (G)**

Purple.

n **porphyrin**

A group of dark red and purple pigments naturally occurring both in animals and plant life.

n **porphyrogenite**

Literally 'a person born in purple' and thus describing someone of noble birth.

n **porphyrophobia**

Fear of the colour purple.

n **porporino**

A yellow powder used in medieval times as a pigment instead of gold and made from quicksilver, tin and sulphur.

a **porraceous**

Leek-green. See **porret**.

c **porret**

A yellowish green – a porret being a baby leak. See **porraceous**.

a **porridge-coloured**

Presumably, having the colour of porridge oats – a light creamy beige.

n **poster paint**

Paint or **gouache** mainly used by children.

c **powder blue**

Used variously to describe both a light blue and a deep blue. Also powdered **smalt** used in the washing of linen to maintain its whiteness.

c **Powder Blue**

One of the 140 colours in the **X11 Color Set.** It has hex code #B0E0E6.

pr **praseo- (G)**

Leek-coloured.

c **prasine**

The green colour of the leek.

a **prasinous**

The colour of the leaves of leeks or onions.

n **Pre-Raphaelite colours**

The natural colours used by those painters, called Pre-Raphaelites, who adopted the style of artists before the time of Raphael (1483-1520).

n **primary colours**

Originally, the colours of the **spectrum**: red, orange, yellow, green, blue, indigo, violet. As regards **surface colour**, **pigments** and **paints** the term now usually refers to the three colours red, blue and yellow (also known as **elementary colours** and **fundamental colours**) from which all other colours can, in theory, be derived. Mixing all three primary colours produces black by the **subtractive process**. Primary colours are colours which cannot be created by mixing any other colours. For digital images and coloured light (for example, on a monitor or television) the primary colours are red, green and blue (or violet-blue) (**RGB**) which, when mixed, make white by the additive process. See **additive colour** and **digital colour**. The primary colours in printing are cyan, magenta, yellow and black (**CMYK**) and in colour photography, cyan, magenta and yellow. There have been other triads of primary colours – such as black, white and red – which have had widespread appeal over the ages. Also Aristotle's *puniceus*, *viridis* and *purpureus* – the exact hues of which are unknown. See also **secondary colours, subtractive primary colours** and **additive primary colours**.

n **primary visual cortex**

That part of the occipital lobe at the rear of the brain (referred to as V1) which receives signals from the eye via the optic nerve and dispatches them to other parts of the brain for processing including V2 and V4 which process colour information. The Nobel prizewinner Professor Roger Sperry determined in the 1960's that, of the two hemisphere's of the human brain, it is the right hemisphere which dominates in relation to the assimilation of colour. The left hemisphere is dominant as regards other disciplines such as language, maths and logic.

n **primer**

Any of the many various substances of different colours applied to a surface and serving as a base in preparation for receiving paint. See **gesso, imprimatura, pink primer, red lead**, and **size**.

c **primrose**

Pale-yellow. Also 'primrose yellow'.

n **primuline**

A synthetic yellow dye also used in the manufacture of primuline red.

n **prismatic colours**

Bright or varied colours in reference to the colours produced by a prism. Also, 'prism-hued'. See also **spectrum**. Sometimes used as an alternative expression for **primary colours**.

a **pristine**

As regards colours, pure. As in 'pristine white'.

n **Procion™**

A range of dyes developed by ICI in the 1950's providing a colourful and cheap dyestuff.

a **procryptic**

As regards animals and insects, having a coloration or other characteristics serving to protect them from predators; **camouflaged**. See also **cryptic colouring**.

n **prodigiosin**

A blood red pigment produced by bacteria called *bacillus prodigiosus* which is found in the soil.

n **Professor Plum**

The last surviving colour surname of the six original suspects in the board game Cluedo®. When first devised these were Colonel Yellow, Mr. Gold, Miss Grey, Mr. Brown and Mrs. Silver together with Professor Plum. Colour surnames vary significantly in the game dependent on the edition and the country in which it is marketed.

n **protanomaly**

A mild form of **colour-blindness** in which there is a reduced ability to appreciate the colour red and sometimes to differentiate between green, red and yellow. See **trichromacy**.

adjective a
adverb adv
a colour c
noun n
prefix pr
suffix su
verb vb

n **protanopia**

A form of **colour-blindness** suffered by 1 per cent of males in which great difficulty is experienced in seeing the colour red, and red and yellow are confused with yellow and green. Sometimes referred to as 'red blindness'. Its sufferers are referred to as 'protanopes'. See **dichromacy**.

a **pruinose**

Having a whitish **bloom** like hoar-frost.

c **prune**

The very dark purple colour of the prune – a colour popular in the 1930's.

a **Prussian**

Pertaining to colours or dye substances originating in Prussia.

c **Prussian blue**

A deep or intense blue or sometimes greenish blue also called **Royal blue**. Created by chance in Berlin in 1704, it was one of the first synthetic **pigments** and was used extensively by Canaletto in painting his skies. Also used by Gainsborough. It is called by many other names including **Berlin blue**, **Chinese blue**, **Milori blue**, **Paris blue**, iron blue and steel blue.

c **Prussian brown**

A dark brown.

pr **psaro- (G)**

Speckled.

n **pseudepisematic**

An animal with colouring enabling it to mimic its prey or its surroundings.

a **pseudoposematic**

The same as **aposematic**.

c **psyche**

A light yellowy-green.

a **psychedelic**

Having an effect (as for example by the display of bright colours) similar to that induced by certain drugs.

n **pterin**

A class of pigments providing colour in the wings of butterflies, wasps and other insects. See **xanthopterin**.

c **puce**

Variously a dull purple, a brownish purple, a pinkish blue and a dark red! Originating from the Latin *pulex* meaning 'flea' the underside of which is puce in colour.

a **puddled**

In reference to paint which fails to penetrate or be absorbed into the **colour ground**.

c **pueblo**

A deep tan colour.

c **puke**

A blackish colour once used in relation to wool and a term now unlikely to come back into fashion!

pr **pulli- (L)**

Dusky.

a **pulveratricious**

An earthy dusty colour; pertaining to those birds whose means of cleansing themselves involves rolling in the dust.

c **pumpkin**

The orange-yellow of the pumpkin.

a **punctate**

Having coloured dots.

a **punctulated**

Covered in small dots.

n **punctum, puncta (pl.)**

A very small round mark or spot of colour on an animal or other creature.

a **puniceous**

Bright red or purple; having the colouring of the pomegranate.

n **punicin**

Ancient purple dye from the whelk.

a **pure**

In relation to colours, not mixed with any other colour. Hence 'pure-coloured'.

n **Puritanism**

The movement followed by certain 16th and 17th century Protestants who believed in the simplification of religious rituals and, in particular, the rejection of the use of colour in their personal attire and in the interior of their churches.

n **purity**

As regards colour, another term for **saturation**.

n **Purkinje Shift**

See **rods**.

c **purple**

A mixture of red and blue; a symbol of rank and the colour of the robes of emperors kings and nobility. (Those next in the hierarchy would be allowed to wear colours such as gold, silver and red but the hoi polloi would not be allowed any colour exuberance in their wearing apparel!). Associated in medieval times with the Zodiac signs Virgo and Gemini and with the planet Mercury. See **Tyrian purple.**

c **Purple**

One of the 140 colours in the **X11 Color Set**. It has hex code #800080.

n **Purple Book**

See **Yellow Book**.

n **purple heart**

An illicit amphetamine.

n **Purple Heart medal**

A U.S army medal.

c **purple of cassius**

A deep purple named after the 17th century physician, Cassius.

n **purple plague**

A compound of gold and aluminium used as a stone in jewellery and displaying a vivid purple colour.

n **purple prose**

A florid over-contrived piece of writing (the integuement to which might possibly have included auxesis or hyperbole) intended to impress the reader with its elaboration. Also a brilliant piece of prose in a literary work. Probably derived from the Roman poet Horace who refers in *Ars Poetica* to *purpureus pannus* to indicate such writing. Also see 'to go through a purple patch' in **Phrases**.

c **purpled pink**

An example of a colour being used as a verb in *The Independent* (17.2.99).

a **purplish**

One of the -**ish**'s.

pr **purpur- (L)**

Purple.

n **purpura**

A blood disorder which can be confused with the purple rash indicating the much more serious meningitis infection.

a **purpuraceous**

Purple.

a **purpurate**

Coloured or covered in purple. Also in verb form, to make something purple.

a **purpure, purpureal**

Purple.

a **purpurescent**

Becoming purple.

adjective a
adverb adv
a colour c
noun n
prefix pr
suffix su
verb vb

a **purpuriferous**

Producing purple.

n **purpurin**

Purple colouring matter from the **madder** plant.

n **purpurisse**

Ancient purple or red colouring matter.

a **purpurogenous**

Yielding a purple colour.

n **purree**

An ancient bright yellow colouring matter also referred to as **Indian yellow**.

c **putty**

The muddy grey or brownish-beige colour of putty; a colour in Winifred Nicholson's 1944 'Chart of Colours'.

n **pyrite**

An iron ore producing a dark brown pigment.

c **pyrite yellow**

A dark yellow.

n **pyrometer**

An electronic instrument containing a filament the colour of which varies according to the light generated by a particular heat source (or a localised part of it) thus enabling the temperature of the heat source on which it is focussed to be accurately measured by reference to the colour of the filament. A pyrometer using optical means is called a pyrophotometer.

pr **pyrrho- (G)**

Reddish orange, flame-colour.

a **pyrrhotism**

Having red hair.

a **pyrrhous**

Reddish.

n **pyrrole**

A group of synthetic organic pigments introduced in 1988; a compound occurring in coal tar from which many colouring agents are derived including chlorophyll. See **pyrrole red**.

c **pyrrole red**

A durable red introduced as a less toxic replacement for cadmium red.

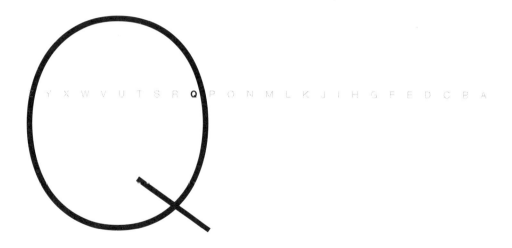

c **qerinasi**

A variant of **cremosin**.

a **quaker-coloured**

Having a drab grey colour.

n **quatre-couleur**

A technique used used to decorate objects d'art (such as Fabergé's eggs) involving an elaborate use of gold – often in four colours.

n **quercetin**

Naturally occurring yellow dye.

n **quercitron**

A natural yellow dye from the bark of the *Quercus nigra* or *tinctoria*.

n **quicksilver**

Mercury; used as the reflecting surface of mirrors.

a **quiet**

As regards colour, moderate, low key.

a **quiet-coloured**

'*The quiet-coloured eve*' Robert Browning *Love Among the Ruins.*

n **quinacridone**

A high-quality organic pigment first discovered in 1896 but not developed until 1958 producing a variety of hues including reds, violets, pinks, scarlets, crimsons, golds, yellows and oranges. Hence, in particular, 'quinacridone red'.

n **quinoline**

A colourless substance made from coal-tar and used in the production of dyes.

n **quinoline yellow**

A greenish-yellow food additive used as a colorant (E104).

adjective	a
adverb	adv
a colour	c
noun	n
prefix	pr
suffix	su
verb	vb

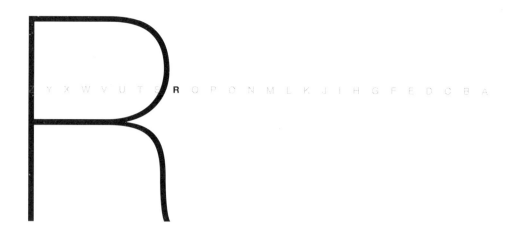

n **racing colours**

The colours worn by a jockey on his **silks** to identify the racehorse's owner.

c **racing green**

The dark green colour of the British racing car of the 1920's.

c **raddle**

A reddish brown; see **ruddle**.

vb **raddle; to**

To paint one's face with red paint or makeup; a variation of **ruddle**.

n **radiance**

Rays of light; intense light or brightness.

a **radiant**

Displaying radiance.

vb **radiate; to**

To emit light.

n **rag-rolling**

One of the decorative effects using **broken colour** and created by rubbing a crumpled rag over a surface to which a **scumble glaze** has been applied.

n **rainbow**

The seven colours of the **spectrum** (red, orange, yellow, green, blue, indigo (or blue/violet) and violet) which are visible in the sky in the shape of an arc and created by the combination of the reflection and refraction of sunlight through raindrops or mist. The colours of the rainbow are often remembered in the UK by the phrase 'Richard Of York Gave Battle Valiantly' indicating only six colours where blue and indigo are merged into one – blue/indigo. Although the rainbow contains an infinite number of hues it is traditionally recognised through the influence of Sir Isaac Newton (1642-1727) as comprising seven colours so that more realistically 'Richard Of York Gave Battle In Vain'. There are many mnemonics for the rainbow colours – 'Roy G Biv' being popular in the US. See **spectrum** and **diffraction grating**.

a **rainbow-coloured**

Having the colours of the **rainbow**; multi-coloured.

a **rainbow-like**

See **iridescent**.

c **raisin**

The dark purplish colour of the raisin verging on black.

n **Rajasthan reds**

A vivid way of describing pungent red hues along with 'Kashmir blues' and 'Topkapi greens'.

a **rambunctious, rumbunctious, rumbustious, robustious**

Having a ruddy **complexion** especially after drinking; boisterous, unruly or highly spirited. Probably from the Indo-European root '*r(e)udh*' meaning 'ruddy'.

c **ramoneur**

A sooty colour from *ramoner* (Fr) to sweep.

c **rare-ripe**

Peach-coloured.

c **raspberry**

The red or purplish-red of the raspberry; also 'raspberry-red' and 'crushed raspberry'.

c **rattan**

A light shade of brown; a medium yellow.

c **raven**

The glossy black colour of the raven; hence raven-coloured; *'raven-coloured love'* in Shakespeare's *Titus Andronicus*.

c **raven-black**

Dark black as in Shakespeare's *Sonnet no. CXXVII* 'raven-black eyes'.

a **raven-haired**

Having black hair.

n **ravenelin**

A yellow pigment from fungus.

a **raw**

As in **raw sienna** and **raw umber** referring to the absence of the need to process the earth.

n **raw sienna**

An earth or iron oxide used in its untreated state as a yellowish-brown pigment slightly darker than **yellow ochre**.

n **raw umber**

An earth used in its untreated state as a brown pigment.

n **ray**

A beam of light.

a **rayed**

Striped (obs.).

n **reactive dyes**

Textile dyes (such as **henna**) that work as a result of a chemical reaction with the molecules of the fibres, in particular, used with viscose and cotton.

n **realgar**

An orange-red pigment containing arsenic. See **Titian's colours**.

a **recalescent**

Glowing with heat.

n **receding colours**

Blues and greens on a surface that have the effect of making it appear to recede; also called **cool colours** and **retreating colours**. Compare **advancing colours**.

c **reckitt**

A **cobalt blue** after Francis Reckitt. Also a trade name of a blue used to whiten laundry.

c **red**

The colour of blood. 'Red' derives from the Indo-European root *r(e)udh* meaning ruddy and perhaps from the more immediate Sanskrit word *rudhira* meaning 'blood'. The colour of revolution and communism; of tomatoes, strawberries, fire appliances, stop lights and London buses. Of the visible **spectrum**, red has the longest wavelength, that is, within the range of approximately 760 and 630 **nanometre**s. Red is one of the three **additive primary colours**. An indicator of danger and a symbol of courage as well as revenge; associated in medieval times with the Zodiac signs Aries and Scorpio and with the planet Mars – the 'red planet'. In English folklore red represents good luck, health and happiness although it is also associated with the devil and blood and as an evil omen. See **black**. According to W B Yeats (1865-1939) red is the colour *'of magic in almost every country'*. An object which is moving away from earth shifts into the red sector of the **spectrum** whereas it moves into the blue part if moving towards us. Under the surface of water red can be distinguished as a colour up to a depth of 150 feet. The corresponding depth for yellow is 300 ft while for green, blue and violet the figure is 600 ft. Red is the colour next to the centre in archery. That part of the roulette table on which a player puts his chips if he wishes to gamble on a red number coming up. An article in the Journal *Nature* in March 2001 refers to research showing that against a green background the human eye can identify the colour red more easily than white. This facility possibly evolved as a result of the need of primates to distinguish red (and therefore riper leaves) from green

leaves and, it has been suggested, may account for the success of English football clubs who play in a red **strip.** Whereas to write to someone in red ink is regarded by some as insulting (writing in blood), in India, red is the colour of many official documents and also of personal greeting cards.

c **Red**

One of the 140 colours in the **X11 Color Set.** It has hex code #FF0000.

n **Red**

Jargon for a communist; referring to the former Soviet Union.

n **red 2G**

A red colouring agent used in food (E128).

n **red alert**

The state of maximum readiness as regards the deployment of emergency measures. Many national forces adopt a gradation often using yellow (high degree of alert), orange (extreme degree of alert) and red (maximum). Applied as regards any situation where drastic action may be required. The US air defence coding uses yellow to indicate that an attack by hostile aircraft or missiles is probable; red that an attack is imminent or in progress and white to indicate that such attack is improbable. See **bikini alert colours** and **phrases.**

n **red arsenic**

Another name for **realgar.**

a **red-blind**

Colour blind as regards the colour red and so on as regards other colours.

a **red-blooded**

Vigorous, highly-spirited, virile, full of life.

n **red-book**

Described in Stormonth's *'English Dictionary'* 1884 as the name of the book *'containing all the names of all persons in the service of the state'*. The Little Red Book is the name popularly given to the thoughts of Mao called *'Quotations from Chairman Mao Tse-tung'*.

a **redbrick**

Referring to those UK universities established during the latter part of the 19th century/early 20th century.

c **red-brown, redbrown**

Frequently found as a compound colour. Relatively few other such colour combinations occur with the same frequency although **blue-green** is common.

n **redcap**

Slang for an officer of the military police.

n **red card**

The card ceremoniously shown by a referee in football to a player sending him off for a second bookable offence. The use of the red card and **yellow card** was conceived by Ken Aston former Chairman of FIFA's referee's committee and introduced in the 1970 World Cup.

n **red cards, the**

Those playing cards in the deck consisting of the hearts and diamonds. See **black cards**.

n **red carpet**

See **phrases**.

n **red cent**

Slang for the smallest sum of money possible. See phrases.

n **redcoats**

The common term used for English soldiers at the time of the American Revolution in reference to their red jackets.

n **Red Crescent**

The symbol used by the International Red Cross in its operations in Islamic countries. It has been reported that the Red Cross is considering a third symbol – the Red Diamond – for use in those places where the Red Cross and the Red Crescent might have adverse religious or cultural connotations.

n **Red Cross**

The international association which was established in 1864 to provide medical care but which now embraces a much wider range of humanitarian causes. Its emblem, a red cross on a white background, is the reverse of the flag of Switzerland and symbolises the neutral position of ambulances and hospitals.

vb **redden; to**

To change one's facial **complexion** when becoming embarrassed, stressed or angry.

a **redder**

The comparative of red and the only palindromic colour in the English language.

a **reddish**

See -ish.

vb **reddle; to**

To paint with **ruddle**.

n **reddleman**

A purveyor of redding, reddle or **ruddle** (a red **ochre**) which was used by farmers to identify their sheep and goats; as figuring in Thomas Hardy's *The Return of the Native* (1878). See **colourman**.

n **red dwarf**

An old star.

n **Red Ensign**

The British Merchant Navy's flag with a red background and the Union Jack in the corner also referred to as the 'red duster'.

n **redeye, red-eye**

An airline flight arriving early morning so as to cause reddening of the eyes of passengers; the red effect occurring to the eyes in some photographs taken by ordinary cameras. Also US slang for alcohol.

n **red eyes**

Tony Blair's devil eyes as portrayed in advertisements published by the Tories in UK's 1997 government election. See also **redeye**.

a **red-faced**

The temporary reddening of the cheeks as a result, particularly, of embarrassment.

n **red flag**

A signal to halt; an indication of danger; a symbol of battle, communism, socialism or revolution. See also **Red Ensign**.

n **red giant**

A large star which having depleted its core hydrogen has become cool. See **blue stars**.

c **red-green**

A colour considered by the philosopher Ludwig Wittgenstein to be a logical impossibility.

n **red haematite**

An ancient iron oxide used as a pigment – see **pigment**.

n **redhead**

Someone who has red hair, particularly, a women. See **dissembling colour** and **hair-dye**. Scotland, according to the University of Edinburgh has a very high proportion of people with red hair – possibly 10 per cent of the population – while a further 40 per cent carry the redhead gene.

n **red heat**

The temperature of hot metal in the range of 500°-1,000° centigrade.

n **red herring, a**

Something which throws one 'off the scent' or misdirects one. An irrelevancey which distracts from consideration of the basic issue in hand. Shakespeare in *King Lear* refers to '*white herring*' being a fresh or pickled herring in contrast, says Onions in '*A Shakespeare Glossary*', to the red herring. This when cured had a pungent smell and was used to distract the hounds from the smell of the fox in hunting.

adjective a
adverb adv
a colour c
noun n
prefix pr
suffix su
verb vb

a **red hot**

Heated to such a temperature as to glow red (particularly as regards metal).

n **Red Indian**

An offensive term for North American Indians.

n **Red Lantern**

The last placed rider in Le Tour de France competition. See **yellow jersey**.

n **red lead**

A bright orange or red toxic pigment made from **white lead**; it has anti-corrosive properties and is used in the manufacture of protective paints and primers; also referred to as **minium. Massicot** is a by-product of red lead See also **litharge**.

n **red-letter day**

Any special day. Historically, a saints' day, a feast day or some other occasion for celebration originating from the practice of indicating festive days in church calendars in red. See **black-letter day**.

n **red-light-dependent photodynamic therapy (PDT)**

The use of red light and light-sensitising drugs to cure cancer.

n **red light district**

An area in a town where prostitutes and sex-shops are situated – a red light being a sign of a brothel.

n **red lines**

See **red route**.

n **red-lining**

The practice adopted by some insurance companies of refusing cover or increasing premiums by reference to the applicant's postcode.

n **Red Lion**

Public houses with colours in their names abound. 'The Red Lion' was (at least in the 1980's before the 'Slug and Lettuce' genre) the most common name of all pub names, however, between 1995 and 2000, 700 pubs in Greater London had name changes. The use of the red lion as a pub sign has been associated with John of Gaunt (1340-1399). Other favoured colours are 'black' (especially 'The

Black Horse'), 'blue' (which was sometimes chosen in allegiance to the Whigs) and 'green' (particularly the 'Green Man' which was associated with Robin Hood). In 1701 *The Spectator* advocated Government intervention to control 'absurd' inn signs such as the many 'blue Boars, black Swans and red Lions'. In 1999 a bill was proposed by Ann Winterton MP which would have made it illegal to change the name of any pub without obtaining planning permission and consulting local opinion. The bill failed. Plus ça change!

n **red mist**

'*the red mist descends as soon as drivers hear the roar of those amazing engines*' and '*a red mist issue*' as regards the patenting of genes (both in *The Times* of 23.6.00). Although I cannot find this phrase in any dictionary Michael Quinion, who runs *World Wide Words* on the Internet, has explained all. It refers to the red film in front of the eyes generated by extreme anger. Compare the phrase 'to see red'. *World Wide Words* refers to the use of the phrase in Rudyard Kipling's Kim: '*He was led to speak harshly by the Red Mist of Anger. That clearing from his eyes he became courteous and of affable heart*'.

n **red muscles**

Muscles of vertebrates containing large qualities of sarcoplasm rendering them red in colour.

adv **redly**

With a red hue.

n **redneck**

An offensive US term for someone who is opposed to change.

n **Red Nose Day**

The biennial British charity event forming part of Comic Relief distinguished by the plastic red noses worn by its participants and supporters. Comic Relief has raised £250m since 1985.

n **red ochre**

An ancient form of red colorant.

n **red onion**

US slang for a low class drinking joint.

n **red plague**

A form of the plague referred to in Shakespeare's *Troilus & Cressida, the Tempest* and *Coriolanus*.

n **red planet**

The planet Mars with its red appearance.

n **red route**

An urban thoroughfare in which it is illegal during particular times for traffic to stop or to park so called because of the use of red lines painted along the kerb.

n **red-sanders**

A red dye made from the Red Sandalwood tree.

n **Red Sea**

Apparently no-one knows why the Romans used the term '*Mare rubrum*' but see **cyanobacterium** and **phycoerythrin**.

n **red shift**

The phenomenon apparent in the observation of galaxies involving a shift towards the red end of the **spectrum** indicating that the galaxy is moving away from the earth. Objects which are moving towards earth give rise to a blue shift.

n **red tape**

A time-consuming procedure requiring adherence to excessively formal and bureaucratic rules. The phrase derives from the practice of tying bundles of paper with red tape as in the case of instructions sent to barristers (although the tape is pink in colour).

n **red tide**

Water containing dinophytes making it red.

n **red tops**

The daily and Sunday broadsheet newspapers in the UK including *the Sun, the Mirror, the Mail, the Daily Express, the Daily Record, the Daily Star, the News of the World, the Mail on Sunday, the Sunday Mirror, the People, the Sunday Express* and *Sunday Sport*. So called because of their red mast-heads (although *the Mirror* and *the Mail*, for example, now use a black mast-head!). Also used as an adjective as in 'red top readers'.

vb **reflect; to**

To redirect light either back to its point of origin or some other direction.

n **reflected colour**

Colour reflected from a surface.

n **refraction**

The bending of light as it passes from one medium to another, for example, when it passes through water or a prism thus separating the light into its various constituent wavelengths.

n **refulgence**

The quality of being **refulgent**.

a **refulgent**

Shining brilliantly; **radiant**; **resplendent**; **gleaming**.

c **regency cream**

Off-white.

a **relucent**

Shining brightly.

c **Rembrandt**

A yellowish-brown.

c **Rembrandt's madder**

A reddish orange.

n **reng**

Colouring for hair combining **indigo** and **henna**.

c **reseda**

Light-green or grey-green colour from the **mignonette** plant also called *Reseda luteola*.

adjective a
adverb adv
a colour c
noun n
prefix pr
suffix su
verb vb

n resist-dyeing

A method of dyeing textiles using a 'resist' such as clay or wax which is applied to selected parts of the fabric before it is put into the dye-vat – the resist preventing the absorbtion of the dye.

a resplendent

Brilliant; shining.

n resultant colour

A third colour perceived by the viewer as a result of an optical mixture of two other juxtaposed colours.

n retina

The membrane surface at the back of the eyeball which is light-sensitive.

n retina-searing colour

Used as a vivid way of describing the bright colours of the Fauvists (see **fauve**).

vb retouch; to

To change dried colour.

n RGB

An acronym standing for the three **primary colours** red-green-blue which, as radiated light, can be mixed to produce any other colour. A combination of the three produces white light by the **additive process**. RGB is used for computer displays while the **CMYK** system is used to provide the hard copy. One of the difficulties in this is to find an effective means of converting the colour on the screen (produced by RGB) into a faithful representation in print (produced by CMYK).

n rhabdom

A light sensitive **rod** in the eyes of certain insects.

n rhamnus

An ancient yellow Middle Eastern dye made from berries.

n rhodamine

A class of synthetic dyes mainly producing red; colours include rhodamine pink.

pr **rhodo- (L)**

Rose.

n **rhodopsin**

A red photoreceptive pigment in the **rods** of the eye enabling colours to be detected and distinguished. See **cones** and **iodopsin**. Also called 'visual purple'.

n **rhodospermin**

The red colouring matter of certain red algae.

c **rhubarb**

The yellowish-brown colour of rhubarb.

n **riboflavin**

A yellow or orangey-yellow colouring matter used in food (E101). Also vitamin B2.

a **rich**

As regards colours, fully saturated or deep.

a **rich-coloured, richly-coloured**

Having deep fully-saturated colours.

c **rifle green**

The dark greyish green colour of the constabulary uniform worn by certain light infantry rifle brigades of the British army in the 19th century, for example, the distinguished Rifle Brigade of Wellington's army – nicknamed 'The Grasshoppers' by the French.

c **Rinmann's green**

See **cobalt green**.

a **risque**

Off-colour.

c **roan**

Reddish-brown; chestnut, sorrel; a dark hue with shade of red; as regards animals, particularly horses, a varied colour predominantly red but mixed with white and grey.

c **Robin's egg blue**

A light greeny blue colour with brown flecks resembling the egg of the Robin and used as a ceramic glaze.

n **roccellin**

A red coal-tar colour used as a dye.

n **rods**

Rods are extremely sensitive cells at the back of the retina of the eye which absorb light – each human eye containing 120 million rods. Rods contain the pigment **rhodopsin** and respond to dim light whereas **cones** are less light sensitive and respond only to brighter light. When light reaches the rhodopsin the molecules of the pigment release a chemical which transmits a message to the brain. As sunlight gradually replaces night the cones slowly replace the rods as the receptors of light. We experience this adjustment in our vision (called the 'Purkinje Shift' after the physiologist J E Purkinje (1787-1869)) when going into sunlight from a darkened room (and vice versa). Rods are sensitive only to light so that we cannot see colour when it is dark.

a **Roman**

As applied to colours and pigments such as Roman ochre, Roman Lake and **Roman Brown**.

c **Roman Brown**

A copper colour also called **Hatchett's Brown**.

pr **ros- (L)**

Rose.

n **rosacea**

A chronic form of acne in which the nose becomes excessively reddened. In advanced form it is called rhinophyma.

n **rosaniline**

A red dyestuff derived from **aniline** known as **magenta**.

c **rose**

A light crimson colour or red; pink.

n **rosé**

Wine with a pink or light red tint achieved by taking colour from the skin of black grapes or from blending white with red wine.

a **roseate**

Bearing the reddish or pinkish colours of roses; rosy, rose-coloured.

c **rose bengal(e)**

A purplish red; a stain used in eye testing to highlight dry areas.

c **rosebud**

A light pink.

a **rose-coloured**

Having the pinkish red colour of a rose.

c **rose doré**

The same as **rose madder**.

c **roseine**

The trade name for the purple dye **aniline red**. See also **magenta**.

c **rose madder**

A purplish red colour originally derived from the **madder** plant.

c **rose marie**

A deep pink or purplish pink; also rose **Pompadour** and rose du Barry – both pinks.

c **rose pink**

Either a strong pink or a purplish pink or more commonly a light red pink. See **English pink**.

c **rose-red**

A vivid red.

c **roset**

A reddish or rose lake pigment made from the Brazil tree.

adjective a
adverb adv
a colour c
noun n
prefix pr
suffix su
verb vb

a **rose-tinted**

Having the pinkish red colour of a rose.

c **rosewood**

The deep reddish brown colour of polished rosewood.

c **rose-wood brown**

Reddish brown.

a **rosiny**

Having the colour or other qualities of resin.

c **rosy**

The pinkish red colour of roses.

c **RosyBrown**

One of the 140 colours in the **X11 Color Set** used for the design of websites. It has hex code #BC8F8F.

n **rosy-fingered**

Homer's normal epithet for the dawn in the Iliad and Odyssey.

n **rottlerin**

A natural salmon-coloured pigment.

n **roucou**

Brazilian tree yielding an orange or red dye; also called **anatta**.

n **rouge**

A powder used by jewellers (see **jeweller's rouge**) and as theatrical rouge made from **colcothar**; the red powder made from **safflower** used to add colour to the face; red **make-up** mainly used to redden or add colour to the cheeks and often made from **carmine**.

c **royal blue**

A dark blue colour made from **smalt**.

c **RoyalBlue**

One of the 140 colours in the **X11 Color Set**. It has hex code #4169E1.

c **royal purple**

A dark purple.

c **royal yellow**

A rich yellow.

a **rubedinous**

Reddish.

n **rubefacient**

Something which causes the skin to redden.

c **Rubens brown**

A brown **ochre**.

a **rubent**

Red (obs.).

a **rubescent**

Reddening, blushing; turning red.

pr **rubi-, rubr- (L)**

Red.

n **rubia**

The ancient pigment **madder**.

n **rubiacin**

An orange or yellow dye from the **madder** plant.

n **rubiate**

Indicating dyes made from the **madder** plant.

c **rubican**

Greyish black.

a **rubicund**

Red; inclining towards redness.

a **rubied**

Having the colour of **ruby**.

a **rubiferous**

Red.

a **rubiform**

Red.

vb **rubify; to**

To redden.

pr **rubigin- (L)**

Rusty.

a **rubiginous**

Having the reddish-brown colour of rust.

a **rubine**

Ruby-coloured.

a **rubineous**

Ruby-coloured.

a **rubious**

Ruby-coloured. *'Diana's lip is not more smooth and rubious'* Shakespeare's *Twelfth Night* Act 1 Scene 4.

n **rubor**

Redness.

n **rubric**

A red earth or **ochre**; a heading or entry to a piece of writing or a manuscript originally so called because these were frequently in red. Also as an adjective indicating that something is written or printed in red.

a **rubrical**

Marked with red.

vb **rubricate; to**

To mark with red.

a **rubriform**

Red (obs.).

c **ruby**

A rich red with a blue tint; hence 'ruby red'.

n **ruddle, reddle, raddle**

Red **ochre** or red **chalk**; crayon used in drawing and produced from red iron **ochre** and clay. See **reddleman**.

vb **ruddle; to**

To make red with **ochre**.

a **ruddy**

Reddish.

a **rufescent**

Reddish; turning red.

pr **rufi- (L)**

Red.

a **ruficarpous**

Having red fruit.

a **ruficaudate**

Having a red tail.

a **rufous**

Brownish-red.

a **rufulous**

Brownish-red.

n **rushlight**

The light of a rush candle.

adjective a
adverb adv
a colour c
noun n
prefix pr
suffix su
verb vb

c **russet**

The colour of autumn; a shade of reddish-brown. From the course common cloth of the same name, hence the use of the word in the phrase '*russet yeas*' from Shakespeare's *Love's Labour's Lost* does not refer to the colour, but means 'simple' or 'homespun'.

c **Russian blue**

A light blue.

c **rust**

Reddish-brown.

c **rust brown**

Reddish-brown.

c **rusty**

Having the colour of rust; discoloured or faded.

a **rutilant**

Glowing with a ruddy or golden light; shining; brightly coloured in yellow, red or orange.

a **rutile**

Shining red.

n **rutile**

A form of **titanium dioxide**.

a **rutilous**

Having a shiny red colour.

n **rya**

The colourful pattern followed in the making of the handwoven Swedish rug of the same name.

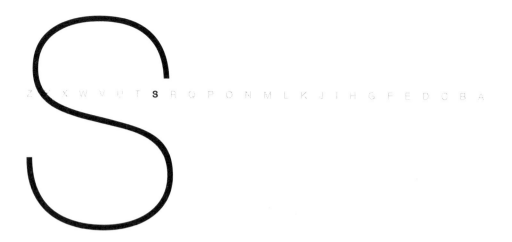

n **s'graffito**

The technique of scratching away oil colour to produce a textural effect or to designate an outline. Sometimes referred to as 'scratching out' or 'scraping back'. Also used in watercolour painting.

a **sabelline**

Having the dark brown colour of the fur of the small carnivore, the **sable**.

c **sable**

A poetic word for black and used particularly in heraldry; 'sable-coloured melancholy' Shakespeare's *Loves Labours Lost* Act 1 Scene 1. However, curiously the fur of the sable is brown. Also used to describe a yellowish brown colour.

n **SAD**

See **seasonal affective disorder**.

a **sad**

Dull, dark.

a **saddle-coloured**

Having a tanned **complexion**.

c **SaddleBrown**

A dark brown – one of the 140 colours in the **X11 Color Set**. It has hex code #8B4513.

n **safety colours**

Those colours used in conjunction with various symbols, pictograms and signs designed to draw attention to health and safety hazards and to provide information and guidance particularly in the workplace and in public areas. Red is customarily used on signs containing prohibitions or indicating danger or the location of fire-fighting equipment. Blue is used on mandatory signs (such as '*Wear ear protectors*'); yellow is often used on warning signs ('*Danger Guard Dogs*') and green appears on signs which indicate emergency exits and items such as first-aid boxes. There are many standards including those laid down in European Directives and, in the UK, the British Standards Institute ('BSi'). Standards are also set by many organizations including the International Organization for Standardization ('ISO') and the European Organization for Nuclear Research ('CERN') which, for example, requires visible pipes to be colour-coded as follows: green – for pipes carrying water, light blue – air; silver-grey – steam; brown – flammable oils/liquids; white – oxygen; amber – other gases; purple – acids; and black – bases.

n **safflower**

A plant whose petals were used to make red dye. A drying oil used to alter the consistency and drying time of oil colours.

c **saffron**

An orangey-red colour or deep yellow.

n **saffron**

A yellowish-orange colorant made from the crocus.

n **safranine, safranin**

The yellow colouring matter of **saffron** (also referred to as **polychroite**) produced from the **safflower**. Now refers to a red or yellowish-red coal-tar dye used on wool and silks.

c **sage-green**

The greyish or yellowish green colour of the leaves of the sage plant.

adjective a
adverb adv
a colour c
noun n
prefix pr
suffix su
verb vb

c **sage-grey**

A greyish olive colour.

c **Sahara**

A shade of brown; also 'Sahara sand colour'.

c **sallow**

Light olive green.

a **sallow**

As regards the **complexion**, a yellowish colouring; pale.

c **salmon**

The orange-pink colour of the flesh of the salmon.

c **Salmon**

One of the 140 colours in the **X11 Color Set**. It has hex code #FA8072.

c **salmon pink**

A deep pink.

c **salmon red**

An orangey-red.

c **sand**

A light yellowy-grey.

c **sandalwood**

A reddish brown.

a **sanded**

Having the colour of sand. Shakespeare's *Midsummer Night's Dream* Act 4 Scene 1. '*My hounds are bred out of the Spartan kind, So flewed, so sanded*'.

c **Sanders blue**

See **verditer**.

c **sandstone**

A reddish brown.

a **sandy**

Having the colour of sand.

c **SandyBrown**

One of the 140 colours in the **X11 Color Set**. It has hex code #F4A460.

c **sang-de-boeuf**

A deep red colour particularly used as a glaze for old chinese porcelain. Literally, 'oxblood'.

c **sang-de-dragon**

See **dragon's blood**.

pr **sangui-, sanguini- (L)**

Blood-red, blood.

c **sanguine**

Blood-red.

n **sanguine**

A red crayon containing iron oxide; also a drawing produced with the use of such crayons.

a **sanguineous**

Having the colour of blood.

a **sanguinolent**

Having the same colour as blood.

n **santalin**

The chemical which gives sandalwood its red colour.

c **santaupe**

A light pinkish grey.

n **sap colours**

Pigments made from vegetable juices such as **sap green**.

c **sap green**

A yellowy green colour originally made in medieval times from the berries of the buckthorn bush. Modern sap green oil paint is usually a coal tar lake.

c **sapele**

The reddish-brown of the wood of the same name when it has been polished.

c **sapphire**

A brilliant blue after the precious stone of the same name. Hence, the adjective 'sapphirine'.

a **sarcoline**

Flesh-coloured.

c **sard**

Deep orange-red – the colour of a form of **chalcedony** of the same name.

c **sarplier**

Possibly derived from a Greek word meaning the colour of withered vine leaves (see **feuillemorte**).

a **saturated**

As regards colour, refers to the purity or amount of white light mixed with a particular **hue**. The most saturated colours contain no white light. Lavender (a mixture of violet and white) and pink (a mixture of red and white) are low saturated colours.

n **saturation**

The intensity or purity of a **hue**; the extent of its colourfulness; the strength or richness of a colour indicating whether it is vivid or dull. The colours of the greatest purity are those in the **spectrum**. A colour with a very low purity is on the verge of becoming grey. The measure of the amount of colour in a particular shade is measured on a scale so that a saturation of 0 indicates an absence of colour whereas a saturation of {240} produces the maximum and brightest colour. The degree of saturation can be indicated by reference to a large number of adjectives including: brilliant, dark, deep, dull, dusky, faint, light, medium, moderate, pale, strong, weak and vivid. Saturation is referred to in some systems of colour notation as 'chroma' or 'intensity' and was first used in relation to the process of dyeing textiles.

c **savannah**

A light brown.

c **saxe blue**

A light blue produced from **Saxon blue**; a greyish blue colour. Also referred to simply as 'saxe'.

n **Saxon blue, Saxony blue**

A blue dye made from **indigo**.

c **scarlet**

A bright orange-red; the colour of the clothing of people of importance in the Bible, for example, Saul (II *Samuel*, i: 24) and hence an indication of royalty or pre-eminence. Scarlet, it is thought, was originally the name of a type of rich cloth – many colours originate from the name of the cloth normally bearing that colour – see **perse**.

adjective a
adverb adv
a colour c
noun n
prefix pr
suffix su
verb vb

n **Scarlet day**

A day on which ceremonial gowns or robes are worn. According to Cambridge University rules, only black and scarlet gowns could be worn on a Scarlet day, but the rule was changed in 1998.

n **scarlet fever**

An infectious disease characterised by a scarlet rash; also known as scarlatina.

n **scarlet lady (woman)**

An abusive term for a prostitute or woman of low morals.

n **scarlet thread**

The thread used to indicate that, of Judah's twins, Zerak rather than Perez was the first born. Although Perez was the first out of the womb, Zerak had shown his hand first. *Genesis* xvii: 28,30. Hence the scarlet thread is an allusion to primogeniture.

n **scattering**

The phenomenon which gives rise to the sky appearing to be blue in colour – blue light being created as a result of sunlight passing through earth's atmosphere.

c **Scheele's green**

A toxic yellowish green pigment discovered in 1775 by the Swede Carl Scheele (1742-1786) and used in paint and in colouring wallpaper. Also called **mineral green**.

n **schiller**

A lustre particularly as applied to certain minerals.

a **schistaceous**

Of the colour of slate.

a **schistous**

A shade of blue.

c **Schweinfurt(h) green**

See **emerald green**.

n **sciagraphy, skiagraphy**
Shadow-painting; painting only the outline or shadow of an object.

a **scialytic**
Casting shadows.

n **sciamachy**
A fight with an imaginary foe – literally a fight with a shadow.

n **sciaphobia**
The fear of shadows.

a **scintillant**
Scintillating.

vb **scintillate; to**
To sparkle.

a **scintillating**
Twinkling, sparkling, emitting flashes of flight.

n **scintillation**
A spark of light.

n **sclererythrin**
A red colouring agent.

c **Scotch blue**
A dark purplish blue.

c **Scotch grey**
A green shade of grey also called olive grey.

pr **scoto- (G)**
Darkness.

n **scotograph**
An instrument for writing in the dark. Hence 'scotography'.

n **scotophobia**

The fear of darkness.

n **scotopia**

The ability of the eyes to adapt to dim light. See **photopia**.

n **scumble glaze**

An oil medium, which can be either clear or coloured, to which a variety of **broken colour** processes may be applied to produce a decorative effect.

vb **scumble; to**

To soften dry colour by applying a layer of opaque colour or glaze over it; also as a noun, the stain or glaze itself. Hence, 'scumbling'.

c **sea-green**

A clear bluish-green; a yellowish-green; a colour in the **Ostwald Circle**.

c **SeaGreen**

One of the 140 colours in the **X11 Color Set**. It has hex code #2E8B57.

c **seal**

Dark brown.

a **searing**

As regards colours, (particularly red), having the appearance of scorching or burning.

c **Seashell**

A light brownish grey colour – one of the 140 colours in the **X11 Color Set**. It has hex code #FFF5EE.

n **seasonal affective disorder ('SAD')**

A medical condition the symptoms of which include depression and lethargy and the treatment for which is exposure to full-spectrum light. Light is used to treat many other conditions including cancer. See **colour therapy**, **photodynamic therapy**.

c **seaweed green**

A yellowish green.

a **sebaceous**

Having a resemblance to **tallow** in colour.

n **secondary colours**

As regards surface colour, violet, orange and green each being colours resulting from the mixture of two of the **primary colours**, namely, red and blue, red and yellow and yellow and blue respectively. In each case the excluded colour is the complementary. Hence, violet is the complementary of the excluded primary, namely, yellow; orange is the complementary of blue and, finally, green is the complementary of red. See **complementary colours**. Further mixing can produce **tertiary colours** and quaternary colours. In coloured light, green is a **primary colour** whereas yellow is a **secondary colour**.

a **see-through**

Transparent.

c **selenium**

A light-sensitive chemical element used in photoelectric cells and photocopiers and taking various forms including a red powder.

a **self-black**

Naturally black – that is not as a result of being dyed.

n **self colour**

A uniform or natural colour.

a **self-coloured**

Having only one uniform colour.

a **sematic**

Those colourings or markings of animals (for example poisonous animals) which serve as a warning.

a **semi-opaque**

A surface which is partially transparent. See **opaque**.

adjective a
adverb adv
a colour c
noun n
prefix pr
suffix su
verb vb

n **semi-permanent**

A **hair-dye** which remains effective for about 6 to 8 washes. A 'tone on tone' is a form of semi-permanent process lasting for perhaps 16 washes. A 'wash-in-wash out' is a temporary water-based rinse. See **permanent** and **colour-fade**.

n **sempervirent**

Evergreen.

c **sepia**

Reddish dark brown originally prepared from ink of the cuttlefish and used as a replacement for **bistre** from the 18th century.

a **septicoloured or septi-coloured**

Having seven colours. Oddly, there does not seem to be a word in current usage to indicate six coloured items. See **bichrome**, **pentachromic**, **tetrachromatic**, **tricoloured**, **trichromatic**, **two-coloured** and **two-tone**.

a **sere-coloured**

Parti-coloured.

c **Sevres blue**

A deep blue.

n **sfumato**

As regards paintings and drawings, subtle gradations from dark to light.

n **shade**

A colour to which has been added black or any other dark hue (often the colour's complementary) produces a shade of that colour.

n **shading**

The act of comparing rolls of wallpaper to make sure they are all of the same shade.

n **shadow**

An area of comparative darkness caused by something blocking off direct sunlight.

n **shaft**

In relation to light, a beam or ray.

c **shammy**

The yellowish-brown or fawn of shammy leather.

n **sheen**

Lustre, **shine**, **radiance**.

a **sheep-hued**

Having the colour of sheeps' fleece.

a **sheer**

As regards colours, pure, unadulterated.

n **shellac**

A resin from the lac insect which is used in inks and paints to aid water resistance and to provide a glossy finish. See **lacquer**.

c **shellfish-purple**

A shade of purple which Gage in his '*Colour and Meaning*' says was associated in the Middle Ages with **puniceus** (see **primary colours**).

a **sherry-coloured**

Having a brown colour; '*sherry-coloured eyes*' used in Galsworthy's *Man of Property*.

n **shikonim**

A natural bronze-coloured pigment.

vb **shimmer; to**

To gleam.

a **shimmering**

Glistening, emitting a flickering light.

n **shine**

Brightness, lustre.

vb **shine; to**

To emit light.

a **shining**

Emitting light, beaming, glistening.

a **shiny**

Having a glossy, lustrous or burnished surface; bright.

c **shocking pink**

A garish variety of pink.

c **shoe grey**

Presumably the grey of grey leather shoes.

a **shot**

Many-coloured.

n **shot**

Usually descriptive of silk woven with the warp and weft having different colours.

c **shrimp**

A vivid pink colour.

n **siderite**

An iron ore producing a brown pigment.

c **sienese drab**

A reddish-yellow brown.

c **sienna, siena**

A brown hue with a reddish or yellowish tinge but orange-red or reddish-brown when burnt. All sienna colours are named after *Siena* in Tuscany, Italy – but spelt 'Sienna' in English. The name of the earth from which the colour is derived is called 'terra di Sienna'.

c **Sienna**

One of the 140 colours in the **X11 Color Set**. It has hex code #A0522D.

n **sienna**

An earth used in its natural state as a yellowish-brown pigment; see also **raw sienna** and **burnt sienna**.

c **sienna brown**

Cocoa colour.

c **signal red**

A vivid red. Coloured lights are now used extensively on railway systems all over the world as warning signals in preference to semaphore signals which can take the form of either coloured flags or mechanical arms operated by signal boxes. A red signal usually requires a train driver to stop; yellow (or in some countries, amber) to slow down or to proceed with caution and green to proceed. The Automatic Warning System (AWS) used on the UK railway network warns the driver by ringing a bell when a green signal is passed and a klaxon if he passes a red signal. The Train Protection Warning System (TPWS), a variant of AWS, is gradually replacing it in the UK but neither system is as effective in avoiding accidents as the computerised Automatic Train System (ATP) which can automatically halt a train going through a red signal.

c **signal yellow**

A colour once popular with the makers of motor cars possibly because yellow vehicles are, apparently, less often involved in accidents than vehicles of other colours.

n **signature colour**

A distinctive colour which is particularly characteristic of an artist or designer and often serves to identify him or her. See, for example, **Cherokee red** and Turner's use of **yellow**.

c **sil**

An ancient mineral which came to mean yellow and later violet or blue.

n **silk colours**

Pigments specially created for decorating or painting silk.

c **silk green**

A yellowish green.

n **silks**

The cap and the coat or jacket worn by a racehorse jockey bearing the colours of the racehorse owner. See **racing colours**.

adjective a
adverb adv
a colour c
noun n
prefix pr
suffix su
verb vb

n **Silurian**

Paper on which is found two contrasting colours.

c **silver**

The lustrous colour of the precious metal – hence 'silver-coloured'. Associated in medieval times with the Zodiac sign Cancer and with the Moon. According to Godfrey Smith in *'Beyond the Tingle Quotient'* this is one of the most beautiful words in the English language. Other words considered by him as beautiful are 'gossamer', 'dawn', 'twilight', 'golden' and 'mist'. The name given to one of the E food additives (E174) providing a metallic surface colour.

c **Silver**

One of the 140 colours in the **X11 Color Set.** It has hex code #C0C0C0.

c **silver grey**

A bluish-grey.

n **silver jubilee**

A twenty-fifth anniversary. The term 'jubilee' is used for any grand celebration marking the passage of 25 years or more although it derives from the Hebrew *'yovel'* which indicated a 50TH anniversary. Queen Victoria highjacked the word 'jubilee' for the celebrations of her 60TH anniversary on the throne in 1897 which was described as her '60th Jubilee' to distinguish it from her 50th anniversary which had previously merely been called 'the Jubilee' – '50th Jubilee' then being a tautology.

n **silver-leaf**

Silver which has been beaten thinly.

a **silverly**

Having the appearance of silver.

n **silver medal**

The prize for second position in a competition. See **gold medal**.

a **silvern**

Made of silver.

n **silver-plate**

Tableware and other utensils made of silver.

n **silverpoint**

A drawing made on specially prepared paper using a silver pencil. The technique originated in Italy in the Middle Ages.

n **silver screen**

A cliché for the cinema; or the cinema screen.

n **Silver Stick**

The commanding officer of the Household Cavalry. He has ceased since 1998 to appear at the Queen's State opening of Parliament although Gold Stick in Waiting, the Colonel of the Household Cavalry, will continue to be present.

n **silver surfer**

A euphemism for the elderly. According to an internet poll reported in *The Evening Standard* (16.3.00) the elderly prefer being referred to as 'wrinklies'. Next in popularity comes 'silver surfer' followed by 'golden ager'.

n **silver-tongued**

Eloquent.

n **silverware**

Cutlery and other tableware made from silver or silver-plated.

n **silver wedding**

A twenty-fifth wedding anniversary.

c **silver-white**

White lead used as a pigment; the same as **Cremnitz white**; '*lady-smocks all silver-white*' Shakespeare's *Love's Labour's Lost Act 5 Scene 2*. See **flake-white**.

a **silvery**

Having the appearance or sheen of silver.

n **simple colours**

The colours blue, red and yellow were, according to the chemist and philosopher Robert Boyle (1627-1691) and the artist Christof le Blon (1670-1741), the three 'simple' colours. It was le Blon who considered that all colours could be derived from this triad and who first made the vital distinction between coloured light and pigment colour. See **subtractive process** and also **essential colours**.

n **simultaneous contrast**

The phenomenon occurring when certain colours (particularly **complementary colours**) juxtaposed in certain conditions (for example, in small uniform patches) produce the appearance of another colour or cause each other to be intensified.

c **sinoper, sinople, sinopia, sinopite, sinope, sinopis, sinopic**

An ancient light red **ochre** or **earth** used as a **pigment** originating from the Black Sea city in Paphlagonia, Greece (but now in Turkey) known as Sinop. Sinop has had many names including Sinopë and Sinopis by which the earth also became to be known. 'Sinoper' by extension was used to indicate the colour red, however, such is the inconstancy of ancient colourwords that sinople until the 15th century also referred to the colour green – particularly in heraldry. The Greeks painted their ships in many colours including in particular sinopic red. Sinopia also means the initial rough sketch (using the reddish brown colour of sinoper) used to prepare frescoes. Sometimes also referred to as **cinnabar**. See also **miltos** and **Venetian red**.

c **sinople green**

A shade of green particularly in heraldry but see previous entry.

n **size**

A dilute solution applied to prime canvasses, panels and other supports to inhibit the absorption of paint or oil. Also used as a **medium** in **watercolour** painting.

n **sketch**

An outline drawing.

c **skewbald**

Describing horses coloured with patches of white and some other colour, but not black – a horse with white and black patches being described as **piebald**.

n **Skiapodes**

Mythical folk from Libya with huge feet used to provide shade from the sun.

c **sky**

Light blue.

c **sky blue**

A light blue. The sky appears blue because the blue end of the sun's rays are gradually filtered as they reach earth causing a scattering of blue light.

c **SkyBlue**

One of the 140 colours in the **X11 Color Set**. It has hex code #87CEEB.

c **sky-colour**

The blue of the sky. See **sky blue**.

a **skyey**

Like the sky in colour.

n **skyglow**

The faint colour of the sky at night resulting from the reflection of the sun on the dust in space.

n **skyrin**

A natural dark orange pigment.

vb **slaister; to**

To paint or add colour in a vulgar manner, particularly as regards the application of **make-up**.

c **slate**

A dark bluish-grey resembling that of slate.

c **SlateBlue**

One of the 140 colours in the **X11 Color Set**. It has hex code #6A5ACD.

adjective a
adverb adv
a colour c
noun n
prefix pr
suffix su
verb vb

a **slate-coloured**

The bluish-grey of slate.

c **slate grey, slate-grey**

The colour of grey slate. A dark grey.

c **SlateGray**

One of the 140 colours in the **X11 Color Set**. It has hex code #708090.

c **sludge-green**

A deep blackish green.

a **sludgy**

Having the colour of sludge.

c **smalt**

A blue colour sometimes referred to as a pale colour but more often a deep blue. The pigment was made from pulverised glass called smalt which had been coloured by means of cobalt oxide. Used extensively in the 16th and 17th centuries as a blue pigment, but subsequently replaced by ultramarine.

c **smaragdine**

Emerald green.

n **smear**

A smudge or a dirty mark.

c **smoke**

A bluey-grey.

c **smoky**

The grey colour of smoke.

a **smouldering**

Used to describe colours as in 'smouldering scarlet' in the description of the shrub the Camellia.

n **smudge**

A dirty mark, stain or blot.

n **smut**

Soot; black spot.

c **smutty**

The dark sooty colour of smut.

n **snip**

As regards horses, a white spot on the muzzle.

n **snooker balls**

In snooker the white ball is the struck ball. The point score for potting the colours is – red 1, yellow 2, green 3, brown 4, blue 5, pink 6 and black 7.

c **Snow**

One of the 140 colours in the **X11 Color Set**. It has hex code #FFFAFA.

n **Snow White**

See **zinc white** (and the friend of the seven dwarfs Bashful, Doc, Dopey, Grumpy, Happy, Sleepy and Sneezy).

c **snowy**

The colour of snow – pure white. Also used to describe whiteness as in 'snowy-white'.

a **snuff-coloured**

Having the brown or yellowish-brown colour of snuff; also 'snuff-brown'.

a **sober-coloured**

Dark-coloured; shabby.

n **Society of Dyers & Colorists, The**

Founded in 1884 it promotes the advancement of Colour Science.

n **sodium lights**

More properly 'sodium-discharge lamps'. Used extensively in street lighting because they are very cost-effective.

a **soft**

In relation to colour, subdued. Hence, softened.

n **soft colours**

See **cool colours**.

a **soft-focussed**

Descriptive of film or photographs where the image has been blurred or muted to create a particular effect.

n **solar orange**

The orange colour of sunlight as perceived by the Impressionist painter George Seurat (1859-1891) and hence the colour of the dots interspersed by him in painting green grass in the light of the sun.

n **solar spectrum**

The range of visible light shown in a rainbow or reproduced by sunlight shining through a prism. See **spectrum**.

c **solferino**

The bright bluish-red or crimson dye discovered in Italy after the battle of Solferino in 1859.

n **Solution to blue-green crossword problem**

See **blue-green**: 'adult'.

n **Solution to coloured hat problem**

See **coloured hat problem 1**. If No.1 sees that No.2 and No.3 are wearing hats of the same colour he will know that his hat must be of the other colour and would be expected to speak out. However, if No.1 is silent No.2 will know from that silence that No.2's hat cannot be the same colour as No. 3's so that No. 2 can. in that event, immediately announce the colour of his own hat – the colour contrary to that of No.3.

n **solvent**

A chemical used to dilute oil paints and to clean brushes.

a **sombre**

As regards colours, dull or dark; having a gloomy aspect.

a **sombrous**

As regards colour, having a sombre effect.

n **son et lumière**

A staged production at night often at an historic sight and consisting of an illuminated spectacle with narration and/or music.

c **sooty**

Black in colour; having a similar colour to soot.

c **sorbier**

A dark burgundy.

c **sorrel**

Reddish-brown, particularly in reference to horses.

a **spadiceous**

Reddish-brown; having the colouring of the fruit, the date.

a **spangled**

Covered with glittering points of light.

a **Spanish**

Indicating pigments or colours considered to originate in Spain.

n **Spanish black**

A black pigment made from calcined cork.

n **Spanish ferreto**

A reddish-brown pigment. See **Venetian red**.

c **Spanish red**

A bright red.

n **Spanish red oxide**

A bright red pigment used for staining and made from iron oxide.

adjective a
adverb adv
a colour c
noun n
prefix pr
suffix su
verb vb

c **Spanish white**

Whiting; also called Paris white.

vb **sparkle; to**

To glisten or to scintillate.

a **sparkling**

Discharging bright points of light.

n **spattering**

The technique of flicking paint onto a surface to create a particular effect such as the appearance of sand.

n **speck**

A small spot of colour.

n **speckle**

A small spot of colour.

a **speckled**

Bearing small spots or marks of colour especially as regards birds.

n **spectra**

The plural of **spectrum**.

a **spectral**

Relating to the **spectrum**.

n **spectral colour**

The colours of the **spectrum**, namely, those seen when **white light** is passed through a **prism**. See **primary colours**.

n **spectrometer**

An instrument for studying the **spectrum** of a light source.

n **spectrophotometer**

An instrument used to measure the intensity of colour.

n **spectroscopy**

One of several techniques for measuring and assessing the colour of a pigment including EDX (energy-dispersive X-ray analysis), microspectral analysis and FTIR (Fourier-transform infrared). Another technique called 'Raman micro probe spectroscopy' has been used to examine the chemical components of the ink used in the Vinland Map and to prove it a fake thus discrediting the theory that the Vikings reached North America before Christopher Columbus.

n **spectrum**

The range of colours produced by the dispersal of white light through a prism – first explained by Sir Isaac Newton (1642-1727). The colour spectrum is a continuous band of merging colours the divisions of which depend on the speed at which the colours comprising white light travel through a prism – red light, for example, having the longest wavelength, thus passes through a prism more quickly than colours with shorter wavelengths. The colour spectrum extends from invisible **infrared** passing through the seven visible colours of the **rainbow** (red, orange, yellow, green, blue, indigo and violet) and ends with the invisible ultraviolet.The colour spectrum always displays itself in the same fashion whether in the spray of a water fountain, in a crystal glass, through a prism or in the rain. The full electromagnetic spectrum embraces many different kinds of energy from radio waves, microwaves, radar, **infrared** light through to **ultraviolet light,** X-rays, and other short wavelength high energy radiation such as gamma rays. Apparently, bees' vision embraces ultraviolet light and owls can see into the infrared part of the spectrum.

a **spicy**

'spicy colours' *The Times* (12.3.99).

c **spinach green**

Olive green or a yellowish green.

c **spinel red**

The scarlet or purplish red colour of the precious stone of the same name similar to the ruby.

n **spirit colour**

Pigment mixed with a very thin application of fluid and formerly used as a varnish; colours or dyes such as 'spirit-blue', 'spirit-yellow' and 'spirit-brown' made from a tin solution.

a **splendent**

Brilliant.

n **split complementary colours**

In relation to any colour on a **colour wheel**, those two colours which are either side of its complementary the three together making a pleasing triad of colours.

vb **spot; to**

To mark with spots.

n **spot**

A small mark.

n **spotlight**

A lamp casting a strong focussed beam;.

a **spotted**

Having spots of colour or similar markings.

n **spraing**

A highly-coloured **streak**.

a **sprainged**

Marked with coloured **streaks** or **stripes** (obs.).

c **spray**

A light bluish green.

a **spring**

An adjective used in the fashion trade to describe those colours considered to be appropriate for wear in spring and in colour psychology to classify and differentiate between certain colour tones in their appropriateness for different personality types.

c **spring green**

The yellowy-green of young leaves.

c **SpringGreen**

One of the 140 colours in the **X11 Color Set.** It has hex code #00FF7F.

c **spruce**

Variously a shade of mauve, a yellowish green, a grey-green and a dark green!

n **stain**

A chemical compound used in laboratory work.

vb **stain; to**

To colour something chemically; to soil clothing, carpet etc accidentally. Scientists at the University of California have found that the popular method of using salt or white wine to remove red wine stains was the least effective of the methods tested. A mixture of hydrogen peroxide and liquid soap was far more effective.

n **stained glass**

Coloured glass stained in the process of manufacture and used for decorative effect especially in windows. To be contrasted with painted glass. Stained glass was often painted to add further colour.

n **staining pigment**

A transparent **watercolour** pigment which cannot be removed from the painted surface without leaving some of its colour.

c **stammel**

The red colour of the coarse cloth of the same name once used in making undergarments; the dye itself used in making such cloth.

a **stark**

As regards colours, dark.

n **startle colours**

The vivid colours on animals or insects intended to frighten predators and sometimes revealed on their approach.

c **steel blue**

A greenish or greyish blue with a resemblance to the colour of steel. Another name for **Prussian blue.** See also **Steel Blue.**

c **SteelBlue**

One of the 140 colours in the **X11 Color Set**. It has hex code #4682B4.

| adjective a |
| adverb adv |
| a colour c |
| noun n |
| prefix pr |
| suffix su |
| verb vb |

c **steel grey**

A dark grey. Also 'steel-black'.

n **stencil**

A painting or drawing created by applying colour to a surface which is masked by paper cut to a particular design so that the result is the shape of that design. The cut-out itself.

n **stercobilin**

The colouring agent in urine and fæces.

pr **stigmato- (G)**

Spotted.

c **stil de grain**

A bright yellow lake; the pigment itself.

a **stippled**

Covered with spots of paint; hence 'stippling', a technique using the tip of the paintbrush. Also a **broken colour** effect produced by applying a brush, rag or sponge to a wet painted surface.

c **stone**

A yellowish grey colour; also 'stone-coloured'.

c **stone blue**

A medium blue colour.

a **storm-darken'd**

As used in *Where My Books Go* W B Yeats (1865-1939).

a **stramineous**

Straw-coloured.

c **straw**

Yellow.

a **straw-coloured**

Having the pale yellow colour of straw. One of the colours which steel takes on when heated and which indicates that the steel has reached the crucial stage of having become annealed and thus less brittle. See **heat-induced colours**.

c **strawberry**

The red of the fruit, strawberry. This derives not from 'straw' but from 'stray-berries' so that there is no more straw in strawberries than there are apples in pineapples or grapes in grapefruit. Also 'crushed strawberry' – the colour of the crushed fruit.

c **strawberry blonde**

A reddish blonde; used particularly as regards a person's hair. As a noun this refers to a person having such colour hair.

c **strawberry roan**

A chestnut-red colour describing horses in particular.

n **streak**

A narrow and irregular stripe of a colour; a marking on animals and also used in reference to dyed tufts of hair.

a **streaked**

Covered with **streak**s. Also 'streaky'.

n **striae**

Narrow stripes or bands of colour. The singular is 'stria'.

a **striated**

Marked with **streaks** or furrows.

a **strident**

As regards colours, loud or **garish**.

c **string**

The colour of string, a light beige-brown or yellow-grey.

n **strip**

A familiar term given to the kit with its distinctive colours and configuration worn by the players of a particular football, rugby, hockey or other team.

n **stripe**

A strip or band of colour. '*Any colour as long as it's stripes*' – headline in *The Evening Standard* (16.11.00).

a **striped**

Bearing stripes.

n **strobe light**

Electric apparatus emitting rapidly flashing beams of light.

a **strong**

As regards colour, intense.

c **strontium yellow**

Yellow made from strontium chromate also called strontium chromate yellow.

n **structural colours**

Those effects (for example, **iridescence**) which some animals can create by making some modification to their skin or top layer.

a **Stygian**

Black in colour as the river Styx – the river of hell in ancient mythology. See **acherontic**.

a **subdued**

As regards colours, lacking in vividness.

a **subfusc**

Dingy, dusky, dull.

n **subjective colour**

See **accidental colour**.

n **sublimed blue lead**

A grey pigment used on iron and steel as a rust inhibitor.

a **substantive**

Descriptive of a pigment or dye which attaches itself without the need for a mordant.

n **subtractive primary colours**

The colours cyan, magenta and yellow (also referred to as the subtractive primaries) combinations of which in photography and in printing can, by the **subtractive process**, produce **primary colours**. These three colours can absorb nearly all the wavelengths – cyan absorbs red and orange; magenta absorbs green and yellow absorbs blue and violet. The subtractive primaries exactly complement the three primary colours – red, green and blue.

n **subtractive process**

The process whereby colours are absorbed to leave a residual colour so that starting with, say, white paper and superimposing successive coloured images (cyan, magenta and yellow – **the subtractive primary colours**) the unwanted colours are replaced by the desired colour. The admixture of all three of these colours produces an (imperfect) black. The above process is referred to as 'subtractive' because the more colours that are added the greater will be the absorption of coloured light waves so that, in consequence, less colour will be reflected back to the viewer – black absorbing ALL light waves. See **primary colours** and **additive primary colours**.

n **successive contrast**

See **after image**.

a **succulent**

As regards colours, rich.

a **suede-coloured**

Having the colour of light brown suede leather.

vb **suffuse; to**

To spread colour over something; usually used in the passive as in 'suffused with colour'.

adjective a
adverb adv
a colour c
noun n
prefix pr
suffix su
verb vb

a **sugar-almond**

Indicating a pale colour as in 'sugar-almond colours' and 'sugar-almond pastel'.

c **sugar-mouse-pink**

A pale pink.

c **sugar-pink**

One of the colours in Winifred Nicholson's 1944 *'Chart of Colours'*.

c **sulphur**

A yellowy-green colour similar to the colour of sulphur; but see also **sulphur yellow**.

c **sulphur yellow**

The pale yellow of sulphur; hence 'sulphur-coloured'.

a **sulphureous**

Having the yellow colour of sulphur.

c **sultan red**

A red dye.

n **sumach black**

A black dye from Sumach plant.

n **sumach, sumac**

A shrub or tree the leaves of which produce a variety of yellow, brown and black dyes such as **sumach black**.

n **sumi**

Ink originating in Japan.

a **summer**

An adjective used in the fashion trade to describe those colours considered to be appropriate for wear in summer and in colour psychology to classify and differentiate between certain colour tones in their appropriateness for different personality types.

c **summer-sky blue**

The **azure** blue colour of the sky on a bright day. See **sky blue**.

c **sun yellow**

A bright yellow. See **maize**. However, from space the sun appears to be white. The sun appears yellow from earth because sunlight is affected by the atmosphere which filters the blue end of the **spectrum** leaving yellow light to predominate. As evening approaches and the sun drops toward the horizon its rays have further to travel gradually allowing more blue light to be filtered so as to give the sun the appearance of orange or pink and then red.

a **sun-drenched**

Bathed in sunlight.

c **sun-glow, sunglow**

The pink or yellowish glow of the sun particularly at sunrise or after sunlight.

a **sunbaked**

Subjected to the persistent heat of the sun – particularly as regards the ground.

n **sunbeam**

A ray of light emanating from the sun.

c **sunburn**

A 1932 Barker's catalogue had tennis shirts in **self colours** of 'sunburn'; this is an old colour term recorded as early as 1590.

c **sunflower**

A dark yellow.

n **sunflower seed**

The oil of some varieties of sunflower seed is apparently capable of enhancing oil paints and enabling them to retain their brightness.

n **sunlight**

Light coming from the sun.

a **sunny**

A weather aspect involving sunshine.

a **sunrise**

Describing bright yellow or orange colours.

n **sunset yellow FCF**

An artificial yellow colour additive used in packet soups, cordials and in preparing curry dishes (E110). Research at the Asthma and Allergy Research Centre suggests that E110 might lead to hyperactivity in children.

n **sunshine**

The light of the sun.

n **sunspots**

The dark spots on the sun's surface indicating the cooler parts of the sun.

n **Super Black**

The darkest colour ever developed – NPL Super Black as it is called – is a black coating made from nickel alloy and phosphorus invented by British scientists at the National Physical Laboratory and claimed to be 25 times blacker than ordinary black paint. It absorbs 97.7 per cent of an overhead light source. As regards light hitting a surface at an angle, NPL Super Black absorbs a far greater proportion of this than would a surface covered in any other black.

n **surface colour**

Pigment and paint colour as opposed to coloured light and digital images.

c **swamp green**

A dark murky green.

n **swart**

Dusky, black, blackening.

a **swarthy**

Dark skinned; '*a swarthy Ethiope*' Shakespeare's *Two Gentlemen of Verona* Act 2 Scene 6.

n **swatch**

A sample usually of cloth or paper bound together to form a swatch-book for potential customers to view the range of a manufacturer's products and their colours.

n **swirl**

A spiral shaped curled pattern.

n **Sylvester Petra-Sancta**

The system devised by Sylvester Petra-Sancta which enables the main **heraldic colours** to be represented in black and white drawings thus: azure (by horizontal lines), gules (perpendicular lines), sable (horizontal and perpendicular crossed lines) vert (lines from left top to bottom right), purpure (lines from right top to bottom left). Or is represented by dots and argent by a plain white background.

n **synæsthesia**

An incurable but harmless neurological condition of one in every 2000 of the population (mainly women) where the stimulation received by one sense is responded to by another sense. Synæsthesia (meaning 'sensory union') takes many forms the most common being the sensation of colour being evoked by sound – referred to as **colour hearing** and **audition colorée** where sounds (particularly vowel sounds) are involuntarily associated with particular colours. Very often individual letters of the alphabet or words are associated with colours – each person having his or her own set of colours. Some synæsthetes taste shapes or smell sounds. The study by scientists of synæsthesia is proving helpful in understanding how the human brain works.

adjective a
adverb adv
a colour c
noun n
prefix pr
suffix su
verb vb

T

c **tabac**

The dark brown colour of tobacco.

a **tabby**

Having a colour which is streaked with darker-coloured stripes as with the tabby-cat. Taffeta or silk with a striped pattern. Anything which is striped. Also a plain weave **canvas**.

n **tache**

A touch or spot of colour. Hence, 'tachisme' – abstract art consisting of blotches of paint irregularly applied.

n **tactile colours**

The use of different surfaces or materials each associated with a particular colour thus enabling the blind by means of touch to determine the colour of the object. Used, for example, on special maps such as have been produced by London Underground.

a **taffy-coloured**

Toffee-coloured.

c **tallow**

The colour of tallow. Hence 'tallowy' – similar to tallow in colour.

c **tan**

The brown or tawny colour of tanned leather; sun-burn in relation to the **complexion**.

c **Tan**

A dark green colour – one of the 140 colours in the **X11 Color Set**. It has hex code #D2B48C.

vb **tan; to**

As regards the skin, to go (or cause to go) brown as a result of exposure to the sun or ultraviolet light; to convert skins or hides into leather by means of some form of tanning agent, such as **tannin**.

c **tangerine**

The reddish orange of the fruit.

c **tango**

Deep orange or deep pink.

n **tanling**

A person having dark skin having been tanned by the sun.

a **tanned**

Bronzed by the sun's rays.

n **tannery**

A place where the tanning process is carried out. See **to tan**.

n **tannin**

The yellow or orange pigment occurring in many plants, in particular, in autumn leaves and carrots. Also called **carotin**. Used to give butter its yellow colour. Any of a group of brown or yellow vegetable compounds used as **mordants** and to convert animal skins to leather.

n **tansy**

Plants of the family *tanacetum* producing a yellow dye.

n **tapestry**

A heavy decorative fabric woven from coloured thread and used as an ornament or wall-covering.

n **TAPPI**

The Technical Association of the Pulp and Paper Industry which regulates testing. TAPPI 452, for example, determines the reflectivity of paper in blue light.

n **tar black**

A **coal-tar** product used as a preservative on wooden posts and fences.

a **tarnished**

Discoloured; no longer having a lustre as in the case of silver and other metals which have become dim or which have lost their brightness.

c **tarragon**

A greyish or greenish yellow.

a **tartan**

The chequered pattern distinctive of the woollen fabric associated with Scottish clans.

n **tartrazine**

A yellow colour **azo** pigment used as an additive in preparing food, particularly, curry dishes (E102). In particular, tartrazine yellow. Research at the Asthma and Allergy Research Centre suggests that E102 might lead to hyperactivity in children.

c **tattle-tale grey**

Off-white.

n **tattoo**

The process (and the result) of puncturing the skin with indelible colours traditionally made from **henna** to form a word, picture, design or pattern. The recent tendency of creating temporary or 'semi-permanent' tattoos using para-phenylene diamine (PPD) instead of natural henna is proving to be very dangerous to those who are allergic to PPD since the reaction to it may be a permanent one. From the Tahitian, '*tatu*'.

c **taupe**

Brownish-grey; mole-coloured – *taupe* being the French for 'mole'. First recorded as a colourword in 1911.

a **tawdry**

As regards colour, showy.

c **tawny**

A dark brown often associated with the colours of birds and animals; an old word used in the Middle Ages and derived from the French *tanné* meaning tan in colour.

a **tea-coloured**

Having the colour of tea leaves.

c **tea dust**

A dark brown colour used as a ceramic glaze with lighter brown **flecks**.

c **tea green**

The greyish green of green tea.

c **teak**

The yellowish brown of the wood of the same name.

c **teal**

The dark greenish-blue colour found on the wings of the teal. Also referred to as 'teal blue'.

c **Teal**

One of the 140 colours in the **X11 Color Set**. It has hex code #008080.

c **tea rose**

A yellowish-pink; sometimes a brownish pink. Maerz & Paul suggests that, since tea roses come in many colours, this colour term should no longer be used. Fowler in his '*English Usage*' refers to the first recorded use of this colour being in 1892.

n **tear white**

A quality of dyed paper.

adjective	a
adverb	adv
a colour	c
noun	n
prefix	pr
suffix	su
verb	vb

n **techelet**

An ancient sky-blue or violet dye made from shellfish possibly used to create the thread of blue in the tsitsit and tallit referred to in *Numbers* xv, 37 to 41 and revived in 1998.

n **Technicolor™**

A proprietary process of producing film in colour. Hence *'in technicolour'* and *'technicoloured'* describe anything very brightly coloured.

n **teesoo**

A yellow dye from the plant of the same name.

c **telegraph blue**

A greyish-purple.

n **tempera**

Paint produced by mixing or grinding powdered **pigment**s with a variety of **medium**s including gum, glue, milk and particularly egg yolk and egg white (hence, egg tempera) – the process being referred to as **tempering**. Tempera has a variety of meanings and now designates pigment mixed with oil and water to form a paste and the technique of painting using tempera most popular in Italy in the 14th and 15th centuries.

n **tempering**

The process of mixing pigments (originally using a stone slab) to create **tempera** paint. Made redundant with the advent of ready-mixed commercial paints.

n **tenary**

A group of three colours. See **simple colours, split complementary colours, three-colour wave, triad colours, tricolour** and **tristimulus**.

pr **tenebri-, (L)**

Darkness, shadows.

a **tenebrific**

Bringing darkness or obscurity.

n **tenebrist**

An artist of the 17th century school of painting making use of light and shade to dramatic effect.

n **tenebrity**

Darkness.

a **tenebrose**

Dark. Hence, 'tenebrosity' – darkness.

a **tenebrous, tenebrious**

Dark, shadowy, gloomy.

c **tenné, tenney**

In heraldry, the colour orange or brownish orange. Derives from the French *tanné* (see **tawny**).

c **terra rosa**

A light red colour similar to **Venetian red**.

c **terra-cotta, terracotta**

Having one of the many brownish-orange shades of unglazed terra-cotta earthenware.

c **terrapin**

A deep golden tan colour.

c **terreau**

A very dark brown; the colour of earth.

n **terre verte, terra verte**

An ancient pigment having many shades from greyish-green to bluish-green to olive-green sometimes having a yellowish hue. Also referred to as **green earth, Verona green**, stone green, verdetta and celadonite.The 14th century artist, Cennino Cennini, recommended in his *Il libro dell'Arte* that terre verte be used as an undercoat in painting human faces.

n **tertiary colours**

The result of mixing one of the **primary colours** with one of the **secondary colours** next to it on the **colour wheel**. The six tertiary colours are: red-orange, yellow-orange, yellow-green, blue-green (or turquoise), blue-violet (or blue-purple) and red-violet (or red-purple) – sometimes referred to as 'intermediate colours'.

pr **tesselat- (L)**

Checkered.

a **tesselated**

Having the appearance of mosaic; containing blocks of colour.

a **testaceous**

Having the reddish-brown colour of unglazed tiles or flowerpots; **brick-red** or brownish-yellow.

a **testudinarious**

Having the colour (and other characteristics) of a tortoise or tortoise-shell.

a **tetrachromatic**

Having four colours.

a **tetrachromic**

Being able to distinguish only four colours.

c **Thalo blue**

See **phthalocyanines**.

c **Thalo red**

See **phthalocyanines**.

pr **thapsino- (G)**

Yellow.

c **Thénard's blue**

A vivid blue pigment discovered by the chemist Louis Thénard in 1802 and consisting of cobalt and aluminium; a greenish-blue; **cobalt blue**.

a **thestral**

Dark, dim.

n **thinner**

A solvent used to dilute paint such as turpentine. See **diluent**.

n **thioindigo**

A red vat dye; thus thioindigo red and thioindigo violet.

n **thionine, thionin**

A violet dye used to dye specimens viewed under a microscope.

c **thistle**

A purple colour.

c **Thistle**

A very pale purple – one of the 140 colours in the **X11 Color Set**. It has hex code #D8BFD8.

n **three-colour ware**

Chinese pottery characterised by the use of three colours, namely, aubergine, blue and turquoise.

c **thrush brown**

A yellowish-brown.

n **tie-dying**

The process of dyeing fabric by tying it using waxed thread so as to cause bunching and the coloration of only those surfaces which remain exposed.

c **Tiffany blue**

The turquoise-blue colour adopted by Tiffany, the jewellers.

c **tilleul**

The delicate yellowish green of the foliage of lime trees.

n **tinct**

An obsolete word for **tint**.

a **tinctorial**

Relating to colour or to dyeing.

n **tinctumutant**

An animal which is able to change its colour. See **aposematic**.

adjective a
adverb adv
a colour c
noun n
prefix pr
suffix su
verb vb

n **tinctumutation**

The quality or process of changing colour. See **cryptic colouring**.

n **tincture**

A tinge or shade of colour particularly in heraldry; a dye or colouring matter used particularly in **cosmetics**.

vb **tinge; to**

To modify the basic colour of something to a small degree; to colour something lightly.

n **tinge**

A delicate tint; an addition of a minute amount of colour.

a **tinged**

'pink-tinged sky', for example.

a **tingible**

Having the property of being able to be coloured.

vb **tint; to**

To colour something lightly; to impart a light colour.

n **tint**

A slight tinge; a variation of a principal colour. In painting (particularly oil painting) the addition of white to any colour produces a tint of that colour. In watercolours dilution by the use of water produces a new tint.

a **tinted**

Tinged with colour or dye.

n **tinting strength**

The extent of the ability of a particular pigment or colour to cover a white **ground** or to influence another colour mixed with it. Sometimes also referred to as 'colouring strength'. **Phthalocyanine blue**, for example, has a very pronounced tinting strength whereas **ultramarine blue** has a very low tinting strength.

n **titanium**

A pigment such as **titanium white** containing titanium.

n **titanium dioxide**

A naturally occurring brilliant synthetic white mineral used as a **pigment** in paint (particularly **titanium white**). It was discovered in 1821 but not commercially available to any significant extent until 1921. It is now the most widely used white pigment. Also used as a **colorant** in food and food supplements and also used to dilute some of the brighter synthetic pigments employed in the cosmetic industry; a component of colours such as titanium white. A food additive (E171) used to colour food white or to provide opacity or whiteness in a variety of products. Also referred to as titania and **permanent white**.

c **titanium green**

A green pigment.

c **titanium white**

See **titanium dioxide**.

c **Titian**

Red; auburn; yellowish red. After the painter Tiziano Vecellio (?1488-1576) referred to in English as 'Titian'. Also referred to as Titian red.

n **Titian's colours**

See previous entry. Titian, one of the greatest masters of colour, used a variety of hand-made colours and pigments in his paintings including **Kermes** (used to make red **lake**), **lead-tin yellow**, **lead white**, **malachite**, **orpiment**, **realgar**, **ultramarine**, **verdigris** and **vermilion**.

c **Titian white**

A pale yellow used by **Titian**, (see previous entries).

n **tiver**

A red colouring agent. Also 'to tiver' – to mark with red.

c **tobacco**

A yellowish-brown.

c **toffee-coloured**

The brown colour of toffee.

n **toga praetexta**

A roman toga having a broad purple border and used by magistrates. Togas, made from wool and worn almost exclusively in Rome, were mainly white. Bright white togas were worn by candidates for offices (*toga candida*). Black togas (*toga pulla*) were worn by those in private mourning. The *trabea* was a purple toga or a toga bearing horizontal purple stripes used as a holy or royal garment. Togas worn by Roman emperors were completely purple.

c **Tomato**

One of the 140 colours in the **X11 Color Set**. It has hex code #FF6347.

c **tomato red**

The rich red colour of the fruit, tomato; an orange-red colour adopted as a colour name by web page compilers on the Internet. Of course, not all tomatoes are red. Heinz have introduced a green ketchup made from green tomatoes. This was such a success in Canada that Heinz introduced purple ketchup to attract children and ketchup in one of three 'mystery' colours (pink, orange or teal) revealed only when the packaging has been removed.

n **tone**

A colour's relative degree of lightness or darkness. The addition of grey to any colour produces a tone of that colour. Also used in reference to variations in hue. In the US 'tone' is sometimes referred to as 'value'. **Tints** and **shades** are sometimes together referred to 'tones'.

n **tone colour**

The quality of a musical tone.

a **toned**

Used with a colour as in 'plum-toned', '**two-toned**', deep-toned'. See also **flesh-toned** and **full-toned**.

vb **tone down; to**

To reduce the brightness, colour or intensity of something.

n **toning colours**

Colours having the same depth of tone; also toning shades.

n **tonking**

The process of removing excess oil paint from the surface of an unfinished painting by the use of absorbent paper.

c **tony, toney**

A red-brown colour fashionable in the 1920's.

c **topaz**

The dark yellow or light brown colour of the precious stone of the same name; sometimes a light muted yellow.

n **toptone**

Another name for **masstone**.

n **torchlight**

The light emanating from a torch.

c **tortoiseshell**

A medium brown.

n **tortoiseshelling**

As regards painting, the technique of creating an effect or appearance similar to that of tortoiseshell.

vb **touch; to**

To mark slightly with colour.

n **touch**

A limited controlled application of colour to a painting etc.

c **tourmaline**

A bluish green; a dark green.

vb **trace; to**

To sketch in outline.

vb **transcolour; to**

To alter the colour of something.

adjective a
adverb adv
a colour c
noun n
prefix pr
suffix su
verb vb

a **translucent**

As regards a surface having a quality which allows the passage of light through it but not so as to enable the viewer to see clearly what is under or beyond it. Also 'translucence' and translucency'.

a **transparent**

See-through or **diaphonous;** having a substance which allows the passage of light to pass through it thus enabling the viewer to see clearly what is under or beyond it. As regards any colour (particularly in watercolour painting) the extent to which light can pass through it and be reflected back to the viewer.

c **transparent green**

See **chrome oxide**.

c **transparent white**

Aluminium hydroxide.

a **transpicuous**

Transparent.

c **travertine**

Off-white, cream.

n **triad colours**

On a colour wheel of twelve colours any combination of three colours which are equidistant from each other. See also **tenary** and **primary colours**.

a **trichroic**

Having the quality (usually as regards crystals) where three different colours are displayed from three different angles; hence 'trichroism'. See **dichroic**.

n **trichromacy**

The ability to distinguish the colours blue, green and red. So-called 'anomalous trichromacy' (in the form of **deuteranomaly**, **protanomaly** or **tritanomaly**) is a form of **colour-blindness** in which there is merely a reduction in the ability to distinguish colours.

n **trichromatic process**

A process of colour printing using the three **primary colours**.

a **trichromatic, trichromic**

Involving three colours; in photography and human colour vision, the three colours used to produce any particular colour, namely, blue, green and red. See **RGB**.

vb **trick; to**

To delineate with colour.

n **tricolour**

A flag with three colours such as the French national flag of blue, white and red and the Italian *tricolore* of green, white and red dating from July 1797 and becoming the national flag in November 1947. Whilst the French are specific about the precise hues of their national flat the Italians are less certain and in April 2003 by what has been described as a 'chromatic coup d'état' the colours of their *tricolore* were apparently changed so to consist of a much darker green, ivory and a dark-reddish brown or ruby. Also an adjective – using or having three colours. Also 'tricoloured'.

a **tricoloured**

Trichroic or having three colours.

n **tristimulus**

The three reference colours (red, green, and blue) which when used additively (tristimulus values) can produce any colour.

n **tristimulus colorimeter**

See **colorimeter**.

n **tritanomaly**

A mild form of **colour-blindness** in which there is a reduced ability to appreciate the colour blue. See **trichromacy**.

n **tritanopia**

A form of **colour-blindness** where green is confused with blue – and grey is confused with yellow or violet. Blindness to blue. Caused by the absence of the appropriate pigment in the **cones** of the retina. Sufferers are called 'tritanopes'. Airline pilots have been alerted by America's Federal Aviation Administration to the fact that the infamous blue impotence drug, Viagra, apparently impairs the ability to distinguish blue from green.

a **true blue**

See 'to be a true blue' in **Phrases**.

n **trypan blue**

A dye used as a stain and as a treatment of certain infections. 'Trypan red' is a drug also used for this purpose.

n **tube colours**

Watercolour paint with glycerine to make it sufficiently pliable to be stored in a tube.

c **tuly**

The rich red of 'tuly' silks – possibly referring to silks originally produced in Toulouse.

n **tungsten lamp**

A lamp using a tungsten filament.

n **turacin, turacine**

A red or crimson dye named after the touraco bird, native to Africa, whose feathers when coming into contact with ammonia release a durable red dye.

n **turacoverdin**

A green pigment found in the feathers of the African bird, the touraco.

a **Turkey**

Originating from Turkey or the Levant.

n **Turkey blue**

A blue dye.

n **Turkey red**

A brilliant red dye made from **alizarin**; yellowish red; and sometimes described as a moderate red or a brownish red. Also called 'Adrianople red' and 'Levant red'. A technique of dyeing cloth and yarn which was extensively practised in Britain between 1785 and the 1930's.

c **Turkey umber**

A yellowish-brown; a good quality **umber** found in Cyprus.

c **turkin**

Titanium dioxide.

n **turmeric**

The yellow powder from the root of the Asian plant of the same name used as a yellow dye as well as an ingredient of curry.

c **Turnbull's Blue**

A light blue. Sometimes taken to be synonymous with **Prussian blue** although this is a darker shade.

c **Turner's yellow**

A vivid yellow. See **patent yellow**.

n **turnsole**

A blue or violet dye made in the Middle Ages from the plant *torna-ad-solem* (turning towards the sun) and used to colour manuscripts. Also referred to as folium; violet-blue colouring matter formerly used in confectionery.

c **turquoise**

Having the greenish-blue colour of the precious stone turquoise so-named in reference to Turkey or Turkestan being regarded as the origin of the pigment. Turquoise is the colour of the universe according to two astronomers at The Johns Hopkins University who have mixed the visible light of 200,000 galaxies and found that this produces a shade a few per cent greener than turquoise. This unexpected result occurs by the mixing of the bluish light of younger stars with the reddish light of older stars. In time, as the universe gets much older, it is thought that the admixture of the light from these galaxies will produce a red colour.

| adjective a |
| adverb adv |
| a colour c |
| noun n |
| prefix pr |
| suffix su |
| verb vb |

c **Turquoise**

One of the colours in the X11 Color Set. It has hex code #40E0D0.

c **turquoise blue**

A bluish green.

a **Tuscan-coloured**

Having the colour of straw.

n **twilight**

The period after sunset when the sun is receding below the horizon (also sometimes used in relation to sunrise); the diffused light during this period.

c **twilight blue**

A greyish or purplish blue.

c **twine**

A greyish olive.

vb **twinkle; to**

To give forth a flickering light; to sparkle; to shine intermittently.

a **two-coloured**

Dichroic or having two colours. Also called 'twi-coloured' or 'twy-coloured'. See **bichrome**.

a **two-tone, two-toned**

Having two different or contrasting colours or two shades of the same hue. See **septicoloured** and terms referred to.

a **twopence-coloured**

Garish or gaudy; cheap. After the low quality 2 pence prints sold in the early 1800's.

c **Tyrian blue**

A greyish blue.

c **Tyrian purple**

A natural crimson/purple/violet dye produced by the Phoenicians and ancient Greeks and much favoured by Roman emperors. The dye was extracted from the purpura shellfish in Tyre and disappeared in the 15th century. It took 60,000 of these creatures to make half a pint of the dye which had a pungent smell. Also the colour itself sometimes referred to as 'whelk red'. The synthetic equivalents produced in the mid 19th century were called Tyrian purple but could not be expected to achieve the splendour of the original colour. See **murex** and **argaman**.

n **tyrosinase**

The gene which produces the colouring of the hair follicle and which can now be artificially produced and used to darken hair.

a **ultra**

As regards any particular colour, on the deep side of that colour.

n **ultra red**

An obsolete term for **infrared**.

c **ultramarine**

A brilliant blue made from **lapis lazuli** and used extensively from the 13th century despite its high cost. Possibly used by Titian as an undercoat when painting flesh. See **Titian's colours**. The colour was first synthesised in 1828 by Jean-Baptiste Guimet in response to a 6000 franc prize offered by the French Government and hence sometimes called 'French ultramarine'. Literally 'from overseas' – the main supply of lapis lazuli being found in Afghanistan.

c **ultramarine blue**

A vivid blue pigment.

c **ultramarine green**

A dark green.

n **ultraviolet light**

Light rays forming part of the electromagnetic **spectrum** which are too blue to be visible to the human eye. Amphibians with four colour receptors as part of the mechanism of their eyes have a colour vision superior to that of humans and are able to see ultraviolet light suggesting that this ability might once have been enjoyed by mammals but has been lost with evolution. Ultraviolet rays have been used for nearly a hundred years to treat conditions such as psoriais and acne. The study of ultraviolet light plays a vital role in understanding the stars. Since only a small amount of ultraviolet light reaches earth much of the research has to be carried out by means of satellites.

c **umber**

A yellowy brown; brown-like. The brown colour of earth. '*All through Winter Britain abounds in exquisite tints… but the writer who endeavours to paint this glory in words finds himself with a galling scarcity of satisfactory epithets of colour*'. *A Word In Your Ear,* Ivor Brown, Jonathan Cape, 1942.

n **umber**

One of the **earth pigments** – an ancient a brown mineral used as a pigment; brown-like.

vb **umber; to**

To render an object with **umber** making it dark brown in colour.

a **umbery**

Having the dark brown colour of **umber**.

n **umbilicaria**

A natural dye made from lichens and yielding reds and pinks.

n **umbra**

Shade; shadow.

n **umbrage**

A shadow or shade; a faint appearance. Also displeasure or annoyance.

a **umbrageous**

Shaded.

adjective a
adverb adv
a colour c
noun n
prefix pr
suffix su
verb vb

a **umbrated**

Drawn in a faint or shadowy way.

a **umbratile**

As regards colour, tending towards a darker shade.

pr **umbri-, (L)**

Shadow; shade.

a **umbriferous**

Shady; providing shade.

a **unbleached**

Not **bleached**.

a **uncoloured**

Without any colour; not having been coloured.

n **undercoat**

A coat of paint applied prior to further coats.

n **undercolour**

The colour underneath the exterior colour. In relation to furry animals, for example, the colouring below their fur.

n **underdrawing**

The sketch made by an artist in preparation for a painting – a particular characteristic of Renaissance artists. Underdrawings are now capable of being detected and captured by infrared reflectogram photography. See **grisaille** and **underpainting**.

n **underpainting**

An initial layer of paint providing an undercoat and a rough plan of a painting's light and shade; an **undercoat**.

n **undertone**

The particular bias of a colour. For example of the two blues – Prussian blue and French ultramarine – the first has a tendency toward green whilst the latter a tendency toward red. A subdued colour. As regards a colour, the effect produced when diluting it with white and spreading it on a surface thus indicating the extent of the pigment within it.

a **ungreen**

The concept of a negative colour is difficult to comprehend. Elizabeth Barrett Browning (1806-1861) uses this word in her *Seraphim: 'I see her vales, ungreen'*.

a **unicolourous**

Having one colour. Also 'unicoloured' and 'unicolour'.

n **unique hues**

Especially in psychology, the four colours blue, green, red and yellow particular shades of which are referred to as 'pure' since they contain no element of any other colour. For example, a unique yellow contains no vestige of green or red.

n **university blue**

See **blue**.

a **unlit**

Having no illumination; without lighting.

n **uplight**

Lighting which casts light towards the ceiling (in contrast to a **downlight**).

n **uranine**

Uranite or uraninite (**pitch-blende**).

c **uranium yellow**

Yellow made from uranium oxide.

n **urobilin**

The yellow pigment in bile and urine.

n **urochrome**

The yellow colouring matter of urine.

n **urrhodin**

A red colour occurring in urine.

a **ustulate**

Blackened or made brown.

n **value**

As regards colour, another term for **tone** or **brightness** (indicating the extent of the lightness or darkness in a colour) and less often a term used to describe the dimensions of a particular **hue** (indicating the extent of its warmth or coolness).

c **Vandyke brown**

A deep brown sometimes a medium brown; a native earth used since the 17th century and taking its name (curiously with a different spelling) from the Flemish artist Sir Anthony Van Dyck (1599-1641). Also known by a variety of names including **Cassel earth**, **Cologne earth**, earth of Cullen, Colens earth and **Rubens brown**. Now made from **carbon black** and synthetic iron oxide.

a **variegated**

Bearing or marked with differently coloured bands, bars, belts, blobs, blotches, blots, camlets, chevrons, dapples, dashes, dots, flecks, freckles, maculae, markings, mails, marks, markings, motes, mottles, ocelli, panes, patches, patterns, plaga, puncta, rings, ripples, smears, smudges, spangles, speckles, specks, spots, spraings, streaks, striæ, strips, stripes, swirls, taches or vittae.

a **varihued**

Having various colours.

a **variously-coloured**

Coloured in different ways or diversely. See **varicoloured, variegated, varihued, versicoloured, multi-coloured, parti-coloured, diversicoloured, mellay.** See also **septicoloured.**

n **varnish**

A transparent solution containing resin which when applied to a surface forms a smooth, glossy, protective top coat.

n **vat dyes**

Dyes made into a soluble form by use of a reducing agent into which textiles are immersed. The dye is then oxidised to form part of the fibre.

n **Vatican-rich colours**

In reference to the deep red and crimson colours of the vestments worn by the Pope and officials of the Vatican.

n **vegetable colour**

A form of hair dye.

n **vehicle**

The mixture of solvent and resin which binds a pigment enabling the paint to stick to the **colour ground.**

c **venet**

Turquoise blue (sometimes greyish-blue); short for the Latin *venetus* meaning Venice blue. Maerz & Paul refers to this term being used in the 15th century to describe the colour of the sails of spy ships wishing to avoid detection by the use of such **camouflage.**

a **Venetian, Venice**

Originating in Venice. The Venetian School of the 15th and 16th centuries, of which Titian (?1488-1576) was the leading master, is particularly acclaimed for its treatment of colour. Amongst the colours used in Venice from the 15th or 16th centuries were **azurite, copper resinate, indigo, lead-tin oxide, realgar, red lake, orpiment, smalt, ultramarine** and **vermilion.** See **Titian's colours.**

adjective a
adverb adv
a colour c
noun n
prefix pr
suffix su
verb vb

c **Venetian blue**

Turquoise.

c **Venetian brown**

A brown used to colour glass.

c **Venetian red**

An orange-red or reddish-brown natural iron oxide known by many names according to those places where it is found including, Venice red, **Indian red**, **Spanish red**, Pompeian red and Persian red. Also referred to as **sinopia**. See also **jeweller's rouge**.

c **Venice red**

See previous entries.

c **verbena**

Violet, lavender or purple.

n **verdaccio**

A brown or green pigment used for shading or under painting.

n **verdancy**

Greenness.

a **verdant**

Green in colour.

c **verdant green**

A pale green.

n **verde azzuro**

A bluish-green pigment possibly made from **malachite**.

n **verde eterno**

A dark green pigment used by Venetian artists of the past. See **Venetian**.

c **verdigris, verdigrisy**

Green or bluish-green; the blue-green forming on copper and brass; the green rusty colour on ancient bronze. From the French *vert de Grice* literally the 'green of Greece'. Also called **Montpellier** green. Also the pigment, copper acetate.

n **verditer**

A green or blue pigment used in water colours. Some authorities suggest this derives from the French *verd de terre*, green earth, but Maerz & Paul prefer *verdâtre*, greenish, as the origin. Blue verditer or verditer blue (also known as Sanders blue, cendres bleu and blue bice) was widely used in the 17th to 18th centuries and was one of the first pigments to be manufactured in bulk on a commercial basis.

n **verdure**

Greenness of vegetation; the colour of vegetation.

a **verdurous**

Rich in greenness or **verdure**.

vb **verge; to**

To approximate in shade to a particular colour.

c **vermeil, vermil**

Vermilion; a vivid scarlet.

a **vermeil-tinctured**

Scarlet; as used by John Milton (1608-1674) in *Comus*.

c **vermilion**

Bright red or scarlet. Originally named after the **kermes** dye and subsequently made from crushing **cinnabar** but in the 19th century made from a combination of sulphur and mercury and hence toxic. Superseded by **cadmium red**. The word vermilion came into the English language in the 15th century from the Latin *vermiculus* – meaning 'small worm' – the kermes insect being wrongly thought to be a worm.

n **vernice liquida**

A varnish consisting of sandarac and **linseed** oil.

c **Verona green**

Another term for **terra verte**, a green earth. Named after the city of Verona in Italy from where the supply of terra verte became exhausted in the 1930's.

c **Veronese green**

Emerald green.

a **versicoloured**

Diversely coloured; also 'versicolorous'.

c **vessey**

Light blue.

vb **vex; to**

To variegate in colour.

a **vibrant**

As regards colours, radiant, bright, dazzling.

c **Victoria green**

A light green.

c **Victoria red**

See **chrome orange**.

c **vicuna**

The tawny colour of the South American mammal related to the llama; also 'vicuna-coloured'.

c **Vienna blue**

A deep greenish blue.

c **Vienna green**

See **emerald green**.

a **vinaceous, vinous**

Of the colour of wine.

c **vine black**

Black with a brown tinge.

c **vine green**

The green of the vine leaf.

a **vinous**

Wine-coloured.

pr **violace- (L)**

Violet.

a **violaceous**

Having a violet colour.

a **violascent**

Approaching violet. Compare with 'violescent'.

a **violescent**

Tending towards violet; or having a violet tinge.

c **violet**

A bluish shade of purple; within the range of approximately 425 to 390 **nanometres**. Hence, 'violetish' (see **-ish**). The caves at Altamira in Spain reveal that violet pigments were used as long ago as the Stone Age – see **pigment**. 'Violet' is one of the many colours for which there is no convenient rhyming word. Others include crimson, orange, purple and silver.

c **Violet**

One of the colours in the X11 Color Set. It has hex code #EE82EE.

n **violettomania**

The condition from which the Impressionists were jocularly accused of suffering having regard to their prediliction for using blue-violet shadows.

n **violine**

A violet colourant.

a **virent**

Having a green colour.

n **virescence**

As regards flowers and plants, the development or retetention of greenness.

a **virescent**

Turning green; abnormally green.

adjective a
adverb adv
a colour c
noun n
prefix pr
suffix su
verb vb

n **virgin-tints**

Unmixed colours on the artist's palette as referred to by William Hogarth. Also called 'bloom-tints'.

pr **virid- (L)**

Green.

a **virid**

Green.

vb **viridate; to**

To make something green (obs.).

n **viridescence**

Greenness.

a **viridescent**

Becoming green; slightly green.

c **viridian, veridian**

A deep green – see **viridian green**.

c **viridian green**

A brilliant deep green produced from **chromium oxide**. It was discovered in 1797 by the chemist Louis-Nicholas Vauquelin (1763-1829), created by the Parisian Pannetier in 1838 and patented by the French chemist C E Guignet in 1859. It is referred to by many names including **emerald green**, **vert emeraude**, **celadon green**, **Veronese green**, **Pannetier green** and **Guignet's green**. It is an excellent pigment for artists and was a favourite of the Impressionists.

n **viridine**

A green dye, aniline based.

n **viridity**

The quality of being green in colour.

n **visible light**

Light within the wavelengths $10^{(-7)}$ to $10^{(-6)}$ which for human beings constitutes the visible **spectrum** – colour in the approximate range of between 400 and 700 **nanometre**s.

c **vistal**

A pale purple colour.

a **vitelline**

Having the deep-yellow colouring of the yolk of an egg.

n **vitiligo**

An auto-immune disorder effecting around 1% of the world population where the skin loses its pigmentation due to a reduced number of **melanocytes** giving rise to localised patches of white skin.

a **vitreous**

Having the colour (and other qualities) of glass. *Vitrium*, the Latin for glass, originates from the Latin word for **blue-green** being the colour which glass takes on if its impurities are not removed in the course of production. Glass usually derives its colour from metallic ions entering molten glass by means of the addition of metallic oxides such as iron, cobalt, chromium, copper and manganese. Iron, for example, will generate a green or amber colour. Copper produces a turquoise colour and chromium produces colours ranging from green to brown.

n **vittae**

Bands of colour particularly as regards birds. The singular form is *vitta*.

pr **vittat- (L)**

Striped.

a **vittated**

Striped; marked with bands or **vittae**.

a **vivid**

Very bright, lively or brilliant in colour; intense.

n **vividness**

The quality of being vivid.

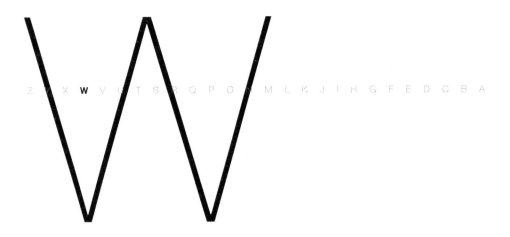

c **wallflower brown**

A reddish brown.

c **walnut**

The brown colour of the English walnut shell; also sometimes the colour of the walnut tree or of the nut itself.

a **wan**

Pallid, pale, ashen or sickly especially as regards the **complexion**; originally meaning the opposite, namely, dark, lacking light, gloomy.

adv **wanly**

Palely.

c **Warhol pink**

A shade of pink (*Sunday Times* Magazine 14.11.99).

a **warm**

A painting term indicating **warm colours** such as orange, red and yellow.

n **warm colours**

Colours which appear to advance towards the viewer such as orange, red and yellow which by reason of their resemblance to fire and flames convey a warmth

compared with, so-called, **cool colours**. There may be some physical reality in this – red light, for example, can stimulate adrenaline in the human body creating an increase in body temperature. Also referred to as 'hard colours'. All colours may be said to have either a warm or a cool aspect. Ultramarine, for example, is sometimes described as a 'warm blue' because it verges towards red.

n **warning colours**

See **aposematic**.

n **wash**

The application of a thin layer of colour, for example, in **watercolour** painting or in decoration such as **whitewash;** a dyestuff applied to change the colour of hair.

c **wasp green**

The concocted definition in '*The Deeper Meaning of Liff*' by Douglas Adams and John Lloyd, Pan Books, 1990 for a catalogue colour '*which is quite obviously yellow*'. See also **English pink**.

c **watchet**

Pale blue; the word is sometimes described as obsolete but John Clare (1793 – 1864) used the term. Perhaps from Watchet in Somerset suggests Partridge.

n **watercolour**

The ancient technique of painting using water-based as opposed to oil-based pigments. Unlike other water-based techniques, such as **gouache**, lighter tones come from thinning the paint rather than adding white; the powdered pigment mixed with a water-soluble medium, such as gum arabic or gelatin as a **binder** to hold it together. Watercolour pigments are either transparent (allowing the white or other ground to remain apparent) or **opaque** (having only a degree of opacity).

n **watering**

The variegated appearance of silk with its watery or wave-like effect, particularly, moiré silk.

a **waterproof**

As regards a pigment, resistant to change from water.

| adjective a |
| adverb adv |
| a colour c |
| noun n |
| prefix pr |
| suffix su |
| verb vb |

a **watery**

Pale, like water in colour; also used in conjunction with colours such as 'watery-blue'.

a **wax-coloured**

Having the yellowish colour of wax.

n **wax-colours**

The colours applied by the Greeks and the Romans to wooden panels by means of burning wax. See **encaustic**.

a **waxen**

As regards the colour of the **complexion** of an ill person or a corpse, **wan** or extremely **pale**.

a **weak**

As regards colours, lacking in intensity or brilliance.

c **Wedgewood blue**

The blue (light or dark) characteristic of Wedgewood pottery.

n **weld**

A natural yellow dye from the plant *Reseda luteola* (see **dyer's rocket**) used particularly in the dyeing of silk.

a **well-coloured**

Fully coloured; coloured to good effect.

n **wet blue leather**

See **blue, in the**.

c **wheat**

A light yellow.

c **Wheat**

One of the 140 colours in the **X11 Color Set**. It has hex code #F5DEB3.

a **wheatish**

Light-skinned.

a **whey**

Pale in colour hence, 'whey-coloured'.

a **wheyface**

Pale faced.

c **white**

The colour of snow. A colour associated with peace and purity (see symbolism) and formerly with wealth – it was only the rich who could afford to wear clothes made from white cloth since they needed such frequent washing. In English folklore the colour white is associated with innocence although it also symbolises death and bad luck. According to superstition it is unlucky to give white flowers (particularly with red flowers) to someone who is ill. In the range of approximately 450-380 nanometres. Defined in Ambrose Bierce's *The Enlarged Devil's Dictionary*, Penguin Books, 1971, as '*White, adj and n., Black*'. The colour of the outer ring in archery. In printing, any space on paper which has no print. The albumen of the egg. Having no hue; light in colour; as regards tea or coffee, having milk added. Strictly, white is not a colour. It is rather the combination of all the colours so that when **white light** is viewed through a prism the **rainbow** effect is created indicating all the colours of which white is comprised. The three white pigments used in the manufacture of white oil colours are **flake white**, **zinc white** and **titanium white**. More white paint is produced than any other colour paint.

c **White**

One of the colours in the X11 Color Set. It has hex code #FFFFFF.

n **Whiteacre**

See Blackacre.

n **white blonde**

A person whose **blonde** hair verges more to white than to light gold; also the colour, 'white blonde', sometimes applied to lace.

n **White Book, The**

Used to describe various official publications, including the Rules of the Supreme Court in England and Wales.

n **whitecap**

See **white horse**.

n **white card**

A card with a computer chip containing personal details of the owner and to which electronic data can be downloaded.

n **White Coat Rule**

The banning by the Federal Trade Commission in the US of advertisements portraying doctors in white laboratory coats who are really actors.

n **white-collar worker**

A person involved in some managerial or office orientated job as opposed to manual workers. See **blue-collar**.

n **whited sepulchre**

An evil person who pretends to be good; a sham; a hypocritical person. A biblical term originating in *Matthew* xxiii: 27.

n **white dwarf**

A small star at the end of its life depleted of nuclear fuel and having collapsed into an extremely dense mass.

n **white elephant**

An item expensive to maintain, difficult to get rid of or of little use or benefit to its owner – or any combination thereof. In reference to Thai kings who made gifts of white elephants the cost of the upkeep of which was intended to ruin the recipient. Thailand, which reveres white elephants, has tried to clone a magnificent deceased specimen in view of their rarity. Apparently, white elephants are never completely white, however, Thai tradition requires that elephants to qualify as white elephants, must have white eyes, white toenails and white genitalia as well as the palest of skins.

n **White Ensign**

The flag used by the Royal Navy. It has a red cross on a white background and the Union Jack in the corner.

n **white feather**

A symbol of cowardice in reference to cockfighting where cocks with white feathers were supposed to be poor fighters.

n **white finger**

A condition caused by the persistent use of drills and pneumatic equipment.

n **white flag**

A sign or symbol raised to indicate surrender.

n **white gold**

A lustrous white or silvery alloy used particularly in jewellery manufacture and made by mixing gold with silver or platinum or other metals.

n **white goods**

Various kinds of household goods, in particular, fridges and washing machines. Also sheets, tablecloths etc. See **brown goods**.

n **white-hats**

The 'good guys' in any situation compared with the 'baddies' – the black hats.

n **white heat**

A term used to describe the temperature of hot metal over 1,000° centigrade.

n **white hope, the great**

Someone expected to achieve great success in a particular endeavour possibly originating in boxing at the beginning of the 19th century in relation to white boxers in competition with black opponents.

n **white horse**

A wave with a white crest or peak. Referred to as 'whitecaps' in US. See also **leucipotomy**.

a **white-hot**

Extremely bright; heated to such a temperature as to generate **white light**; extremely hot; by extension exceedingly eager or enthusiastic.

n **white knight**

Business jargon for a company or person who, often at the last moment, rescues a target company from the clutches of a hostile party making an unwelcome takeover bid. In the US the term 'white squire' is preferred.

adjective a
adverb adv
a colour c
noun n
prefix pr
suffix su
verb vb

a **white-knuckle**

Causing severe fear, terrifying. A phrase alluding to the intense grip maintained by a person subjected to a terrifying experience, for example, on a turbulent fairground ride.

n **white lead**

An ancient white pigment made from lead carbonate. See **lead white** and **flake white**. When heated white lead produces **red lead**, a brilliant red pigment also called **minium**. When further heated it creates a yellow pigment known as **litharge** or **massicot**. See **Cremnitz white**.

n **white leather**

Leather prepared in such a way as to retain its natural colouring.

n **white lie**

See **phrases**.

n **white light**

A mixture of light (such as sunlight) comprising all of the wavelengths visible to the human eye. The components of white light were first identified by Sir Isaac Newton (1642-1727). Gemstones give the appearance of being coloured because some of the white light entering them becomes absorbed thus creating colour.

n **white lightning**

US slang for home-brewed alcohol.

n **white lines**

Markings on the surface of thoroughfares and carriageways indicating a variety of warnings and rules to be followed by drivers as set out in The Highway Code.

a **white-livered**

Lacking in courage.

adv **whitely**

With a white appearance or aspect; having a light skin.

n **white magic**

Magic used for benign purposes compared with black magic; slang for beautiful women.

n **white mail**

See **blackmail**.

n **white man's burden, the**

The perceived obligation of the white race to rule the colonies. Derived from Rudyard Kipling's poem.

n **white mule**

Same as **white lightning**.

n **whitening**

The process of becoming or of making something white in colour.

n **white noise or white sound**

A constant uniform low volume random noise or hum electronically generated and which can be used to hide unwanted noise.

n **white paintings**

Those paintings which consist of only the colour white – a concept perhaps originating with the artist Kasimir Malevich (1878-1935) and his 'White on White' painted in 1918. Since then the concept has been widely extended by artists such as Robert Rauschenberg and the U.S artist Robert Ryman who has from the 1960's confined his labours to the production of square works of art in white, some of which sell for over £1m. The monochrome white picture is the subject of Yasmina Reza's play 'Art' which has had a long run in the West End of London.

n **White Paper**

A government document in the UK to be presented to Parliament containing proposals for new policies or legislation. See **Green Paper.**

n **white pieces, the**

The white pieces in chess, draughts, backgammon, go and other board games.

n **white plague, the**

Tuberculosis – so called because TB has the effect of turning joints white.

n **white rent**

See **blackmail**.

n **whites**

As regards humans, having a fair complexion or slight pigmentation of the skin, **Caucasian**. Those bits of white laundry which must be washed separately from 'coloureds' to avoid discolouration. A cricketer's white trousers.

n **white sale**

A sale of household linen. See **white goods**.

a **white-shoe, white shoe**

Particularly as regards businesses, having a long-established reputation for providing a top-notch reliable service to prestigious clients. Used particularly in the US as regards firms of lawyers and brokers, but also in the UK. Possibly derived from the wearing of white shoes by the wealthy when summer arrives.

n **white slave**

A woman forced into prostitution.

n **whitesmith**

A tin-smith in comparison to a blacksmith.

c **WhiteSmoke**

One of the colours in the X11 Color Set. It has hex code #F5F5F5.

n **white spirit**

A colourless liquid made from petroleum and used as a **solvent** or as a **thinner** of paints.

n **white squall**

A violent storm over a small area of ocean generating white waves or **white horses**.

n **white van male**

The driver of the ubiquitous white delivery van with the reputation of taking liberties on the road in order to meet his delivery schedules.

n **whitewash**

A liquid mixture containing lime or **whiting** and water and **size** used to whiten walls or other surfaces; hence 'to whitewash'. The act of hiding or covering up some wrongdoing or questionable conduct. Jargon for the process whereby Section 151 of the Companies Act, 1985 (financial assistance) can be disapplied.

n　**white water**

Foaming water usually over a short stretch of a turbulent river such as rapids, hence, white water rafting.

n　**white wine**

Wine made from white grapes or from dark grapes from which skin and seeds have been extracted. The colour of 'white' wine varies from amber to yellow to green but is never colourless let alone white. The categorization of wine into either white or red dates back to the Middle Ages and is one of the longest standing wine conventions although there is a French wine from the Jura called *vin jaune* or yellow wine. See **rosé**.

n　**whiting**

Pulverised white **chalk** used to make **whitewash** and putty.

a　**whitish**

Having a colour which is near to but not quite white; see **-ish**.

a　**whole-coloured**

Having one colour throughout.

c　**willow green**

A yellowish green.

c　**Wimbledon-coloured**

Used to describe a field of lavender flowers in Wimbledon week. The Championships at Wimbledon, staged by The All England Lawn Tennis & Croquet Club and the Lawn Tennis Association, require competitors to wear predominantly white tennis kit.

c　**wine-colour**

The colour of red wine.

adjective	a
adverb	adv
a colour	c
noun	n
prefix	pr
suffix	su
verb	vb

c **wine-dark**

Having the colour of dark red wine. Homer often refers to the sea as 'wine-dark' in his Iliad and Odyssey. It has often been commented that there are so few colour-terms used by Homer and indeed in the whole of classical Greek literature. Those that are used often have connotations not so much of hue but of brightness and luminosity suggesting that the ancient Greeks were more affected by the lustre or finish of an object's surface than with its colour. An alternative explanation, namely, that the ancient Greeks were colour-blind has been discounted!

c **wine-gum red**

A dark red.

c **wine red**

A dark red.

c **wine yellow**

A light reddish-yellow.

c **Winsor blue**

A purplish blue.

c **Winsor green**

A strong green.

c **Winsor violet**

A reddish violet.

a **winter**

An adjective used in the fashion trade to describe those colours considered to be appropriate for wear in winter and in colour psychology to classify and differentiate between certain colour tones in their appropriateness for different personality types.

c **wistaria**

A purple 'art shade'; a light purple; violet. Named after the 19th century anatomist, Wistaria.

c **woad**

Purple-blue; a blue dye from a plant of the same name and also referred to as dyer's woad – whose Latin name is *isatis tinctoria*. **Indigo** replaced the use of woad in the 1700's.

n **wodge**

A mass of colour.

c **womb-red**

Illustrated as a scarlet colour but with no clue as to the origin of the term. Perhaps indicating the warmth of the womb.

c **wood brown**

The brown colour of wood.

n **wood colours**

Colours such as **ebony, mahogany, oak, pine, teak, walnut**.

c **Worcester green**

An artificial green dye originating in Worcester, England.

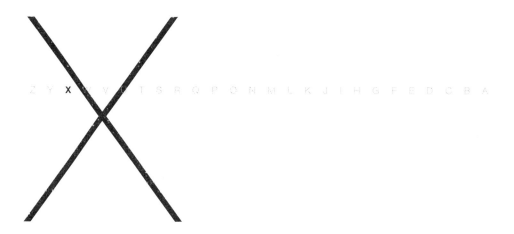

n **X- rays**

An electromagnetic wave with a short wavelength created when electrons hit a solid target at high speed. X-rays penetrate any body which is **opaque**.

n **X11 Color Set**

One of the many sets of colours used in designing websites for the Internet. There are many different syntaxes and methodologies used to represent colour including the 16 VGA colours (aqua, black, blue, fuchsia, green, grey, lime, maroon, navy, olive, purple, red, silver, teal, white and yellow) the 216 colours of the 'Color-Safe Palette', the 4096 colours of '#RGB', the 16, 777, 216 colours using the syntax '#RRGGBB' and the 140 colours in the X11 Color Set all of which are included in this Dictionary. Palm, the computer manufacturer was sued in August 2002 by purchasers of its handheld m130 PDA (personal digital assistant) because, though marketed as capable of supporting 65,000 colours, in fact it can handle only 4,096!

n **xanthein**

One of the constituent parts of the pigment in yellow flowers.

n **xanthene**

A yellow compound found in some dyes, in particular, **rhodamine**.

a **xanthic**

Yellow; particularly used in the descriptive word of flowers.

n **xanthin**

A yellow pigment which is derived from the **madder** plant.

n **xanthism**

As regards skin or other body covering, the condition where the colour yellow is dominant.

pr **xantho-, xanthin(o)-, (G)**

Yellow, fair.

n **xanthochroid**

Races having a light **complexion** with fair hair.

n **xanthochroism**

The abnormal condition where the skin pigment turns yellow (as in the case of certain birds) or gold (in the case of goldfish).

n **xanthocyanopsia**

Colour-blindness as regards yellow and blue.

n **xanthoderm**

A yellow skinned race.

a **xanthodont**

Having yellow teeth. It has become fashionable (and not only for film and television stars) to undergo some form of cosmetic treatment to whiten one's teeth. Whitening toothpastes are widely available as well as more elaborate processes such as 'power whitening' involving the application of hydrogen peroxide gel subjected to a light source which bleaches the teeth.

a **xanthogenic**

Yielding yellow.

a **xanthomelanous**

Having a yellow **complexion** and black hair.

n **xanthones**

A compound which forms the basis of various natural colouring matters.

adjective	a
adverb	adv
a colour	c
noun	n
prefix	pr
suffix	su
verb	vb

n **xanthophore**

A **chromatophore** with a yellow pigment.

n **xanthophyll**

The yellow pigment of autumn leaves. Also called **phylloxanthin** and **anthoxanthin**. The yellow colouring matter used as a food additive (E161) with its seven sub-classes (a) to (g).

n **xanthopsia**

A condition in which everything appears yellow in colour.

n **xanthopterin**

A pigment or **pterin** found in the wings of some butterflies and in the urine of mammals generating a yellow colour.

n **xanthosis**

Yellowing of the skin.

a **xanthospermous**

Possessing yellow seeds.

a **xanthous**

Yellowish; having yellowish hair and a fair **complexion**.

n **xeroderma pigmentosum**

A genetic disease in which the skin if exposed to the sun and ultraviolet light can become permanently damaged.

n **xylography**

Colour printing on wood.

su **-y**

A suffix capable of being appended to some colours to produce an adjective indicating a hesitancy in the exact shade intended, such as 'browny','greeny', 'plummy' or 'yellowy'. Frequently used in conjunction with another colour as in 'greeny-blue'. Compare 'greenish-blue' which has more of the feel of a noun. Compare also those few colours which can take the '-ly' suffix (see **blackly, bluely, brownly, greenly, greyly, pinkly, redly, silverly, whitely** and **yellowly**) so as to create an adverb rather than the adjective formed merely by using the '-y' suffix.

c **Yale blue**

A reddish-blue colour used as the distinctive colours of Yale University.

n **yehma**

A red pigment used by the ancient Peruvians for painting the body and face and made from **cinnabar**.

c **yellow**

The colour of the daffodil, egg yolk and the rind of ripened lemons; colours with a wavelength in the range of approximately 585 to 575 **nanometre**s. One of the three **subtractive primary colours**. When Her Majesty the Queen visited Brunei in July 1998 she apparently avoided wearing yellow – a colour reserved for the Sultan. In China, yellow was the colour used by the emperor but in the West it has perjorative connotations. It is a slang term for cowardly, hence 'yellow-bellied'

and 'having a yellow streak'; also slang for jealous. The colour represents jealousy, cowardice and adultery in symbolism. The colour of the medieval fool. In electrical wiring, the colour designates the earth. Yellow and green uniforms are being worn in some British prisons by those prisoners who are regarded as possible escapees. See also **blue**. The favourite colour of the artist J M W Turner (1775-1851) and his hallmark. In October 2002 litigation was initiated against the UK Government in an attempt to stop police forces from painting traffic speed cameras yellow on the grounds that cameras would be less likely to inhibit speeding if they were easily spotted from a distance. 'Yellow' derives from the Indo-European *gel, ghel* or *gohl* from which we have evolved many associated words such as **gold, glaucous, glistening** and yolk (see **yolk-coloured**).

c **Yellow**

One of the 140 colours in the **X11 Color Set**. It has hex code #FFFF00.

n **yellow 2G**

A yellow food colourant (E107) used particularly in soft drinks.

n **Yellow Arsenic**

See **orpiment**.

n **Yellow Book**

The term used in the UK to describe various business publications including the rules of the London Stock Exchange (now contained in the Purple Book) and the UK legislation concerning income tax, corporation tax, capital gains tax and other taxes produced each year by Butterworths Tolley. In France certain official publications and reports are referred to as Yellow Books.

n **yellow card**

The card shown by a referee in football to a player for a foul or other offence. See **red card**.

n **yellow dog**

A term of contempt and now used in the US in reference to contracts of employment outlawing the membership of trade unions.

n **yellow earth**

Ochre.

adjective a
adverb adv
a colour c
noun n
prefix pr
suffix su
verb vb

n **yellow fever**

A tropical and sub-tropical infectious disease in human beings spread by the mosquito.

n **yellow flag**

A flag flown by vessels to indicate that there is no disease aboard.

n **yellow goethite**

An ancient iron oxide used as a pigment – see **pigment**.

c **YellowGreen**

One of the colours in the **X11 Color Set**. It has hex code #9ACD32.

n **yellowing**

The yellow discolouration, in particular, of paintwork.

adj **yellowing**

Nothing to do with the colour but a combination of yelping and bellowing and hence a 'blend' or 'portmanteau' word. '*Let us sit down and mark their yellowing noise*', Shakespeare's Titus Andronicus Act 2, Scene 3.

a **yellowish**

See **-ish**.

n **yellow jack**

Another name for **yellow fever** and another name for **yellow flag**.

n **yellow jersey**

The garment worn by the rider who has the lowest cumulative time for all previous stages of *Le Tour de France* cycle race. The green jersey is given to the rider with the greatest number of points awarded for sprinting. The 'king of the mountains' wears a white jersey with pink spots (called the Polka-Dot Jersey) and the fastest overall young rider bears a plain white jersey. Le Tour de France was created by Henri Desgrange, the editor of the cycling magazine, *L'Auto,* in 1903 but it was not until 1919 that he conceived the idea of the *maillot jaune* opting for a yellow coloured jersey partly because his magazine was printed on yellow paper. The green jersey introduced in 1953 was green because its first sponsor sold gardening supplies. The Polka-Dot Jersey introduced in 1975 derives from the wrapper design of its sponsor, the chocolate company, Poulain.

n **yellow journalism**

That kind of cheap journalism which adopts a sensationalist approach often relying upon lurid descriptions. The term derives from the yellow ink used in the *New York World* at the end of the 19th century.

n **yellow light**

The equivalent in the US of the UK amber traffic light.

n **yellow lines**

Yellow markings on the surface of thoroughfares and carriageways indicating a variety of restrictions on drivers of vehicles as regards waiting, parking, loading and unloading. See also **red route**.

adv **yellowly**

With a yellow aspect.

c **yellow ochre**

An **ochre** used as a yellowish-brown pigment.

n **Yellow Pages™**

The trademark of the well-known telephone directory which lists entries by according to their trade classification.

n **yellow peril**

A derogatory term no longer appropriate to use for Chinese, Japanese or other orientals.

n **yellow ribbon**

The ribbon traditionally worn in the 19th century by women in the US awaiting the return of their men from battle.

n **yellow star**

The yellow six-pointed star which Jews were required to wear both before and during WW2 particularly by occupying Nazi forces. Such stars were also used in Nazi concentration camps where patches and badges of various colours were required to be worn to indicate a variety of other groupings. Brown triangles indicated gypsies; purple or violet – Jehovah's witnesses; green – habitual criminals; red – political in-mates; pink – homosexuals; black triangles indicated members of a supposedly asocial grouping including prostitutes and lesbians (and in some camps, gypsies) and a blue triangle indicated emigrants.

n **yellows**

Jaundice particularly in horses – '*rayed with the yellows*', Shakespeare's *Taming of the Shrew* Act 3, Scene 2.

a **yolk-coloured**

Having the colour of the yolk of the egg; also 'yolk-yellow'.

c **yolk-yellow**

See **yolk-coloured**.

adjective	a
adverb	adv
a colour	c
noun	n
prefix	pr
suffix	su
verb	vb

n **zaffer**

Oxide used as a pigment for pottery.

a **zebra-striped**

Having the black and white markings of the zebra particularly as regards fabrics.

c **zenith blue**

A violetish blue also known simply as 'zenith'.

n **zigzag**

A pattern or line resembling the outline followed by the teeth of a woodsaw; hence 'zigzag design'.

c **zinc green**

See **chrome green**.

n **zinc oxide**

A white powder used as a pigment in the manufacture of **zinc white** paint developed in 1782 in France as a substitute for the poisonous **lead white**. Also referred to as 'philosophers' wool'.

n **zinc white**

A transparent white oil paint composed of **zinc oxide**. Also known as **Chinese white** and first manufactured in 1834 as a water-colour by Winsor & Newton. Known also as 'snow white'.

n **zinc yellow**

A yellowish pigment made from zinc chromate.

n **zing**

Zest or vigour, but according to '*Colour*', Mitchell Beazley, 1980, the word denotes the effect in a work of art or design where certain colours, when incorporated in small doses in a larger display of saturated colour, create an effective contrasting impact.

c **zinnober**

See **cinnabar** and **cinnabar green**.

c **zircon**

Green 'Parisian art shade'.

c **zircon blue**

Light blue.

c **Zulu brown**

A reddish-brown.

adjective a
adverb adv
a colour c
noun n
prefix pr
suffix su
verb vb

Artists
can colour
the sky
red

because they
know it's
blue.

Those of us who aren't
artists, must colour things
the way they really are, or
people will think we're

stupid

JULES FEIFFER (1929- PRESENT)

Appendix one:
Colour phrases

black and blue; to beat someone

To inflict blows on someone causing bruising; also used figuratively.

black and white; to state something in

To reduce a statement or promise to writing by way of confirmation; to express something in the clearest terms with a view to avoiding misunderstanding or confusion; to distinguish between opposing ideas or statements. In Shakespeare's *Much Ado About Nothing*, Dogberry refers to a matter *'under white and black'* Act 5, Scene 1.

black as coal; to be as

There are many similes involving black including as black as death, ebony, hell, ink jet, night, pitch, soot, thunder and as black as the ace of spades, as black as a collier, coalhole, crow, kettle, pan, raven's wing, your hat and Newgate's knocker etc. Saul Bellow, the author, talks of *'as black as wealth'*.

black as one is painted to be; not as

Not as bad as one appears to be.

black as the inside of a cow

A sailor's way of expressing nil visibility.

black as thunder; to look as

To look angrily at someone.

blackball someone; to

By casting a black ball in a secret ballot, to vote against someone joining a club etc; also used figuratively.

black books; to be in someone's

To be resented by or to have caused annoyance to another usually for some specific misdeed; to be out of favour with someone. Perhaps from the Black Book in which Henry VIII recorded the excesses of the monasteries.

blacken someone's name; to

To disparage another person.

black eye; to give someone a

To cause another's eye to bruise usually as a result of a fight. Figuratively, to deliver a severe rebuff to someone.

black is beautiful

A 1965 slogan asserting Black pride.

black is white; to swear

To be prepared to say anything in order to get one's own way; to be a liar; to argue an untenable proposition. A favourite game in Victorian times involved transforming one word into another of equal length. The rules require one letter at a time to be changed on each occasion leaving another word and to reach the target word in as few changes as possible. Lewis Carroll changed black into white as follows: **black**>blank>blink> clink>chink>chine>whine>**white**.

black look; to give someone a

To look at a person with contempt or anger.

black mark; to be given a

To be censured for bad conduct or behaviour; to have a punishment recorded on one's record; to be regarded with disapproval.

black mark; to get a

To incur the disfavour of someone.

black market; to buy (sell) on the

To carry on trade in breach of the law.

black mood; to be in a

To be very depressed; to be very angry.

black out; to

To lose consciousness or faint; to obliterate with black; to extinguish stage lighting.

black ox has not trod on his (her) foot; the

A common proverb in Renaissance times but now almost lost to us. It indicated that the subject had a happy marriage or had not yet suffered sorrow or disease or deprivation.

black penny; to pay the

To pay the full price for goods or services as opposed to obtaining a discount.

blacks don't make a white; two

Another form of the saying *'two wrongs don't make a right'* – you cannot justify committing a wrong by arguing that it corrects another wrong.

black sheep of the family; the

A member of a group (such as a family) who has behaved badly or committed some misdemeanour or crime bringing discredit or disgrace to it; the odd one out; a deviant. Black sheep were worth less to farmers than white sheep since their wool could not be dyed like ordinary fleece. In English folklore, however, a black sheep may, depending on its situation, be regarded as a harbinger of good luck. For example, a 'black lamb' indicates good luck in Sussex but bad luck in Wiltshire.

black side; to look on the

To be pessimistic; to expect the worst outcome.

black stump; beyond the

To fall below the standard considered proper in reference to black stumps in the ground used (in Australia) to indicate the way.

black; the pot calling the kettle

A situation where someone hypocritely accuses another of a failing which the accuser also possesses. Possibly originating from from Cervantes *'Don Quixote'* and alluding to the fact that on the stove ALL utensils get blackened by usage.

black; things look

Said when there does not seem to be any possibility of a successful outcome so that the worst should be expected.

black; to

To boycott an employer in a labour dispute.

black; to be in the

Operating on a profitable basis; not in debt; to be in credit. Compare being **in the red**.

black; to go

To pass out or go unconscious as in ' *and then everything went black*'. Used almost exclusively in the past tense.

black; to look

To look at someone in an angry way.

black; to play

To play chess or draughts with the black pieces.

black/red; to put one's money on

In the game of roulette, betting on one of the colours.

black; to put up a

To make a serious mistake.

black; to turn

A term used by the Police indicating a fatality.

black; to wear

To wear black clothing usually as a sign of mourning.

black up; to

To colour one's face with black for a stage performance or for camouflage or for some nefarious purpose.

black; you can have any colour you like so long as it is

Attributed to Henry Ford (1893-1943) when first selling the Model T Ford in 1922 and now a catchphrase indicating a situation where there is no (or a very limited) choice.

blonde bombshell

An attractive blonde – often a film star.

blue; a bolt from (out of) the

Something which is sudden and completely unexpected – as a thunderbolt from a blue sky would be; hence *'out of the blue'*.

blue-arsed fly; to run (buzz) around like a

To run around in an uncontrolled and excited or frantic manner; to be hectically busy. The origin of this phrase is difficult to find but perhaps refers to the Bluebottle fly (blowfly) which has an iridescent blue body.

blue blood; to be of

Of royal, aristocratic or noble blood.

blue; enough blue sky to make a sailor's trousers

A homespun saying suggesting that if the condition of the phrase was satisfied it was in order to venture outdoors.

blue-eyed boy; to be a

An especially favoured employee or pupil who can do no wrong; the darling of the group. The US equivalent is a 'fair-haired boy'.

blue for a boy and pink for a girl

Used mainly in the UK.

blue funk; to be in a

In a state of extreme fear, anxiety or nervousness; in a state of extreme panic; sometimes to be in a dejected mood or to be depressed. According to Charles Earl Funk, 'blue' here retains its early Oxford University slang meaning of 'extreme'.

blue in the face; to (do something) until one is

To persist with a particular action (usually) without any effect or without any likelihood of achieving the desired end – often applied to arguing or complaining.

blue moon; to happen once in a

Very rarely; the phrase was used at least as far back as 1528 and originally meant 'never'.

blue murder; to get away with

To avoid detection or punishment for a crime or misdeed; to do what one wants without detection or punishment.

blue murder; to scream

To make a lot of noise in alarm, opposition or complaint. Possibly originating from the fact that 'murder' used to be a cry for help from someone in danger (Shakespeare's *Othello* Act 1 Scene 27, '*I am maym'd for euer: Helpe hoa: Murther, murther*'). Alternatively, the phrase may be derived from the French expletive '*morbleu*' (blue death) which in turn was a corruption of '*mordieu*'.

blue pencil; to use a

To delete or censor a piece of writing alluding to the blue pencil of the censor.

blues; to have the

To be sad, despondent or depressed.

blue sea; to be between the devil and the deep

To find oneself in a position where neither of two alternative solutions to a dilemma would be palatable. Tom Burnam, in the *Dictionary of Misinformation*, Thomas Y. Crowell suggests that the 'devil' here may merely refer to the seam in a ship's hull which, though a dangerous place for a sailor to be, was preferable to falling into the sea. This seems to be a plausible explanation where 'devil' means the upper plank of a sailing ship.

blue streak; to talk a

To talk quickly; to speak interminably. In reference to a streak of lightning and its rapidity.

blue; the boys in

Members of the police force or navy by way of allusion to the colour of their uniforms; in the US, Federal troops.

blue touchpaper and retire; to light the

To sit back and wait for the action in reference to the instructions on fireworks. A catch-phrase of Arthur Askey in the pre-WW2 BBC radio programme *Bandwagon*.

blue water between the two; there is clear

Descriptive of any contest where there is a clear leader. Used often, for example, in relation to the relative popularity of opposing political parties as indicated by opinion polls. Derives from boat races.

blue yonder; the wild

Referring to the sea or sky.

blue; to

To treat laundry with *blueing* as part of the washing process.

blue; to

To spend lavishly.

blue; to be a true

To be extremely constant or loyal usually to a cause. This is derived from **Coventry blue** an extremely lightfast dye. Blue was adopted as the colour of the Whigs and Tories thus becoming associated with an opposition to change.

blue; to be tangled up in

Possibly originating from Bob Dylan's much celebrated and enigmatic 1974 song *'Tangled Up In Blue'* which appears to be dealing with depression and mental illness. Other lyrics used by Dylan include *'Like a bird that flew, tangled up in blue'* and *'tangled up in the blueprints'*.

blue; to come out of the

To occur or arise unexpectedly or without warning; also 'bolt from the blue'.

blue; to feel

To feel sad.

blue; to look

To look unhappy.

blue; to make the air turn blue

To swear profusely.

blue; to vanish (go off) into the

To disappear.

break up colour [with another colour]; to

To introduce another colour in clothing or decoration.

bright spark; a

A lively person; a clever person.

brown as a berry; to be

Suntanned, having a dark skin. Used in Chaucer's *Prologue to the Canterbury Tales:* *'His palfrey was as broun as is a berye'* The Monk's portrait.

brown study; to be in a

To be fed up; to be deep in thought. From the French 'brun' indicating melancholy or gloomy. Also sometimes meaning absentminded.

browned off; to be

To be fed up. There are many equivalent slang phrases including *cheesed off, peed off, pissed off, brassed off, hacked off etc.*

carte blanche

Having complete freedom of action or power to act as one will. A French military expression literally meaning 'white paper' signifying a blank sheet on which the vanquishing side can dictate whatever terms of surrender it wishes.

clear as mud; to be

Obscure or unclear.

colour; a horse of a different

An entirely separate matter; a change of plan. In Shakespeare's *Twelfth Night* Act 2 Scene 3 Maria in talking of her plans says: *'My purpose is, indeed a horse of that colour'*.

colour; a riot of

Indicating a profusion of bright and varied colours often in reference to a display of flowers.

colour; a splash of

The addition of a bright or contrasting colour to an otherwise ordinary background.

colour of –; to do (say) something under

To use some pretext or excuse for a particular action.

colour of someone's money; to require to see the

To require proof of a person's ability to make payment for something.

colour something in; to

To fill an empty space with colour as in a child's colouring book.

colour; to change

To go pale or red with fear or embarrassment.

colour; to feel (be) (look) off

To feel or to appear unwell in a non-specific way.

colour; to lose

As regards one's complexion, to go pale.

colour to one's cheeks; to bring some

To do something the effect of which is to make the face more pink or more red thus giving the appearance of better health.

colour to something; to lend (give)

To assist in giving something the appearance of truth; to give credence to something; to make something appear plausible; to endorse.

colour to something; to give false

To give a false or misleading impression.

colour; to turn

To change colour as for example in the case of ripening fruit or autumn leaves.

colour up; to

To go red in the face; to blush; to exchange gambling chips for others of a higher denomination so as to reduce the number on the table. In the US white is usually the value of $1 chips; red the colour of $5 chips; green of the $25 and black the colour of $100 chips.

colours of the rainbow; all the

All the colours of the visible **spectrum**.

colours one's opinion; to be told something which

To receive information which has the effect of changing one's mind or influencing one's pre-existing views.

colours; the coat of many

Joseph's multi-coloured coat *Genesis* xxxvii:3.

colours; to desert one's

To become a deserter; to change sides; to go against one's principles – colours referring here to the flag in battle.

colours; to get one's

To be selected to play for one's school, university or country in some sporting activity or competition and thus to be awarded a cap or badge or other recognition.

colours; to join the

To join the army.

colours; to lower one's

To cease to defend a course of action – as a defeated army would lower its flag.

colours; to paint someone (something) in glowing

To speak of someone in very favourable terms.

colours; to pass with flying

To succeed in an examination with excellent marks or distinction referring to the colours of a winning army triumphantly displayed.

colours; to sail under false

To pretend to subscribe to particular views or beliefs; to deceive others about one's antecedents.

colours; to see someone in their true

To understand the true nature of someone – Act 2, Scene 2 in Shakespeare's *Henry IV Part 2*.

colours; to show (oneself in) one's true

To show one's true self.

colours to the mast; to pin (or nail) one's

To indicate or promise support as, for example, by attaching a ship's flag to its mast thus showing a commitment not to lower one's colours in surrender; to declare one's views on a particular subject. See **to lower one's colours**.

colours; to stick to one's

To continue to support a particular argument, belief or approach again in reference to the flag of battle.

colours; to strike one's

To indicate an intention to surrender. A nautical allusion to sea captains who lowered their ship's flag for this purpose.

crystal clear; to be

Said of a proposition, statement or idea etc which is capable of being fully understood by the listener or reader; said of a surface which has the highest degree of transparency.

dark horse; to be a

A person whose attributes are hidden; a competitor whose abilities are unknown or under-stated. This is said to allude to those circumstances where a horse was expected to win a horserace and made darker in colour so as to pass it off as an unknown competitor.

dark; to be in the

Lacking awareness or knowledge of a particular situation.

dark; to keep something

To keep something secret.

dark; to take a leap in the

To attempt action the outcome of which is uncertain and difficult to predict.

dark; to whistle in the

To show cheerfulness in a situation where optimism is inappropriate.

darken my doorstep!; do not

A clichéd exhortation to keep away as in Tennyson's Dora 'You shall pack / And never more darken my doors again'.

darkness; the powers of

Evil forces, Satan being referred to as the prince of darkness.

dawn; at the crack of

First thing in the morning; as early as possible. Not to be confused with the phrase *'to get up at the crack of noon'*!

daylight robbery; to commit

Blatantly to overcharge for goods or services in.

daylight; to see

To have in sight the end of a particular extended task in reference to the approach of dawn. See also **light at the end of the tunnel, to see the.**

daylights out of someone; to beat; the (living)

To beat someone severely; 'daylights' being US slang for a person's vital organs.

drip-white; to go

To be drained of all colour on hearing bad news. Said of a factory worker who had pulled out of a three-strong lottery syndicate a few weeks before it won £1.9 m. Perhaps from the phrase **to go as white as a sheet** combined with the slow 'drip-feed' realisation of the enormity of one's bad luck.

dyed in the wool; to be

Having definite and unalterable habits or views in reference to the fact that the colour of wool dyed in its raw as opposed to its processed state has greater permanence.

fair-haired boy; to be a

See **blue-eyed boy.**

gild the lily; to

To do something which is an unnecessary excess or which is superfluous. Possibly a variation on Shakespeare's: *'To gild refined gold, to paint the lily....or add another hue unto the rainbow... is wasteful and ridiculous excess'* King John Act 4 Scene 2.

gold; all that glisters (glistens) (glitters) is not

A proverb referring to an item which does not have the value (or the characteristics) which it appears to possess; looks may be deceptive. The original phrase as appearing in Shakespeare's *Merchant of Venice* Act 2 Scene 7 employs 'glisters'.

golden calf; to worship the

Revering wealth – a reference to the golden calf worshiped by the Israelites at the foot of Mount Sinai (*Exodus* Ch 32).

golden egg; to kill the goose that lays the

To act in a foolish manner out of greed as in the Aesop Fable involving the man who killed the goose which produced golden eggs so as to get his hands on all of them at once.

golden oldies

Items of the past (particularly pop songs) which have been revived.

golden; silence is

Keeping quiet can sometimes be a virtue; from an old proverb *'speech is silvern but silence is golden'*.

green about the gills; to be

To look ill or sick.

green as grass; to be as

Inexperienced, untutored or naive.

green as one is cabbage-looking; not to be as

Said of a person who may be ugly but who should not be taken to be naive; a person who is not as inexperienced as he may appear to be.

green cheese; the moon is made of

Alluding to the foolishness of anyone who believes this old saying – 'green' here meaning 'new'.

green fingers; to have

To have a natural talent for gardening or to make plants grow; the equivalent in American-English being *'to have a green thumb'*.

green gown; to give a girl a

To have sexual relations with a women – the green emanating from the grass on which the 'romp in the hay' took place. A slang expression from Elizabethan times.

green light; to give the

To give the 'go-ahead' or permission to someone to start or to continue with something; in reference to the green signals originating on the railways in the 19th century. Also 'to get the green light'.

green old age; (enjoying a)

Not showing the trappings of old age; agerasia.

green; to be in the

To be on the stage – green for many centuries being associated with the theatre. See green room.

green; to be on the

A golfing term, but also a colloquialism indicating that someone is in the proximate vicinity of reaching a successful outcome.

green shoots of recovery; the

Fledgeling businesses emerging from the aftermath of a downturn in the economy.

green with envy; to be

Green as a colour was possibly first associated with envy by Shakespeare in *The Merchant of Venice* in which Portia refers to 'green-eyed jealousy' (Act 3 Scene 2). In *Othello* (Act 3 Scene 3) Iago speaks of the 'green-eyed monster' in reference to jealousy. Previously, yellow was the colour associated with this trait.

greener on the other side (of the fence); the grass is (always)

A proverb expressing feelings of envy, jealousy and discontent intermingled with the notion that one's lot would be better if one were someone or somewhere else. One of the most commonly used English proverbs although its origin is uncertain. There are many variations including 'the grass always looks greener on the other side'.

grey in the dark; all cats are

An old proverb suggesting that a person's appearance is of little importance in bed once the lights are off.

grey mare is the better horse; the

The wife rules the husband.

grey matter; to use one's

To use one's brain.

grey; to go

To experience the greying of one's hair. Also used figuratively.

indigo; to be in mood

Feeling deeply unhappy or depressed – bluer than blue.

jaundiced eye; to look at something with a

To be critical or negative; to examine something with preconceived ideas. The phrase originated out of the notion that those with yellow jaundice saw everything in a yellow hue. 'Jaundice' comes from *'jaune'* – yellow in French.

light !; strike a

An expression of surprise.

light at the end of the tunnel; to see the

To get within sight of the outcome or the end of a troublesome period. See also **to see daylight**.

light; bathed in a new

Showing characteristics not previously apparent.

light-fingered; to be

To have an inclination towards stealing in reference to the skills that go with having the nimble (light) fingers of a pickpocket or thief.

light of day; in the (cold)

After due and careful consideration.

light of someone's life; to be the

To enjoy the all-consuming love, affection or attention of another.

light of (something); in the

After taking account of some particular information, facts or advice.

light on something; to shed/throw

To make something clear or understandable; to provide an explanation for something which has been the subject of uncertainty.

light; to be a guiding

To become a significant and lasting influence on another person usually as a mentor or teacher or suchlike; to set a good example.

light; to be a leading

A pre-eminent figure in any particular discipline or endeavour.

light; to be all sweetness and

A cliché indicating someone who is of a very equable or placid temperament. Often used in the context of someone who is putting on a particular show of being good-tempered.

light; to be shown in a bad

To be represented in an unfavourable way.

light; to be shown in a good

To be represented in a manner which highlights one's good points.

light; to come to

In reference to something hidden, lost or kept secret becoming found or revealed.

light; to go out like a

Said of anyone who suddenly falls asleep.

light; to see the

To come to understand or find the answer to something. The phrase originally alluded to a religious experience – 'light' being a reference to God.

light; to stand in one's own

To impede one's own advancement.

light; to stand in someone's

To inhibit someone else's progress or achievement; to act in a way which leads to another failing to receive the praise or glory due to him.

lights; according to one's

According to the level of the abilities of a person.

lily-livered; to be

To be timid or cowardly. According to the ancient notion of the four humours of the body a cowardly person's liver lacked bile or blood and was accordingly pale or white.

limelight; to be in the

To be in the news or the centre of attention (usually public attention) in reference to the limelight once used in theatres. See **limelight** in the main Dictionary.

limelight; to steal (hog) the

To act in a way which attracts all the attention (see previous phrase); to be pre-eminent.

pale with fear; to become

Similar to **to go as white as a sheet**.

pink of condition; to be in the

To be in the best of health; in excellent condition; '*in the very pink of courtesy*' Romeo & Juliet Act 2 Scene 4 – 'pink' there signifying perfection. It is also suggested that the phrase originates from 'pink', a flower. Hence, '*to be in the pink*' which also refers to the apparel worn by fox-hunters. See **pink** in the main Dictionary.

pink out; to

To cut cloth with pinking shears so as to produce scalloped edges.

pink; to be tickled (as)

To be thrilled; overcome with delight or excitement. Possibly in reference to tickling causing redness.

pink!; (well) strike me

An expression of disbelief or surprise.

porphyry-born

See **born to the purple**.

purple; born to the

Born into a wealthy or influential family in reference to the purple robes favoured by the nobility in ancient times; also expressed as 'porphyry-born'. Also 'to accede, or be promoted to, the purple' meaning to achieve high office.

purple patch; to go through a

To experience a period when everything goes well. See **purple prose** in the main Dictionary.

rainbow; the end of the (the rainbow's end)

Great wealth; alluding to the saying that a crock of gold can there be found.

rainbows; to chase

To seek impossible goals.

red alert; to be on

To be prepared for any kind of danger. See **red alert** in main Dictionary.

red as a beetroot; to be (go) as

To go red in the face usually as a result of embarrassment or shyness.

red carpet treatment; to get

To get special treatment and hospitality in reference to the red carpet traditionally rolled out for important or distinguished visitors. Just why the carpet has to be red is not easy to find. The phrase is probably of 20th century origin.

red cent; not to have a

US phrase meaning to be without any money in reference to the coin of the lowest denomination, the dime. Also *'not worth a red cent'*.

red-faced; to be

To be embarrassed or ashamed – in reference to the blushing reflex.

red-handed; to catch someone

To catch someone in the act of committing a crime or indiscretion; an allusion to finding someone with blood on his hands at the scene of a crime of violence. Willard R. Espy's *'Words To Rhyme With'*, Macmillan, 1986, refers to Rudy Ondrijka's fun word 'dishpano-phobia' – the fear of being caught red-handed'!

red in the gills as a turkey-cock; to go as

To become excessively angry; to go red in the face with anger.

red in tooth and claw; to be

To be a merciless and violent revolutionary. From Alfred Lord Tennyson's *In Memoriam*.

red light; to get the

To receive an indication or information that it is not possible or appropriate to proceed with a particular proposal.

red light; to see the

To become aware of the danger involved in a particular situation.

red line of heroes; thin

Those remaining of a larger grouping who have stuck it out to deal with a difficult situation. Originating from the Crimean War and referring to a heroic band of soldiers. Also referred to as 'the thin red line'

red lorry yellow lorry

Merely a tongue twister.

red rag to a bull; a

A cliché referring to the situation where a person is likely to react angrily to a particular stimulus. Based on the false notion that a bull is infuriated by the matador's red cloak whereas it is more likely that bulls are merely angered by the movement of the cloak.

red sky in the morning – shepherd's warning,
red sky at night – shepherd's delight

A 16th century proverb and also a seaman's ditty. Perhaps originating from the bible (Matthew xvi. 2).

red than dead; better

A catchphrase from the 1940's suggesting that it would be better to live under a communist regime than to die to resist it.

red; to be in the

To be in debt. In the preparation of accounts a red entry indicates a debit item.

red; to go

To change one's facial complexion when becoming embarrassed, stressed or angry.

red; to paint the town

To go out to celebrate – usually on a drinking binge. Possibly an allusion to the **red light district**.

red; to see

To become extremely angry in reference to bullfighting and the red cape used to antagonise the bull. But see the entry **colour blindness** in main Dictionary and **a red rag to a bull**.

red up; to

A US version of 'readying up', that is to get things ready and nothing to do with the colour.

red with anger; to become

To become so extremely angry that one's face reddens.

rose-coloured/tinted glasses; to look at things through

To see things in an unduly optimistic light; to fail to see the adverse factors; to have an overly positive attitude;.

sacré bleu

An exclamation of surprise in French – a euphemistic modification of sacré Dieu.

shade; to put (cast) someone in the

To make someone look insignificant or inferior in contrast to oneself.

shades of....

Said as regards anything which bears comparison (usually a poor comparison) with a particular thing, person, act etc. Shade here refers to a ghost.

shadow; to be afraid of one's own

To be lacking in courage.

shadow; to be worn to a

To become weak after exercise or illness.

shot in the dark; to take a

To make a wild guess without any background information for guidance.

silver lining; every cloud has a

A cliché suggesting that out of adversity will eventually come good or that there is hope even in the direst of situations.

silver spoon in one's mouth; to be born with a

Referring to someone from a very wealthy or aristocratic family; perhaps originating from the custom of giving spoons as christening presents.

silver tongue; to have a

To be an eloquent speaker.

spotlight; to be in the

To be the subject of particular attention.

tarred with the same brush; to be

To share the same fault; to be subject to the same accusation as another.

technicolour yawn

An Australian expression for the process of vomiting.

white as a sheet (snow) (chalk); to be (go)

To go white in the face as a result of fear or illness.

white bread

A disparaging US slang expression referring to the mediocracy of the white middle class.

white chief; the big

The leader or most important person in a particular group or organisation.

white feather; to show the

To show cowardice; originating from cockfighting where a white tail feather would indicate a cock not of a top fighting breed and thus lacking the fighting spirit.

white flag; to show the

To indicate an intention or a wish to surrender.

white lie; to tell a

To say something untrue in circumstances where the teller believes the falsehood to be justified to avoid hurt feelings or in the interests of politeness; to tell lies without malice or any intention to cause hurt.

white out; to

To erase errors on paper with correction paper or fluid.

whiter than white; to be

To be completely honest or virtuous; to have nothing to hide; to be innocent of a particular accusation.

white; to bleed someone

To cheat or deprive another of his money or belongings by a slow relentless process.

white; to speak

The intolerant plea of English-speaking Canadians made to their French-speaking fellow Canadians to use the English language.

yellow-livered, to be

To be cowardly.

yellow streak; to have a

To be a coward.

Appendix two:
The colours in alphabetical order

Legend

*	indicates one of the 140 colours in the **X11 Color Set**	l	light	r	red	
		ll	lilac, lavender	s	silver	
b	black	met	metallic colour	v	violet	
bl	blue	mul	multi-coloured or single coloured	w	white	
br	brown			y	yellow	
d	dark	o	orange			
g	green	p	pink			
gl	gold	pl	pearl, rainbow-like, iridescent			
gr	grey	pp	purple			

g	absinthe, absinth	y	acridine yellow	
y	acacia	bl	Adam blue	
bl	academy blue	p	adobe	
br	acajou	r	Adrianople red	
g	acid green	br	adust	
y	acid yellow	g	æruca	
y	acid-drop yellow	v	african violet	
met	acier	bl	Air Force blue	
g	Ackermann's Green	bl	air-blue	
br	acorn brown	r	alesan	

| | | | | |
|---|---|---|---|
| br | Algerian | g | Aquamarine* |
| bl | AliceBlue* | g | aquamarine |
| bl | Alice blue | g | aquarelle |
| r | alizarin crimson | br | aran |
| r | almagra | g | arcadian green |
| p | almond | s | argent |
| g | almond green | s | argental |
| g | Alp green | br | argil |
| br | amadou brown | g | artichoke green |
| pp | amaranth | y | arylide yellow |
| y | amber | gr | ash |
| y | amber yellow | w | ash-blond(e) |
| bl | amethyst | gr | ashes of roses |
| v | anemone | g | asparagus |
| r | aniline red | b | asphalt |
| br | antelope | y | asphodel |
| y | antimony yellow | g | asphodel green |
| met | antique bronze | b | atred |
| w | antique ivory | pp | aubergine |
| w | Antique White* | pp | aubergine purple |
| bl | Antwerp blue | r | auburn |
| g | apple-green | o | aurora |
| r | apricot | y | aurora yellow |
| bl | Aqua* | br | autumn brown |
| bl | aqua blue | br | aventurine |
| g | aquagreen | g | avocado |

p	azalea pink	g	billiard green	
bl	azulin, azuline	g	bird's-egg green	
bl	azure	br	biscuit	
bl	Azure*	br	Bismarck	
bl	azurine	br	Bismarck brown	
bl	baby blue	br	bisque	
p	baby pink	br	Bisque*	
y	Bacon's pink	br	bistre	
br	badger brown	b	black	
y	banana	b	Black*	
y	barium yellow	b	black glamma	
br	bark	b	blackberry	
gr	battleship grey	b	blackcurrant	
br	bay	b/bl	blae	
br	beaver	y	BlanchedAlmond*	
g	beech-green	p	blancmange-pink	
o	beeswax	pp	blatta	
r	beet	w	blonde (f), blond (m)	
r	beetroot red	r	blood-dark	
r	begonia	r	blood-red	
br	beige	r	bloody	
br	Beige*	bl	bloom	
gr	berettino	p	blossom	
bl	Berlin blue	bl	Blue*	
g	beryl	bl	blue	
bl	bice	bl	blue violet	

| | | | | |
|---|---|---|---|
| bl | bluebell | r | brique |
| bl | bluebird | g | brocoli green |
| bl | bluet | met | bronze |
| v | BlueViolet* | br | brown |
| bl | blunket | br | Brown* |
| r | blush | br | brunette |
| p | blush pink | b | Brunswick black |
| r | blush rose | bl | Brunswick blue |
| g | boat-green | g | Brunswick green |
| br | bois de rose | pp | bruyère |
| b | bone black | p | bubble-gum pink |
| w | bone white | g | bud green |
| bl | bonny blue | br | buff |
| r | Bordeaux | br | buffish |
| bl | Bordeaux blue | r | Burgundy |
| bl | Botticelli blue | br | BurlyWood* |
| r | Botticelli pink | r | Burmese ruby |
| g | bottle green | br | burnt |
| br | bracken | br | burnt ochre |
| br | bran | o | burnt orange |
| r | brazilwood | br | burnt sienna |
| bl | Bremen blue | br | burnt sugar caramel |
| g | Bremen green | br | burnt umber |
| r | brick | br | burnt-almond |
| r | brick-red | y | butter yellow |
| y | brilliant yellow | y | buttercup yellow |

| | | | | |
|---|---|---|---|
| gr | butter-nut | y | cantaloupe |
| y | butterscotch | br | canvas |
| g | cabbage green | o | capucine |
| br | cacao brown | br | caramel |
| g | cactus green | r | cardinal (red) |
| bl | cadet blue | r | carmine |
| bl | CadetBlue* | r | carnadine |
| g | cadmium green | p | carnation |
| y | cadmium lemon | r | carnelian |
| y | cadmium lithopone | o | carrot orange |
| o | cadmium orange | r | carrot red |
| r | cadmium red | r | carroty |
| r | cadmium vermilion | br | Cassel brown |
| y | cadmium yellow | y | Cassel yellow |
| y | cadmopone yellow | r | Castillian |
| bl | cæruleum | gr | castor |
| br | café | br | catechu brown |
| br | café au lait | pp | cathay |
| bl | Cambridge blue | br | cedar |
| br | camel | y | cedary |
| bl | campanula | g | celadon |
| bl | canard | b | celestial blue |
| y | canary | bl | celestine |
| g | canary green | gr | cendre |
| y | canary yellow | r | cerise |
| br | cannelas | bl | cerulean |

bl	cerulean blue		y	Chinese yellow
bl	cerulin, cerulein		bl	ching
r	chalcedony		bl	chinoline-blue
w	chalk		g	chlorine
w	chalk-white		br	chocolate
bl	chambray		br	Chocolate*
y	chamois		br	chocolate brown
y	champagne		bl	chow
gr	charcoal		y	chrome
br	charcoal brown		b	chrome black
gr	charcoal grey		g	chrome green
bl	Charron blue		o	chrome orange
g	Chartreuse*		r	chrome red
bl	chasseur-blue		y	chrome yellow
r	Cherokee red		met	chromium
r	cherry		y	chrysanthemum
r	cherry-red		g	chrysolite green
br	chestnut		g	chrysoprase
br	chestnut-brown		bl	ciel
r	Chianti		br	cigar
r	chilli-red		gr	cimmerian
bl	China blue		r	Cincinatti Red
bl	Chinese blue		g	cinnabar green
r	Chinese red		r	cinnabar red
r	Chinese vermilion		r	cinnabar, cinnebar, zinnober
w	Chinese white		r	cinnamon

| | | | | |
|---|---|---|---|
| y | citrine | v | columbine |
| y | citron | r | columbine-red |
| bl | clair de lune | r | Congo red |
| r | claret | bl | Copenhagen blue |
| br | clay | met | copper |
| bl | clematis | r | coquelicot |
| bl | Cleopatra | o | corabell |
| br | clove brown | p | coral |
| p | clover | r | Coral* |
| b | coal-black | p | coral pink |
| b | coaly | r | coral red |
| bl | cobalt blue | r | coralline |
| g | cobalt green | g | corbeau |
| bl | cobalt turquoise | p | corinthian pink |
| v | cobalt violet | br | cork |
| y | cobalt yellow | r | cornelian red |
| r | cochineal red | bl | CornFlowerBlue* |
| br | cocoa | br | Cornsilk* |
| br | cocoa brown | gr | corpse grey |
| bl | coeruleum | r | couleur de rose |
| br | coffee | bl | Coventry blue |
| br | cognac | y | cowslip |
| gr | coke bottle green | r | coxcomb |
| g | colibri | r | cramoisy |
| gr | colombe | r | cranberry red |
| r | colorado | y | cream |

| | | | | |
|---|---|---|---|
| w | creamy-white | bl | DarkCyan* |
| v | creme de violette | br | DarkGoldenrod* |
| w | Cremnitz white, Kremnitz white | gr | DarkGray* |
| r | cremosin | gr | DarkGreen* |
| g | cresson | br | DarkKhaki* |
| p | crevette | r | DarkMagenta* |
| r | crimson | gr | DarkOliveGreen* |
| r | Crimson* | o | DarkOrange* |
| r | crimson lake | v | DarkOrchid* |
| g | cucumber green | r | DarkRed* |
| br | cuir | p | DarkSalmon* |
| o | cumquat, kumquat | gr | DarkSeaGreen* |
| y | custard-yellow | bl | DarkSlateBlue* |
| bl | cyan | gr | DarkSlateGray* |
| bl | Cyan* | bl | DarkTurquoise* |
| r | cyclamen | v | DarkViolet* |
| gr | cypress | gr | Davy's grey |
| g | cypress green | y | daw |
| g | Cyprus green | p | day-glo pink, dayglo pink |
| y | daffodil yellow | gl | dead gold |
| r | dahlia | br | dead-leaf brown |
| p | damask | p | DeepPink* |
| r | damson | bl | DeepSkyBlue* |
| y | dandelion | bl | Delft blue |
| gr | dapple-grey | bl | delphine |
| bl | DarkBlue* | bl | delphinium blue |

r	Derby red	br	fallow
bl	Devonshire blue	br	fawn
y	Diarylide yellow	w	feldspar
gr	DimGray*	bl	fesse
pp	dioxazine purple	y	festucine
bl	DodgerBlue*	g	feuille
gl	doré	gr	field grey
gr	dove	o	fiesta
gr	dove-grey	p	fiesta pink
br	drab	br	filemot
y	dragon	g	fir green
bl	Dresden blue	r	fire engine red
g	duck green	r	fire -red
bl	duck-egg blue	r	FireBrick*
br	dun	r	fire-orange
d	dusk	g	fir-green
gr	elephant's breath	bl	flag
g	emerald green	w	flake white
g	emeraude	y	flambe
bl	empire blue	r	flame
y	English pink	p	flame pink
r	English red	r	flame red
bl	ensign	y	flame-yellow
g	epinard	r	flamingo
bl	Eton blue	p	flamingo pink
g	evergreen	gl	flax

bl	Flemish blue	br	French yellow	
r	flesh	r	fresco	
r	flesh-red	pp	Fuchsia*	
w	FloralWhite*	r	fuchsia	
r	Florence brown	p	fuchsia pink	
br	Florentine brown	gr	Gainsboro*	
g	flower de luce green	y	gamboge/camboge	
r	fondant pink	r	garnet	
g	forest-green	bl	garter-blue	
g	ForestGreen*	y	gaugoli	
bl	forget-me-not blue	bl	gentian	
br	fox	r	geranium	
br	foxy	p	geranium pink	
r	fraise	bl	German blue	
r	framboise	w	GhostWhite*	
b	Frankfort black	y	giallorino, giallolino, gialolino	
br	French beige	r	ginger	
y	French berry	r	gingerline, gingeline, gingelline, gingeoline, gingioline	
bl	French blue			
g	French green	bl	gobelin blue	
gr	French grey	gl	gold	
bl	French navy	gl	Gold*	
y	French ochre	br	golden brown	
y	French pink	y	golden yellow	
pp	French purple	y	Goldenrod*	
bl	French ultramarine	gr	goose grey	
		gr	gooseberry green	

| | | | | |
|---|---|---|---|
| g | gosling-green | gl | Guinea |
| r | Goya | r | gules |
| br | grain | gr | gull |
| r | Granada | r | guly |
| gr | granite | gr | gunmetal |
| pp | grape | g | han green |
| gr | graphite | y | Hansa yellow |
| g | grass-green | r | harmala red |
| gr | gray | br | Hatchett's brown |
| gr | Gray* | br | havana |
| g | green | g | hay |
| g | GreenYellow* | br | hazel |
| br | grège | bl | heather |
| gr/br | greige | o | helio |
| r | grenat | p | helio fast pink |
| g | Gretna Green | r | helio fast red |
| gr | grey | p | heliotrope |
| gr | greystone | r | henna |
| gr | gridelin | br | hickory |
| gr | gris | w | hoar |
| gr | grizzle, | w | hoary |
| bl | grotto | g | holly green |
| bl | grotto blue | bl | homage |
| bl | grulla | p | homard |
| g | Guignet's green | y | honey |
| y | Guimet's yellow | g | Honeydew* |

p	honeydew	r	Indian red	
y	honeysuckle	y	Indian yellow	
g	Hooker's green	r	IndianRed*	
bl	horizon blue	bl	indigo	
o	hot orange	bl	Indigo*	
p	hot pink	bl	indigo blue	
p	HotPink*	g	ingenue	
g	Hunter's green	bl	ink	
r	hunting pink	bl	ink-blue	
bl	hyacinth blue	bl	international Klein blue	
r	hyacinth red	o	international orange	
bl	hyacinthine	g	invisible green	
p	hydrangea pink	r	iodine scarlet	
v	ianthine	y	iodine yellow	
bl	ice blue	r	Iraq red	
g	ice-green	bl	iris	
bl	imperial blue	g	iris green	
g	imperial green	met	iron	
r	imperial red	gr	iron grey	
y	imperial yellow	r	iron red	
br	inca brown	y	isabel yellow	
r	incarnadine	gr	isabel, isabella	
bl	Indanthrone blue	y	isabelline	
pp	inde blue	y	Italian pink	
br	Indian brown	w	ivory	
o	Indian orange	w	Ivory*	

b	ivory black	br	khaki
g	ivy green	br	Khaki*
w	ivory white	bl	kingfisher blue
y	ivory yellow	bl	King's blue
r	jacinth(e)	y	King's yellow
pp	jacinthine	w	Krems white
r	jacqueminot	bl	labrador blue
g	jade	r	lac
g	jade green	b	lacquer-black
b	Japan black	r	lake
bl	Japan blue	bl	lapidary blue
r	Japanese red	bl	lapis lazuli
y	jasmine	bl	larkspur
g	jasper	g	laurel
y	jaune brilliant	r	lava-red
gr	Jenkin's green	ll	lavender
bl	Jersey blue	ll	Lavender*
b	jet	ll	LavenderBlush*
b	jet black, jet-black	ll	LawnGreen*
b	jetty	g	LawnGreen*
bl	jockey club	met	lead
y	jonquil	w	lead white
g	jungle green	bl	lead-blue
g	Kelly green	y	lead-tin oxide
g	Kendal green	y	lead-tin yellow
r	kermes	g	leaf-green
		o	leafmold

br	leather brown	w	lily-white
g	leek-green	g	lime
y	leghorn	g	Lime*
y	lemon	y	lime
y	lemon yellow	bl	lime blue
y	LemonChiffon*	g	lime green
g	lettuce green	g	LimeGreen*
r	Levant red	w	lime white
g	lichen-green	y	lime yellow
r	light red	gr	limestone
y	light straw	g	Lincoln green
bl	LightBlue*	g	linden green
p	LightCoral*	br	Linen*
b	LightCyan*	bl	Littler's blue
y	LightGoldenrodYellow*	br	liver-colour
g	LightGreen*	g	lizard-green
gr	LightGrey*	g	loden
p	LightPink*	pp	London purple
p	LightSalmon*	o	lotus-colour
g	LightSeaGreen*	g	lovat
bl	LightSkyBlue*	br	lychee
gr	LightSlateGray*	bl	mackerel blue
bl	LightSteelBlue*	r	madder lake
y	LightYellow*	bl	madonna blue
ll	lilac	r	Magdala red
g	lily-green	r	magenta

| | | | | |
|---|---|---|---|
| v | Magenta* | o | Mars orange |
| p | magnolia | r | Mars red |
| br | mahogany | v | Mars violet |
| r | mail box red | y | Mars yellow |
| y | maise | br | mastic |
| y | maize | bl | matelot blue |
| g | malachite green | gl | matt gold |
| bl | mallard blue | r | mauve |
| r | mallow | r | mauvette |
| r | mallows (mallow) red | bl | Maya blue |
| gr | Maltese | bl | mazarine blue |
| y | Mandarin | bl | MediumAquamarine* |
| o | Mandarin orange | bl | MediumBlue* |
| bl | manganese blue | v | MediumOrchid* |
| v | manganese violet | pp | MediumPurple* |
| y | mango | g | MediumSeaGreen* |
| br | manilla | bl | MediumSlateBlue* |
| y | maple | g | MediumSpringGreen* |
| y | marigold | g | MediumTurquoise* |
| g | Marina green | v | MediumVioletRed* |
| bl | marine blue | y | meline |
| r | marmalade | y | mellow yellow |
| r | maroon | r | mennal |
| r | Maroon* | b | midnight black |
| br | marron glace | bl | midnight blue |
| v | Mars brown | bl | MidnightBlue* |

| | | | | |
|---|---|---|---|
| v | mignon | bl | moros |
| g | mignonette | g | moss |
| w | milk-white | g | moss green |
| bl | Milori blue | gr | moss-grey |
| g | Milori green | pl | mother of pearl |
| bl | mineral blue | br | mud |
| g | mineral green | br | mud brown |
| r | minium | r | mulberry |
| br | MintCream* | br | mummy brown |
| g | mint-green | pp | murrey, murry |
| o | mirador | br | mushroom |
| bl | mist | g | mushy-pea green |
| p | MistyRose* | y | mustard |
| g | mitis green | br | mustard brown |
| w | mixed white | y | mustard yellow |
| br | Moccasin* | g | myrtle green |
| br | mocha | g | mythogreen |
| gr | mode | o | nacarat |
| r | modena | y | nankeen |
| gr | mole | r | naphthamide maroon |
| bl | molybdenum blue | r | naphthol red |
| v | monsignor | y | Naples yellow |
| g | Montpellier green | mul | nasturtium |
| l | moonlight | bl | National blue |
| br | mordoré | bl | Nattier blue |
| r | morello | g | nauseous green |

| | | | | |
|---|---|---|---|
| w | NavajoWhite* | w | off-white |
| bl | navy | o | old coral |
| bl | Navy* | gl | old gold |
| bl | navy blue | br | OldLace* |
| bl | Negro | p | old rose |
| p | neon pink | g | olive |
| g | neptuna | g | Olive* |
| g | nettle | g | olive drab |
| br | nigger brown | g | OliveDrab* |
| bl | Nile blue | g | olive green |
| g | Nile green | g | olive grey |
| bl | Nippon | bl | Olympic blue |
| b | noir | g | opal |
| p | nude | g | opaline |
| gr | nugrey | gl | or |
| v | Nuremberg violet | o | orange |
| br | nut-brown | o | Orange* |
| br | nutmeg | r | OrangeRed* |
| br | nutria | r | orange-tawny |
| br | oak | o | orange-vermilion |
| br | oakwood | v | Orchid* |
| y | oatmeal | p | orchid pink |
| g | ocean green | r | orchil |
| y | ochre yellow | g | oriole |
| br | ochre, ocher | y | orpin |
| r | oeil-de-perdrix | r | orseille |

| | | | | |
|---|---|---|---|
| br | otter | bl | Paris blue |
| br | otter brown | g | Paris green |
| r | oxblood | r | Paris red |
| bl | Oxford blue | w | Paris white |
| y | Oxford chrome | pp | parma |
| gr | Oxford grey | r | parma red |
| y | Oxford ochre | v | parma violet |
| r | oxheart | g | parrot green |
| gr | oyster | g | parsley green |
| gr | oyster grey | gr | Parson grey |
| w | oyster white | bl | patent blue |
| r | pæonin | y | patent yellow |
| br | PaleGoldenrod* | bl | pavonazzo |
| g | PaleGreen* | gr | Payne's grey |
| g | PaleTurquoise* | g | pea green |
| r | PaleVioletRed* | p | peach |
| y | palew | p | peach bloom |
| mul | pandius | b | peach-black |
| g | Pannetier green | p | peach-blossom |
| bl | pansy | r | PeachPuff* |
| r | Pantone Red | bl | peacock blue |
| br | PapayaWhip* | g | peacock green |
| o | paprika | pl | pearl |
| r | para-red | gr | pearl grey |
| w | parchment | br | peat |
| b | Paris black | y | peoli |

p	peony-pink	br/g	pine
r	peony-red	p	pink
g	peridot	p	Pink*
br	perique	r	pink carmine
bl	periwinkle	g	pistachio green
bl	periwinkle blue	b	pitch-black
r	permanent rose	w	plaster white
bl	permanent blue	met	platinum
g	permanent green	y	platinum blonde
w	permanent white	y	platinum yellow
bl	perse, pers	pp	plum
bl	Persian blue	r	Plum*
o	Persian orange	met	plumbago
pp	Persian red	met	plumbine
bl	persimmon	bl	plunket
br	Peru*	bl	poilu-blue
bl	pervenche blue	r	pomegranate
bl	petrol blue	g	Pomona green
pp	petunia	r	Pompadour
met	pewter	g	Pompadour green
br	philimot	bl	Pompeian blue
mul	piebald	r	Pompeian red
br	piecrust, pie-crust,	r	ponceau
r	pigeon's-blood, pigeon blood	pp	pontiff purple
r	pillar-box red	g	popinjay
r	pimento red	r	poppy

g	porret	r	raspberry	
bl	powder blue	br	rattan	
bl	Powder Blue*	b	raven	
g	prasine	b	raven-black	
y	primrose	bl	reckitt	
pp	prune	r	red	
bl	Prussian blue	r	Red*	
br	Prussian brown	w	regency cream	
g	psyche	br	Rembrandt	
pp	puce	o	Rembrandt's madder	
br	pueblo	g	reseda	
b	puke	r	rhubarb	
o	pumpkin	g	rifle green	
pp	purple	g	Rinmann's green	
pp	Purple*	r	roan	
pp	purple of cassius	bl	Robin's egg blue	
p	purpled pink	met	Roman Brown	
br	putty	r	rose	
y	pyrite yellow	r	rose bengal(e)	
r	pyrrole red	r	rose doré	
r	qerinasi	r	rose madder	
g	racing green	p	rose marie	
br	raddle	p	rose pink	
pp	raisin	p	rosebud	
b	ramoneur	pp	roseine	
r	rare-ripe	r	roset	

| | | | | |
|---|---|---|---|
| r | rosewood | p | salmon pink |
| br | rose-wood brown | r | salmon red |
| r | rosy | gr | sand |
| br | RosyBrown* | br | sandalwood |
| bl | royal blue | bl | Sanders blue |
| pp | royal purple | br | sandstone |
| y | royal yellow | br | SandyBrown* |
| bl | RoyalBlue* | r | sang-de-boeuf |
| b | Rubens brown | r | sang-de-dragon |
| b | rubican | r | sanguine |
| r | ruby | gr | santaupe |
| r | rudian | g | sap green |
| br | russet | br | sapele |
| bl | Russian blue | bl | sapphire |
| br | rust | r | sard |
| br | rust brown | br | sarplier |
| br | rusty | b | savannah |
| b/br | sable | bl | saxe blue |
| br | SaddleBrown* | r | scarlet |
| y | saffron | g | Scheele's green |
| g | sage-green | g | Schweinfurt green |
| gr | sage-grey | bl | Scotch blue |
| br | Sahara | gr | Scotch grey |
| g | sallow | g | sea-green |
| p | salmon | g | SeaGreen* |
| p | Salmon* | br | seal |

| | | | | |
|---|---|---|---|
| gr | Seashell* | bl | sky blue |
| g | seaweed green | bl | SkyBlue* |
| r | selenium | bl | sky-colour |
| br | sepia | gr | slate |
| bl | Sevres blue | gr | slate grey |
| y | shammy | bl | SlatcBlue* |
| pp | shellfish-purple | gr | SlateGray* |
| p | shocking pink | g | sludge-green |
| gr | shoe grey | bl | smalt |
| p | shrimp | g | smaragdine |
| br | sienese drab | gr | smoke |
| br | sienna, siena | gr | smoky |
| br | Sienna* | b | smutty |
| br | sienna brown | w | Snow* |
| r | signal red | w | snowy |
| y | signal yellow | r | solferino |
| y | sil | b | sooty |
| g | silk green | r | sorbier |
| s | silver | br | sorrel |
| s | Silver* | r | Spanish red |
| gr | silver grey | y | Spanish white |
| w | silver-white | g | spinach green |
| r | sinoper, sinople, sinopia, sinopite, sinope, sinopis, sinopic | r | spinel red |
| | | gr | spray |
| g | sinople green | g | spring green |
| b/w | skewbald | gr | SpringGreen* |
| bl | sky | | |

| | | | | |
|---|---|---|---|
| g | spruce | br | Tan* |
| r | stammel | br | tan |
| bl | steel blue | o | tangerine |
| gr | steel grey | o | tango |
| bl | SteelBlue* | y | tarragon |
| y | stil de grain | w | tattle-tale grey |
| gr | stone | gr | taupe |
| bl | stone blue | br | tawny |
| y | straw | br | tea dust |
| r | strawberry | g | tea green |
| r | strawberry blonde | r | tea rose |
| r | strawberry roan | br | teak |
| br | string | g/b | teal |
| y | strontium yellow | g | Teal* |
| p | sugar-mouse-pink | bl | telegraph blue |
| p | sugar-pink | o | tenné, tenney |
| g | sulphur | r | terra rosa |
| y | sulphur yellow | br | terra-cotta, terracotta |
| r | sultan red | br | terrapin |
| y | sun yellow | br | terreau |
| br | sunburn | bl | Thalo blue |
| y | sunflower | r | Thalo red |
| y | sun-glow, sunglow | bl | Thénard's blue |
| g | swamp green | pp | thistle |
| br | tabac | pp | Thistle* |
| y | tallow | br | thrush brown |

| | | | | |
|---|---|---|---|
| b | Tiffany blue | bl | Tyrian blue |
| g | tilleul | pp | Tyrian purple |
| g | titanium green | bl | ultramarine |
| w | titanium white | bl | ultramarine blue |
| r | Titian | g | ultramarine green |
| w | Titian white | br | umber |
| br | tobacco | bl | university blue |
| r | Tomato* | y | uranium yellow |
| r | tomato red | br | Vandyke brown |
| r | tony, toney | bl | venet |
| y | topaz | bl | Venetian blue |
| br | tortoiseshell | br | Venetian brown |
| g | tourmaline | r | Venetian red |
| g | transparent green | r | Venice red |
| w | transparent white | v | verbena |
| w | travertine | g | verdant green |
| r | tuly | g | verdigris, verdigrisy |
| br | Turkey umber | r | vermeil, vermil |
| bl | turkin | r | vermilion |
| bl | Turnbull's Blue | g | Verona green |
| y | Turner's yellow | g | Veronese green |
| bl | turquoise | bl | vessey |
| g | Turquoise* | g | Victoria green |
| bl | turquoise blue | r | Victoria red |
| bl | twilight blue | br | vicuna |
| g | twine | bl | Vienna blue |

| | | | | |
|---|---|---|---|
| g | Vienna green | g | Winsor green |
| b | vine black | v | Winsor violet |
| g | vine green | pp | wistaria |
| v | violet | bl | woad |
| v | Violet* | r | womb-red |
| g | viridian green | br | wood brown |
| g | viridian, veridian | g | Worcester green |
| pp | vistal | bl | Yale blue |
| br | wallflower brown | y | yellow |
| br | walnut | y | Yellow* |
| p | Warhol pink | y | yellow ochre |
| g | wasp green | g | YellowGreen* |
| bl | watchet | y | yolk-yellow |
| bl | Wedgewood blue | bl | zenith blue |
| y | wheat | g | Zinc green |
| br | Wheat* | g | zinnober |
| w | white | g | zircon |
| w | White* | bl | zircon blue |
| w | WhiteSmoke* | br | Zulu brown |
| g | willow green | | |
| r | wine red | | |
| y | wine yellow | | |
| r | wine-colour | | |
| r | wine-dark | | |
| r | wine-gum red | | |
| bl | Winsor blue | | |

Appendix three:
The colours in colour order

Legend

*	indicates one of the 140 colours in the **X11 Color Set**	l	light	r	red	
		ll	lilac, lavender	s	silver	
b	black	met	metallic colour	v	violet	
bl	blue	mul	multi-coloured or single coloured	w	white	
br	brown			y	yellow	
d	dark	o	orange			
g	green	p	pink			
gl	gold	pl	pearl, rainbow-like, iridescent			
gr	grey	pp	purple			

b	asphalt	b	celestial blue
b	atred	b	chrome black
b	Black*	b	coal-black
b	black	b	coaly
b	black glamma	b	Frankfort black
b	blackberry	b	ivory black
b	blackcurrant	b	Japan black
b	bone black	b	jet
b	Brunswick black	b	jet black, jet-black

b	jetty	bl	Alice blue*
b	lacquer-black	bl	amethyst
b	Light Cyan*	bl	Antwerp blue
b	midnight black	bl	Aqua*
b	noir	bl	aqua blue
b	Paris black	bl	azulin, azuline
b	peach-black	bl	Azure*
b	pitch-black	bl	azure
b	puke	bl	azurine
b	ramoneur	bl	baby blue
b	raven	bl	Berlin blue
b	raven-black	bl	bice
b	Rubens brown	bl	bloom
b	rubican	bl	blue
b	savannah	bl	Blue*
b	smutty	bl	blue violet
b	sooty	bl	bluebell
b	Tiffany blue	bl	bluebird
b	vine black	bl	bluet
b/bl	blae	bl	blunket
b/br	sable	bl	bonny blue
b/w	skewbald	bl	Bordeaux blue
bl	academy blue	bl	Botticelli blue
bl	Adam blue	bl	Bremen blue
bl	Air Force blue	bl	Brunswick blue
bl	air-blue	bl	cadet blue

bl	CadetBlue*	bl	Coventry blue
bl	cæruleum	bl	cyan
bl	Cambridge blue	bl	Cyan*
bl	campanula	bl	DarkBlue*
bl	canard	bl	DarkCyan*
bl	celestine	bl	DarkSlateBlue*
bl	cerulean	bl	DarkTurquoise*
bl	cerulean blue	bl	DeepSkyBlue*
bl	cerulin, cerulein	bl	Delft blue
bl	chambray	bl	delphine
bl	Charron blue	bl	delphinium blue
bl	chasseur-blue	bl	Devonshire blue
bl	China blue	bl	DodgerBlue*
bl	Chinese blue	bl	Dresden blue
bl	ching	bl	duck-egg blue
bl	chinoline-blue	bl	empire blue
bl	chow	bl	ensign
bl	ciel	bl	Eton blue
bl	clair de lune	bl	fesse
bl	clematis	bl	flag
bl	Cleopatra	bl	Flemish blue
bl	cobalt blue	bl	forget-me-not blue
bl	cobalt turquoise	bl	French blue
bl	coeruleum	bl	French navy
bl	Copenhagen blue	bl	French ultramarine
bl	CornFlower Blue*	bl	garter-blue

bl	gentian	bl	labrador blue
bl	gobelin blue	bl	lapidary blue
bl	German blue	bl	lapis lazuli
bl	grotto	bl	larkspur
bl	grotto blue	bl	lead-blue
bl	grulla	bl	LightBlue*
bl	heather	bl	LightSkyBlue*
bl	homage	bl	LightSteelBlue*
bl	horizon blue	bl	lime blue
bl	hyacinth blue	bl	Littler's blue
bl	hyacinthine	bl	mackerel blue
bl	ice blue	bl	madonna blue
bl	imperial blue	bl	mallard blue
bl	Indanthrone blue	bl	manganese blue
bl	indigo	bl	marine blue
bl	Indigo*	bl	matelot blue
bl	indigo blue	bl	Maya blue
bl	ink	bl	mazarine blue
bl	ink-blue	bl	MediumAquamarine*
bl	international Klein blue	bl	MediumBlue*
bl	iris	bl	MediumSlateBlue*
bl	Japan blue	bl	midnight blue
bl	Jersey blue	bl	MidnightBlue*
bl	jockey club	bl	Milori blue
bl	kingfisher blue	bl	mineral blue
bl	King's blue	bl	mist

bl	molybdenum blue	bl	poilu-blue	
bl	moros	bl	Pompeian blue	
bl	National blue	bl	powder blue	
bl	Nattier blue	bl	PowderBlue*	
bl	navy	bl	Prussian blue	
bl	Navy*	bl	reckitt	
bl	navy blue	bl	Robin's egg blue	
bl	Negro	bl	royal blue	
bl	Nile blue	bl	RoyalBlue*	
bl	Nippon	bl	Russian blue	
bl	Olympic blue	bl	Sanders blue	
bl	Oxford blue	bl	sapphire	
bl	pansy	bl	saxe blue	
bl	Paris blue	bl	Scotch blue	
bl	patent blue	bl	Sevres blue	
bl	pavonazzo	bl	sky	
bl	peacock blue	bl	sky blue	
bl	periwinkle	bl	SkyBlue*	
bl	periwinkle blue	bl	sky-colour	
bl	permanent blue	bl	SlateBlue*	
bl	perse, pers	bl	smalt	
bl	Persian blue	bl	steel blue	
bl	persimmon	bl	SteelBlue*	
bl	pervenche blue	bl	stone blue	
bl	petrol blue	bl	telegraph blue	
bl	plunket	bl	Thalo blue	

bl	Thénard's blue	br	aran
bl	turkin	br	argil
bl	Turnbull's Blue	br	autumn brown
bl	turquoise	br	aventurine
bl	turquoise blue	br	badger brown
bl	twilight blue	br	bark
bl	Tyrian blue	br	bay
bl	ultramarine	br	beaver
bl	ultramarine blue	br	beige
bl	venet	br	Beige*
bl	Venetian blue	br	biscuit
bl	vessey	br	Bismarck
bl	Vienna blue	br	Bismarck brown
bl	watchet	br	bisque
bl	Wedgewood blue	br	Bisque*
bl	Winsor blue	br	bistre
bl	woad	br	bois de rose
bl	Yale blue	br	bracken
bl	zenith blue	br	bran
bl	zircon blue	br	brown
br	acajou	br	Brown*
br	acorn brown	br	brunette
br	adust	br	buff
br	Algerian	br	buffish
br	amadou brown	br	BurlyWood*
br	antelope	br	burnt

br	burnt sugar caramel		br	cork
br	burnt-almond		br	Cornsilk*
br	cacao brown		br	cuir
br	café		br	DarkGoldenrod*
br	café au lait		br	DarkKhaki*
br	camel		br	dead-leaf brown
br	cannelas		br	drab
br	canvas		br	dun
br	caramel		br	fallow
br	Cassel brown		br	fawn
br	catechu brown		br	filemot
br	cedar		br	fox
br	charcoal brown		br	foxy
br	chestnut		br	French beige
br	chestnut-brown		br	French yellow
br	chocolate		br	golden brown
br	Chocolate*		br	grain
br	chocolate brown		br	grège
br	cigar		br	Hatchett's brown
br	clay		br	havana
br	clove brown		br	hazel
br	cocoa		br	hickory
br	cocoa brown		br	inca brown
br	coffee		br	Indian brown
br	cognac		br	khaki
br	columbine		br	Khaki*

br	leather brown		br	otter brown
br	Linen*		br	PaleGoldenrod*
br	liver-colour		br	PapayaWhip*
br	lychee		br	peat
br	mahogany		br	perique
br	manilla		br	Peru*
br	marron glace		br	philimot
br	mastic		br	piecrust, pie-crust,
br	MintCream*		br	Prussian brown
br	Moccasin*		br	pueblo
br	mocha		br	putty
br	mordoré		br	raddle
br	mud		br	rattan
br	mud brown		br	Rembrandt
br	mummy brown		br	rose-wood brown
br	mushroom		br	RosyBrown*
br	mustard brown		br	russet
br	nigger brown		br	rust
br	nut-brown		br	rust brown
br	nutmeg		br	rusty
br	nutria		br	SaddleBrown*
br	oak		br	Sahara
br	oakwood		br	sandalwood
br	ochre, ocher		br	sandstone
br	OldLace*		br	SandyBrown*
br	otter		br	sapele

| | | | | |
|---|---|---|---|
| br | sarplier | br | vicuna |
| br | seal | br | wallflower brown |
| br | sepia | br | walnut |
| br | sienese drab | br | Wheat* |
| br | sienna, siena | br | wood brown |
| br | Sienna* | br | Zulu brown |
| br | sienna brown | br | burnt ochre |
| br | sorrel | br | burnt sienna |
| br | string | br | burnt umber |
| br | sunburn | br | Florentine brown |
| br | tabac | br/g | pine |
| br | Tan* | d | dusk |
| br | tan | g | absinthe, absinth |
| br | tawny | g | acid green |
| br | tea dust | g | Ackermann's Green |
| br | teak | g | æruca |
| br | terra-cotta, terracotta | g | almond green |
| br | terrapin | g | Alp green |
| br | terreau | g | apple-green |
| br | thrush brown | g | aquagreen |
| br | tobacco | g | Aquamarine* |
| br | tortoiseshell | g | aquamarine |
| br | Turkey umber | g | aquarelle |
| br | umber | g | arcadian green |
| br | Vandyke brown | g | artichoke green |
| br | Venetian brown | g | asparagus |

| | | | | |
|---|---|---|---|
| g | asphodel green | g | cresson |
| g | avocado | g | cucumber green |
| g | beech-green | g | cypress green |
| g | beryl | g | Cyprus green |
| g | billiard green | g | duck green |
| g | bird's-egg green | g | emerald green |
| g | boat-green | g | emeraude |
| g | bottle green | g | epinard |
| g | Bremen green | g | evergreen |
| g | brocoli green | g | feuille |
| g | Brunswick green | g | fir green |
| g | bud green | g | fir-green |
| g | cabbage green | g | flower de luce green |
| g | cactus green | g | forest-green |
| g | cadmium green | g | ForestGreen* |
| g | canary green | g | French green |
| g | celadon | g | gosling-green |
| g | chartreuse* | g | grass-green |
| g | chlorine | g | green |
| g | chrome green | g | GreenYellow* |
| g | chrysolite green | g | Gretna Green |
| g | chrysoprase | g | Guignet's green |
| g | cinnabar green | g | han green |
| g | cobalt green | g | hay |
| g | colibri | g | holly green |
| g | corbeau | g | Honeydew* |

g Hooker's green

g Hunter's green

g ice-green

g imperial green

g ingenue

g invisible green

g iris green

g ivy green

g jade

g jade green

g jasper

g jungle green

g Kelly green

g Kendal green

g laurel

g LawnGreen*

g leaf-green

g leek-green

g lettuce green

g lichen-green

g LightGreen*

g LightSeaGreen*

g lily-green

g lime

g Lime*

g lime green

g LimeGreen*

g Lincoln green

g linden green

g lizard-green

g loden

g lovat

g malachite green

g Marina green

g MediumSeaGreen*

g MediumSpringGreen*

g MediumTurquoise*

g mignonette

g Milori green

g mineral green

g mint-green

g mitis green

g Montpellier green

g moss

g moss green

g mushy-pea green

g myrtle green

g mythogreen

g nauseous green

g neptuna

g nettle

g Nile green

g	ocean green	g	psyche
g	olive	g	racing green
g	Olive*	g	reseda
g	olive drab	g	rifle green
g	OliveDrab*	g	Rinmann's green
g	olive green	g	sage-green
g	olive grey	g	sallow
g	opal	g	sap green
g	opaline	g	Scheele's green
g	oriole	g	Schweinfurt green
g	PaleGreen*	g	sea-green
g	PaleTurquoise*	g	SeaGreen*
g	Pannetier green	g	seaweed green
g	Paris green	g	silk green
g	parrot green	g	sinople green
g	parsley green	g	sludge-green
g	pea green	g	smaragdine
g	peacock green	g	spinach green
g	peridot	g	spring green
g	permanent green	g	spruce
g	pistachio green	g	sulphur
g	Pomona green	g	swamp green
g	Pompadour green	g	tea green
g	popinjay	g	Teal*
g	porret	g	tilleul
g	prasine	g	titanium green

g	tourmaline	gl	gold
g	transparent green	gl	Gold*
g	Turquoise*	gl	Guinca
g	twine	gl	matt gold
g	ultramarine green	gl	old gold
g	verdant green	gl	or
g	verdigris, verdigrisy	gr	ash
g	Verona green	gr	ashes of roses
g	Veronese green	gr	battleship grey
g	Victoria green	gr	berettino
g	Vienna green	gr	butter-nut
g	vine green	gr	castor
g	viridian, veridian	gr	cendre
g	viridian green	gr	charcoal
g	wasp green	gr	charcoal grey
g	willow green	gr	cimmerian
g	Winsor green	gr	coke bottle green
g	Worcester green	gr	colombe
g	YellowGreen*	gr	corpse grey
g	Zinc green	gr	cypress
g	zinnober	gr	dapple-grey
g	zircon	gr	DarkGray*
g/b	teal	gr	DarkGreen*
gl	dead gold	gr	DarkOliveGreen*
gl	doré	gr	DarkSeaGreen*
gl	flax	gr	DarkSlateGray*

gr	Davy's grey	gr	limestone
gr	DimGray*	gr	Maltese
gr	dove	gr	mode
gr	dove-grey	gr	mole
gr	elephant's breath	gr	moss-grey
gr	field grey	gr	nugrey
gr	French grey	gr	Oxford grey
gr	Gainsboro*	gr	oyster
gr	goose grey	gr	oyster grey
gr	gooseberry green	gr	Parson grey
gr	granite	gr	Payne's grey
gr	graphite	gr	pearl grey
gr	gray	gr	sage-grey
gr	Gray*	gr	sand
gr	grey	gr	santaupe
gr	greystone	gr	Scotch grey
gr	gridelin	gr	Seashell*
gr	gris	gr	shoe grey
gr	grizzle,	gr	silver grey
gr	gull	gr	slate
gr	gunmetal	gr	slate grey
gr	iron grey	gr	SlateGray*
gr	isabel, isabella	gr	smoke
gr	Jenkin's green	gr	smoky
gr	LightGrey*	gr	spray
gr	Light Slate Gray*	gr	SpringGreen*

gr	steel grey		o	burnt orange
gr	stone		o	cadmium orange
gr	taupe		o	capucine
gr/br	greige		o	carrot orange
l	moonlight		o	chrome orange
ll	lavender		o	corabell
ll	Lavender*		o	cumquat, kumquat
ll	LavenderBlush*		o	DarkOrange*
ll	lilac		o	fiesta
met	acier		o	helio
met	antique bronze		o	hot orange
met	bronze		o	Indian orange
met	chromium		o	international orange
met	copper		o	leafmold
met	iron		o	lotus-colour
met	lead		o	Mandarin orange
met	pewter		o	Mars orange
met	platinum		o	mirador
met	plumbago		o	nacarat
met	plumbine		o	old coral
met	Roman Brown		o	orange
mul	nasturtium		o	Orange*
mul	pandius		o	orange-vermilion
mul	piebald		o	paprika
o	aurora		o	Persian orange
o	beeswax		o	pumpkin

o	Rembrandt's madder	p	fuchsia pink
o	tangerine	p	geranium pink
o	tango	p	helio fast pink
o	tenné, tenney	p	heliotrope
o	burnt orange	p	homard
p	adobe	p	honeydew
p	almond	p	hot pink
p	azalea pink	p	HotPink*
p	baby pink	p	hydrangea pink
p	blancmange-pink	p	incarnate
p	blossom	p	LightCoral*
p	blush pink	p	LightPink*
p	bubble-gum pink	p	LightSalmon*
p	carnation	p	magnolia
p	clover	p	MistyRose*
p	coral	p	neon pink
p	coral pink	p	nude
p	corinthian pink	p	old rose
p	crevette	p	orchid pink
p	damask	p	peach
p	Dark Salmon*	p	peach bloom
p	day-glo pink, dayglo pink	p	peach-blossom
p	Deep Pink*	p	peony-pink
p	fiesta pink	p	Pink*
p	flame pink	p	pink
p	flamingo pink	p	purpled pink

p	rose marie		pp	MediumPurple*
p	rose pink		pp	murrey, murry
p	rosebud		pp	parma
p	salmon		pp	Persian red
p	Salmon*		pp	petunia
p	salmon pink		pp	plum
p	shocking pink		pp	pontiff purple
p	shrimp		pp	prune
p	sugar-mouse-pink		pp	puce
p	sugar-pink		pp	purple
p	Warhol pink		pp	Purple*
pl	mother of pearl		pp	purple of cassius
pl	pearl		pp	raisin
pp	amaranth		pp	roseine
pp	aubergine		pp	royal purple
pp	aubergine purple		pp	shellfish-purple
pp	blatta		pp	thistle
pp	bruyère		pp	Thistle*
pp	cathay		pp	Tyrian purple
pp	dioxazine purple		pp	vistal
pp	French purple		pp	wistaria
pp	Fuchsia*		r	Adrianople red
pp	grape		r	alesan
pp	inde blue		r	alizarin crimson
pp	jacinthine		r	almagra
pp	London purple		r	aniline red

r	apricot	r	Castillian
r	auburn	r	cerise
r	beet	r	chalcedony
r	beetroot red	r	Cherokee red
r	begonia	r	cherry
r	blood-dark	r	cherry-red
r	blood-red	r	Chianti
r	bloody	r	chilli-red
r	blush	r	Chinese red
r	blush rose	r	Chinese vermilion
r	Bordeaux	r	chrome red
r	Botticelli pink	r	Cincinatti Red
r	brazilwood	r	cinnabar, cinnebar, zinnober
r	brick	r	cinnabar red
r	brick-red	r	cinnamon
r	brique	r	claret
r	Burgundy	r	cochineal red
r	Burmese ruby	r	colorado
r	cadmium red	r	columbine-red
r	cadmium vermilion	r	Congo red
r	cardinal (red)	r	coquelicot
r	carmine	r	Coral*
r	carnadine	r	coral red
r	carnelian	r	coralline
r	carrot red	r	cornelian red
r	carroty	r	couleur de rose

r coxcomb

r cramoisy

r cranberry red

r cremosin

r crimson

r Crimson*

r crimson lake

r cyclamen

r dahlia

r damson

r DarkMagenta*

r DarkRed*

r Derby red

r English red

r fire engine red

r fire -red

r FireBrick*

r fire-orange

r flame

r flame red

r flamingo

r flesh

r flesh-red

r Florence brown

r fondant pink

r fraise

r framboise

r fresco

r fuchsia

r garnet

r geranium

r ginger

r gingerline, gingeline, gingelline, gingeoline, gingioline

r Goya

r Granada

r grenat

r gules

r guly

r harmala red

r helio fast red

r henna

r hunting pink

r hyacinth red

r imperial red

r incarnadine

r Indian red

r Indian Red*

r iodine scarlet

r Iraq red

r iron red

r jacinth(e)

r jacqueminot

| | | | | |
|---|---|---|---|
| r | Japanese red | r | oeil-de-perdrix |
| r | kermes | r | OrangeRed* |
| r | lac | r | orange-tawny |
| r | lake | r | orchil |
| r | lava-red | r | orseille |
| r | Levant red | r | oxblood |
| r | light red | r | oxheart |
| r | madder lake | r | pæonin |
| r | Magdala red | r | PaleVioletRed* |
| r | magenta | r | Pantone Red |
| r | mail box red | r | para-red |
| r | mallow | r | Paris red |
| r | mallows (mallow) red | r | parma red |
| r | marmalade | r | PeachPuff* |
| r | maroon | r | peony-red |
| r | Maroon* | r | permanent rose |
| r | Mars red | r | pigeon's-blood, pigeon blood |
| r | mauve | r | pillar-box red |
| r | mauvette | r | pimento red |
| r | mennal | r | pink carmine |
| r | minium | r | Plum* |
| r | modena | r | pomegranate |
| r | morello | r | Pompadour |
| r | mulberry | r | Pompeian red |
| r | naphthamide maroon | r | ponceau |
| r | naphthol red | r | poppy |

r pyrrole red

r qerinasi

r rare-ripe

r raspberry

r Red *

r red

r rhubarb

r roan

r rose

r rose bengal(e)

r rose doré

r rose madder

r rose-coloured

r roset

r rosewood

r rosy

r ruby

r rudian

r salmon red

r sang-de-boeuf

r sang-de-dragon

r sanguine

r sard

r scarlet

r selenium

r signal red

r sinoper, sinople, sinopia, sinopite, sinope, sinopis, sinopic

r solferino

r sorbier

r Spanish red

r spinel red

r stammel

r strawberry

r strawberry blonde

r strawberry roan

r sultan red

r tea rose

r terra rosa

r Thalo red

r Titian

r Tomato*

r tomato red

r tony, toney

r tuly

r Venetian red

r Venice red

r vermeil, vermil

r vermilion

r Victoria red

r wine red

r wine-colour

r wine-dark

| | | | | |
|---|---|---|---|
| r | wine-gum red | v | verbena |
| r | womb-red | v | violet |
| s | argent | v | Violet* |
| s | argental | v | Winsor violet |
| s | silver | w | antique ivory |
| s | Silver* | w | AntiqueWhite* |
| v | african violet | w | ash-blond(e) |
| v | anemone | w | blonde (f), blond (m) |
| v | BlueViolet* | w | bone white |
| v | cobalt violet | w | chalk |
| v | columbine | w | chalk-white |
| v | creme de violette | w | Chinese white |
| v | DarkOrchid* | w | creamy-white |
| v | DarkViolet* | w | Cremnitz white, Kremnitz white |
| v | ianthine | w | feldspar |
| v | Magenta* | w | flake white |
| v | manganese violet | w | FloralWhite* |
| v | Mars brown | w | GhostWhite* |
| v | Mars violet | w | hoar |
| v | MediumOrchid* | w | hoary |
| v | MediumVioletRed* | w | ivory |
| v | mignon | w | Ivory* |
| v | monsignor | w | ivory white |
| v | Nuremberg violet | w | Krems white |
| v | Orchid* | w | lead white |
| v | parma violet | w | lily-white |

w	lime white	y	amber	
w	milk-white	y	amber yellow	
w	mixed white	y	antimony yellow	
w	NavajoWhite*	y	arylide yellow	
w	off-white	y	asphodel	
w	oyster white	y	aurora yellow	
w	parchment	y	Bacon's pink	
w	Paris white	y	banana	
w	permanent white	y	barium yellow	
w	plaster white	y	BlanchedAlmond*	
w	regency cream	y	brilliant yellow	
w	silver-white	y	butter yellow	
w	Snow*	y	buttercup yellow	
w	snowy	y	butterscotch	
w	tattle-tale grey	y	cadmium lemon	
w	titanium white	y	cadmium lithopone	
w	Titian white	y	cadmium yellow	
w	transparent white	y	cadmopone yellow	
w	travertine	y	canary	
w	white	y	canary yellow	
w	White*	y	cantaloupe	
w	WhiteSmoke*	y	Cassel yellow	
y	acacia	y	cedary	
y	acid yellow	y	chamois	
y	acid-drop yellow	y	champagne	
y	acridine yellow	y	Chinese yellow	

y	chrome	y	Guimet's yellow
y	chrome yellow	y	Hansa yellow
y	chrysanthemum	y	honey
y	citrine	y	honeysuckle
y	citron	y	imperial yellow
y	cobalt yellow	y	Indian yellow
y	cowslip	y	iodine yellow
y	cream	y	isabel yellow
y	custard-yellow	y	isabelline
y	daffodil yellow	y	Italian pink
y	dandelion	y	ivory yellow
y	daw	y	jasmine
y	Diarylide yellow	y	jaune brilliant
y	dragon	y	jonquil
y	English pink	y	King's yellow
y	festucine	y	lead-tin oxide
y	flambe	y	lead-tin yellow
y	flame-yellow	y	leghorn
y	French berry	y	lemon
y	French ochre	y	lemon yellow
y	French pink	y	LemonChiffon*
y	gamboge/camboge	y	light straw
y	gaugoli	y	LightGoldenrodYellow*
y	giallorino, giallolino, gialolino	y	LightYellow*
y	golden yellow	y	lime
y	Goldenrod*	y	lime yellow

y	maise	y	saffron
y	maize	y	shammy
y	Mandarin	y	signal yellow
y	mango	y	sil
y	maple	y	Spanish white
y	marigold	y	stil de grain
y	Mars yellow	y	straw
y	meline	y	strontium yellow
y	mellow yellow	y	sulphur yellow
y	mustard	y	sun yellow
y	mustard yellow	y	sunflower
y	nankeen	y	sun-glow, sunglow
y	Naples yellow	y	tallow
y	oatmeal	y	tarragon
y	ochre yellow	y	topaz
y	orpin	y	Turner's yellow
y	Oxford chrome	y	uranium yellow
y	Oxford ochre	y	wheat
y	palew	y	wine yellow
y	patent yellow	y	Yellow*
y	peoli	y	yellow
y	platinum blonde	y	yellow ochre
y	platinum yellow	y	yolk-yellow
y	primrose		
y	pyrite yellow		
y	royal yellow		

Appendix four:
Adjectives of colour

Legend

b	black	mis	miscellaneous	rt	paint	
bl	blue	mul	multi-coloured or single coloured	r	red	
br	brown			s	silver	
chg	changing colour	nc	no colour or particular colour; little colour	u	unknown	
d	dark			v	violet	
dw	dye	o	orange	w	white	
g	green	ori	origin, name	y	yellow	
gl	gold	p	pink			
gr	grey	pa	pattern word			
l	light	pl	pearl, rainbow-like, iridescent			
ll	lilac, lavender					
met	metallic colour	pp	purple			

d	acherontic	l	acronichal	
nc	achlorophyllaceous	bl	adularescent	
nc	achromatic	d	adumbral	
nc	achromatistous	met	aeneous	
nc	achromic	g	aeruginous	
nc	achromous	br	aithochrous	
nc	achroous	w	alabaster	
chg	acid-washed	w	albescent	

w	albicant	r	atrosanguineous
w	albiflorous	b	atrous
w	albinotic	w	au blanc
chg	allochorous, allochroous	bl	au bleu
chg	allochroic	br	au brun
chg	allochromatic	br	au gratin
w	all-white	r	au rouge
mis	almost...	gl	aureate
mis	alpine	gl	aurelian
w	alutaceous	gl	auriferous, aurous
pp	amethystine	gl	aurocephalous
cw	amphichroic	l	auroral
mis	antique	l	aurorean
cw	apatetic	gl	aurose
l	aphotic	d	austere
l	aplanatic	mis	autumn
mis	aposematic	br	avellaneous
r	ardent	mis	barely
s	argatate	l	bdellium-coloured
s	argenteous	mis	beautiful
s	argentine	br	beaver-hued
s	argyranthous	pa	begaired
gr	ashen	pa	belted
gr	ashy	d	benighted
b	atramentaceous, atramentous	r	berry-coloured
b	atrorubent	pa	bespeckled

| | | | | |
|---|---|---|---|
| mul | bichrome | pa | brocked |
| mul | bicoloured, bi-coloured | mis | broken |
| mis | bilious | br | brownish |
| pa | birdseye | br | brumous |
| pa | bizarre | br | brunneous |
| b | black hearted | mis | burnt |
| b | black-clad | w | cadaverous |
| b | blacked | mis | cadmium |
| nc | bland | gr | caesious, caesius |
| l | blazing | r | cain-coloured |
| w | bleak | y | calcareous |
| pa | bloached | d | caliginous |
| r | bloodshot | pa | camleted |
| r | blowzed, blowzy | w | candent |
| bl | blue-ringed | pa | candy-striped |
| bl | bluish | y | cain-coloured |
| ac | bold | w | canescent |
| y | bombasic | br | cappucino-tinted |
| y | bombycinous | br | castaneous |
| mul | box-coloured | w | Caucasian |
| met | brazen | w | Caucasoid |
| pa | brended | w | chalky |
| r | bricky | bl | chalybeous |
| l | bright | b | charcoal |
| l | brilliant | mul | chatoyant |
| pa | brindled, brinded | pa | checked |

pa	chequered, checkered	dw	colour-tinted
ori	Chinese	mis	coloury
g	chlorocarpous	br	conker-coloured
y	chlorophanous	met	coppery
g	chloroxanthous	y	corn-coloured
mis	chromatic	b	corvine
chg	chromatogenous	gr	crane-coloured
mis	chromogenic	gr	crane-feather
dw	chromophil	y	cream-faced
chg	chromotropic	y	creamy
gl	chrysal	l	crepuscular
gl	chryselephantine	y	croceous
gr	cinereous	br	crottle, crotal
gr	cinerescent	met	cupreous
gr	cineritious	bl	cyaneous
y	citreous	pl	cymophanous
mis	clear	pp	damascene
l	clinquant	pa	dappled
mis	cobalt	d	dark
r	coccineous	d	darkling
mis	colorific	d	dark-skinned
mis	colourable, colorable	d	darksome
mis	coloured	l	dazzling
mis	colourfast	w	dead white
mis	colourful	w	deathly white
nc	colourless	mis	deep

mis	deep-hued	d	dysphotic
br	deer-coloured	mul	earth-coloured
mis	delicate	w	eburnean
nc	diaphonous	l	effulgent
mul	dichroic	mis	eggshell
mul	dichromatic	mis	eidetic
mul	dichromic	cw	elydoric
l	diffusion	pa	embossed
mis	diluted	r	embrued
d	dim	u	emily-coloured
d	dingy	mul	encaustic
mis	dirty	pa	enchased
mis	discoloured	mul	engrailed
mis	distinct	bl	epipolic
mul	diversicoloured	chg	episematic
pa	dogtooth	br	erne-coloured
pa	dotted	r	erubescent
gr	dove-coloured	r	erythroid
d	dreary	mis	etherean
mis	dull	l	euphotic
d	dusk	nc	evanescent
d	duskish	g	evergreen
mis	dusky	mis	exuberant
br	dust-coloured	nc	faded
mis	dusty	nc	faint
dw	dyeable,	cw	fair

dw	fast	w	fleeten	
cw	fauve	r	flesh-coloured	
r	favillous	r	flesh-toned	
pa	fernticled	gr	flinty	
br	ferruginous	mis	florid	
br	feuillemorte	r	foxy	
r	fiery	pa	freckled	
br	ficelle-coloured	y	freestone-coloured	
ac	flake	ori	French	
r	flame-coloured	mis	fresh	
ac	flamboyant	g	frog-coloured	
ac	flaming	s	frosted	
r	flammeous	mis	fucate	
r	flammulated	mis	fugitive	
r	flamy	l	fulgent	
l	flaring	l	fulgid	
l	flash	b	fuliginous	
l	flashy	mis	full	
nc	flat	mis	full-toned	
y	flavescent	y	fulvid	
y	flavicomous	y	fulvous	
y	flavid	mul	funky	
y	flavous, flavus	br	fuscescent	
gl	flaxen	r	fusco-ferruginous	
pa	flecked	b	fusco-piceous	
pa	fleckered	br	fusco-testaceous	

br	fuscous	g	greenish
mis	gaily-coloured	gr	griseous
y	gambogious	gr	grizzled, grizzly
l	garish	pa	gutté, goutté, goutty, guttée, gutty
mis	gaudy	mul	hand-dyed
gl	gilt-edged	pa	harlequin
br	glandaceous	r	hectic
l	glaring	r	hepatic
bl	glaucous	mul	heterochromatic
l	gleaming	mis	high-coloured
l	gleamy	mis	highly-coloured
l	glenting	b	hirsutoatrous
l	glimmering	r	hirsutorufous
l	glinting	mul	homochromatic
l	glistening	mis	hot
l	glistering	nc	hyaline
l	glittering	mis	hyaloid
d	gloomy	y	icteritious
mis	glossy	mis	ill-coloured
mis	glowing	r	imbrued, embrued
gl	golden	mis	imperial
gl	gold-flecked	gl	inaurate
mis	graphic	l	incandescent
g	grassy	r	incarnadine
g	green	r	incarnate
g	green-eyed	ori	Indian

| | | | | |
|---|---|---|---|
| bl | indigoid | gr | leaden |
| mul | ingrain | gr | leaden-coloured |
| b | inky | l | leaming |
| mis | insipid | pa | lentiginous |
| mis | intense | w | leucomelanous |
| mis | intercoloured | w | leucospermous |
| mis | intermingled | w | leucous |
| mis | intermixable | l | light-coloured |
| mis | intermixed | d | lightless |
| mis | inwrought, enwrought | l | lightproof |
| pl | iridal | l | light-skinned |
| pl | iridescent | ll | lilaceous |
| l | irisated | ll | lilacky or lilacy |
| pa | irrorate | w | lily-livered |
| mul | isochroous | mis | lime-proof |
| pa | jaspé | pa | lineated |
| y | jaundiced | b/bl | livid |
| mis | jazzy | mis | loud |
| mis | juicy | l | lucent |
| mul | labradorescent | l | lucid |
| l | lacklustre, lack-lustre | l | luciferous |
| w | lacteous | l | lucifugous |
| r | laky | nc | luculent |
| l | lambent | l | luminescent |
| r | lateritious, latericeous | l | luminiferous |
| bl | lazuline | l | luminous |

l	lurid	l	micacious	
l	lustrous	mis	mid	
y	luteolous	w	milken	
y	luteous	ori	Milori	
y	luteo-virescent	mis	mineral	
y	lutescent	ori	Ming	
met	manganese	r	miniate, miniatous	
mul	many-coloured	r	minious	
pl	margaric	d	mirk	
pl	margaritaceous	mis	misty	
pa	marmorated	mis	moderate	
ori	Mars	mis	monestial	
y	mastic, masticine	mul	monochroic	
pa	medley	mul	monochromatic	
pa	melanochorous	l	moon-blanched	
b	melanotrichous	ori	Moroccan	
b	melanous, melanic	pa	motley	
y	melichrous	pa	mottled	
pa	mellay	gr	mouse-coloured	
mis	mellow	gr	mousy, mousey	
mis	mellow-coloured	mis	muddy	
pa	menald	br	mulatto	
chg	metachromatic	mul	multi-coloured, multicoloured	
met	metallic	mul	multi-hued, multihued	
chg	metameric	d	murky	
chg	meteoric	br	musk-coloured	

mis	muted	br	ochreous
pl	nacreous	y	ochroid
pa	nævous	br	ochry, ochery
ori	Naples	nc	off colour
mul	natural	d	offusc
w	natural-coloured	mis	old
d	nebulous	g	olivaceous
nc	neutral	pl	opalescent
y	nicotine-stained	pl	opalesque
b	nigrescent	pl	opaline
b	nigresceous	l	opaque
b	nigricant	o	orangey, orangy
b	nigrous	r	orthochromatic
l	nitid	d	overcast
l	nitidous	pa	Paisley
w	niveous	mis	pale
w	nixious	l	pallid
l	noctilucent	l	pallidiventrate
l	noctilucous	mis	panchromatic
chg	non-fading	mul	paned
d	obfuscous	nc	parachrous
d	obscure	w	parsnip-coloured
d	obsidian	pa	parti-bendy
d	obsidional, obsidionary, obsidious	mul	parti-coloured
		mis	pastel
pa	ocellated	pt	pastose
br	ochraceous, ochreous, ocherish		

w	pasty	met	plumbeous
bl	pavonine	mul	polychroic
bl	peacock-coloured	mul	polychromatic
pl	pearlescent	mul	polychrome
l	pellucid	g	porraceous
mul	pentachromatic	br	porridge-coloured
u	pepper-coloured	g	prasinous
mul	pentachromic	mis	pristine
pl	perlaceous	chg	procryptic
mis	permanent	w	pruinose
d	phalochrous	ori	Prussian
r	phenicious	chg	pseudoposematic
br	philimot	mul	psychedelic
l	phosphorescent	cw	puddled
l	photic	br	pulveratricious
l	photophilous	pa	punctate
mis	phthalo	pa	punctulated
b	piceous	r	puniceous
pa	piebald	mis	pure
pa	pied	pp	purplish
p	pinkish	pp	purpuraceous
pa	pinto	pp	purpurate
b	pitchy	pp	purpure, purpureal
nc	plain-coloured	pp	purpurescent
mul	pleochroic	pp	purpuriferous
met	plumbaceous	pp	purpurogenous

r	pyrrhotism	nc	risque
r	pyrrhous	ori	Roman
gr	quaker-coloured	r	roseate
mis	quiet	r	rose-coloured
u	quiet-coloured	r	rose-tinted
l	radiant	r	roslny
pl	rainbow-coloured	r	rubedinous
mul	rainbow-like	r	rubent
ori	Rajasthan (reds)	r	rubescent
r	rambunctious, rumbunctious, rumbustious, robustious	r	rubicund
		r	rubied
b	raven-haired	r	rubiferous
mis	raw	r	rubiform
pa	rayed	br	rubiginous
r	recalescent	r	rubine
r	red hot	r	rubineous
r	red-blind	r	rubious
r	red-blooded	r	rubrical
r	redbrick	r	rubriform
r	redder	r	ruddy
r	reddish	r	rufescent
r	red-faced	r	ruficarpous
l	refulgent	r	ruficaudate
l	relucent	r	rufous
l	resplendent	r	rufulous
mis	rich	r	rutilant
mis	rich-coloured, richly-coloured		

r	rutile	w	sheep-hued
r	rutilous	mis	sheer
br	sabelline	br	sherry-coloured
mis	sad	l	shimmering
br	saddle-coloured	l	shining
y	sallow	l	shiny
y	sanded	mul	shot
y	sandy	s	silver
r	sanguineous	s	silverly
r	sanguinolent	s	silvern
r	sarcoline	s	silvery
mis	saturated	bl	skyey
gr	schistaceous	gr	slate-coloured
bl	schistous	gr	sludgy
d	scialytic	mis	smouldering
l	scintillant	br	snuff-coloured
l	scintillating	mis	sober-coloured
l	searing	mis	soft
y	sebaceous	mis	soft-focussed
nc	see-through	mis	sombre
b	self-black	mis	sombrous
mul	self-coloured	br	spadiceous
chg	sematic	l	spangled
nc	semi-opaque	ori	Spanish
mul	septicoloured or septi-coloured	l	sparkling
mul	sere-coloured	pa	speckled

| | | | | |
|---|---|---|---|
| mis | spectral | l | sun-drenched |
| mul | spicy | l | sunny |
| l | splendent | l | sunrise |
| pa | spotted | d | swarthy |
| pa | sprainged | pa | tabby |
| mis | spring | br | taffy-coloured |
| mis | stark | br | tanned |
| pa | stippled | chg | tarnished |
| d | storm-darken'd | pa | tartan |
| y | stramineous | mis | tawdry |
| y | straw-coloured | br | tea-coloured |
| pa | streaked | d | tenebrific |
| pa | striated | d | tenebrose |
| mis | strident | d | tenebrous, tenebrious |
| pa | striped | pa | tesselated |
| mis | strong | br | testaceous |
| b | Stygian | br | testudinarious |
| mis | subdued | mul | tetrachromatic |
| d | subfusc | mul | tetrachromic |
| cw | substantive | d | thestral |
| mis | succulent | mis | tinctorial |
| br | suede-coloured | mis | tinged |
| p | sugar-almond | mis | tingible |
| y | sulphureous | mis | tinted |
| mis | summer | br | toffee-coloured |
| l | sunbaked | mis | toned |

nc	translucent	ori	Venetian, Venice
nc	transparent	g	verdant
nc	transpicuous	g	verdurous
mul	trichromatic, trichromic	r	vermeil-tinctured
mul	tricoloured	mul	versicoloured
bl	true blue	mis	vibrant
ori	Turkey	r	vinaceous, vinous
ori	Tuscan-coloured	r	vinous
mul	two-coloured	v	violaceous
mul	twopence-coloured	v	violascent
mul	two-tone, two-toned	v	violescent
mis	ultra	g	virent
br	umbery	g	virescent
d	umbrageous	g	virid
d	umbrated	g	viridescent
d	umbratile	y	vitelline
d	umbriferous	nc	vitreous
w	unbleached	pa	vittated
nc	uncoloured	ac	vivid
g	ungreen	d	wan
mul	unicolourous	mis	warm
l	unlit	pt	waterproof
b	ustulate	mis	watery
pa	variegated	y	wax-coloured
mul	varihued	w	waxen
mul	variously-coloured	mis	weak

mis	well-coloured
w	wheatish
w	whey
w	wheyface
w	white-hot
w	white-knuckle
w	white-livered
w	whitish
mul	whole-coloured
mis	winter
y	xanthic
y	xanthodont
y	xanthogenic
y	xanthomelanous
y	xanthospermous
y	xanthous
y	yellowish
y	yolk-coloured
pa	zebra-striped